W. BARKSDALE MAYNARD

Yale University Press New Haven & London

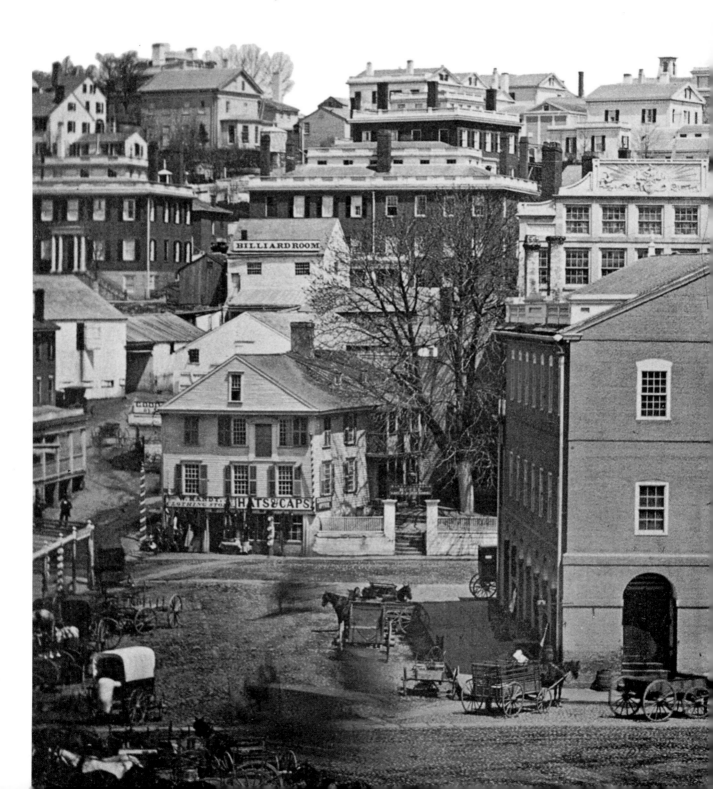

ARCHITECTURE IN THE UNITED STATES, 1800–1850

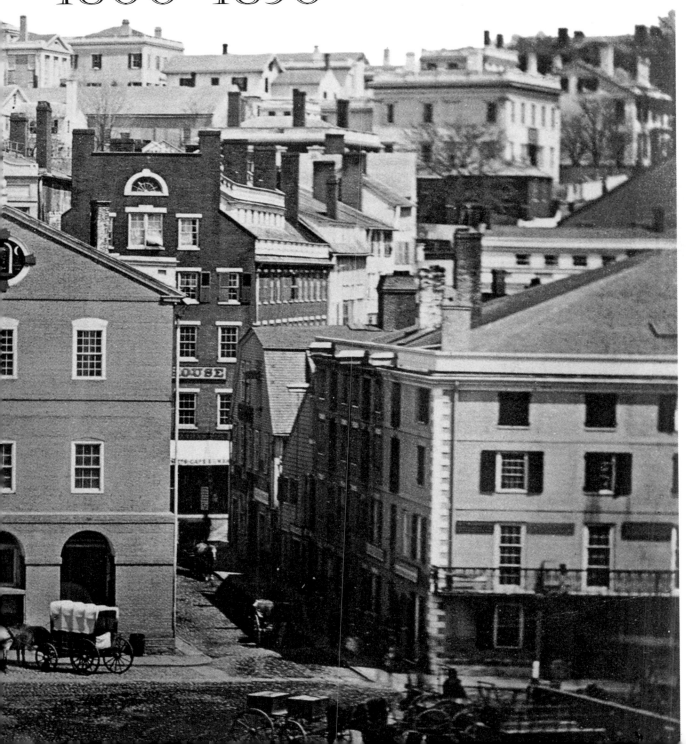

Published with the support of a grant from the
Graham Foundation for Advanced Studies in the
Fine Arts

Designed by Richard Hendel
Set in Monotype Bell and Castellar by Eric M. Brooks
Printed in China through World Print LTD

Library of Congress Cataloging-in-Publication Data
Maynard, W. Barksdale (William Barksdale)
Architecture in the United States, 1800–1850 /
W. Barksdale Maynard.
 p. cm.
Includes bibliographical references and index.
ISBN 0-300-09383-7 (alk. paper)
1. Architecture—United States—19th century.
2. Architecture—United States—European influences.
I. Title.
NA710 .M39 2002
720'.973'09034—dc21 2001008496

A catalogue record for this book is available from the
British Library.

The paper in this book meets the guidelines for permanence
and durability of the Committee on Production Guidelines for
Book Longevity of the Council on Library Resources.

10 9 8 7 6 5 4 3 2 1

Additional illustration credits: p. i: fig. 3.12; pp. ii–iii: fig. 2.37,
detail; p. vi: fig. 3.10; p. xiv: fig. 1.18, detail; p. 50, fig. 2.27, detail;
p. 166: fig. 4.15, detail

CONTENTS

PREFACE

This book addresses a subject that many people find intriguing, the development of United States architecture between 1800 and 1850, from the age of Jefferson to the antebellum period. Much has changed in the field since William H. Pierson's coverage of these years in *American Buildings and Their Architects* in the 1970s: half of all dissertations ever written on American architecture have appeared; there have been biographies of Mills, Downing, and other major figures; the Latrobe papers have been published; the field of vernacular architectural history has exploded. A great tide of regional and local studies has flowed from academics and preservationists, so that every state would now seem to have at least one book on its architecture—and the *Buildings of the United States* series promises one or more additional volumes for all of them. A surprising number of individual counties and cities have received monographic treatment. As its bibliography will show, the present book owes an enormous debt to the many historians who have contributed to this extraordinary, ongoing renaissance.

In spite of all that has been written, however, the period 1800–1850 is arguably understudied. It has received only half as much attention as 1850–1900, to judge by the number of dissertations produced. And persistently neglected has been one of the most important themes of the era—the profound dependence of American architecture, in both theory and practice, upon Great Britain. One can judge how little this subject has been emphasized by trying to find comparative illustrations of English buildings in books on American architecture, or the names of foreign architects in their indexes. Looking up "John Nash" in twenty-five likely sources recently yielded a mere ten references out of eight thousand total pages—and this for the chief figure in the architecture of early-nineteenth-century Britain. Some writers seem to take the British connection for granted, perhaps finding it too obvious to warrant examination; others, however, have deliberately denied it. The latter tendency goes back at least as far as the most influential volume ever written about the era, Talbot Hamlin's *Greek Revival Architecture in America* (1944).

This vastly erudite and thoroughly researched study, which appeared just as the United States came to the rescue of European civilization during World War Two, ignored the British Greek Revival almost completely. Not one of the leading architects of that movement—Wilkins, Smirke, Cockerell, Barry, Burton, Goodwin, Foulston, Foster, Hamilton, Playfair, Burn—was even mentioned.

Hamlin's stirring, heroic narrative of nineteenth-century American architecture stressed feisty independence, not insecure reliance upon the traditions of the Old World. Awed by America's modern greatness, we easily overlook how small, undeveloped, and culturally backward the nation once was, or how dependent upon the aesthetic example of Europe. Political freedom came in 1782, but cultural freedom took much longer. To paraphrase Horatio Greenough's 1843 essay on "American Architecture," "We forget that, though the country was young, yet the people were old"—we suppose that a clean break came at Yorktown and underestimate how slow the close ties of nearly two hundred colonial years were to diminish. Perhaps it helps to recall that every United States president up until 1837, well beyond the midpoint of the period we are considering, had been born a British citizen.

Of course, the English cultural tradition was not the only one in the United States. A 1986 book gave near-equal space to the architectural contributions of twenty-two ethnic groups, English being only one. But this model cannot be applied to the early Republic, during which time the English element overwhelmingly dominated. In 1790, three-fifths of whites in the United States were of English descent, and the combined 15 percent who were of German, Dutch, French, or Swedish heritage were vastly outnumbered by the 80 percent who came from the British Isles. Even among newcomers, the Isles remained a dominant presence: they accounted for more than half of all immigrants who arrived between 1820 and 1830, the middle decade of our period; they were the birthplace of 60 percent of foreign-born Americans as late as 1850; and even in 1900, more than one in three second-generation Americans claimed primary ancestry there. In 1800–1850, the other ethnic traditions were lively and interesting, but localized and not absolutely fundamental to understanding the shared architectural culture of the entire nation. The Spanish architecture of the Southwest was especially rich, but not discussed here for the simple reason that the vast majority of American citizens had no contact with it at all. This is not a history of contemporary America, but of America of some two centuries ago, and the following facts about 1850 should always be kept in mind: nearly 90 percent of the United States population still lived east of the Mississippi; more Americans inhabited Penn-

sylvania than the entire trans-Mississippi West; Texas and California had a combined population smaller than Vermont's; and, remarkably, the center of the nation's population still lay within the bounds of the state of Virginia.

So this book treats the architectural culture of the majority of the citizens of the United States, who happened to inhabit the East. This subject alone is vast, even without adding discussions of adobe missions, sod houses, or Native American lodges. Compare it to the contemporaneous architecture of Great Britain, about which many books have been written: the one state of Virginia had 1.3 times the area of England, and there were more than thirty states by 1850. The United States in 1840 was only half the geographical size it is today, but even so was eight times bigger than France and nearly nineteen times the size of the United Kingdom.

Any study of strictly fixed length must be highly selective and will show the author's own predilections. The present book tries to offer something new: a survey built around intellectual themes, one that places the United States in transatlantic context and casts a skeptical eye on overstated claims for American uniqueness. Its five chapters are designed each to discuss a few major topics in detail, rather than attempting to cover numberless points superficially in pursuit of a putative completeness. They deliberately avoid treading in the tracks of previous studies, which will explain certain reasoned omissions. Churches in general and the Gothic Revival in particular are not emphasized, as no one doubts that England played the chief role in our religious architecture, from James Gibbs to the Ecclesiological Gothic movement. Instead, domestic architecture is stressed, both because it was disproportionately important in early, rural America and because here England's role has been especially slighted. There are many good books currently available on building types, individual architects and patrons, and architectural technology, so the present one—hoping to cover new, neglected ground—does not consider these subjects in detail. For more on architects' lives, interested readers will want to consult biographical dictionaries and the *Macmillan Encyclopedia of Architects* (1982).

The years covered are 1800–1850, with a few examples given from earlier or later if they shed valuable light. This half-century forms a convenient unit for consideration; it follows the post-Revolutionary transitions of the 1780s and 1790s and precedes the enormous stylistic and technological changes of the 1850s. If the emphasis often seems to be on the latter half of the period, that is due to the greater abundance of written sources and the dramatic growth in population. To extrapolate from the census, for every one dwelling standing in 1800 there were likely two by 1820, three by 1840, and more than

four in 1850. There is simply more architecture to consider in the later decades, and more architects.

As much as possible, contemporary voices have been allowed to tell the story. This has been done partly to suggest, as Sir Nikolaus Pevsner's 1972 book *Some Architectural Writers of the Nineteenth Century* did for England, the enormous wealth of primary materials that exist, as well as to escape the fishbowl of secondary citations. The illustrations have been chosen carefully, with the goal of showing the original, unaltered building in context. Because the total number of pictures was tightly restricted, after careful consideration it was decided that plans would not be included; their great utility had to be weighed against the even greater value of first-rate historical prints and photographs, some rarely or never published before, which are here treated as important sources of their own. The reader may be glad to know that many thousands of plans, drawings, and photographs from the Historic American Buildings Survey, Library of Congress, have recently become available to everyone online, in a searchable, easy-to-use format that can abundantly supplement the illustrations in the present volume.

"A man will turn over half a library to make one book," Samuel Johnson said, and for nine years mine was the University of Delaware's. Its Special Collections are outstanding, and its Unidel History of Horticulture and Landscape Architecture Collection deserves to be better known. It was a pleasure to explore some of its 5000 publications, which include Bishop G. W. Doane's copy of Downing's *Landscape Gardening*, signed by Doane at his New Jersey villa, Riverside, on 15 August 1841. The present book originally derived from my Delaware dissertation (1997), and so I wish to thank my committee, William I. Homer, Wayne Craven, David B. Brownlee, and especially my adviser, Damie Stillman, whose book on neoclassicism in the Young Republic is eagerly awaited. I am grateful, too, for a 1997 Winterthur Research Fellowship and the chance to study the Picturesque at a country estate that bears many of the hallmarks of that earlier philosophy.

For their kind assistance I wish to thank William Allen, Jenny Ambrose, John Archer, Charles E. Brownell, Jeffrey A. Cohen, Arthur Channing Downs, William A. Frassanito, Joel T. Fry, Robert S. Gamble, Bernard L. Herman, J. Murray Howard, Jane Holtz Kay, Francis R. Kowsky, Gary Kulick, Elizabeth Laurent, Carl Lounsbury, Thorpe Moeckel, Dennis Montgomery, James F. O'Gorman, Ellwood C. Parry, C. Ford Peatross, Charles Peterson, Jessie Poesch, Daniel D. Reiff, Pamela Scott, Neville Thompson, and Leslie P. Wilson. At Yale University Press, Judy Metro accepted the manuscript and Patricia

Fidler expertly saw it through to publication, along with the extraordinarily capable staff of editors and designers. Anonymous readers assisted with the manuscript and grant proposal. Many librarians were tirelessly helpful, including those at The Library Company. For a young scholar, the cost of purchasing hundreds of photographs for publication can be nearly overwhelming, and so I am grateful to this and other institutions that thoughtfully waived or reduced certain fees. Color photographs were made possible by a generous grant from the Graham Foundation for Advanced Study in the Fine Arts.

I am deeply grateful for the assistance of my parents, George and Isabel Maynard, without whom this book could never have been written, and my sister, Mims Zabriskie. Very special thanks to Susan Matsen for her constant support and good ideas.

I hope this book will be readable and useful. For the mistakes that a study of this length must inevitably contain, I apologize and hope that readers will inform me of them. I will be pleased if something in the pictures or text captures the imagination of a student; if the house-museum docent finds information to broaden a public interpretation; if the homeowner comes away with a greater appreciation of the history of the American suburban dwelling; and if a critical and spirited dialogue is encouraged on the true transatlantic contexts of the architecture of the United States.

ARCHITECTURE IN THE UNITED STATES, 1800–1850

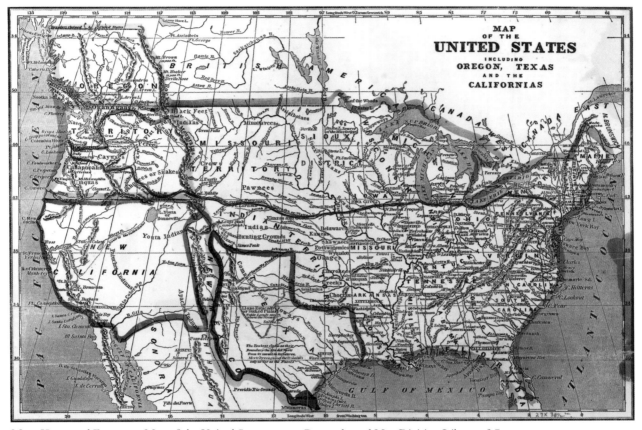

Map. *Haven and Emmerson,* Map of the United States, *1846. Geography and Map Division, Library of Congress*

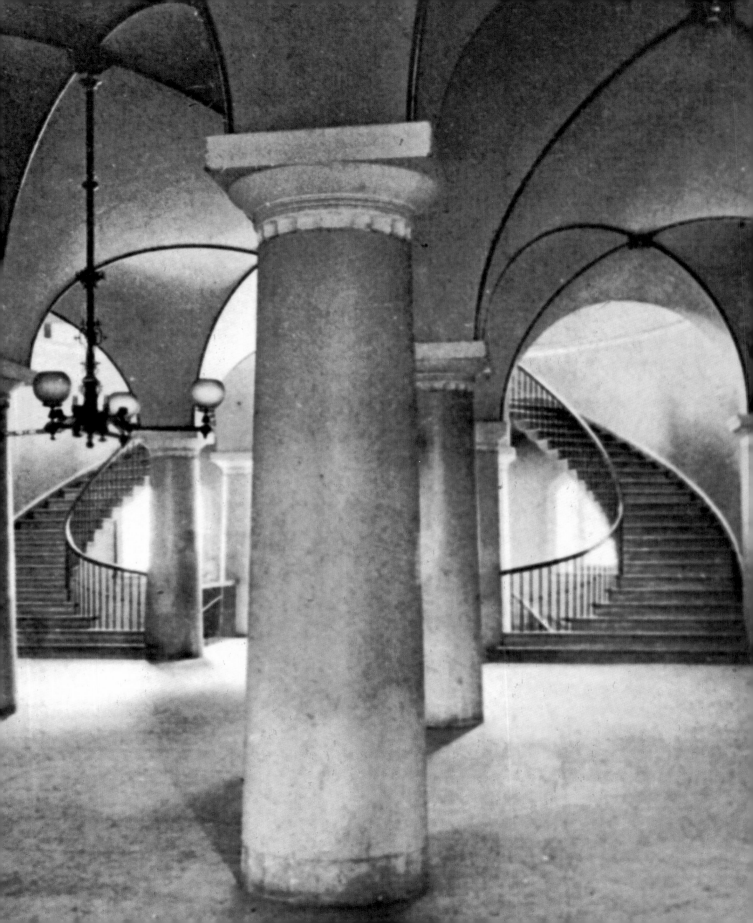

 n the outskirts of Philadelphia in the spring of 1845, a shining marble temple neared completion. Its surroundings were very different from the scenic rocky promontories of ancient Greece—it rose among fallow fields that were just beginning to sprout houses along a grid of streets as the burgeoning city flowed northwestward—but in feel and attention to detail, it enthusiastically emulated Greek architectural achievements (fig. 1.1). The side colonnades of Girard College had been finished in 1841 and the front in 1844; now the rear elevation was rising, and tourists wandered among the stonemasons and craned their necks upward at "one of the most beautiful structures of modern times." Architect Thomas U. Walter had designed the classroom building and campus following somewhat-oddball instructions in the will of Stephen Girard, the wealthiest private banker America has ever produced, with the purpose of housing a school for three hundred "poor male white orphan children." The philanthropic and reformist bent of the endeavor was typical of the times, as was Girard's inspiring rise from the modest fortunes of an immigrant to a man of great means. A sum of $1.93 million was being spent on the institution, about equal to the price of completing the United States Capitol during the sixteen years following the 1814 fire, four times what William Strickland's Second Bank of the United States had cost, and eleven and a half times Benjamin Henry Latrobe's Bank of Pennsylvania—the latter two being handsome predecessor Greek Revival buildings elsewhere in Philadelphia (figs. 2.15, 5.6, and 5.4).[1]

The superlatives of Girard were proudly quoted: 13,537 tons of marble were employed and twelve million bricks; the front door was thirty-two feet high; the thirty-four columns each soared to fifty-five feet, with some of the drums taller than a person (fig. 1.2). The Choragic-Monument-of-Lysicrates capitals alone were more than eight feet high, composed "of twelve separate pieces, all securely dowelled and cramped together." Marble slabs four feet square and each weighing 776 pounds comprised the roof, as Girard had wanted; there were 2,064 in all, and the total weight of the covering (includ-

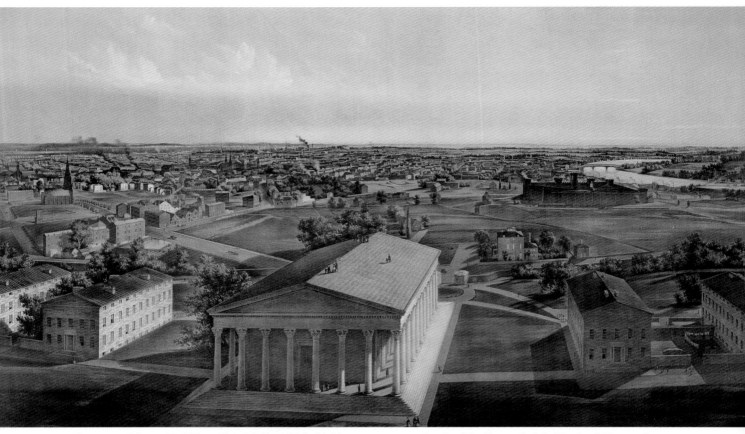

Figure 1.1. *Thomas U. Walter, Girard College, Philadelphia, 1833–47, rear view. In right distance is John Haviland, Eastern State Penitentiary, 1823–29. B. F. Smith, Jr.,* Philadelphia, from Girard College, *1850, tinted lithograph, 27⅓ × 41½ in. (69.5 × 105.5 cm). The Library Company of Philadelphia [7633.F]*

ing marble chimney tops, cast-iron skylights, and lead gutters) was 970 tons. Reckless as it may seem to us today, rooftop promenading was cheerfully allowed, and tourists enjoyed a sweeping view from high atop this showpiece of architectural and cultural progress in the young Republic.[2]

At the exact moment that laborers worked in spring 1845 to raise the remaining columns of Girard College—at a staggering cost of $12,994 each—a very different kind of building was under construction outside Boston. In March, writer Henry David Thoreau "borrowed an axe and went down to the woods by Walden Pond, nearest to where I intended to build my house, and began to cut down some tall arrowy white pines, still in their youth, for timber." With his own hands he fashioned the frame of main and floor timbers, studs, rafters, and king and queen posts. In addition, he used recycled boards from an Irishman's shanty and bricks from an eighteenth-century chimney.

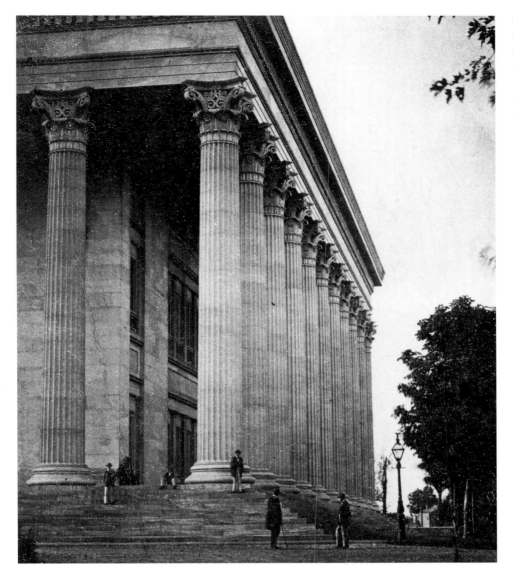

Figure 1.2.
*Girard College, side
colonnade. Photograph
by John Moran, ca. 1863.
The Library Company
of Philadelphia
[8339.F.11]*

His house measured ten by fifteen feet and cost him all of $28.12½. No one
ever promenaded on its roof, but a whippoorwill sometimes sang from the
ridgepole. Thoreau eventually wrote a book about the two years he spent liv-
ing alone there, *Walden*, and illustrated his house prominently on the fron-
tispiece (fig. 1.3).[3]

Girard College and Thoreau's Walden house stand at the opposite extremes
of American architecture in the period 1800–1850, but they are not entirely
dissimilar. Walter and Thoreau were both young, ambitious sons from the
kind of hardworking and respectable families that were often pointed to as

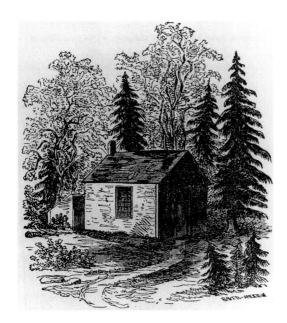

Figure 1.3.
Henry David Thoreau,
House at Walden Pond,
Concord, Massachusetts,
1845. Removed 1847.
Frontispiece to Thoreau,
Walden, *1854. University*
of Delaware Library,
Newark

an ideal: Walter's father was a skilled brick mason, Thoreau's a pencil maker who, by 1850, could afford the plain but substantial "Yellow House" on Concord's Main Street. Thoreau helped make pencils in an annex but spent most of his time writing at his desk in an attic room. Both Walter and Thoreau turned to architecture to communicate lofty aspirations and ideals: Walter's temple expressed the noble theme of charity and the potential for cultural sophistication that was latent in the young nation, whereas Thoreau's Walden house symbolized his Transcendental ethos of simplicity and essentialism. Both buildings were ultimately undergirded by the contemporary zeal for reform. Even the classical heritage of Walter's edifice was not entirely foreign to Thoreau's little house; Thoreau's thought, like that of many educated contemporaries, had been molded by "the classics . . . the noblest recorded thoughts of man," and he seems to have conceived of his dwelling as a so-called primitive hut of the kind believed to have been ancestral to the Greek temple, a fitting place for him to emulate the life of "the heroic writers of antiquity." In this regard, a suggestive link between his house and Girard College was the temple-form log cabin designed a few years earlier by New York architect Alexander Jackson Davis (fig. 1.4).[4]

In these years, architecture did not yet belong to architects alone; educated laypersons often made vigorous contributions to theory and practice. The tangible achievements of both Walter and Thoreau were put on public display through text and image for the edification of a wide audience, particularly the middle class from which the builders themselves emerged. A lively dialogue concerning architecture and culture was encouraged, and although Thoreau's book found little following until a generation or two later, Girard College was a contemporary sensation, and Thoreau himself, in 1854, was one of its countless visitors. Finally, although both men were proudly American, their intellectual tradition was defined by Britain—Thoreau imitating the style of radical Scotsman Thomas Carlyle, Walter working within the Greek Revival pioneered by English architects and traveling to England for advice on the marble roof. As different as they may appear, then, both buildings sprang from the common conditions and concerns of the times and can suggest the fascinating, diverse, and—most appealing—*intellectually rich* nature of American architecture, 1800 to 1850.

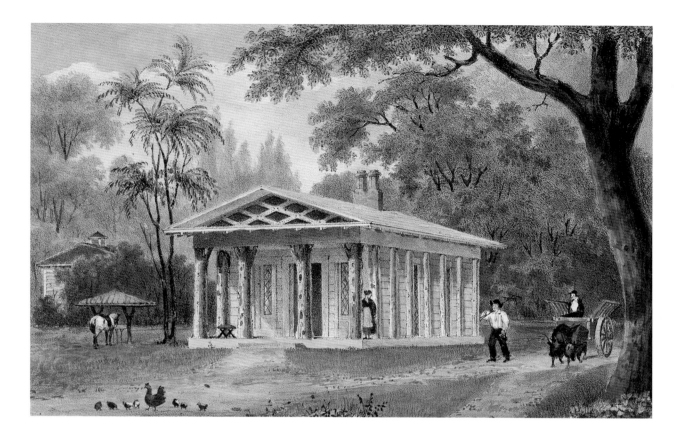

Change

These years brought profound alterations as the Industrial Revolution worked its myriad effects and the economy began to surge. They are especially interesting for being divided in nature, for traditional eighteenth-century attitudes persisted even as the modern world and its noisy technologies arrived; in the writings of the time the measured gentility of the old order often contrasts strikingly with the brash hyperbole of the new. Progressive and conservative social impulses struggled for dominance, so that a period that brought many humane improvements ended bleakly with the Fugitive Slave Act. The elegance of southern architecture, in particular, coexisted with the painful reality of slavery, as when one of the finest New Orleans hotels doubled, without thought of incongruity, as an auction house for slaves (fig. 1.5). In Harriet Beecher Stowe's novel, Uncle Tom was sold in such a place, "beneath a splendid dome"—for "these days men have learned the art of sinning expertly and genteelly."[5] For the student of history, the steam press and the

Figure 1.4.
Alexander Jackson Davis,
American House or
American Cottage No. 1,
*1837, lithograph with
watercolor and ink, 13⅝ ×
10¼ in. (34.3 × 26 cm).
Avery Architectural
and Fine Arts Library,
Columbia University in
the City of New York*

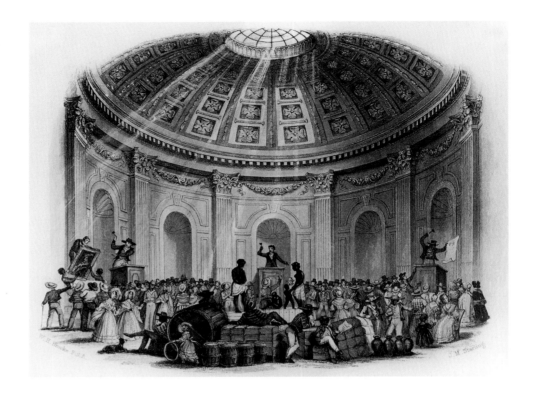

explosion of publishing ensure that there are a great number of sources about architecture for this period, a happy medium between the relative poverty of eighteenth-century written accounts and the near-unmanageability of the late nineteenth, when whole journals were devoted to the subject. The prose is fluent and detailed, providing a copious store of historical information, particularly since architecture was a favorite subject of discussion. Its prestige among the public was as high, perhaps, as at any other time in our history; Americans were attuned to the beauties of classicism through the Greek and Latin texts of their education, the bountiful press allowed wide dissemination of architectural ideas, prosperity put homebuilding within the reach of many, and the civil engineer had barely begun to rival the architect in garnering a measure of popular esteem—indeed, as with Latrobe, they were often still the same person.

In imagining ourselves back into the past, it is essential to keep in mind that, by any measure, America of the early nineteenth century was profoundly different from America in the twenty-first—still "rural-minded, racially homogeneous, economically differentiated, regionally oriented, unprepared for the onslaught of technology." Population is a key index: the United States in 1813 had only as many people as the small state of New Jersey has today, and

in 1860 only as many as California. New York was by far the most populous city in 1850, with 645,000 inhabitants, but with that same number today it would rank sixteenth, behind Columbus, Ohio (fig. 1.6). Incredibly, some world *cities* now have more people than the entire United States did in 1850 (23 million). Population densities are far higher, as a rural and agricultural America has given way to suburban development on a scale formerly unimaginable—a triumph, ironically, of the Picturesque mindset we shall be considering. The traveler who was surprised to find suburbia creeping up the scenic Hudson Valley in 1843 would be amazed to hear that even remote canyons of the Rocky Mountains are today filling with houses. In 1828 the states of Massachusetts, Connecticut, and Rhode Island, which collectively boasted fewer than 70 persons per square mile, marked "the maximum of the density of American population." The densities of these same three states in 1999 were 745, 654, and 818 persons per square mile—an astonishing increase. Even at its *densest*, then, the American landscape of the early nineteenth century was what we would call sparsely settled today. These and other great differences between their world and ours should make us pause before we jump to easy conclusions about their mentality. We are far removed from them in almost every way.[6]

Agriculture was a fundamental reality of life for most Americans—involving 76 percent of the workforce in 1820—and rural architecture loomed large as a subject of importance, larger than it ever would again. No sooner did Thoreau cross the railroad tracks at the edge of his native Concord than he was surrounded by agricultural activity of all kinds: "The farmers improve this season which is the driest [September]—their haying being done & their harvest not begun to do these jobs—burn brush—build walls—dig ditches cut turf. This is what I find them doing all over the country now—also topping corn & digging potatoes." Thoreau was one of America's most sensitive recorders of the complex countryside interplay between tradition and innovation, old folkways and modern technologies, that made the period fascinating and yet painfully disruptive; his mood was often elegiac, and he was sure he had been born "in the very nick of time." Today the railroad still rumbles through Concord, but Thoreau would be startled to find that farming is extinct and that second-growth woods or tract houses stand where he knew fields and pastures. Again, that earlier America is gone forever, the agriculture that provided a livelihood for 42 percent of its citizens as late as 1890 dwindled to 1.9 percent by 1990, so that, argues farmer-scholar Victor Davis Hanson, "Americans have completely forgotten the original relationship between farming and democracy" and no longer have the old agricultural "love

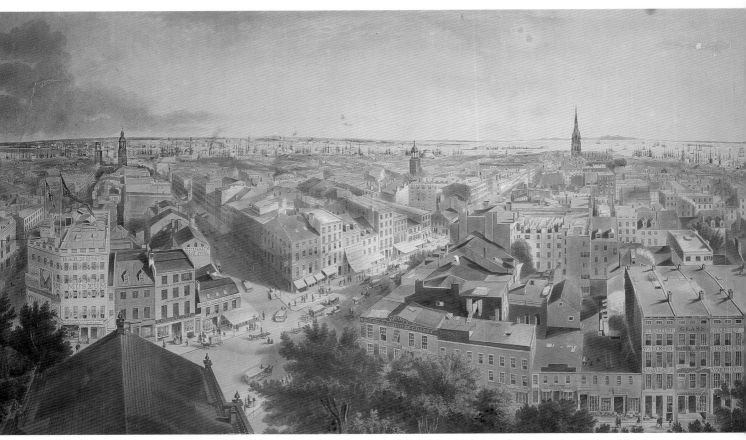

Figure 1.6. *John William Hill, engraved by Henry A. Papprill,* New York from St. Paul's Steeple, *1848, colored lithograph, 21⅜ × 36⁷⁄₁₆ (53.9 × 92.7 cm). At left, Barnum's Museum. At distant right, Richard Upjohn, Trinity Church, 1841–46. I. N. Phelps Stokes Collection, Miriam and Ira D. Wallach Division of Art, Prints and Photographs, The New York Public Library, Astor, Lenox and Tilden Foundations [Deak 578]*

of soil, . . . legacy of hard work, loyalty to family, town, and country, or even fealty to a common culture." Certainly we have difficulty appreciating the single-mindedness of the Massachusetts soldier pinned upon the ground with his unit by Confederate fire in the bloody Battle of the Wheatfield at Gettysburg, who even in these alarming circumstances carefully gathered seeds from Mr. Rose's vigorous wheat crop to send home. We are culturally oriented toward cities and can hardly conceive what a source of artistic and cultural strength the countryside was considered to be. It may seem odd to us, for example, that A. J. Downing's important architectural ideas were disseminated in a journal called *The Horticulturist.* No one today would argue, as architect John W. Ritch did in 1847, that "Agriculture is the great Parent of the Arts," or readily understand what the marquis de Chastellux meant in saying,

"As long as a taste for the arts can assimilate itself with rural and domestic life, it will always be advantageous to [the] country."[7]

Even before the huge territorial additions of 1845–48, the area of the United States was three times that of the United Kingdom, France, Spain, and Italy combined. To an extent that is difficult to appreciate, development, then called "improvement," seemed a matter of tremendous collective urgency, given the vastness of the landscape to be tamed and made habitable and fruitful. House building played a key role in this national drama. We are so enamored of the idea of the log-cabin pioneer living in the wilderness, however, that we easily forget that most Americans lived in safe, long-settled regions even in 1800. Their efforts were expended in more mundane matters than hewing down monstrous oaks or battling Indians but ultimately shaped the patterns of national life far more than did those relatively few people living on the western fringes (fig. 3.34). Wilderness, for all its awesomeness in our collective mythology, constituted a surprisingly fragile web of ecological relationships that had broken down rapidly in the face of human encroachment, and to a degree greater than is commonly supposed, it had already been subdued throughout much of the eastern states before the end of the eighteenth century. Peter Kalm wrote of the Middle Colonies in 1748, "The country is well peopled, and the woods are cut down," and Thoreau looked in vain even for deer in Concord. At his Walden house he occupied not the forest primeval but a brambly clearing larger than eight football fields, with a remnant pine woodlot behind him.[8]

The challenge that confronted most Americans was not doing battle with wild nature but imposing a European model of pastoralism on an untidy post-wilderness environment of stump-strewn clearings, in order to overcome what visitor Basil Hall called "that ragged appearance, so comfortless and hopeless-looking in most newly settled countries." For the aesthetic-minded, America needed to move quickly to tidy up these omnipresent "scruffy realities of rural life." This problem was not confined to remote regions but was acute on the suburban fringe of major towns, where, a contemporary wrote, "vacant building lots—everything of that kind which forms the outskirts of a city—[we]re dreary, desolate, and dolorous to a very great degree, neither city nor country, but a detestable approximation to both." Girard College rose in such a setting. These places had long since been conquered; now came the difficult nineteenth-century challenge, to render them civilized and aesthetic. This was hard to do, as Frances Trollope discovered when her rural retreat near Cincinnati was spoiled when "a slaughter-house for hogs" was erected nearby.[9]

The most interesting dwellings of the period were considered to be those of the "opulent Agriculturist" or the "retired Merchant"—that is, the new homes being built in the farmed countryside or the suburbs—for it was in the "desolate" outskirts of the cities that the familiar American suburban identity began to coalesce. Bigger cities meant bigger outskirts, and urban growth was extraordinary: the fastest rate of urbanization in American history occurred between 1820 and 1860. In 1800 there were 33 towns with a population of more than 2,500; by 1830 there were 90, and by 1850, 236. The ninety-one-year-old former signer of the Declaration of Independence, Charles Carroll of Carrollton, told visitors in 1827 that he could remember when Baltimore "was a village of only seven houses," whereas it now had a population of 70,000. By 1850 it was America's fourth-largest city, at 169,000 (fig. 1.7). Many of Carroll's peers could share similar stories of phenomenal growth and change during their lifetimes. John Kane remarked to the crowd gathered for the dedication of the Philadelphia Exchange on busy Dock Street in 1832, "There are even now those living amongst us, who perhaps may remember when the site which it is to occupy, was the shore of a sluggish and winding stream, where the fisherman might dry his nets" (fig. 5.10). Other citizens enjoyed reminding one another of childhood visits to bucolic duck ponds out Market Street—flooded claypits for the brick trade—that were scattered across districts densely urbanized by 1850. By that date, the exploding Quaker City boasted 60,000 houses and added 3,500 new buildings every year.[10]

The suburbanization of America is often considered hermetically as a national development that began "anywhere from 1869—the founding date of Riverside, Ill.—to 1880." In fact, suburbia was a habit learned from England early on, where, a historian writes, "many a man who, after the Battle of Waterloo, had built himself a stylish villa on a dusty road leading out of town found that he was surrounded on every side by other equally stylish villas—Greek, French, Italian, Gothic; each with an ample garden. This clearly was suburban development." England had the jump on America because it was much more urbanized. In 1850, the United Kingdom had thirty-three cities of more than forty thousand inhabitants; the United States, though by then a more populous nation, had only fourteen. The center of suburban development was around London, which grew at great speed and reached a size no American city could rival. In 1850 it was three and a half times larger than New York and had been the world's largest city for a generation; Gotham would not surpass it until the 1920s. A Londoner wrote in 1834, "The increase in the size and population of the British metropolis within a few years is truly amazing. It is no unusual event to meet in society persons who recol-

Figure 1.7.
Baltimore, 1849.
On horizon is Benjamin
Henry Latrobe, Baltimore
Cathedral, 1804–18; in
front of it, Robert Cary
Long, Sr., Saint Paul's
Episcopal Church,
1812–17, burned 1854;
center, Robert Mills,
Washington Monument,
1815–24, statue raised
1829. Daguerreotype by
Henry H. Clarke. The
Maryland Historical
Society, Baltimore

lect those portions of what must now be called the metropolis when they were nothing but fields or swamps."[11]

These burgeoning British cities spawned the modern suburban movement, partly as a result of the ongoing removal of wealthy and talented individuals from the countryside (as seen, for example, in the early career of biographer James Boswell). Suburbia offered a partial return to familiar surroundings for these new urban dwellers. Such development became more desirable as cities grew fearfully crowded, their skylines studded with thousands of polluting chimneys, as views of the period strikingly show (fig. 1.8). In modern times, however, the longstanding British love of suburbia has borne the same ill fruit as has America's: depopulated cities and rampant low-density development of the landscape. England is today one of the world's most densely populated regions, yet its *urban* housing concentration is the lowest in the European Union, some of its failing cities like Liverpool and Manchester showing one-tenth to one-fiftieth the density of Continental cities where sprawl is deliberately discouraged. This crisis stems from a prosuburban mentality first apparent well before 1850.[12]

Not only the largest American cities could boast "suburbs" with interesting

developments in architecture and landscape design. Those fast-multiplying smaller towns were the crucibles of some of the most exciting innovations. A visitor to Newburgh, New York, in 1836 wrote that "the Botanic Gardens and Nurseries of the Messrs. Downing, a little north of the village . . . are by no means the least attractive portion of the suburbs of this place." This was the establishment inherited by Charles and Andrew Jackson Downing from their father, which Andrew would operate until 1846–47—by which time he had turned to spearheading the American villa movement by means of his popular writings from this suburban outpost, on the edge of a growing town and three hours by train from New York. *A Treatise on the Theory and Practice of Landscape Gardening* (1841), *Cottage Residences* (1842), and *The Architecture of Country Houses* (1850) helped spread British architectural theories to a wide American audience, with emphasis upon the distinctively American conditions of social mobility, egalitarianism, and opportunity for home ownership in town and countryside; in contrast to class-bound England, here we are "all landlords."[13]

Long before Downing, even, the ideal American town was held to be suburban in character, defined by the tasteful villa on its landscaped lot. Hall said in 1827 that upstate New York *villages* were really more like English *towns*,

"not composed of cottages clustered together; but of fine houses, divided by wide streets, and embellished by groves of trees and flower gardens. . . . The houses at Canandaigua, for instance, have more the appearance of separate country houses, than of mere component parts of a village." Novelist James Fenimore Cooper wrote of the so-called Templeton, New York, "There might be a dozen streets. . . . Of the dwellings of the place, fully twenty were of a quality that denoted ease in the condition of their occupants. . . . Of these, some six or eight had small lawns, carriage sweeps, and the other similar appliances of houses that were not deemed unworthy of the honor of bearing names of their own." Swedish writer Fredrika Bremer observed in 1850, "The streets in the lesser cities of America are a succession of small detached villas, with their grass plots, elegant iron palisading, and fine trees in front of the houses." Trees took years to grow, but home owners everywhere made an earnest attempt to be fashionable (fig. 1.9). These suburban conditions strike us as distinctively American but were very much how the newer districts of English towns were then developing, gardenesque and expansive.[14]

Lath and Plaster

American architecture differed most greatly from English in two regards, scale and materials. As for scale, when architect Ithiel Town visited Britain, a thrilling encounter that inaugurated a "new era in my life," a chief lesson was the huge size of the public buildings. In materials, a distinguishing feature of American architecture was that it was chiefly of wood (fig. 1.10). This was made possible by the vast eastern deciduous forest, which although gradually depleted in many areas was never exhausted, as England's woodlands had virtually been since 1700. In the relatively dry American climate scantling was surprisingly durable, still strong today after 250 years in some of the houses at Colonial Williamsburg in Virginia, for example. A lively theme of American architecture before the Revolution was the adaptation of English building techniques to the availability of wood, and this continued in the nineteenth century, a British architect visiting New York in 1834 observing, for example, that "a much greater quantity of timber is . . . used in the joists and roof than in England." He might have been impressed that even the ostensibly stone-and-brick Tremont House hotel, Boston, employed 486 tons of wood (fig. 1.11). Wooden architecture suited the pragmatic American habit of building quickly and cheaply. This advantage was apparent to architect Charles Bulfinch when he planned a huge dome to crown the U.S. Capitol; to build in

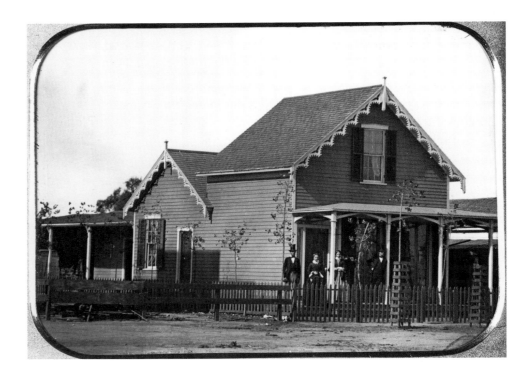

timber would cost $19,745, a *savings* of $5,200 over brick and $41,000 over stone (fig. 2.15).[15]

Inexpensive buildings, or those erected with no concern for fireproofing, were usually wooden; an 1843 survey of New York State schoolhouses showed 969 of masonry construction, but 8,392 of wood. That material was universal on the frontier, where sawmills increasingly made log construction the exception, not the rule. In the period, the balloon frame much discussed by historians accounted for little of this wooden architecture, however. Its invention has been traced to Chicago in 1833, although a recent study shows that it evolved gradually and with many variants. Its spread was made possible by the increasing availability of machine-cut nails and sawmill scantling of regular dimensions, transported by railroad. A resident of Indiana in 1845 described "the *baloon plan*, which has not a single tennon or mortice in the frame, except the sills; all the upright timber being very light, and held together by nails." But it was slow to catch on, being "unknown in the East until the end of the fifties" and, even in the Midwest, only "generally accepted in practice" in the late 1870s. Thoreau built his Walden house with traditional framing, as seen in the raising of a facsimile that closely followed his written accounts (fig. 1.12).[16]

Even the old-fashioned wooden construction—using heavy, braced frames—

could allow rapid building (fig. 1.13). An extraordinary example of haste was the instant town of Nevada City, California, which sprouted like a mushroom on what had been an uninhabited stretch of Deer Creek until placer deposits were found in fall 1849. Within a year there were six thousand residents, and by the time a daguerreotypist showed up in 1852 the immigrants had erected in flimsy wooden materials a microcosm of the American city, complete with painted advertisements ("EMPIRE," a lucrative mine) and a church (fig. 1.14). Back east, where the poorest individuals often lived in ramshackle wooden dwellings on the fringes of towns, persons of taste were offended by this kind of claptrap. In the reform spirit typical of the times, such architecture was considered an offense to decency, as suggested by Thoreau's distress on his seeing daily on the way to Walden Pond "the shanty in the woods, where [Irish] human beings are lodged literally no better than pigs in a stye"—and there were repeated calls to cease building in wood as part of the larger campaign to improve architectural conditions nationwide.[17]

Figure 1.10.
Attic of William Nichols, attrib., James Jackson house, "Forks of Cypress," Lauderdale County, Alabama, ca. 1830. Burned 1966. HABS, Library of Congress

"The evil in our architecture lies principally in this, that we build with wood," wrote a Bostonian in 1794, and authors from Thomas Jefferson ("a country whose buildings are of wood, can never increase in its improvements") to Downing ("the worst material for building") stressed the point. Our buildings could not match those of Europe, Philadelphia architect Samuel Sloan warned, because "we are unwilling to expend the time or the money required. . . . The American architect therefore, often to his regret, is compelled to arrange his plans and project his designs accordingly."[18] So long as it persisted in using wood, America would remain "a nation of lath and plaster and temporary shifts." Much wooden construction was truly squalid. Of those 9,368 elementary schools surveyed in New York—a relatively progressive state—two-thirds were in disrepair and 6,423 had no privy. This is hardly the America we recall from Currier and Ives (fig. 3.6). The impulse to decorate wooden buildings—even turning them into "a gew-gaw palace, or a gingerbread cottage"—owed to a desire to elevate them far above the low common level of wooden architecture.[19]

Wood posed terrible dangers, too. This was an age, almost unimaginable today, when rampant fires could destroy vast areas of cities, with huge loss of

Figure 1.11.
*Isaiah Rogers, Tremont
House, Boston, 1828–29.
Demolished 1895. Courtesy
Boston Public Library,
Print Department*

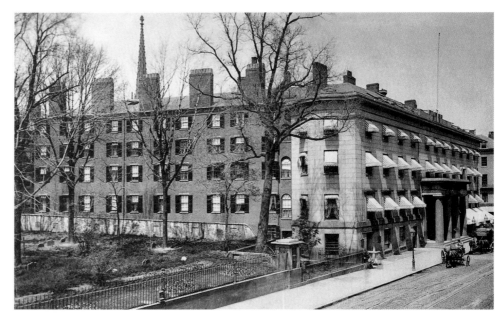

Figure 1.12.
*Replica of Thoreau's
1845 Walden House under
construction, June 2001.
Thoreau Institute, Lincoln,
Massachusetts*

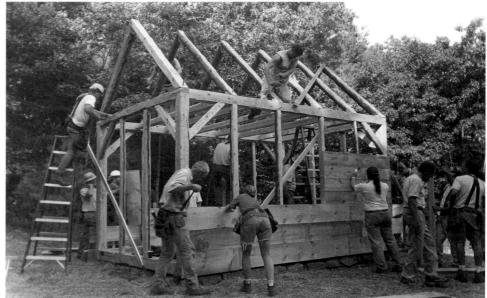

life and property. It happened in Savannah, 1820; New York, 1835 (fig. 1.15) and 1845; Charleston, 1838; Pittsburgh, 1845; Albany, 1848; Saint Louis, 1849; and Philadelphia, 1850. Half of Nevada City's business district burned in 1851; it was rebuilt only to burn down entirely in one half-hour four years later. A fire that leveled forty-five acres and left two thousand people homeless in Oswego, New York, in 1853 was captured by George N. Barnard in da-

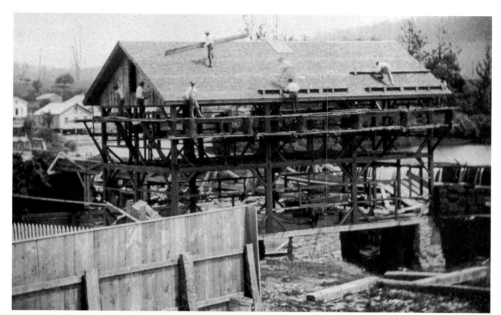

Figure 1.13.
American mill under construction, location unknown, ca. 1855. Ambrotype, detail. Wm. B. Becker Collection/American Museum of Photography. "Building the Mill" © The American Photography Museum, Inc.

Figure 1.14.
Nevada City, California, 1852. Daguerreotype. Courtesy California History Section, California State Library, Sacramento

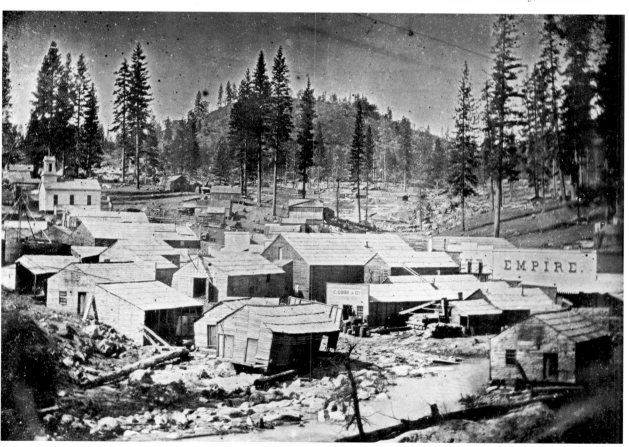

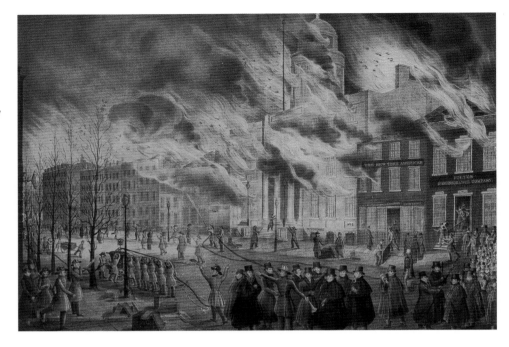

guerreotypes, among the first documentary photographs ever taken. He would go on to record the aftermath of destructive fires at Atlanta, Columbia, and Charleston in the Civil War and at Chicago in 1871—urban conflagrations being a grim, recurrent theme of nineteenth-century life. As with all things relating to safety, standards were extraordinarily low compared to what we expect today. Railroad stations were routinely built of wood in spite of the dangerous sparks: a wooden station in East Boston was engulfed in flames the day it opened, and Pittsfield's burned to the ground in thirty minutes. With their smoke and cinders, these early terminals could be fearsome places, as suggested by the anecdote about the little boy tugging at his father's sleeve in a famous station of the day (fig. 3.29) and asking in wonder, "Is this Hell?"—"No son, it is only New Haven."[20]

But there was an awakening interest in preventing fiery calamities, with fireproofing an ambitious architectural effort. Philadelphia was a model city in its use of brick almost exclusively (fig. 1.16). The commercial district of Fredericksburg, Virginia, suffered fires in 1799, 1807, 1816, 1822, and 1823, and insurance policies show that property owners responded by building in brick and replacing wooden shingles with tile and slate. Fires were so common in New York, citizens awakened by nighttime alarms would "put the hand on the wall at the head of the bed, and, if it feels rather warm . . . get up; but, if otherwise, . . . turn about and go to sleep again." Encouraging was the

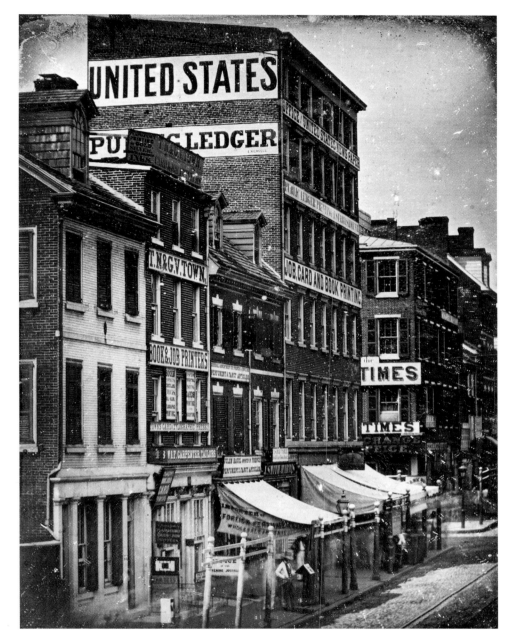

Figure 1.16.
*United States Public
Ledger, Third and Chestnut
Streets, Philadelphia, 1840.
Demolished. Daguerreotype,
July 1842. Courtesy George
Eastman House, Rochester,
New York*

fact that "all the old fashioned wood tenements with shingle roofs, are disap-
pearing, and brick houses with slate roofs occupy their place." Town carefully
fireproofed his own New Haven house (ca. 1835–37) with concern for his ar-
chitectural library of nine or ten thousand volumes that occupied a spacious
second-floor room. Fireproofing measures in Tremont House included slate

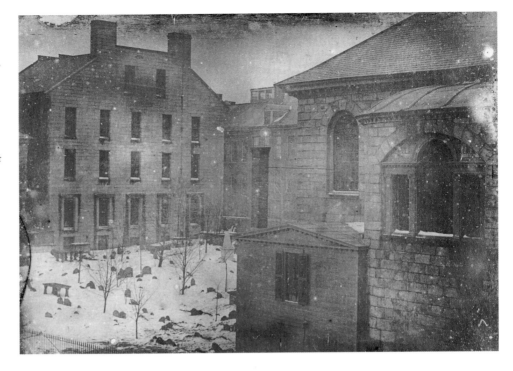

windowsill casings in the kitchen. Elsewhere in Boston, when the Massachusetts Historical Society lost valuable books in an 1825 fire (they had unwisely been loaned out to a member), it decided to abandon its quarters in Bulfinch's elegant Tontine Crescent (fig. 2.1) and move into a bank building with granite walls and parapet roof, a stern-looking bastion against conflagration that was recorded at the dawn of photography (fig. 1.17). This new "Granite Style" of architecture popular in Boston was in no small measure a response to fire danger, although it did little to prevent the city from burning in 1872.[21]

The destruction of the Treasury Department in Washington by fire in 1833 was a stimulus to a campaign to construct fireproof government buildings, to which task was tapped Robert Mills, the Latrobe-trained South Carolina architect who had devoted his career to this problem. Mills used brick vaulting throughout the Patent Office, covering it with hydraulic cement to waterproof it during construction (fig. 1.18). His structurally daring designs came under severe criticism but survive today—the building having escaped demolition in 1953 for a parking lot—as a monument to a bold new kind of permanence in American architecture (fig. 5.24).[22]

Even with inspiring advances in fireproofing technology, many places were swallowed by flames. State capitols show the doleful record of destruction: Kentucky, 1813 and 1824; Illinois, early 1820s; North Carolina, 1831; Ala-

bama, 1849; and Vermont, 1857 (fig. 5.13). In Portland, Maine, Richard Bond's Merchants' Exchange was a handsome essay in the Greek Revival, with eight thirteen-ton monolithic columns and a dome sixty-three feet in diameter. A photographer recorded a fire brigade drilling in the street nearby, not many years before the Exchange was destroyed in a conflagration (fig. 1.19). In 1895 crowds watched in dismay as Jefferson's Rotunda at the University of Virginia was reduced to a blackened shell (fig. 4.29). The fire started in Mills's conjoined Annex, which unfortunately employed his trademark fireproofing on its porches only—he ordered that the "groin arches are to be turned, laid in hydraulic mortar, spandrels filled up with brick," with "the best quality heart or white pine" used for the framing inside the building. This interior woodwork burned like a match.[23]

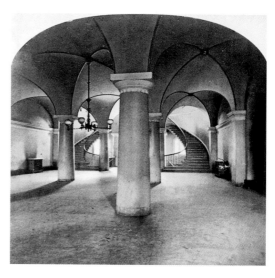

Figure 1.18. *Vestibule of Robert Mills (following Ithiel Town and William P. Eliot), Patent Office, Washington, D.C., 1836–40. National Portrait Gallery, Smithsonian Institution*

Today, vernacular structures are often held to be the rarest survivals, because nobody bothers to preserve the everyday architecture of the lowly; but old high-style buildings are hardly less scarce, given the relentless forces of fire and progress, and this is especially true when one looks for unaltered examples that contain all the little decorative and functional details that make a building of superlative quality. In 1898, William Rotch Ware was moved to publish *The Georgian Period* (covering architecture through the first thirty years of the era we are considering) by "the constant appearance in the daily papers of accounts of the destruction by fire of this or that ancient building." By 1931 architect John Mead Howells could fill a book with 244 *Lost Examples of Colonial Architecture* (again, through 1830 or later) for which Fiske Kimball wrote an introduction: "To turn these pages is to realize the depth of our artistic and historic loss through the destruction of old buildings by war, by fire, by revolutions of taste, and by the ruthless march of improvement." Even today, arsonists or accidental fires not infrequently destroy American buildings of this period—and the losses are irreplaceable, because those early builders will never come again.[24]

Whether high-style or vernacular, by fire, decay, and the wrecking ball American architecture of 1800–1850 has been reduced to a fraction of its original quantity, smaller than we perhaps realize. Low-style buildings have vanished through neglect, whereas high-style structures have been subjected to cultural cleansings that accompany changes in taste. Ever progressive, Americans have never had much reverence for old buildings and were knock-

Figure 1.19. *Richard Bond, Merchants' Exchange, Portland, Maine, 1835–39. Burned 1854. Daguerreotype.*
Collections of the Maine Historical Society

ing down colonial landmarks even in 1800, but gradually in the course of the nineteenth century some preservationist sentiment did arise—too late for most structures, however. There was vast elimination of antebellum fabric in the boom years that followed the Civil War—we can hardly imagine what was lost—and most of the remainder was swept away in the twentieth century, up through the heavy-handed urban renewal campaigns of 1950 to 1975. The dense and intriguingly unfamiliar Philadelphia that stretched north of Inde-

pendence Hall in the 1840s was later wiped away by the mercantile explosion of the late nineteenth century, all traces of which were obliterated in turn by renewal after World War Two (fig. 1.20). It has always been so in America.

The extent of the loss can be quantified in the case of one architect, Samuel Sloan, thanks to a thirty-year investigation by historian Harold Cooledge. For the period 1849–60, 102 of the architect's works were identified, if we count only those commissions the present condition of which could be determined with reasonable certainty. Just 10 percent were found to be extant and unmodified; another 13 percent were altered, often heavily. The remaining 77 percent of Sloan's output for these years has been utterly destroyed. Compare this to the survival rate for the works of a noted artist: in two decades of activity, the Dutch painter Jan Vermeer produced forty-five to sixty paintings, of which some thirty-five still exist—infamously few, but representing at least 58 percent of the original total, compared to just 23 percent for poor Sloan. His case, by the way, is entirely typical for an early-nineteenth-century American architect, and indeed better than some.[25]

The reliance upon old photographs in the present book is necessary and deliberate, given a stark reality: few antebellum buildings exist today in their original state, if they survive at all; seldom are they fitted up for their intended purposes; almost always their surroundings have been radically altered; and the best-preserved are often more museum interpretation than historical reality. Many building types have been entirely eradicated—the large urban hotels, for example. Having said this, one does occasionally encounter remarkable concentrations of surviving pre-1850 dwellings, and churches in particular are sometimes nearly unchanged (for example, the South Carolina church and monument in fig. 5.22 remain today, but the adjoining residential neighborhood is long-gone). Churches account for 30 percent of Sloan's surviving works. Often a challenge lies in distinguishing what is original and what is twentieth-century restoration work, not always easy to do. In many books, Jefferson's Virginia State Capitol is illustrated using photographs of the building as it stands today, massively rebuilt around 1900 by local architects in a form significantly different from the original. Jefferson's University of Virginia Rotunda, too, was reconstructed following its fire, and in both cases only the larger part of the brick walls is old. William Strickland's blue marble Merchants' Exchange still presides gracefully over Dock Street in Philadelphia, and one might assume that this much-photographed place is a rare, intact survival. But its celebrated interior was gutted and its lantern replaced in 1901, and its steps were torn off in 1922, leading a historian of the time to deem it "thoroughly ruined by modern additions." The exterior that

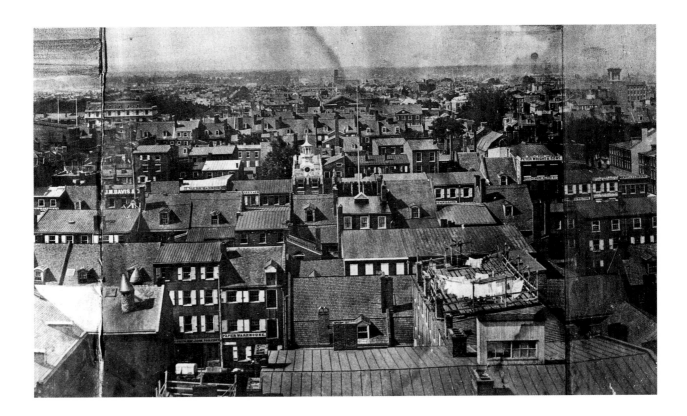

Figure 1.20.
Frederick and William
Langenheim, panoramic
photograph from the
State House, Philadelphia,
1840s. The Historical
Society of Pennsylvania
[Bb865 L275]

the visitor sees today owes much to a 1953–65 restoration (fig. 1.21)—the lantern, for example, rebuilt on the basis of old photographs and a curving scrap of wooden ornament found in an attic, from which the radius of the structure could be extrapolated. The building's interior at the outset of the twenty-first century was starkly empty and awaiting adaptive reuse. It is sobering to find that even such textbook examples have fared quite badly.[26]

Architects and Books

The architectural profession as we know it today was still in its infancy in the United States before 1850, with master carpenters and builders dominating the scene. The struggles of Latrobe to achieve legitimacy are well known. Years after his death, however, architects even in America's largest city were still striving to establish themselves as professionals, as James Gallier tells us in that catalogue of personal woes that is his autobiography (we find him stricken with disease, kicked by a horse, and nearly crushed by a wall, among other trials). An Irishman, he had worked with William Wilkins and others in

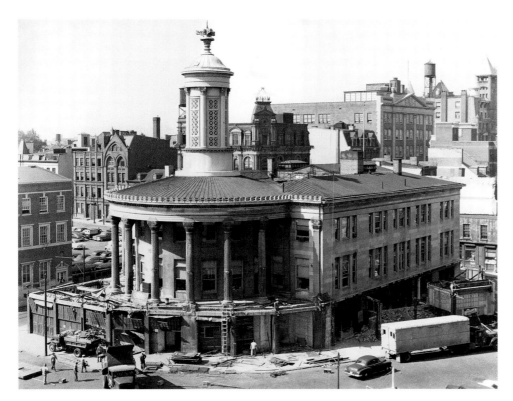

Figure 1.21.
*William Strickland,
Merchants' Exchange,
Philadelphia, 1831–33.
Interior gutted and tower
replaced with version
shown here, 1901.
Exterior restoration
begins, September 1953.
Independence National
Historical Park*

London, but his lack of connections to "people in high station" threatened to blight his career. "Having heard that any person well acquainted with the practice of building, as well as having a fair knowledge of architecture as an art, could scarcely fail of success in the United States of America, I therefore came to the conclusion that *there* lay the proper field for my labours." On arriving in New York in April 1832, however, Gallier "found that the majority of the people could with difficulty be made to understand what was meant by a professional architect; the builders, that is, the carpenters and bricklayers, all called themselves architects, and were at that time the persons to whom owners of property applied when they required plans for building." He found himself trapped in a "horse-in-a-mill routine of grinding out drawings for the builders," which he escaped only by moving to New Orleans. Latrobe's former pupil Strickland had found a similar situation obtaining in Philadelphia in the 1810s: "Architecture was at a low standing and Master carpenters directed the taste of the city edifices."[27]

"Our domestic architecture is for the most part copied, and often badly copied too, from the common English books," a contemporary observed in 1815. These were the pattern and villa books, produced in large numbers in

Figure 1.22.
*"Design for a Small
Residence." From Dearn,*
Sketches in Architecture,
*1807, pl. 5. University of
Delaware Library, Newark*

Britain and eventually imitated here. In colonial times, American architecture had been famously dependent upon imported books, and this continued after the Revolution: twenty-eight British architectural titles published in the 1780s and 1790s had already arrived in the United States by 1800 and were publicly available in libraries or at booksellers, more than a third of them having come over within three years of issue. This tide would increase immeasurably in the decades that followed. Asher Benjamin was the undisputed American leader in the pattern-book genre, with seven handbooks appearing in forty-seven editions between 1797 and 1856; later came Minard Lafever, of great influence in the Greek Revival, with five handbooks in fifteen editions (1829–56). Lafever, like Benjamin, drew heavily on English publications, including Peter Nicholson's *Carpenter's New Guide* (1827) and James Elmes's *Metropolitan Improvements* (1827), not to mention the touchstone of the international Greek Revival, James Stuart and Nicholas Revett's *Antiquities of Athens* (1762–1830).[28]

Benjamin's and Lafever's works were sober, steel-engraved "builder's guides," not the pretty aquatint or wood-engraved English villa books that later inspired emulation by Davis and Downing. Davis's *Rural Residences* (1837) owed a debt to John Buonarotti Papworth's *Rural Residences, Consisting of a Series of Designs for Cottages, Decorated Cottages, Small Villas, and Other Ornamental Buildings* (London, 1818); and Downing freely acknowledged his dependence upon J. C. Loudon's writings, including the immense, eleven-hundred-page *Encyclopedia of Cottage, Farm, and Villa Architecture* (London, 1833). As just one example of how designs were transmitted and adapted, "Design for a Small Residence" in an 1807 English publication by T. D. W. Dearn (fig. 1.22) was borrowed by Davis for a villa scheme (fig. 1.23), which in turn was copied in a house in New Haven; later the design reappeared as "Suburban Cottage in the Italian Style" in a book by Downing.[29]

Sloan wrote that in America, "Every citizen is interested in the art of building, and each expects or hopes at some day to erect a dwelling for himself suited to his peculiar notions of living. He examines architectural works with interest." Accordingly, the popular villa books showcased models for progress in domestic architecture, offering designs "adapted to every grade of living, from the humblest cottage to the noblest mansion." A frequent focus, however, was the suburban home of the working person or the gentleman of moderate means, which might more-or-less-interchangeably bear the names "cottage" or "villa." These books were texts addressed less to builders than

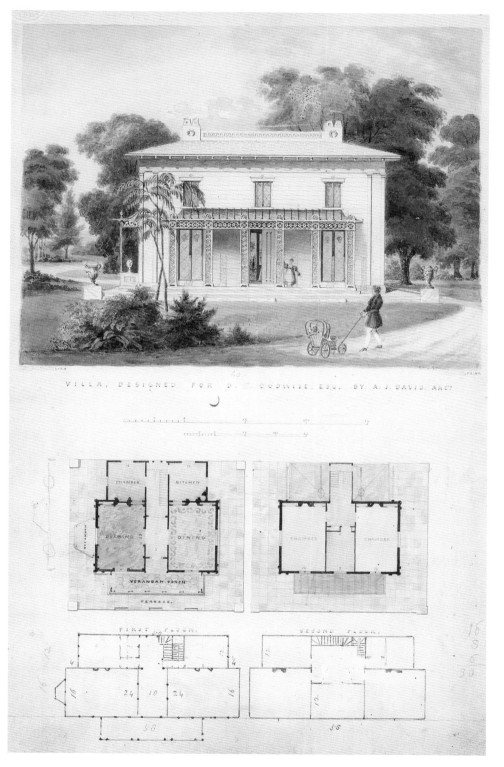

VILLA, DESIGNED FOR D. E. CODWISE, ESQ. BY A. J. DAVIS, ARCT

Figure 1.23.
Alexander Jackson Davis,
Jay Codwise villa scheme,
1835. A. J. Davis, House
for David Codwise, near
New Rochelle, N.Y.,
front elevation and floor
plans, *watercolor, ink, and*
graphite on paper, 14⅜ ×
9 in. (36.2 × 22.9 cm). The
Metropolitan Museum of
Art, Harris Brisbane Dick
Fund, 1924 [24.66.790].
Photograph © 1991 The
Metropolitan Museum of
Art

to prospective home owners of the emerging middle class, economically tied to the burgeoning cities, who sought a return to traditional ways of living through suburban retirement. The dwellings they illustrated were highly varied, but the authors—usually practicing architects—tended to favor recognized historical styles of architecture, though sometimes they offered radically astylar designs.[30]

The spread of these books—as imports from England and later as indigenous productions—was regarded as a promising step in the promulgation of taste and the development of the nation's moral character. Ritch wrote, "The highest and what will be one of the most enduring characteristics of our day is the POPULARIZATION and diffusion of USEFUL knowledge," including that about architecture, and there was noble purpose in producing "a publication, containing Designs and Plans for CHEAP DWELLINGS." The villa books are more sophisticated intellectually than is sometimes warranted; far from being mere grab bags of eclectic ornament, the best of them offer in their prefaces serious-minded advice on domestic economy and architectural fitness, subjects inherited from eighteenth-century thought. As models of fitness, they pointed to the vernacular architecture of the English countryside and to the lowly cottage (fig. 1.24, as sympathetically reinterpreted by a painter of the American frontier), stressing the dwelling's intimacy with nature, employment of locally available materials, and lack of pretension. Their thought paved the way for the strictures of twentieth-century modernism, as in the rule of Loudon's that Downing took as gospel: *Nothing should be introduced into any cottage design, however ornamental it may appear, that is at variance with propriety, comfort or sound workmanship.*" In addition, a "rustic" mode, Picturesque in its irregularity and resonating with theories of the primitive hut, was put forward as an alternative to the more pretentious architectural styles. The transatlantic villa movement these books promoted was far more than a literary exercise; it was a cultural phenomenon of wide scope, fostered by the print explosion of the day. By 1840, the essential tenets of suburban, villa book thought—architectural fitness and humility, sensitivity to the landscape, Romantic historicism, the cult of the rustic—had been widely disseminated in journals and newspapers, poems and novels, letters and conversation. Thoreau did not escape them even in his isolated clearing beside Walden, for his rationales for seeking retirement and his account of his dwelling and its situation owe a debt to villa book ideas.[31]

Of the many concepts put forward in the English villa books, one of particular interest to Americans was the middle state, familiar to modern readers of Leo Marx. Dearn's *Sketches in Architecture* (1807) bore the subtitle *Consist-*

Figure 1.24.
George Caleb Bingham,
Cottage Scenery, *1845,*
oil on canvas, 25½ × 30 in.
(64.7 × 76.2 cm). In the
Collection of the Corcoran
Gallery of Art, Museum
Purchase, Gallery Fund
and Gift from Charles C.
Glover, Jr., Orme Wilson,
and Mr. and Mrs.
Lansdell K. Christie
[61.36]

ing of Original Designs for Cottages and Rural Dwellings, Suitable to Persons of Moderate Fortune. In 1804, Edmund Bartell observed that "of late, the ornamented cottage has frequently become the residence of people of fortune; it is, perhaps, to a mind delighting in retirement, the happy apparent medium between poverty and riches." He warned against both "the unadorned" and "frippery," declaring that "to steer the middle course in matters of this kind, and to avoid either extreme, is not the least worthy effort of taste." His and other villa books aimed to serve the new middle class, whose values they codified and celebrated and whose aspirations they sought to accommodate. These ideas were taken up in a democratic America, where, Richard L. Bushman has written, there was concern about "the contradiction between republicanism and fashionable living. . . . Americans appreciated the lofty spiritual reaches of refined living and admired the beautification of the world that was gentility's great project. They simply had to establish firm limits to their indulgence." William Wirt, considering Jefferson's Monticello (fig. 2.38), recalled that "the Roman moralist [Seneca] . . . has descended even to prescribe

the kind of habitation in which an honoured and distinguished man should dwell. It should not, he says, be small, and mean, and sordid; nor, on the other hand, extended with profuse and wanton extravagance"—rather, it should seek a middle state. Downing complained that modern houses were "either of the plainest and most meagre description" or, conversely, "shingle palaces, of very questionable convenience," and he recommended his "Suburban Cottage in the Italian style" (derived, as mentioned earlier, from Davis's Codwise villa, fig. 1.23) as "an attempt to redeem" houses "from the entire baldness of some examples and the frippery ornament of others." And William Brown offered a design for an Italian villa "to meet the wants of a class of gentlemen, whose means and republican principles will not admit of their erecting more classical or regal edifices."[32]

But all did not embrace recommendations of architectural modesty. Americans' ambitiousness was a frequent theme with Alexis de Tocqueville; Washington Irving's crass Yankee "wanders away in search of new lands—again to fell trees—again to clear cornfields—again to build a shingle palace, and again to sell off, and wander"; and Downing's "ambitious" farmer "likes to dazzle passers-by with a great shingle palace stuck full of windows." The "Bracketed American Farm House" Downing recommended resembled its "English Rural" counterpart, except that it was of the American material, wood, and its profile was taller, the latter adjustment being a grudging concession to his countrymen's "ambitious spirit too often begotten by the constant effort to rise in the world" (figs. 1.25, 1.26). (It was a practical modification, too—America's hot summers made sleeping under an attic roof intolerable, as Thoreau found in his parents' Yellow House.) Not that the English cottage was inapplicable, aesthetically and philosophically, to America; but it would need modification away from extreme humility to suit the New World dream of social mobility. These adjustments seem to afford rare instances of "Americanness" in design—although in England, Loudon had already warned that "low damp cottages" were suited to paintings but not to real life and that they needed to be scaled upward.[33]

Downing took pride in his role as adapter of English villa book schemes to American conditions. When in 1851 an English émigré dared tread upon his turf, he responded with a furious attack, letting slip the veneer of politeness that he ordinarily cultivated in his writing and showing the "critical, and rather sarcastic turn of mind" that friends sometimes saw. He savaged Gervase Wheeler's *Rural Homes* for its "*un*-American" approach, calling the author one of those "pseudo-architects from abroad" who had no comprehension of

the country's climate or society. He ridiculed Wheeler's Anglican assumption that a town would have only one church, as well as his elitist and ostentatious gesture of putting "*stained glass* into the windows of a *stable* of a gentleman's country seat!" Wheeler's frontispiece design was in a "*bastard* style," and its gables showed the "twist of an eel in spasms." Downing moved swiftly to quash this threat from abroad; he was not about to be outdone in his role of *arbiter elegantiarum*, famed for his unique and subtle understanding of the American middle-state.[34]

As has often been discussed, contemporaries equated the cottage with moral and democratic virtues and looked to taste as a road to personal and national salvation. The writer N. P. Willis reveled in his middle-state condition at his Hudson River home, Glenmary: "Rich, though poor! / My low-roofed cottage is, this hour, a heaven." Hannah F. S. Lee espoused middle-state virtues in her extraordinarily popular *Three Experiments of Living: Living Within the Means. Living Up to the Means. Living Beyond the Means:* "Give me neither poverty nor riches," a character declares, and "let us strive to retain our simplicity." A wise uncle scorns the profligacy of a young couple—"'So,'

said he, looking round him, 'we have a palace here!'"—and deplores living "luxuriously" in "costly apartments" rather than being "dutiful and humble, charitable and self-denying, sincere, and a conscientious disciple of truth."[35]

Economic conditions in the United States made middle-state living almost inevitable. Unlike England, there were no laws of primogeniture, and at death, assets were scattered among a person's many heirs. Latrobe wrote in 1811 that "the subdivision of wealth, resulting from our laws of inheritance" was a factor in retarding the fine arts in America. "But little concern is felt for the family mansion, which soon passes into the hands of strangers," a contemporary lamented. Architects recognized that, with the absence of primogeniture, it made no sense "to tie up any considerable portion of an estate in the dwelling house," which thus made for smaller homes: "As, with us, a man rarely dies in the house in which he was born, elegance and comfort are more studied in our domestic structures than grandeur and durability."[36]

Economics played a crucial role in shaping the American rural residence, as Downing recognized when he simplified English villa book designs in his publications. Phrenologist George Combe, visiting in 1838, sought to explain *"Why many objects in America appear unfinished,"* especially "the grounds and fences around the mansions of the rich," which were "deficient in that finish and high order which distinguish similar objects in England." The answer lay in high interest rates (3.5 percent in Britain, 7 percent in New York State) and exorbitant labor costs (five garden workers cost £156 per year in Britain, £325 in America). "In America, both capital and labor are so much in demand for productive employment, and yield such large returns, that a reflecting mind soon becomes reconciled to the rough and unfinished appearance which so many objects present." At the very least, one had to come to terms with the frequent mingling of beauty and utility that Cooper observed everywhere in the American landscape; he wrote in 1828 of the "mixture of use and appearance in the disposition of the grounds, that I am inclined to think very common about the residences of Gentlemen of this country."[37]

Pattern and villa books alone cannot explain the spread of architectural ideas and fashions in the United States. Many factors contributed, including travel accounts and other general literature—notwithstanding historian Henry-Russell Hitchcock's opinion that "early descriptive works, such as guide books" could hardly have had an "influence on the architectural production of their own day the way Builders' Guides and House Pattern Books" did. In fact, these travel guidebooks were probably of considerable importance, given that they were widely distributed, endlessly discussed, and made frequent reference to proper taste. They were often written and read by

women, who had increasing say in the arrangement and embellishment of homes, on which subjects they had, Latrobe said, "50 times the common sense of the men."[38]

And frequently, no books whatsoever were involved in the design process. This was the case among the nearly anonymous legion of builders that Gallier deprecated. He explained how architectural ideas spread in New York in the 1830s: "Some proprietors built without having any regular plan. When they wanted a house built, they looked about for one already finished, which they thought suitable to their purpose; and then bargained with a builder to erect for them such another, or one with such alterations upon the model as they might point out." An Englishman who spent two fruitless months seeking work in New York as a building surveyor complained to Loudon, a "gentleman assured me there had been no drawings made for his house, and that the almost invariable practice is, to fix upon a house already built, as a model, either to be copied exactly, or with such variations as the proprietor may think fit: an agreement is then drawn up, in few words." Examples have been found from North Carolina to Massachusetts of building contracts that specifically refer to one, two, or more nearby buildings as design models. So the American architectural landscape was the complex product of owners' aspirations and tastes as shaped by reading, travel, and experience; builders' capabilities, perhaps augmented by pattern books; the aesthetic example of buildings that happened to stand in the vicinity; and only occasionally the informed input of a trained architect—whose attire might distinguish him from the tradesmen who otherwise would have done the designing (fig. 1.27).[39]

Pattern books passed back and forth between owners and builders, and evocatively, many survive today with pencil sketches in the margins that attest to the lively process of adapting printed designs to individual circumstances. John Hall included in the title of his villa book the words *Adapted to the Style of Building in the United States*, which meant not some uniquely American aesthetic but rather the habitual manner in which American laborers were accustomed to work. "The Carpenter will be considerably benefitted by this production, as it will not only enable those who wish to build to express more clearly to him their views, but it will elicit new ones, of which they had previously no idea, and which the Carpenter will be called upon to supply." It is frequently possible to trace details of specific houses to plates in the villa books. Mills Lane's series *Architecture of the Old South* offers many examples of how designs from, say, Lafever found their way into actual buildings—evidence that buttresses his thesis that "Southern" architecture fundamentally obeyed larger United States trends.[40]

Figure 1.27.
*Frontispiece from
Edward Shaw,* The
Modern Architect,
*1854. University of
Delaware Library,
Newark*

The introduction of foreign styles through the pages of books required adjustments by American builders. In conceiving of designs for his publication, Ritch was limited by the constraint that "architraves, mouldings, and trimmings . . . must conform to those modes with which the ordinary Carpenter is familiar." When William Bailey Lang built Youle Cottage at Roxbury, Massachusetts, in 1837, it was, he claimed, the first attempt at "Elizabethan ornamented cottage architecture" in that part of the country, and "the novelty of its style met with much opposition from the mechanics employed." In 1840, it took a carpenter in Northfield, Massachusetts, a month to build a three-columned portico, because he had no experience with fabricating the big, hollow shafts the newly fashionable Greek Revival required. What looked straightforward in books was sometimes difficult in practice.[41]

Truth, Beauty, and Utility

Truth in architecture—a crucial component of the villa books and of early-nineteenth-century architectural thought in America—has a venerable pedigree. The functionalist philosophies of A. W. N. Pugin and John Ruskin, usually regarded as innovative, were largely derived from eighteenth-century theories: in 1798, James Malton had urged readers "never to *aim* at regularity, but to let the outward figure conform only to the internal conveniency," a concept reformulated by Pugin as *"the elevation being made subservient to the plan."* This, of course, would become a cherished tenet of twentieth-century modernism, one of many such ideas descended from thought in the age of the Picturesque. Functionalism needed to be applied to ornamental detail, in particular; James Peacock wrote in a villa book of 1785, "The truth seems to be, that all architectural ornaments should be as much as possible essential parts of the design they decorate."[42]

English authors of villa books were deeply concerned with what Downing called *"truest* expression" and the challenge "to unite the beautiful and the true." Concerning a certain house design, Loudon wrote, "Beauty, in this case, as in most others, goes hand in hand with utility." This concern with balancing beauty and utility— *"to adorn the needful"*—was readily transferred to a developing America, where, as we have seen, frugality was frequently an economic imperative. Downing stressed *"simplicity"* and held that it should do no less than "pervade every portion of cottage architecture," including its ornament, an attitude that agreed with Richard Payne Knight's earlier assertion in Britain that "no decoration should we introduce, / That has not first been naturalized by use."[43] Ritch wrote, "Embellishments should be useful, seldom ornamental merely." And Downing's disciple Bremer said, "The 'cottage' of the New World is a type of the pretty and the convenient united." Twentieth-century modernism would blithely equate beauty with utility, but the earlier attitude was far different. To Downing, "the Useful and the Beautiful" were "most intimately combined," but it was foolish to "imagine that they are identical. This is the grossest error." They were involved, rather, in a complex and mutually reinforcing interplay—the pleasing aestheticization of the utilitarian, the test of fitness applied to the aesthetic. This led to the artistic embellishment even of industrial items; for example, side-lever steam engines on ships of the 1830s and 1840s were supported by huge, attractive cast-iron frames of pointed-arch Gothic design, though only grease monkeys would see them.[44]

On the basis of his essays "American Architecture" (1843) and "Aesthetics at Washington" (1851), Horatio Greenough is often cited as a pioneer of functionalism, but in fact that imported philosophy "played a significant part in American aesthetic opinion well before" his day. Eventually it helped shape the thought of the New England Transcendentalists: in an 1843 *Dial* article, Samuel G. Ward wrote, "Have done with this paltry concealment; let us see how the thing is built. A Swiss cottage is beautiful, because it is wooden *par excellence*; every joint and timber is seen, nay the wood is not even painted but varnished. So of the old heavy-timbered picturesque houses of England." He went on to demand, "Let our joints and beams be made beautiful, not hidden,—let our wood work show the grain of the wood for ornament, not hide it under paint." English villa books, or Downing's reformulations of them, were likely the source of these ideas, which Thoreau echoed in his description of his Walden house with its "rough brown boards full of knots, and rafters with the bark on high overhead."[45]

Frankness appeared in Downing's preference for vertical battens as opposed to horizontal boards for "expression of strength and truthfulness" in a wooden dwelling, given that "the main timbers" of a house frame "are vertical, and hence the vertical boarding properly signifies to the eye a wooden house" (fig. 3.25). The porch of a farmhouse should be "larger . . . simpler, and ruder, and stronger than that of the cottage," and the whole building "should rely on its own honest, straightforward simplicity, and should rather aim to be frank, and genuine, and open-hearted." Frankness was taken up, too, by his rival, Wheeler, who designed a house about 1849 for Henry Olmsted near East Hartford, Connecticut: "The sharp gable over the side is framed so that the construction shows externally—this being no sham, but the actual framing of the roof within." Moreover, "no ornamental work is any where introduced which does not serve some constructive purpose of design." By this time, the English writings of Ruskin were reinforcing the old theme, and Robert Dale Owen was one of many Americans in the 1840s to call for "TRUTH. External form should be the interpreter of internal purpose."[46]

Truth to materials was a principle highly regarded by architects and laymen alike, as when visitors to Mount Auburn Cemetery near Boston complained about the Egyptian gateway by Jacob Bigelow (1832): "The material has not escaped criticism. Many persons are dissatisfied with even a good wooden imitation of stone." Fanny Kemble wrote, "My astonishment was unfeigned, when, upon an after inspection, I found this very lofty gateway was constructed of *painted wood*. What, a cheat, a sham thing at the threshold of the grave!" Bigelow may not have foreseen this reaction, although he had

taken ingenious steps to spare visitors' Protestant sensitivities by tinkering with the sculpture on the gateway, replacing evil-looking but archaeologically accurate serpents on either side of the "winged globe" with innocuous, drooping lotus flowers. The much-maligned wooden structure was rebuilt in the more truthful Quincy granite in 1843—but it was never as aesthetically successful as the brownstone Grove Street gateway in New Haven, with its battered (that is, sloping) sides and cavetto cornice (fig. 2.25).[47]

The popular ideal of beauty conjoined with utility—*utile et dulce*, it was sometimes called—went hand in hand with the rapid development of new architectural technologies. Improvements in truss design made ever-larger interior spaces possible, but wooden construction made such places firetraps (fig. 1.28). Fortunately, brick and stone increasingly replaced wood for public buildings, with a concomitant revolution in the creation of masonry vaults and domes. These were rarely used in America before 1800, with the exception of a few barrel-vaulted cellars, mostly. Latrobe's great importance to the development of United States architecture lay, in large measure, in the knowledge of vaulting he brought from England. His 115-foot-high dome on the

Figure 1.28.
Castle Garden, New York, 1844. Nathaniel Currier, First Appearance of Jenny Lind in America: At Castle garden Septr. 11th, *1850, watercolor, 10½ × 14⅛ in. (26.5 × 30 cm). Eno Collection, Miriam and Ira D. Wallach Division of Art, Prints and Photographs, The New York Public Library, Astor, Lenox and Tilden Foundations [Eno 244]*

Figure 1.29. *Benjamin Henry Latrobe, Baltimore Exchange, first design, 1815. Latrobe,* Sectional View of the Baltimore Exchange Elevation Sketch, *1817, pencil, ink, and watercolor on paper, 8⅞ × 25⁵⁄₁₆ in. (22.3 × 64.8 cm). The Maryland Historical Society, Baltimore [E-52]*

Baltimore Exchange has been called "a tour de force of constructional skill as unprecedented in the America of its time as was the interesting interior shape to which it gave rise" (figs. 1.29, 1.30). The architect called it a "double dome" because there was a second, open one inside; the upper was of brick securely "bound not only by Iron chains but by Frames of Oak." Every beauty was tied to use: the proud dome advertised civic pride and also lighted the Exchange Hall; its ornamental wind vane registered on the tall ceiling inside, allowing merchants to estimate the progress of their ships; "the four immense windows, 90 feet above ground," as Latrobe's son proudly described them, recalled the thermal windows of ancient Rome, even as they illuminated the hall and afforded sweeping views of the harbor and the shipping signals on Telegraph Hill.[48]

In Philadelphia, Girard's will called for his namesake college to be "constructed with the most durable materials and in the most permanent manner . . . it shall be fire-proof inside and outside . . . no wood may be used, except for doors, windows, and shutters." Walter had trained as a brick mason under Strickland, himself taught by Latrobe, and so he skillfully saw that the college was entirely vaulted with brick in "groin arches" and "pendentive domes." Iron was increasingly embraced as a valuable new material in building, and by 1854 it was possible for him to conceive of a 4,500-ton iron dome to replace Bulfinch's wooden one atop the United States Capitol (fig. 2.28). This was not an American innovation, but based upon the similar dome of Saint Isaac's Cathedral, Saint Petersburg, Russia (1818–58), by French architect Auguste Ricard de Montferrand. Today, Walter's dome is surely the most widely known nineteenth-century American structure.[49]

Figure 1.30.
Benjamin Henry Latrobe,
Baltimore Exchange,
1815–20. Dome built
1818–19. Demolished
1901–2. The Maryland
Historical Society,
Baltimore

Utile et dulce in architecture is further illustrated by the successive build-
ings of the Philadelphia waterworks, in which changing technologies were
embraced and made beautiful, the conjunction of the two imperatives yielding
results that seemed fascinating to contemporaries. In support of efforts to
bring clean Schuylkill River water to the low-lying, yellow fever–ridden
streets of the city, Latrobe moved from Richmond in December 1798 and by
month's end had proposed two steam engines, one on the riverbank and one
at Center Square, the two connected by a tunnel nearly a mile long. At Cen-
ter Square Engine House, water was pumped into an upstairs "elevated reser-
voir" from which it flowed by gravity throughout the town (fig. 1.31). From
the start the tall, prominently located building was "designed to be ornamen-
tal, as well as useful to the city," its forms commensurate with the Advanced
Neoclassicism Latrobe had learned in Britain, and it borrowed rather specifi-
cally from John Soane's *Sketches in Architecture* (London, 1793). The order was
fluted Greek Doric (rather than the unfluted Delos variety Latrobe had used
at Hammerwood Lodge, Sussex, in 1792) and employed monolithic marble
columns of a size never before quarried in America. Center Square was land-

Figure 1.31.
*Benjamin Henry Latrobe,
Center Square Engine
House, Philadelphia, 1799–
ca. 1803. Demolished 1826.
John Lewis Krimmel,*
Fourth of July in Centre
Square, *1810–12, oil
on canvas, 22¾ × 29 in.
(57.8 × 73.7 cm). Courtesy
of the Pennsylvania
Academy of Fine Arts,
Philadelphia. Pennsylvania
Academy purchase (from the
estate of Paul Beck, Jr.)
[1845.3.1]*

scaped with the fast-growing, classicizing Lombardy poplars popular in the day and fitted with a fountain (1809) for which William Rush carved *Water Nymph and Bittern*. The combination of art and technology, *rus in urbe*, and the beautiful and the useful were central to the appeal of the square, which the city grew westward to meet.[50]

All this was soon supplanted by the larger Fairmount Waterworks, at which Schuylkill water was pumped to a basin on the schist-rock plateau where the Philadelphia Museum of Art now stands. Latrobe's assistant Frederick Graff designed a house on the riverbank for two steam engines, a low-pressure Boulton and Watt type on the south end and a high-pressure Oliver Evans on the north. Together they could pump nearly five million gallons a day to the reservoir, but they consumed 2,560 cubic feet of wood in the process. This expense, plus an 1818 boiler explosion that killed three workers, led to their replacement with waterpower—a retreat to a more primitive technology, which one not infrequently encounters in this era of transition to the Industrial Revolution. A dam was built across the river, and eight wooden breast wheels thundered in Graff's new Mill House, with a public promenade over the forebays behind it (figs. 1.32 and 4.18). In its massing as seen from the far shore, this waterwheel terrace seemed to owe something to Robert and

Figure 1.32. *Frederick Graff, Fairmount Waterworks, Philadelphia. Large building is Engine House, 1812–15. To its right, Mill House and Promenade ("Waterwheel Terrace"), 1821–22, later altered. Dam, 1819–21; Gazebo, 1835. In distance, with greenhouse, is Lemon Hill, 1799–1800. John T. Bowen,* A View of the Fairmount Waterworks, *ca. 1838, hand-colored lithograph, 14⅓ × 21½ in. (36.5 × 54.5 cm). The Library Company of Philadelphia [W9/P.2006]*

James Adam's Adelphi, a riverfront terrace in London (1768–72). The Fairmount Waterworks became a pleasure garden and one of the most famous urban locales of nineteenth-century America, depicted in almost fifty popular prints, which show us its appearance before alterations in 1867–72. The Engine House, fitted with a portico, became a saloon in 1835. Promenading townsfolk or curious tourists (Thoreau paid the obligatory visit) could enjoy the classical architecture and scenic river view while congratulating themselves on the American technological genius that could pump clean drinking water to thousands—beauty and utility perfectly wedded.[51]

To take another example, utile et dulce would later come to bear upon the architecture of James Bogardus, born in the town of Catskill, New York, in 1800. He lived in London for four years (1836–40) and studied innovations in cast-iron design there and on the Continent. His five connected Edgar Laing Stores, New York, were a pioneering essay in cast-iron-façade construction completed in just a few weeks' time near the end of the period (February–April 1849) (fig. 1.33). Laing was a wealthy coal merchant who built the stores on speculation. One-hundred-fifty tons of iron were employed in the façade as cast panels just one quarter inch thick bolted to iron spandrels and posts, an aesthetic and practical breakthrough that seems to have been one of the few truly American contributions to world architectural technology of the era—although, as Hitchcock pointed out, "Around 1850 cast-iron architecture was coming to its climax everywhere."[52]

Photographs taken of the building late in its life show a harshly utilitarian appearance only because nearly all the decorative elements had been vandalized away. Originally, above the engaged Doric columns were affixed ornamental castings that were both attractive and useful, covering the junction of two spandrels (fig. 1.34). Iron was supremely functional—relatively fireproof and allowing rapid construction—but utile et dulce demanded that it be

rendered aesthetic, so the façade was covered with tan-colored paint mixed with sand in order to imitate stone. Thus the emergence of new technologies was humanized by the suggestion of traditional architectural motifs and allusions. Even in its neglected state, the elegant face peering out at us is symbolic of the cautious progressivism of the era, seeking to reconcile bourgeois expectations about taste and associationism with the urge to build cheaper, stronger, and faster. At the time of demolition in 1971 it was possible to study how the massive timber floor joists were notched to fit a wide flange in the spandrels of the façade, an intriguing conjunction of traditional, heavy, slow-burning warehouse construction and the radical novelty of a load-bearing metal wall (fig. 1.35). The ironwork was carefully scraped and stacked for future preservation, but thieves stole it all for scrap—a depressing episode in a period that saw New York lose some of its finest old buildings.[53]

Figure 1.34.
Laing Stores, detail.
HABS, Library of
Congress

In point of surviving intact, few building types have fared worse over the generations than commercial ones in major cities, so old photographs are our best record of the earliest cast-iron structures, including Bogardus's first truly sizable achievement, the Sun Iron Building in Baltimore, which followed soon after the Laing Stores (fig. 1.36). This ultramodern building housed that most contemporary of concerns, a city newspaper printed in enormous runs by steam press. As with London's Crystal Palace, under construction at the same moment, the edifice was a triumph for the new iron technologies, with cast-iron columns and beams inside and a richly ornamental iron façade outside, complete with twenty-three statues of Washington, Franklin, and Jefferson on repetitious parade along the top story. All elements were prefabricated and repeating, applying the lessons of the new industrialized foundry work that was simultaneously churning out railroad locomotives and bridges, and the same molds would later produce an *identical* façade for Bogardus and John B. Corlies's Harper and Brothers Building, New York (1854)—a remarkable example of the new potential for standardization of parts, a huge architectural revolution in the making. A thicket of wires swept high over the streets and entered the building on the second floor, where two telegraph companies were housed. Such cast-iron architecture proved enormously influential and would transform the American cityscape over the next half-century. Within eighteen months of the Sun's completion there were twenty-two

Figure 1.35.
*Laing Stores during
demolition, 1971.
HABS, Library of
Congress*

buildings in town with façades at least partially of cast iron, and by the time it burned in the great Baltimore fire of 1904 no fewer than eighty other iron-front buildings in its neighborhood burned, too.[54]

Every American city had its "lions," those public buildings commented upon by travelers and universally considered proof of the taste and sophistication of the citizenry. In cities of brick and wood, the large new public buildings of stone that began to appear in numbers after 1800 made a striking impression. Looking up Broadway, New York, the City Hall's gleaming front of Stockbridge, Massachusetts, marble was unforgettable, "said to be the most beautiful edifice in the United States" (fig. 1.37). Such places were described in ways that demonstrate the dual importance of utile et dulce in the mind of the day: an account of Tremont House discussed the beauties of its classical detailing but also the two million bricks used in construction and the huge dimensions (three hundred hogsheads) of the rainwater cistern in its courtyard. Typically, speed of completion was a source of pride; the Quincy granite contract had yet to be signed in mid-July 1828, yet the 170-room hotel opened for business in October of the following year (fig. 1.11). The immensity of the construction project was itself typical of nineteenth-century progress, with constantly increasing specialization in both materials and labor. At Tremont

Figure 1.36.
*James Bogardus and
Robert G. Hatfield, Sun
Iron Building, Baltimore,
1850–51. Burned 1904.
Photograph courtesy
Maryland Department,
Enoch Pratt Free Library,
Baltimore*

House the architect was overseer of a vast workforce under the supervision of a cohort of "master mechanics," who consisted of one architect's assistant, three master masons, five master carpenters, four master plasterers, four master painters, two ironworkers, one slater, three copper roofers, two plumbers, one carver of capitals, two circular-stair builders, one wood grainer, one freestone carver, one wooden-pump maker, and a host of furniture makers. This rationalized organization of labor seemed as impressive a fact as the high aesthetic quality of the building or its technological advances. Tremont prided itself in being forward-looking; in 1833 its owners even bought a lot on

Hawthorne Path in the new Mount Auburn Cemetery and erected a tasteful "stranger's" tomb of Quincy stone for convenient burial of out-of-towners who happened to die at the hotel.[55]

In the matter of utile et dulce, many of the most-remarked structures of the period were not architecture at all. There was widespread interest in advances in bridge technology, which seemed to underscore the boundless potential of American inventiveness. In fact, most bridge-building achievements here built upon English and European innovations, although American ideas sometimes spilled back across the Atlantic: some think a short-lived wire suspension bridge at Philadelphia for pedestrian use only (1816) may have encouraged later foreign essays in this technology, and Town became famous worldwide in the railroad age for his innovative bridge truss.

One of the remarkable American bridges, now forgotten, soared over the Deep Cut of the Chesapeake and Delaware Canal (fig. 1.38). The waterway had been proposed in the eighteenth century as a way of chopping three hundred miles off the journey from Baltimore to Philadelphia. Begun by Latrobe in 1804, it remained unfinished due to the canal company's bankruptcy. Strickland resurveyed the route in 1822, and construction began two years later along a line several miles south of Latrobe's. By summer 1826 there were more than 2,600 men, mostly Irish or black, removing ninety million cubic feet of earth at the Deep Cut. The fourteen-mile canal opened in 1829,

Figure 1.38.
*Summit Bridge,
Deep Cut of the Chesapeake
and Delaware Canal,
Delaware, 1826.
Photographed during
demolition (replacement
drawbridge beyond),
1865–66. U.S. Army
Corps of Engineers*

2,400 passages were taken in 1830, and 12,900 by 1850. The canal would play an important role in troop movements during the Civil War. Tourists made the trip just to see the Deep Cut from Summit Bridge, a covered wooden truss some 247 feet long at the dizzying height of 90 feet above the water. It was not as long as the record 360-foot span at McCall's Ferry, Pennsylvania (1814–15, destroyed by ice 1818), but it was elevated much higher. A Baltimore newspaper urged its readers not to miss the "opportunity of viewing this stupendous public work. The passage through the deep cut and under the summit bridge . . . is awfully grand and beautiful." Here the citizen could reflect upon the astonishing progress of the young Republic, where $2,250,000 could be expended on this kind of internal improvement at a cost nearly nine times greater per mile than the Erie Canal (1817–25), owing to the hugeness of the Summit dig. The remarkable bridge was removed in 1866, and the old Deep Cut vanished from memory in a twentieth-century widening of the canal, which remains in constant use today. Most nineteenth-century American covered bridges are only memories now; there were once 10,000 or so, but just 990 survived to 1970.[56]

The Summit Bridge was a dramatic application of conventional wooden-truss technology to the long-span problem—a matter that became more urgent every year as new roads and railroads laced the landscape in support of a booming, "intensive" economy (its rate of output for the first time exceed-

ing population growth). As one measure of this phenomenal change, the American railroad network went from twenty-three miles in 1830 to nearly ten thousand in 1850 and more than thirty thousand in 1860—by then equal to the rest of the world combined. With so many huge rivers to cross, metal offered a better solution than wood, for roads and railroads alike. Charles Ellet, Jr., was a Pennsylvania farm boy who dreamed of becoming an engineer and managed to attend the Ecole des Ponts et Chaussées in Paris (1830–31), during which time he observed with fascination the construction of an iron suspension bridge across the Loire. Such bridges were, he said, "To be found spanning all the principal rivers of France and England, in every part of the continent, from the Baltic to the Mediterranean," but there were none in America.[57]

Back home and working for canal companies, he wrote *A Popular Notice of Wire Suspension Bridges* (1839) and lobbied unsuccessfully for their construction at Washington and Saint Louis. In 1838 the "Colossus" bridge over the Schuylkill in Philadelphia burned—a marvel of a past decade, a covered wooden span of five parallel arched trusses strengthened with iron rods, for which Mills had provided an aesthetic sheath (fig. 4.18). A year later the twenty-nine-year-old Ellet designed a replacement, the first permanent suspension bridge in the western hemisphere (fig. 1.39). It had a span of 357 feet between 32-foot towers of Hallowell, Maine, granite with iron rollers atop, over which passed ten cables each composed of 260 strands of wire, individually boiled in linseed oil and varnished. The cables were designed to "hang in festoons" and were linked to fastenings buried deep in the ground. Ellet rebuffed an offer from a young German immigrant to serve as assistant on the project—John Roebling, who would become his archrival and years later design the Brooklyn Bridge. Skeptics doubted that the bridge would hold, so Ellet performed a public demonstration, crowding it from end to end with thirty-nine horse-drawn carts each loaded with 2 tons of stone, which he put in motion all at once. He calculated that these—plus a trusting crowd of two hundred spectators—added up to only one-fifth of the bridge's 2,100-ton maximum load. The Schuylkill Wire Bridge was a contemporary sensation for its beauty and practicality and opened the way for many more suspension spans, including Ellet's Wheeling Bridge, West Virginia (1848–49), at 1,010 feet the world's longest. The Wheeling Bridge deck collapsed in a storm in 1854 but was rebuilt by Roebling and still carries traffic today. During the Civil War, Ellet proposed a fleet of steam-powered rams and was killed commanding one in a naval battle off Memphis. His body lay in state in Independence Hall (fig. 2.35) before he was buried at Laurel Hill Cemetery (fig. 2.24)

upstream from his Wire Bridge—that pioneering American essay in suspension technology and a celebrated example of *utile et dulce* in design.[58]

Building the young Republic meant suiting European building practices to the conditions of the New World—*Adapted to North America* being a subtitle of Downing's books—and making necessary adjustments to suit American social customs, technological abilities, and local materials. The challenge was to make these adaptations while at the same time improving the general architectural taste in city, suburb, and countryside alike, even in the face of the familiar American biases in favor of expediency over the artistic, speed over patient care, mobility over rootedness. English philosophies of truth and fitness promised to help. A United States correspondent of Loudon's hoped that "your *Architectural Magazine* will . . . render this country an essential service, by promoting the knowledge and taste for a science which has been but very little attended to out of our large cities," and, as we shall see in the next chapter, the prevalent English architectural ideas of the day were brought to bear with real enthusiasm upon the American situation.[59]

Figure 1.39.
Charles Ellet, Jr.,
Wire Bridge, Schuylkill
River, Philadelphia,
designed 1839, built
July–December 1841.
Removed 1875. At left,
Fairmount Waterworks
being enlarged, 1867–72.
Newell Album, The
Library Company of
Philadelphia [P.9062.81a]

PAINTED BY T COLE
FOR I. TOWN ARCH.
1840.

At the moment America began its tremendous post-1800 economic and geographic expansion, the British Isles (population 15.9 million) were in the midst of a fertile artistic and architectural age. The people of the fledgling United States (5.3 million), only eighteen years a free nation, could hardly have escaped Britain's dominance had they wanted to. In 1834 the U.S. population first exceeded that of England and Wales, but for years afterward Americans continued to look to the mother country for aesthetic direction. Although many of the architectural ideas that reached America were ultimately Continental in origin, especially French, usually they had passed through Britain on the way. The hugely influential Regent's Park, London, of John Nash "utilized concepts which appear to be at least as French as they are English," but by the time they arrived in America it was proper to speak of them as English imports. Several French-born architects were active in the United States, including Pierre L'Enfant, Joseph Mangin, Joseph Jacques Ramée, Jacques de Pouilly, and Maximilian Godefroy, but they were greatly outnumbered by their British counterparts.[1]

Indeed, a bounteous Britannia showered the young Republic with expatriate architects, thereby decisively shaping its nineteenth-century direction. Among the immigrants, all of whom made important contributions, were James Hoban (1785), William Thornton (English educated; 1786), George Hadfield (1795), Benjamin Henry Latrobe (1796), William Nichols (1800), James O'Donnell (1812), William Jay (1817), John Haviland (1816), Richard Upjohn (1829), John Notman (1831), James Gallier, Sr. (1832), John McArthur, Jr. (1833), Gervase Wheeler (ca. 1846), and Calvert Vaux (1850). These were only the major ones; a host of minor figures joined them, some of whose roles have hardly yet been ascertained. For the years 1794–97 alone, Philadelphia newspapers ran advertisements from three newly arrived Englishmen, all claiming stellar credentials: Joseph Bowes ("Draftsman for several years past, to the celebrated Robert [Adam]"); Christopher Minifee ("architect from the Adam's, London"); and Christopher Myers ("clerk to Sir William Chambers, architect,

for some years"). Still more of these lesser-known architects arrived in Philadelphia after 1800: Charles A. Busby (1814), Hugh Bridport (ca. 1816), John G. Hall (by 1835), James C. Sidney (by 1845), Frank Wills (1848), and John T. Mahony (by 1850).[2]

A large number streamed into New York, too, either in their youth or as adults; they included George Parkyns (1794), Peter Banner (by 1795), George Harvey (1820), Upjohn (1829), Thomas R. Jackson (ca. 1830s), Thomas Griffith (1838), Frederic Diaper (by 1838), Frederick Catherwood (1836), Alfred J. Bloor (ca. 1840s), Patrick C. Keeley (1841), Henry Flockton (by 1842), and John W. Welch (ca. 1850). British-born practitioners shaped the architecture of several United States cities: George Morton (ca. 1815, Pittsburgh and Saint Louis), Robert T. Elliott (1819, Rochester and Detroit), Thomas W. Walsh (ca. 1830s, Saint Louis), William L. Woollett (ca. 1834, Albany), George Ingham Barnett (ca. 1840, Saint Louis), James H. Willett (ca. 1840, Chicago), Alfred B. Mullett (1845, Washington, D.C.), Isaac Hodgson (1848, Indianapolis), Jeremiah O'Rourke (ca. 1850, Newark, N.J.), and William Tinsley (1850, Indianapolis).[3]

Especially in the earlier decades of the period, a time lag was evident in the transmission of British ideas. It took thirty-five years, for example, for the Italianate villa form essayed by Nash at Cronkhill, Shropshire (1802), to appear across the Atlantic in Notman's Bishop Doane House, Burlington, New Jersey (1837). But an American's visit abroad could swiftly close the gap, as the life of Charles Bulfinch shows. He made the Grand Tour to England, France, and Italy in 1785–87 before returning to Boston and beginning his architectural career, with the help of a library of British books by John Soane, Plaw, and others. His Tontine Crescent, sixteen brick houses in a curving row four hundred feet long, was suggested by the work of John Wood I he had seen in Bath (fig. 2.1). Asher Benjamin hailed it as "the first impulse to good taste" in New England, and it would have been stylish even in London, notwithstanding the fact that Wood had died forty years earlier; row houses were perennially popular, and the Tontine's Adamesque decorative elements were identical to ones published by Plaw as late as 1802. Likewise up-to-date was the Picturesque relationship of the arc to a "Grass plat 300 feet long Surrounded by Trees," the whole forming a sophisticated kind of urbanism new to America. It was an early example of the Romantic desire to integrate art with nature in the city or, as a contemporary wrote of it, "to serve the purposes of health by purifying the air, at the same time that it adds a natural ornament to artificial beauty." Here Americans for once had overcome what an English visitor called their "unconquerable aversion to trees," which they cut

Figure 2.1.
Charles Bulfinch,
Tontine Crescent,
Boston, 1793–95.
Demolished 1858.
Urn from Bath,
England. Photograph,
ca. 1857. Boston
Athenaeum

down at every opportunity for agriculture or firewood. An urn formed the centerpiece, a memorial to Benjamin Franklin, but when the crescent was demolished that ornament was fittingly moved to Mount Auburn Cemetery to mark the grave of Bulfinch himself.[4]

Tontine Crescent epitomizes the Federal Style, or Adamesque, that dominated the American scene as this period began. One of its signatures was the fanlight, such as one that Latrobe used at his Bank of Pennsylvania, as seen

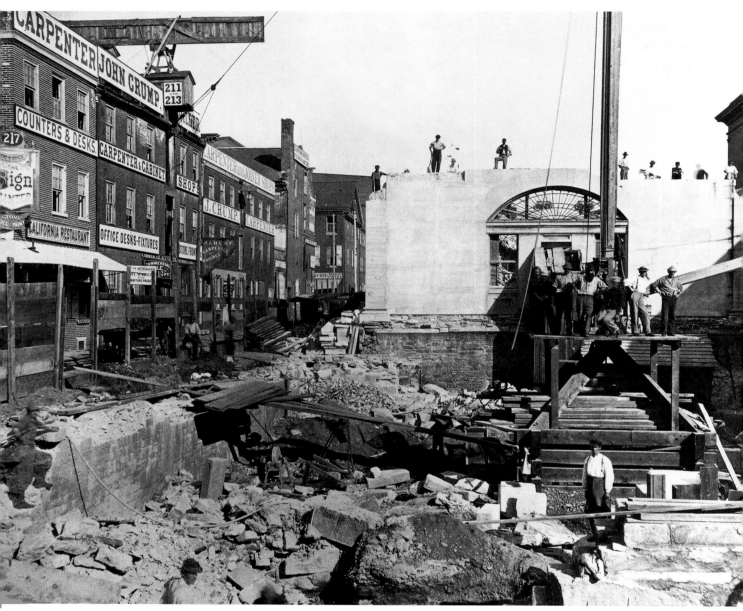

Figure 2.2. *Benjamin Henry Latrobe, Bank of Pennsylvania, Philadelphia, 1798–1800. Rear (west) elevation during demolition, 1867. The Historical Society of Pennsylvania [Penrose Small B.4]*

in a never-before-published photograph taken during demolition (fig. 2.2). Under magnification, this view reveals subtleties of the glazing (fig. 2.3). As in the colonial period, the forms of Federal public buildings were often highly similar to domestic design, and this fanlight recalls those on the finest post-Revolutionary town houses. The light, graceful forms of Federal Neoclassi-

Figure 2.3.
*Bank of Pennsylvania
demolition, detail of
fig. 2.2. The Historical
Society of Pennsylvania
[Penrose Small B.4]*

cism were to be found across the nation, in buildings both public and domestic (fig. 3.7). There was Gothic, too, but for a long time it seldom appeared outside religious architecture. By 1830 there were good examples of Gothic Revival churches in the major cities, such as Josiah R. Brady's Saint Thomas's Church, prominent on Broadway (fig. 2.4)—this burst of Gothic church construction paralleling a similar development in Britain. These ecclesiastical buildings set the stage for the eventual advent of the Gothic library, school, villa, and cottage, for which the chief credit must go to A. J. Davis, who got his start as a young draftsman in Brady's office at the time Saint Thomas's was under way.

The five decades up to midcentury were to see the gradual replacement of the harmonious and widespread Federal aesthetic with increasingly varied approaches, most of which were bolder, heavier, more archaeological. The successive courthouses of Saint Louis demonstrate the trend, as the Federal-style first building with its curving portico and fanlights was swallowed up by a bulky Greek-Revival descendant, with massive triglyph-and-metope frieze (fig. 2.5). Increased scale and magnificence were deliberate, being proud emblems of progress and "improvement" as frontier towns strove to rival long-settled centers. Watching the new building rise, a citizen gushed, "What city can boast of such improvements—can New York?—Philadelphia?—Baltimore?—*Cincinnati?*—NO!" Another wished for the speedy demolition of the old courthouse, not long ago a source of pride but now seeming "like an unhealthy decaying fungus which had grown out from beneath its overshadowing neighbor. . . . There is an apparent struggle . . . as if the modern march of improvement were laboring to usurp the place of the old and faded grandeur of past days." Courthouses such as these were symbols of local pride nation-

Figure 2.4.
Josiah R. Brady,
Saint Thomas's Church,
Episcopal, Broadway at
Houston Street, New York,
1824–26. Burned 1851.
George Harvey, Nightfall,
St. Thomas' Church,
Broadway, New York,
ca. 1837, watercolor on
paper, 8⁵⁄₁₆ × 13⅝ in.
(21 × 34.3 cm). Bequest
of Mrs. J. Insley Blair,
Museum of the City of
New York [52.100.1]

Figure 2.5.
At right, Joseph Laveille
and George Morton,
Old Courthouse, Saint
Louis, Missouri, 1826–28.
Demolished 1851–52. At
left, Henry Singleton and
others, New Courthouse,
1839–45, enlarged and
dome replaced, 1852–64.
Thomas M. Easterly
daguerreotype, 1851.
Missouri Historical Society,
Saint Louis

wide and lively centers of civic life; the historic first two Dred Scott trials were held in the far left wing of Saint Louis's new building in 1847 and 1850.[5]

Interiors, too, displayed the march of stylistic progress and tendency toward greater show. When artist Henry Sargent depicted two rooms at Tontine Crescent about 1820, the dining room still retained its original Federal-era furnishings (fig. 2.6), but the parlor had been redone in Empire. A comparison of the Tontine dining room with Davis's depiction of double parlors (fig. 2.7) suggests continuing, nationwide changes over ten years, in the direction of increased monumentalism and archaeological correctness. Francis H. Heinrich's painting *Mr. and Mrs. Ernest Fiedler, 38 Bond Street, New York City* (1847, formerly Museum of the City of New York) could be used to carry the progression still further, the interior of this New York townhouse showing chimneypieces, chandeliers, and picture frames grown ever bigger and bolder.

The various new architectural styles, like the Adamesque they replaced, were English imports. Architect Henry Hudson Holly would write during the Civil War of "that long-dreamed-of aim, an *American style*," but after eighty years of nationhood it remained a dream. It is difficult to understand from today's superpower perspective why Americans persisted in aping the tra-

The Role of Britain and the Picturesque [57

Figure 2.7.
*Alexander Jackson
Davis*, Greek Revival
Double Parlor, *ca. 1845,
watercolor on paper, 13¼ ×
18⅛ in. (33.7 × 46.1 cm).
The New-York Historical
Society [1908.28].
Photograph © Collection
of The New-York
Historical Society*

ditional styles of Europe rather than forging a new style based on unique conditions in the New World. Indeed, many contemporaries called for innovation—although this in itself was not so much an American development as an echo of loud foreign calls for a "new style for the nineteenth century." Perhaps thinking of the outspoken Horatio Greenough, A. J. Downing spoofed these peers: "What they demand, with their brows lowered and their hands clenched, is an 'American style of architecture!'" At the end of the period, social reformer and sometime Indiana congressman Robert Dale Owen considered the necessary "Conditions of an Architecture for America." He proclaimed that no traditional style could, without modification and "as a whole, serve as a suitable model for us, now in this nineteenth century and here on this North American Continent." Whatever was formulated must be flexible, adaptable to regional variations in climate—and, he added, "Our national Architecture must not be of elaborate or expensive style." But what would this new style look like? He could envision that "the next generation may see, arising on our Continent, villages, or it may be cities, of iron," but he doubted that such an architecture could truly be made aesthetic. His choice for the "National Style of Architecture for America" was, to our eyes, thoroughly traditional and European: Norman Romanesque, as of the Smithsonian Institution he promoted, a style already popular in Britain and on the Continent (fig. 2.8).[6]

Not only did no uniquely American style arise, but American architecture

was, for the most part, cautiously conservative and arguably produced few truly world-class innovations or achievements. In 1963, the learned English architectural historian Nikolaus Pevsner helped dedicate Paul Rudolph's glass-and-concrete Art and Architecture Building at Yale University. He found time on the morning of that day to stroll over to nearby Street Hall by Peter B. Wight, longtime home of the architecture school. His historical conclusion on the High Victorian Gothic structure was emphatic: "Street Hall is thoroughly provincial. . . . In the history of architecture the United States in 1864—with a few exceptions—were still a backwater. One could write a history of Western architecture without mentioning them more than once or twice." His stinging judgment goes to the heart of the problem of early- to mid-nineteenth-century American architecture: can buildings be interesting or important if they are derivative rather than on the cutting edge?[7]

For most of the modernist-dominated twentieth century the question

Figure 2.8.
James Renwick, Jr.,
Smithsonian Institution,
Washington, D.C.,
1846–51. Landscape is
Andrew J. Downing,
Smithsonian Pleasure
Grounds, designed
1850–51. Photograph
by A. J. Russell, 1860s.
Library of Congress

Figure 2.9.
Thomas Jefferson and Charles-Louis Clérisseau, with Samuel Dobie, Virginia State Capitol, Richmond, 1785–98. Pediment windows added 1801. Edifice largely rebuilt by John K. Peebles and others, 1902–4. Photograph, 1865. Library of Congress

could only be answered "no," and some sought a way around the problem by stubbornly asserting American architectural uniqueness, sometimes to the point of engaging in what Thoreau memorably called a "hip hip hurrah & mutual admiration society style." The chief theme of the period was taken to be the quest for complete cultural and aesthetic independence from Europe, with architects striving for novelties that would express distinctly American themes. Jefferson, in particular, assumed a heroic role as a champion of "republican" architecture whose achievements were worthy of the world stage, especially his invention of the Neoclassical, temple-form public building in the Virginia State Capitol: it was "the first American public building to reject altogether the English tradition. It thus stands as the first positive step toward American cultural independence"; it "marked a conscious break with the English architectural tradition"; "this was the first post-revolutionary American building utterly to reject British architectural traditions" (figs. 2.9, 2.10). Jefferson has been hailed as an innovator of vast importance—"one can argue that no other American architect has surpassed Jefferson in his influence on the built environment of the United States"—and the style-guides found in

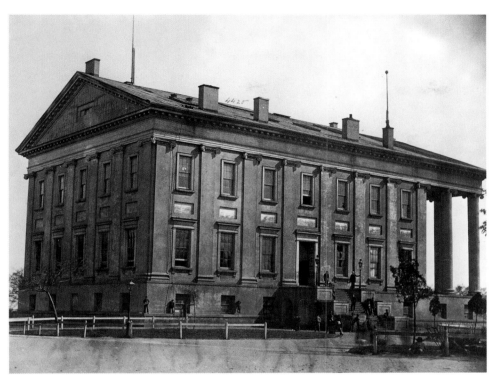

Figure 2.10. *Virginia State Capitol, side and rear. Steps altered 1846. Landscape is John Notman, Capitol Square, 1850–ca. 1860. Photograph, 1865. Library of Congress*

bookstores, following historian Talbot Hamlin, commonly speak of an entire architectural movement called "Jeffersonian Classicism."[8]

But Giles Worsley, operating from an English perspective, has recently dared to question the uniqueness of Jefferson's vision and the novelty of his capitol. He starts by grounding him in the conservative tradition of the gentleman-architect: "Like Lord Burlington and other English eighteenth-century amateurs, Jefferson was obsessed with Palladio and, through Palladio, with the Antique. English amateurs could have been responsible for virtually all Jefferson's buildings." He famously copied the ancient Roman temple, the Maison Carrée, but to use a temple in fashioning a public building was not wholly original; already "numerous British architects had experimented with the idea of designing a church in the form of a temple" at the time of London's Fifty New Churches Act. Examples include James Gibbs's first scheme for Saint Mary-le-Strand (1714), based on the Maison Carrée or Temple of Fortuna Virilis, and Nicholas Hawksmoor's Saint George's (1716), with its portico taken from Baalbek in modern-day Lebanon. Arguably the capitol portico was less a revolutionary leap into the temple form than an evolutionary de-

velopment out of the tall Palladian porch popular on fine southern homes before the Revolution and a feature of the 1751–53 Williamsburg Capitol, for which Jefferson expressed his approval as "light and airy." The great innovation, some say, was to copy *one specific* ancient temple in a modern building—notwithstanding the examples cited above—but lately this idea has been shown to have been Charles-Louis Clérisseau's, not Jefferson's. We are rarely given side views of the capitol, which inconveniently reveal that the structure as carried out by Samuel Dobie looked less like the Maison Carrée than it did Saint Martin-in-the-Fields (minus the steeple, of course) from that old-fashioned Virginia touchstone, Gibbs's *Book of Architecture* (fig. 2.11). Worsley debunks the idea that Jefferson's oft-quoted dislike for British architecture amounted to much more than "political antipathy" and concludes, "To see Jefferson as an innovative neo-Classicist breaking the trammels of British architecture to create a new independent style worthy of a young republic is grossly to misrepresent his work. Jefferson was the culmination, the very worthy culmination, of English neo-Palladianism," his manner not French, as is usually said on the basis of some of his written remarks, but English of "a distinctly conservative manner." Whether one is convinced by this reappraisal, it must be admitted that English historians have too often had to remind us of the essentially derivative nature of our architecture and of the modest roles played by even our most celebrated early architects.[9]

Perhaps the waning of certain twentieth-century ideologies makes it easier to accept the idea that secondhand architectural ideas can be as intriguing as firsthand. In any case, derivative notions usefully illuminate the complex intellectual relationship between the United States and England in the years when, as Cushing Strout has written, "The Old World was both an inspiration and lure to Americans, even while it remained in political terms the incarnation of the enemy." To embrace English Romanticism "was a characteristic American way of sympathetically relating oneself to a Europe which by national self-definition was regarded as the alien opposite of the New World." This curious ambivalence is one of the great and difficult themes of the period, and it appears again and again in architecture. Even as they clamored for cultural independence, Americans wholeheartedly embraced the architectural standards of Britain and struggled to conform to the canons of taste that prevailed in that country. "That this should occur during a period of intense nationalism and local pride demonstrates the continuing influence of European tradition and culture in the United States," writes John W. Reps in discussing this paradoxical American adoption of English architectural fashions.[10]

Those who would emphasize American unique-
ness might heed the comments of tourist William
Strickland (not the architect), who arrived in New
York from Yorkshire in September 1794 to find
extraordinary similarities:

> I have a thousand times said to myself, Have I
> been traversing the Ocean for so many weeks,
> to be sett down again in the country I quitted?
> Surely this cannot be America; This cannot be
> a new town, in a new world; for such must be
> attended with many new objects, new faces, new manners, new customs,
> but here I can find nothing different from what I have quitted, or anything
> but what I might have met with in any commercial town, in Hull, in Liv-
> erpool, or Bristol. . . . Wonderful is the similarity between the general
> appearance of things in the two countries. . . . The dress and external ap-
> pearance of the people is the same. The houses are in the stile we are ac-
> customed to; within doors the furniture is all English or made after En-
> glish fashions. The mode of living is the same.

In a similar vein, traveler Moreau de St. Méry said of the Americans, "In
spite of their pretended detestation of the English, they really love them . . .
In spite of their conceit, they subconsciously feel themselves to be inferior to
the English, and this leads them to treat them with adulation. Their tastes,
their customs and above all their habits are really the same as those of the
English."[11]

Nor did this similarity disappear with time. Ties were maintained by
travel, which proved increasingly easy with the development of the passenger
steamship. The triumphant arrival of paddle steamers *Sirius* and *Great West-
ern* in New York Harbor in April 1838 promised an even closer cultural bind-
ing of the two nations; in this sudden new "epoch of annihilated space,"
Nathaniel Hawthorne wrote, "I might [in a few weeks] have snatched a
glimpse at England, and been back again." Thoreau left his Walden Pond
shanty and bean field to manage Emerson's household while Emerson trav-
eled abroad: "It is hard to believe that England is so near as from your letters
it appears; and that this identical piece of paper has lately come all the way
from there hither . . . from England, which is only historical fairyland to me,
to America, which I have put my spade into." Even before the first steamers
arrived, Basil Hall found that "communication with Europe is easy and fre-

quent," which helped ensure that "nearly all that [America] has of letters, of arts, and of science, has been, and still continues to be, imported from us."[12]

American writer N. P. Willis worried in the 1830s that the steamship would actually erode Americanness, making the United States merely "the suburban or provincial" satellite of Britain, exacerbate "our general rule of imitating English habits too exclusively," and underscore "our similarity to themselves in most things." British tourist Frederick Marryat wrote in 1839, "Boston [is] essentially English as a city. The Bostonians assert that they are more English than we are." Geologist Charles Lyell's first impression on arriving in America in 1841 was "finding the people here so very English"; "We are often amused to observe how much the conversation turns on what is going on in London." Even the exoticism of the American language had been exaggerated, he discovered: "There are scarcely any American idioms or words which are not of British origin." "Yankee" pragmatism was characteristic of both nations, Emerson observed, the English having "impressed their directness and practical habit on modern civilization" generally. He added that "the American is only the continuation of the English genius into new conditions." In Philadelphia, historian John Fanning Watson noted "our national predilection as English" and that "as English colonists we early introduced the modes of our British ancestors . . . and we, even now, take all annual fashions from the ton of England."[13]

It follows that most high-style American architecture throughout the period showed a debt to English traditions and ideas, with necessary adaptations, as we have seen, to modest budgets and wooden construction. The dependence is obvious in public buildings, but contemporaries saw close similarities even in vernacular and domestic design. Latrobe wrote in 1805, "In America our manners are English, but our climate is in almost every particular the contrary of the climate of the British Islands. Our buildings however are exact copies of those erected in Great Britain especially the dwelling houses of our cities." A Russian visitor noted in 1811–13, "English architecture prevails here throughout." Writing in 1828, James Fenimore Cooper concurred: "The Americans have not yet adopted a style of architecture of their own. Their houses are still essentially English, though neither the winters nor the summers of their climate would seem to recommend them." At a country house in New York, "The interior arrangements of this, no less than of most of the houses I have entered here, are decidedly of an English character." Fanny Kemble wrote of Cambridge in 1833, "The village . . . with its white cottages, and meeting roads, and the green lawns and trees round the college, reminded me of England." In Boston, "The houses are like English

Houses; the Common is like Constitution Hill; Beacon street is like a bit of Park lane."[14]

Many have argued for Downing's commitment to the expression of Americanness in domestic design, and certainly he built his reputation around his ability to reformulate foreign ideas to suit American needs. But we must be cautious about this tricky subject—for really his goal was not a break with Britain so much as it was the encouragement of a national maturation into conformity with Britain's high standards. Most of his efforts toward "Americanness" were really an accommodation to moderate means and the use of wood—important adjustments, but ones we must be careful not to exaggerate. Architect William H. Ranlett observed in 1849 that "the cheapness of travel, which induces our people to go abroad" had "had a marked influence upon the character of our domestic architecture," and a year later Downing himself made a trip to Britain that reaffirmed his commitment to the Picturesque, reinforcing his dream "that at no distant day our country residences may rival the 'cottage homes of England,' so universally and so justly admired." Asher Benjamin is acclaimed as America's first writer of architectural books, but it is seldom recalled that chunks of his *American Builder's Companion* (second edition, 1811) were plagiarized from the popular writings of London-based architect Chambers. As late as 1852, the year of Downing's death, Samuel Sloan could write, "American works on architecture are few in number, and no works on American architecture have yet been written. . . . We have been, and still are dependent upon foreign publications." In sum, there were uniquely American *building practices*, but, contemporaries believed, there was really no such thing as American *architecture*. Introducing his survey of world architecture in 1853, the American John Bullock wrote matter-of-factly, "It need excite no surprise that, in our sketch of Architecture in various countries, we have not treated of that in America. There is no peculiar American style or order."[15]

Should we conclude that United States architecture of the period was merely a pale reflection of Europe's, semicompetent and hardly worth considering? Certainly not. The high quality of American design and construction are obvious to anyone who has studied the surviving remains of the past. Secondhand ideas need not be less compelling than original ones, and the very acts of translation and emulation shape architecture in fascinating ways. Rome reinterpreted the ideas of Greece, adapting them to changed conditions; to pay ardent homage to the greatness of the parent culture becomes in itself an inspiring theme, in a historical sense blessing both the society that gives and the society that takes. What needs reassessment is how we evaluate

United States architecture, our long-standing tendency to overstate American uniqueness and to suppose that aesthetic independence was the fundamental goal of a cocksure young nation.

It is an inescapable fact that architectural "Americanness," far from being a cherished goal, was in fact commonly equated with crudity and tastelessness by contemporaries, synonymous less with exciting innovations than with disastrous solecisms. Commentators were especially quick to spot New World deviations from the principles of classicism, which they pointed out in order to shame their fellow citizens into the true path of improving the general taste of the nation—for "in no civilised country" were "the rules of architecture . . . less regarded than in the United States," one contemporary lamented. There was no bending the rules, theorist Archibald Alison had warned in England: "Deprive these orders . . . of their customary ornaments . . . or change only in the slightest degree their forms . . . and their beauty will be in a great measure destroyed." Armed with a remarkably high level of awareness of the conventions of classical architecture, a desire to appear knowing, and a contempt for provincialism, a parade of travelers both native and European ridiculed every possible instance of architectural Americanness.[16]

British tourists set the tone. Englishman A. J. Foster arrived in 1804 and wrote of James Hoban's President's House in Washington (1792–1800), "The exterior looks well from its size and regularity but the style of the architecture is by no means pure. The pilasters are Ionic but the volutes are heavy and ill executed. The shafts are too long and upon small pedestals. . . . there is much ill executed ornament of garlands and modules." Tourist Thomas Hamilton, unstinting in his criticism of United States architecture, attacked the Providence Arcade (fig. 4.16):

> The only building [in town] which makes any pretension to architectural display is the arcade, faced at either extremity with an Ionic portico. Judging by the eye, the shaft of the columns is in the proportion of the Grecian Doric, an order beautiful in itself, but which, of course, is utterly barbarized by an Ionic entablature. By the way, I know not any thing in which the absence of taste in America is more signally displayed than in their architecture. The country residences of the wealthier citizens are generally adorned with pillars, which often extend from the basement to the very top of the house, (some three or four stories,) supporting, and pretending to support, nothing. The consequence is, that the proportions of these columns are very much those of the stalk of a tobacco-pipe, and it is difficult to conceive any thing more unsightly. Even in the public buildings, there is often an ob-

trusive disregard of every recognised principle of proportion, and clamourous demands are made on the admiration of foreigners, in behalf of buildings which it is impossible to look upon without instant and unhesitating condemnation.

Another public building that came in for Hamilton's censure was Tremont House (fig. 1.11): "The dining-hall, which is here the chief object of admiration, is defective, both in point of taste and proportion. The ceiling, in the first place, is too low; and then the ranges of Ionic columns, which extend the whole length of the apartment, are mingled with the Antae of the Composite order; thus defacing, by the intermixture of a late Roman barbarism, the purer taste of Greece." And again on private homes, he wrote of Springfield, Massachusetts, "It abounds with white frame-work villas, with green Venetian blinds, and porticoes of Corinthian or Ionic columns sadly out of proportion. . . . these transatlantic Palladios seem to despise the antiquated notions of fitness and proportion which prevail in other parts of the world. They heap tawdry ornament upon their gingerbread creations, and you enter a paltry clapboard cottage, through—what is at least meant for—a splendid colonnade."[17]

One might expect English travelers to have thumbed their noses at American buildings, but what is remarkable is how enthusiastically Americans themselves joined in, excoriating one another's architectural tastelessness and, as J. Meredith Neil has written, "attempting to bully their countrymen back to the true way." Connecticut editor Theodore Dwight held that "our best plans of architecture in the United States are notoriously defective"; Greenough chastised the "Aesthetics at Washington" and pointed out the architecturally "shabby," "slovenly," "absurd," "ignorant," and "barbarous"; and poet Fitz-Greene Halleck declared sarcastically, "In architecture, our unrivall'd skill, / Cullen's magnesian shop has loudly spoken / To an admiring world." In England, J. C. Loudon asked an American correspondent for "specimens of American architecture" to publish in his influential *Architectural Magazine*, but the reply came feebly, "I cannot promise you any, unless you would accept of one or two of our commodious barns." Downing wrote ironically, "No one pretends that we have as yet . . . a national architecture . . . unless our Yankee clap-board house be taken as a specimen." Susan Fenimore Cooper ended an insightful overview of American architectural history with the conclusion, "Certainly there is not much to boast of among us in the way of architecture as yet, either in town or country."[18]

Condemnations of architectural Americanisms came from every region. A visiting New Yorker called Philadelphia "the city of ugly buildings *par excel-*

lence. There's not a church in it but's downright *hideous*." For one traveler, "miserable huts" in Kentucky qualified as "a specimen of the *first* order of *American Architecture*," and he sneered at the "new order of architecture" hatched at the Fayette County Courthouse, Lexington (Hallet M. Winslow and Luther Stephens, 1806), columns with "the thick end uppermost"— shades of an Italian architect described by Chambers who "placed the capitals at the feet of his columns." Crazy columns marked the grotesque "Mansion-house" in Cooper's *Pioneers* (1823): here "four little columns of wood" that were meant to support "the shingled roof of the portico—this was the name that Mr. Jones had thought proper to give to a very plain, covered entrance"—in fact dangled from it, so that the roof served "to uphold the pillars." A citizen of the 1830s wrote, "There may be no American literature, painting, sculpture, but there certainly is American architecture. We have columns which mock at the narrow limits of the Grecian orders; . . . ornaments which it would baffle the genius of Palladio to class; and 'shingle palaces' that rival pandemonium." Cooper declared, "In architecture the Americans have certainly no great reason to exult," and he even blasted the much-praised New York City Hall: "Neither is its *façade* in good taste, being too much in detail, a fault the ancients were not fond of committing"; it exhibited "glaring defects" (fig. 1.37). Marryat, too, found the architecture of that building "very indifferent" and called Girard College "incorrect, according to the rules of architecture, in the number of columns on the sides in proportion to those in front. This is a great pity" (fig. 1.1). In Natchez, Mississippi, Joseph Ingraham remarked upon "the very small number of handsome public buildings in the United States, and the total contempt for order or style." Architect Daniel H. Jacques condemned "the general ugliness of our buildings." Artist Thomas Cole wrote in 1839 of an edifice under construction, "I am afraid that the building when finished will be like most other buildings erected in this country, a monument of Bad Taste and Architectural Ignorance." With considerable relief, Catharine Sedgwick observed of Stockbridge, Massachusetts, "There is not a single 'Italian villa,' no 'Grecian front,' not one wooden Corinthian column without a capital, nor a capital without a column!"[19]

In an age of insecurity, it was customary for architects to attack each others' work ferociously. In 1835, a visiting practitioner called James Dakin and Ithiel Town's New York University (1833–37) "incongruous," marked by "hideous abortions and monstrous absurdities" (fig. 2.12). In Massachusetts, Edward Shaw said, "The architecture of our country is at present in a very undefined, we may almost say in a chaotic state," and he found fault with several buildings, including George M. Brimmer's Trinity Church, Boston

Figure 2.12. *James Dakin and Ithiel Town, with Alexander Jackson Davis, New York University, 1832–37. At right, James Dakin, Reformed Dutch Church, 1840. Both demolished 1894. Anonymous,* University of the City of New York, Washington Square, *1850, ink and watercolor, 6¼ × 9⅛ in. (15.9 × 23.1 cm). I. N. Phelps Stokes Collection, Miriam and Ira D. Wallach Division of Art, Prints and Photographs, The New York Public Library, Astor, Lenox and Tilden Foundations [Deak 600, Stokes Uncat. Colleges]*

(1829): "The sides belong to an age of the Gothic different from the front. . . . The central arch of the roof is altogether out of proportion." A reviewer of Shaw's *Rural Architecture* meandered off into condemnations of various American buildings, including the U.S. Capitol ("flaunting and meretricious," "the weak puerilities of Latrobe"); Ammi B. Young's 1837–47 Custom House, Boston ("so incongruous and absurd a pile, that we scarcely know where to begin or where to end our enumeration of its deformities"); and the Boston Exchange (within "a tawdry and miserable failure," and "Who can look without laughing at the allegorical display over the front entrance . . . ?") (fig. 5.16). Davis, visiting Philadelphia in 1844, noted in his diary a series of aesthetic "Objections to Girard College." In a particularly nasty episode, a congressional committee summoned Thomas U. Walter to investigate supposed flaws

in Robert Mills's Treasury Department, then under construction (fig. 5.26). Walter pulled no punches, saying that the long colonnade with its "monotony, can never be considered as beautiful"; the architecture as a whole was "by no means creditable to the nation"; and he went so far as to call upon the government "to take down the whole building."[20]

We should not conclude from these remarks that United States architecture was of dismally low quality. On the contrary, it was quite high, given the newness of the nation and the difficulties to be overcome. But what is revealed are contemporary attitudes and the intellectual climate that shaped the development of American architecture: sharply critical and impatient with error, regarding the European example not with contempt or scorn but with something close to awe. The aesthetic ideas of the day, very different from our own, stressed conformity, not novelty; respectful obedience to established principles, not striking innovation. Even factoring in the contemporary propensity to be outspoken and to complain, there is no question that architectural "Americanness" was viewed with enormous skepticism. Conforming to minimal European standards was the goal, not the creation of some new approach distinctive of national uniqueness. Indeed, the latter would have seemed appalling to most informed observers, as no good could come from deviations from the long-established traditions of England, to which architects ardently looked for guidance and help. Uniqueness, when it occurred, was gross error.

It is mostly a modern idea that the old European architectural rules, rooted in history and tradition and a show of erudition, were stultifying trammels or artificial impediments to the expression of genius. This latter-day attitude is far removed from that of the early nineteenth century, when contemporaries no more resented them than we begrudge using proper English grammar in writing or speech—or, as it has been said, playing tennis with a net. Although a few radicals decried them, these inherited rules were generally accepted as the universal architectural language of educated persons everywhere, and within their bounds was a wide field for experimentation and creativity. They were considered proper and salutary, and indeed indispensable if there were to be improvement in the naive architecture of the new United States.

If any one building should have displayed "Americanness," it was the capitol of the Republic. Hamlin managed to discover in it "The Birth of American Architecture," but a glimpse at its complex history will show that it obeyed at every turn the accepted principles of classicism and dutifully followed the evolving fashions of European and especially English design. Not that it was tame or insipid—far from it; visitors from their time to ours have found its spaces elegant and inspiring. These were not, however, dramatically different

from foreign examples, and if they seem "American" it is mostly through the skillful reinterpretation of Old World ideas. Manpower and materials at the capitol were of the United States, but the design concepts were derivative ones effectively synthesized to suit indigenous conditions.[21]

When the Sixth Congress gathered in Washington in the fall of 1800, the north wing was already finished, a squarish box of freestone-faced brick on a hill overlooking a city of only 372 houses (fig. 2.13). A young Robert Mills, in training to be an architect, climbed to the top of the edifice in July 1803 to enjoy "a most commanding and beautiful prospect, variegated with woods, clear'd lands, mounts and vales," but the town was not much to speak of— "great quantities of Dog fennel grow about the City on the unclear'd spots." The capitol as Mills knew it that summer was the result of a competition held eleven years earlier, in the first Washington administration, following which a parade of foreign-born architects and amateurs had been rather confusingly involved: Stephen Hallet (French), William Thornton (English educated), George Hadfield (English trained), and James Hoban (Irish). The European mindset of these men collectively ensured that the Renaissance classicism of the 1790s capitol would have been right at home overseas a couple of decades earlier; in particular it shows close affinities to the façade of Chambers's Somerset House (1776–80), a landmark along London's busy Strand.[22]

In 1803, President Jefferson appointed Latrobe surveyor of public buildings, and the English émigré worked until 1811 finishing the south wing and redesigning the north, so that the interiors of the capitol became completely his. He "changed the building's aesthetic direction from Thornton's British distillation of Italian Renaissance traditions to [a] radically modern Neoclassical vision"—not an "American" approach, however, but a manner he had learned and practiced in England in the 1780s and 1790s. His "architectural rationalism" in the capitol has recently been called "more democratic" than it would have been in Britain, but this draws a highly subtle and perhaps overly idealistic distinction. In the vigorous interplay between Latrobe and Jefferson, Latrobe favored the Greek while Jefferson constantly nudged him toward the Roman forms of the old Palladianism. Latrobe was not averse to Rome, so long as the date was early enough: "I am a bigotted Greek, to the condemnation of the roman architecture of Balba, Palmyra, Spalatro, and of all the buildings erected subsequent to Hadrians reign"—and at various times in his schemes for the capitol he proposed Greek elements (temples at Paestum and Delos, Tower of the Winds, Propylaea, Parthenon frieze, Choragic Monument of Lysicrates) as well as Roman (Theater of Marcellus, Pantheon, thermal windows, a "Dioclesian Portico"), with Egyptian lotus and papyri thrown

Figure 2.13.
William Thornton and others, U.S. Capitol north (Senate) wing, Washington, D.C., begun 1792. William Russell Birch, A View of the Capitol of Washington Before It Was Burnt Down by the British, *1800, watercolor [dimensions unknown].* Library of Congress

in. But he never introduced a Roman capital; these (when historicizing) were always Greek, signaling his commitment to the chastest classicism.[23]

Then came the War of 1812 and Admiral Cockburn's British troops. In April 1815, the architect arrived in Washington and stood among "the ruins of the Capitol . . . a melancholy spectacle"; "the devastation has been dreadful." In the House of Representatives eight months earlier, the marauders had heaped "the Mahogony furniture, desks, tables and Chairs" in "a great pile in the Center of the room . . . and retiring, set fire to a large quantity of Rocket stuff in the middle. The whole was soon in a blaze." The conflagration swiftly spread to the "double floor of light pine wood," wooden gallery, and "roof of pitch pine plank." Molten glass streamed down from the skylights.[24]

In the aftermath of this calamity, Latrobe set out to redesign the chamber, improving the lighting and acoustics of the old room by refashioning it as a

semicircular hall, one evidently derived from French precedent, in particular J. F. T. Chalgrin's Senate Chamber, Palais du Luxembourg (1803–7) (fig. 2.14). Rather than rebuild the place entirely in "the brittle freestone of Acquia," he decided that the columns would be of finer materials. In August 1815 he explored the banks of the Potomac River above Washington and found, overhanging the water, outcrops of breccia, "a Stone consisting of fragments of ancient Rocks bound together by a calcareous cement." It was a colorful pudding stone, or conglomerate, but he proudly took to calling it "Columbian marble" and boasted that it would provide columns "of beauty not exceeded in any modern or ancient building." Some doubted whether it was strong enough for the purpose, but President James Monroe braved foul weather to visit the newly opened quarry in March 1817 and approved Latrobe's choice. By June there were "100 Men, laborers and Stonecutters at work in the Quarry," and blocks had already been delivered to the stone yard in front of the south wing of the capitol, where they were shaped into three drums per column, probably with black locust pins between them as a dowel. They were topped with three-ton, white marble capitals in Choragic Monument Corinthian, shipped from Carrara, Italy, where they had been carved under the supervision of sculptor Giovanni Andrei. The 28.5-foot columns would cost not $1,550 each as the maximum estimate had it, but more like $5,000; yet they were splendid, giving the effect of the *verde antico* shafts employed years earlier by Robert and James Adam in the anteroom at Syon House, London (1761–64).[25]

Latrobe's columns are the glory of the Old House chamber, still one of the finest rooms in America. It has not echoed to the bustle of congressional business since 1857, but during its time it witnessed the fiery drama of sectionalism and the march to disunion, from Missouri Compromise to Kansas-Nebraska Act. Artist Samuel F. B. Morse showed it in the early 1820s, as Congress prepared for a night session. He hoped to make money by mounting a traveling exhibition of this picture and went to great trouble to depict the room accurately, using a camera obscura to get the drawing right and setting up a studio in an adjoining office where members of Congress posed for their portraits. A key could be purchased, identifying eighty-six of the ninety-four people shown, including the Supreme Court justices assembled against the framed Declaration of Independence on the far wall and visiting Pawnee Indian chief Petalesharro in the balcony. Lyrical though it may be, the painting is poignantly symbolic of the difficulties artists and architects faced in the young Republic. It shows the wooden ceiling illusionistically painted to resemble the coffered masonry vaults of the Romans; Latrobe had protested ve-

Figure 2.14.
Benjamin Henry Latrobe,
House of Representatives,
United States Capitol,
Washington, D.C.,
1815–19. Floor raised
1838; ceiling replaced
1901–2. Samuel F. B.
Morse, The Old House of
Representatives, *1822, oil*
on canvas, 86½ × 130¾ in.
(219.7 × 332.1 cm). In the
Collection of the Corcoran
Gallery of Art, Museum
Purchase, Gallery Fund
[11.14]

hemently against this use of wood instead of brick, but he lost the battle and soon thereafter quit his job at the capitol, disgusted by his ill treatment at the hands of the meddling and intransigent building committee. A desperate need for employment soon forced him to fever-plagued New Orleans, where he died. As for Morse, his dreams of profit were dashed when the public ignored the picture, which made its way to dusty obscurity in England as the painter himself gradually turned from art to science, a field Americans could appreciate. In quarters at New York University in 1835 he would find fame at last by inventing the telegraph (fig. 2.12).[26]

In 1806, Latrobe had drawn a picture that imagined the completed capitol with a portico on the east front and a dome atop, an arrangement that Bulfinch would put into place in the 1820s. Except for some sculptural campaigns, this finished the building in the form in which it stood for the last two decades of our period (fig. 2.15). In fall 1850 a competition was announced for a great extension, and Thomas U. Walter was chosen. Once again, styles had changed, albeit subtly, to "Victorian . . . derived partially from Italian Renaissance." Like the previous ones featured in this most all-American of buildings, the manner was European in derivation and made little attempt to demonstrate uniquely American qualities. Indeed, in an age that supposedly cherished the quest for Americanness, virtually the only architectural innovations that received acclaim from travelers *anywhere* in the United States were the corn (1809) and tobacco capitals (1816–17) introduced by Latrobe in the heavily

Figure 2.15. *United States Capitol, Washington, D.C., showing east portico and dome by Charles Bulfinch, 1820s. Dome removed 1855; east front rebuilt 1958–62. John Plumbe,* The United States Capitol, *1846, daguerreotype, ½ plate, image 3½ × 4⅝ in. (8.9 cm × 11.9 cm). The J. Paul Getty Museum, Los Angeles*

traveled vestibules of the capitol—hailed by a Scotsman as "the American School of Architecture" (fig. 2.16). (The magnolia capitals, destroyed in the 1814 fire, garnered less attention.) The capitals were considered successful, however, because they accommodated themselves respectfully to the rules of classicism and participated in a legitimate European tradition of creative, associative orders. Even then, they had slight influence, being picked up only

much later by James Renwick (1846), Downing (1850), and Davis (1850, 1854). Latrobe's handsome orders are constantly illustrated in textbooks, but at the time this kind of self-consciously Americanizing innovation was very much the exception, not the rule.[27]

The Problem of Style

Architectural styles can be difficult and confusing. For one thing, there were so many—one book lists for this period Dutch Colonial, French Colonial, Spanish Colonial, Georgian, Adam, Early Classical Revival, Greek Revival, Gothic Revival, Italianate, Egyptian, Oriental, and Swiss Chalet—and at times they mixed and mingled. To the educated contemporary they spoke a definite language, aesthetic and historicizing, but many of us cannot understand that language today. Every recent generation has heaped invective upon style; modernists scoffed at the wild stylistic miscellanies that burst forth in the nineteenth century once "the floodgates of eclecticism opened wide"; the folklorish resurgence of interest in style that took place about 1960 struck some observers even then as "curiously patronizing"; and, more recently, vernacularists have warned against "the persistent reliance on categorizing most buildings according to flawed interpretations of the concept of style" and deplored the "deep and crippling belief in the utility of stylistic labels as a general tool for understanding the built environment." And yet among the public the appeal of styles is far from dead; since 1969, publishers have profited from a series of guides with such titles as *What Style Is It?*[28]

In the nineteenth century, styles played a fundamental role in elevating *buildings* to the more exalted status of *architecture*—a distinction that hardly exists today. We cheerfully ignore Pevsner's famous dictum about bicycle sheds and Lincoln Cathedral—just the second deserving to be called architecture, because "the term . . . applies only to buildings designed with a view to aesthetic appeal." But from a historical perspective, he was right: for centuries, architecture meant the application of taste to the craft of building, and, as Loudon said, "*A correct taste in architecture* always implies a reference to the details of some particular style." His follower Downing took pains to distinguish among the relative virtues of different building types and adumbrated Pevsner in saying, "A cotton-mill, one of the most useful of modern structures, is not so beautiful as the temple of Vesta." We often dismiss style as elitist or superficial, but in doing so we risk overlooking an essential avenue to understanding the built world as contemporaries conceived it. A history

of vernacular design may with some safety ignore style, perhaps, but one that aims to consider the productions that the nineteenth-century observer called *architecture* must grapple with the meanings of styles—not using them as a convenient crutch but looking beyond their surface qualities to understand their complex relationship to contemporary culture.[29]

Styles are often read as political but in fact spoke their own language of taste, which allowed their application across all kinds of ideological divides, regardless of politics. This can be seen at work in the home of a leading politician of the day—Andrew Jackson's Hermitage in Tennessee. His life was emblematic of the westward movement of America and the rise to wealth and power that its egalitarian traditions could offer. Born in South Carolina of poor Scotch-Irish immigrant parents, Jackson carried all his life saber scars incurred in the Revolution; despite his slight education, he became a lawyer, politician, general, successful planter, and finally, in 1828, president of the United States. Like many contemporaries he had left the Tidewater region for the west, crossing the Wilderness Trace in 1788, and his homes showcased his steady rise to fortune and status. From 1804 to 1821 he and his family occupied log cabins at the Hermitage farm. In 1819 he began construction of a brick house of Federal style, a great advancement in comfort and sophistication, although it had little exterior ornament other than a fanlight (fig. 2.17).[30]

As president he began extensive additions, corresponding from Washington with his architect, David Morrison, who told him that he had

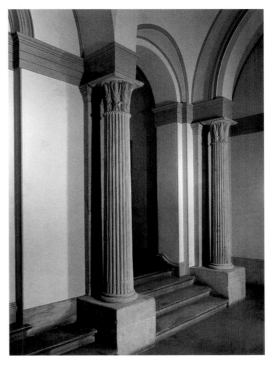

Figure 2.16.
Benjamin Henry Latrobe, Corn Order Vestibule, United States Capitol, 1809. Carving by Giuseppe Franzoni. Photographic Archives, National Gallery of Art, Washington, D.C. Photographed for the Dunlap Society by Richard Cheek

erected a neat and appropriate Portico on the back side of the center building, which adds very much to the comfort and convenience of your dwelling— The Hermitage as improved presents a front of 104 feet, the wings project 9 feet in front of the center building and are connected by a colonnade of the same breadth. The colonnade consists of 10 lofty columns of the *Doric* order the entablature is carried through the whole line of front, and has wreaths of laurel leaves in the freeze. On the cornice is raised a blocking course that supports an appropriate balustrade. The upper story consists of a Portico surmounted by a pediment which breaks the monotony of the composition, in a very satisfactory manner [fig. 2.18].

The Role of Britain and the Picturesque ⌈ 77

Figure 2.17.
Evolution of the Hermitage, Andrew Jackson home, near Nashville, Tennessee. Above, first version, 1819–21. Upper right, additions by David Morrison, 1831; building burned 1834. Lower right, rebuilt by Robert Mills, attrib., 1836. Drawings by Ken Spradley. The Hermitage: Home of President Andrew Jackson, Nashville, Tennessee

This was a long way indeed from Jackson's first log cabins. The double-porch Federal design was a widespread form that, like Jackson himself, had migrated inland from the coastal states (fig. 4.14), but here the laurel wreaths spoke of the military and political achievements of this particular owner. Excellent materials were employed: "The colonnade is covered with the best copper the sheets weighing from 12 to 14 lb. each sheet, and the gutters that convey the water from the front to back are also of copper the wing buildings and Porticos are roofed with good cedar shingles." The $2,488 outlay included expenses to "stone cutter stone masons & brick layers," "carpenters & joiners," "Painters & glasers," "Plasterers," "Copper smiths & tinners." Morrison considered Jackson's needs as a man of public renown: "The dining room is large and will dine 100 persons at one time comfortably. The wing at the east end contains the library a large and commodious room, an overseer room, and a covered way."[31]

This attractive and stylish residence was short-lived, for it burned in 1834. Repairs were begun immediately, resulting in the Greek Revival house in which the elderly statesman died in 1845 (fig. 2.17). The design has been attributed to Robert Mills. The salient point is that, with every building campaign, the Hermitage became grander, and the new, nationwide styles were applied more or less promptly as they came along. Jackson's constantly "improving" house thereby expressed his growing wealth with its ever more monumental presence. This ambitious drive toward architectural show, this

eagerness to display the latest fashions, was universal in America—even with Jackson, the representative of the brash New West and champion of the uncouth common man. Aesthetics, not politics, governed his choices; his egalitarian outlook and democratic bent had no bearing whatsoever on the houses that he built, which were guided entirely by the principles of taste and the changing styles of the day. Anglo-American aesthetics fol-

lowed its own course and, some heated squabbles aside, generally formed a rare point of widespread agreement in an age torn by ideological strife: "Angry volumes of politics have we written none; but peaceful books," Downing pointedly wrote on the first page of *The Horticulturist*, directly across from bucolic pictures of "A Common Country House" and "The Same, Improved."[32]

The multiplication of styles in the years before 1850 cannot be understood without reference to the larger body of theory that unified the disparate modes—namely, the cult of the Picturesque, a topic that British scholars seem more comfortable discussing than their American counterparts, though it was as influential in the new nation as in the land of its birth. The word *picturesque* is famously indeterminate, "a notoriously difficult category to define," and indeed as early as 1813 it was possible to speak of "the *picturesque*, a term which volumes have been written in attempts to define."[33]

It is most readily applied to landscape and is the appropriate way to describe many of the garden designs of the era. Downing greatly admired the Picturesque effects of Blithewood (fig. 2.19, though this view perhaps tends toward the "Beautiful"; see also fig. 4.30), in Annandale-on-Hudson, New York, and his own work in this mode reached an apogee in his 1851–52 scheme for the Mall in Washington. The only part carried out was the Smithsonian Pleasure Grounds, a rolling English park with shade trees and conifers scattered naturalistically, exhibiting the irregularity and chance effects that lay at the heart of the Picturesque "point of view" (fig. 2.8). Downing knew that in dealing with Picturesque styles of building, such as the Romanesque of the Smithsonian, "spiry-topped trees" were sure to "harmonize well with the architecture." This ambitious landscape bore important fruit: his associate at the time was Englishman Calvert Vaux, who worked with him from September 1850 until Downing's death in the July 1852 burning of the steamer *Henry Clay* as he was en route to Newport and, eventually, to superintend the work at Washington. Vaux went on to become famous for creating, with Frederick Law Olmsted, the Picturesque "Greensward" plan for New

York's Central Park (1857–58). It is interesting to note that, even as Vaux pioneered the large, sophisticated urban park of the future, the urn that he designed as a memorial to Downing on the Washington Mall (1856) recalled that to Franklin on the "Grass plat 300 feet long Surrounded by Trees" at England-inspired Tontine Crescent—that tiny progenitor of the modern, Picturesque designed landscape in America.[34]

When architecture is the subject, too often the term *Picturesque* is taken to connote an ethos of cheapness and frivolity, silly aestheticism that was fundamentally shoddy and dishonest. In studying the Greek Revival, Hamlin in 1944 condemned as "picturesque" the corruptions of the Neo-Gothic: "The whole cult of the picturesque was designed to disintegrate building techniques and lower building standards," yielding mere "tracery [of] jigsaw wood . . . battlements of boards" and "claptrap, stage-scenery construction." This modernist critique ignores the villa-book emphasis on sound construction techniques. Other Americans have exclusively associated the supposedly

"anticlassical" and asymmetrical Picturesque with the Gothic Revival and disallowed it before 1830. This, however, is to overlook the important role of Picturesque thought as early as the arrival of Latrobe, who wrote a thoroughly Picturesque "Essay on Landscape"; designed villas in a variety of styles, including the neo-Gothic Sedgeley, Philadelphia (1799); and exhibited the lively curiosity about ruins and other architecture of the past that the Picturesque encouraged.[35]

It may be helpful to think of the Picturesque as Romanticism applied to the material world, with a focus on naturalness, humility, variety, and (often) irregularity. Associationism and intense feeling were typical. Travel writers and topographical printmakers saw America through a Picturesque lens, and by the 1840s its role was unmistakable in the scenographic multiplication of styles in American towns and cities. Born in the eighteenth century and nurtured in the period we are considering, the Picturesque saw its greatest American impact after 1850, and it has been persuasively argued that the majority of high-style American buildings of 1845–90 were "shaped by the picturesque vision"; more sweepingly, "the picturesque was the predominant aesthetic of the whole century"; and although it was subjected to "disciplining" after 1880, it still maintained its hold on domestic architecture well into the twentieth century. Downing's published cottage designs were being pirated as late as 1883, and his *Landscape Gardening* entered a tenth edition in 1921, nearly seventy years after he died. The functionalist component of the Picturesque eventually helped provide a foundation for Frank Lloyd Wright and modernism, and American home designs up to 1930 sometimes bore startling similarity to English villa-book illustrations of the 1790s, essays in the half-timbered cottage that had lost none of their appeal across the generations.[36]

As we have seen, rapid growth of nineteenth-century populations, along with extraordinary social and technological change, brought the need for new building types on a scale hitherto unknown. A desire for stylistic choice simultaneously arose, and so the 1830s saw the flowering of an increasingly disparate eclecticism, various styles bound by a common commitment to fitness and the Picturesque. Davis turned to "the picturesque Cottages and Villas of England" as his model in *Rural Residences*, that pioneering American villa book, which offered designs in classical, rustic, Gothic, Italianate, "Oriental (East Indian)," "English Collegiate," "English Decorated," and other modes. Choice was the watchword. New styles were introduced in an empirical spirit, including the strange Egyptian, employed in contexts where an earlier generation might have used the primitivistic, classical Doric of Paestum or Delos (fig. 1.18). "We are in the midst of what may be called the experimental stage

Figure 2.20.
*John Haviland, Pagoda
and Labyrinth Garden,
Philadelphia, 1828.
Demolished soon after.
Lithograph, William B.
Lucas,* The Pagoda and
Labyrinth Garden.
Near Fairmount Water-
works, Philadelphia,
*1828. The Historical
Society of Pennsylvania
[Bc81 H388]*

of architectural taste," Downing said. "With the passion for novelty, and the feeling of independence that belong to this country, our people seem determined to *try everything.*" The habit came from abroad, of course; at Ker Street, Devonport (1823–24), English architect John Foulston had arranged an urbanistic grouping of Roman Corinthian terrace, Greek Doric town hall and column, "Oriental" chapel, Greek Ionic houses, and Egyptian library, calling it "an experiment (not before attempted) for producing a picturesque effect, by combining in one view" many styles.[37]

Such juxtapositions would soon become common, with the propriety of each new approach hotly debated. One innovator was Haviland, who trained for three years with James Elmes in England before immigrating to America in fall 1816. He played an important role in popularizing the Greek Revival in the early 1820s, partly through his *Builder's Assistant* (1818–21), but his most famous work is his castellated-Gothic Eastern State Penitentiary, Philadelphia (see fig. 1.1), about which much has been written. Its imposing façade derives from earlier English prisons. In a lighter mood he produced the Pagoda and Labyrinth Garden a few blocks away, in Chinoiserie style (fig. 2.20). He must have known Nash's infamous, eight-story Chinese Pagoda on an arched bridge in Saint James's Park, London, built for a fireworks display in 1814 and accidentally burned up during the show. More enduring was Chambers's Chinese Pagoda, Kew Gardens (1763), and it was a plate in that architect's *De-*

Figure 2.21.
Jonathan Tyers,
Vauxhall Gardens,
London, expanded
ca. 1750. Rotunda at left.
J. S. Muller after Samuel
Wale, A General Prospect
of Vaux Hall Gardens,
etching and engraving,
after 1751, 10¹/₁₆ × 15⅝ in.
(25.6 × 39.1 cm). Yale
Center for British Art,
Paul Mellon Collection

signs of Chinese Buildings (London, 1757) that Haviland copied in his seven-story design. He hoped to capitalize on the success of the nearby Fairmount Waterworks, with a nod to the Eastern exoticism popularized by London's Vauxhall Gardens (fig. 2.21), and in so doing he achieved an architectural novelty "in the light eastern style" that was very close to the spirit of Regency Britain. The project quickly resulted in his bankruptcy, however, and was soon demolished.[38]

This Picturesque taste had roots in the eighteenth century. The Chinese mania that gripped England around 1750 had found a sympathetic audience among Philadelphians; and later, in the 1780s, English émigré Samuel Vaughan had transformed the grounds of "a common Inn" at Gray's Ferry into an elaborate designed landscape with the aid of an English gardener and ten laborers. These public gardens (formerly behind the building in fig. 2.22) had "three very high arched bridges . . . in the Chinese style," "a curious labyrinth with numerous windings," "Grottoes wrought out of the sides of ledges of rocks, the entrance almost obscured by the shrubs and thickets that were placed before them, and the passage into them by a kind of labyrinth," and "a spacious summer-house. . . . The roof was in the Chinese form. It was surrounded with rails of open work, and a beautiful winding staircase led up to it"—eighteenth-century developments that prepared Philadelphians for the variety and playfulness of the nineteenth-century Picturesque.[39]

Figure 2.22.
Old Gray's Ferry
Tavern, near Philadelphia.
Piazza added after
ca. 1792. Photograph
by Robert Newell,
ca. 1870s. Demolished.
Newell Album, The
Library Company
of Philadelphia
[P.9062.79a]

A few miles north of Fairmount, Notman's Laurel Hill Cemetery exemplified the increasing stylistic pluralism of the 1830s United States as well as its strongly British tincture. On a thirty-two-acre ridge top that was seemingly far too distant from downtown ever to be threatened with urbanistic encroachment, the Scottish-born architect brought the rural cemetery movement to Philadelphia by closely following the much-publicized layout of Henry Kendall's Kensal Green Cemetery, London (1831–32). Entering through the wooden-porticoed North Lodge, the visitor discovered an ambitious, fully landscaped public garden in the English tradition (fig. 2.23). Contemporaries took enormous pride in this kind of tasteful development; several books were written on the place, and crowds were so thick on Sundays that admission had to be restricted, legitimate mourners being advised to visit early on weekday mornings. Crowded conditions here and at Boston's earlier Mount Auburn were cited by Downing as evidence that cities needed big Picturesque parks, which they would nearly all have by 1900.[40]

Today the crowds are gone, and one approaches Laurel Hill through a landscape that has, contrary to hope, long since become bleakly urbanized. North Lodge still stands, as does the *Old Mortality* sculptural group just beyond it, Sir Walter Scott and a pony at the side of a sepulchral slab upon which sits the peripatetic tombstone-restorer of Scott's popular novel. It was the work of a Scottish sculptor who exhibited the group in Edinburgh and London before bringing it to America, re-creating Scott (originally plaster) and pony (smashed in transit) in New Jersey brownstone before delivering them to Philadelphia. Forever gone from Laurel Hill, however, are eight of the nine original buildings that comprised Notman's diverse ensemble, including Gothic Chapel (fig. 2.24); Picturesque, verandaed superintendent's Cottage; and Ionic Summer House observation platform overlooking the winding Schuylkill. As with Haviland's Labyrinth Garden, the flavor of the latter two structures exactly recalled the delicately attenuated forms popularized by the first generation of English villa books.

Figure 2.23. *John Notman, North Lodge, Laurel Hill Cemetery, Philadelphia, 1836. Gardener's quarters to left of gate, porter's to right. Stereo photograph by Frederick and William Langenheim. The Library Company of Philadelphia [1322.F(III).50e]*

Stylistic variety was the watchword at Laurel Hill, as seen in the Roman Doric gateway (complete with sacrificial paterae in the frieze) opening abruptly onto the Gothic associated with Scott. The managers of the cemetery urged lot holders to use a variety of styles in their memorials, designs for which Strickland and Walter would be happy to provide. These monuments were celebrated at the time and seemed to signal a promising new epoch in the artistic life of America, forming part of a rich ensemble of architecture, statuary, trees, and winding paths bordered by hedges and iron fences, a concept so familiar today that it is hard to imagine ourselves back to when it was excitingly new. Laurel Hill still has its monuments—badly weathered—but time has robbed the place of many gracious little touches, so that early accounts are our best source for the original experience of a Sunday stroll through this Picturesque utopia. "The scene from the front of the chapel is one of unparalleled loveliness. Through it innumerable monuments are tastefully disposed—some of them exquisite works of art; while trees, shrubs, and flowers of every variety and hue throw a delicious shade around. In such a pleasing spot, when the birds are singing and the trees and plants present their verdure, the dreariness of the grave is lost, the utter oblivion that awaits

the tenant of the tomb is forgotten; death is here robbed of half its terrors." These anxieties were inescapable in an era when old and young alike might die without warning, as happened to Alfred T. Miller at age seven months in 1840. Strickland designed his Doric tomb, which was carved by J. Struthers and Sons at 360 Market Street, continuing an architect-stonemason collaboration that had produced the 1837 sarcophagus of Washington at Mount Vernon as well as several important public buildings (fig. 5.7).[41]

In this era of new styles, the imported rural cemetery movement—a suburbanistic attempt, ultimately French, to escape the crowding and "putrid miasmatas" of city burying-grounds—ushered in many Egyptian tombs and gateways (fig. 2.25). Walter and Strickland had submitted Egyptian designs for the Laurel Hill entrance, and an Egyptian gateway was erected at rival Odd Fellows' Cemetery (Button and Hoxie, ca. 1849), even as Monument Cemetery elsewhere in town distinguished itself by Gothic. Egyptian connoted afterlife, but one pro-Gothic American condemned it as even uglier than the Grecian and "disgusting and absurd" as a reminder of "the most degraded and revolting paganism which ever existed. It is the architecture of embalmed cats and deified crocodiles." Its heyday was brief; with the rise of the flexible Italianate and Renaissance modes along with Gothic in the

1840s, it became much easier to build in a freer, less literal manner, and architects mostly abandoned Egyptian.[42]

What allowed Strickland and contemporaries to switch freely between styles, or to mingle them? In the age of the Picturesque, the professional was not bound to one style or another but developed an expertise in several, all the while maintaining a higher allegiance to the principle of fitness. Davis bounced back and forth between creative design in Grecian and Gothic—as at the Ravenswood suburban-villa development for Charles H. Roach on Long Island—without fretting about any supposed "battle of the styles" (fig. 2.26). So did Richard Bond and many others (figs. 1.19 and 5.32). When Cole painted *The Architect's Dream* on commission for Davis's sometime-partner, Ithiel Town, he showed both worlds open to the architect, the classical past in sunlight and Gothic in shadow, two necessary sides of the Western heritage: rationality and feeling, the Antique and Christianity, Romance cultures and the Anglo-Saxon (fig. 2.27). The architect himself belongs to a profound continuum of tradition, his pose echoing the river gods whose statues line the basin in the distance. He rests upon massive publications, for Town "had been once or twice to London, and bought there a large collection of books in various languages upon the arts, and furnished his office with a very respectable library," which Cole's painting was likely intended to grace. Town loaned him books to help, including J. N. L. Durand's *Recueil* of ancient and modern architecture (Paris, 1800) and, evidently, John Britton's *Cathedral Church of Salisbury* (1836), the source for the Gothic church in the picture. Cole was no stranger to architecture, having dabbled in it and employed various styles: in 1838 he won the two-hundred-dollar third prize for his Greek Revival design for the Ohio State Capitol, his drawings helping shape the final form of the building; and when his local church burned the following year, he designed a Gothic Revival replacement at the same time that he was painting *The Architect's Dream*. Considering its modern fame, it is ironic that Town rejected the picture; he had wanted a green, arcadian landscape with a few buildings half-hidden, not a seven-foot-wide survey of the architectural history of the Western world.[43]

In designing the Smithsonian at the height of the Pugin-Ruskin craze spilling over from England, Renwick provided designs both Romanesque and Gothic, letting the committee choose. Either style was plausible for the job at

Figure 2.25.
Henry Austin, Grove Street Cemetery Gateway, New Haven, Connecticut, designed 1839, built 1845–48. HABS, Library of Congress

Figure 2.26. *Alexander Jackson Davis, Ravenswood Development Proposal for Charles H. Roach, Long Island, 1836. Nathaniel Currier, lithograph, after drawing by Moses Sweet.* © Collection of The New-York Historical Society [26288]

hand; and eventually his rejected Gothic façade happily found use as a church across town (fig. 2.28). Washington was increasingly eclectic, a Scottish visitor finding it in 1849 "like a village in the wideness of its road-like badly-paved streets, and in the contrariety in the styles of the different buildings." The Smithsonian collections moved into their new Romanesque quarters from old ones in Mills's Greek Revival Patent Office, a "National Gallery" that itself exemplified the early Victorian love of variety and historicism (fig. 5.24). Mills thought of his exterior portico and gracefully curving double interior stairway (fig. 1.18) as parts of a grand procession to the museum upstairs, where the visitor was confronted by multifariousness: fifty-five oil paintings, 2,300 stuffed birds, the "Original Declaration of Independence," "War implements, &c., from the Feejee Islands," "Peruvian Mummies and Human Crania from various regions," and sundry "Relics of Washington." This strange variety was exciting to many, an associationist feast to contemporaries who tolerated or even savored the increasing juxtaposition of architectural styles in the streets of Washington City.[44]

Washington Irving's house of the 1830s, Sunnyside, was likewise historicizing, eclectic, and emblematic of the Picturesque vision (fig. 2.29). Irving spent the years 1815–32 in England and on the Continent, and when he returned to New York on the *Havre* he was America's most famous native-born author, having built a brilliant career upon the close study of English literary examples, including those of Scott, whom he had visited at his castlelike home, Abbotsford, in 1817. His decision to build a Picturesque retreat must have owed much to that famous Gothic Revival literary shrine. A dozen miles north of Manhattan, near Tarrytown, Irving bought a seventeenth-century Dutch colonial farmhouse and transformed it into a step-gable composition that emulated the bare handful of Dutch townhouses still standing in New

Figure 2.27.
Thomas Cole,
The Architect's Dream,
1840, oil on canvas,
53 × 84¹/₁₆ in. (134.6 ×
213.5 cm). Toledo Museum
of Art, Toledo, Ohio,
Purchase with funds from
the Florence Scott Libbey
Bequest in Memory of Her
Father, Maurice A. Scott
[1949.162]

Figure 2.28. *James Renwick, Trinity Episcopal Church, Washington, D.C., 1849–51. Demolished 1936. Visible behind is Thomas U. Walter, United States Capitol dome, designed 1854, built 1858–63. Library of Congress*

Figure 2.29.
Washington Irving and George Harvey, Sunnyside, near Tarrytown, New York, 1835–37. George Harvey, Sunnyside, *ca. 1836–38, watercolor on paper, 18 × 22¼ in. (45.7 × 56.5 cm). Historic Hudson Valley, Tarrytown, New York [SS.79.22]*

York and Albany (of which none survives today). Once his own Romantic writings had re-created in words the vanished Knickerbocker world of the Dutch; now the evocation was tangible. The work was carried out with the assistance of English-born landscape and miniature artist George Harvey. Irving called it the Cottage, but by 1841 he was heading letters "Sunnyside" in reference to its setting, basking in the afternoon light on the eastern shore of the wide Tappan Zee.

Appropriate to its English conception, Irving's constant word for the Cottage was "picturesque," as in a letter to Harvey in November 1835: "I have determined to finish the kitchen gable different from the others—carrying the eaves beyond it to correspond with the dormant windows. This will save mason work, and will, I trust, have a picturesque effect. I observe in some designs of old buildings a mixture of gables with 'crow steps' and projecting eaves, so that I presume there will not be any glaring incongruity in it." His study of native historical-vernacular precedent was all but unheard of in American architecture but fully in the spirit of the English Picturesque, pointing the way to the Colonial Revival, which would flourish after 1876.[45]

Visitors understood Sunnyside's Picturesque attitude and essential En-

glishness; the approach down a "picturesque English-like lane" led to "a wonderfully unique little edifice, totally unlike any thing else in our land, but always calling up our remembrances of our fancies of merrie rural England, with a hint here and there at its old Dutch leaven." It was a vigorous essay in the Picturesque a year before Davis's important work at nearby Blithewood and two years before twenty-four-year-old Downing's construction of his own Elizabethan-style house, Highland Garden, following a design in Englishman Francis Goodwin's 1835 *Rural Architecture* (figs. 4.30 and 2.30). With great suddenness the ideas of Loudon and the second generation of English villa books had arrived on these shores, so that H. R. Cleveland, Jr., could write in 1836, "Nothing can be more admirable for imitation than the English cottage style, as it is perfectly adapted to our climate, and in good keeping with our taste in ornamental gardening; and we would earnestly recommend to our architects to import plans and elevations of these buildings, which constitute the true style of domestic architecture." Downing was intrigued by Sunnyside as an ideal *cottage ornée* and described it in his influential book of 1841, with an illustration by Davis. It may have spurred his thinking about the small-scale residence and therefore has been called a crucial "precursor of American suburban design."[46]

Suiting Irving's desire for privacy, Sunnyside's grounds were densely planted in order to "deny all vagrant observation from without. One can scarcely believe himself as thickly surrounded as he really is here by crowding cottage and castle, so entire is the repose and seclusion of the spot. Years ago, when Mr. Irving first took up his abode at Sunnyside, he was all alone by himself, yet now every inch of the adjacent country is gardened, and lawned, and villaed, to the extreme of modern taste and wealth." By the time of this 1856 account the villa movement had washed entirely across the Hudson River countryside. With it came an obnoxious corollary, the railroad, cutting through the Sunnyside lawn at the riverbank in 1848. Irving took a cash payment rather than join his neighbors in suing the unwanted railroad company, but the noise spoiled his cottagesque seclusion; it was loud enough "as to drown the voices within," and on an August evening in 1850 the fretful writer lay awake all night after having been roused by the locomotive's "steam-trumpet," no doubt musing painfully on the new tribulations of nineteenth-century life and how "Poetry and Steam can not be made to harmonize." He was not the last American to seek suburban quiet, only to find it shattered by civilization's noisy encroachments (fig. 3.16). Already the Fitchburg Railroad had interrupted Thoreau's meditations at Walden Pond. At Cooperstown, New York, N. P. Willis noted, "The sloping banks abound in 'capabilities'

Figure 2.30.
Andrew J. Downing,
Highland Garden,
Newburgh, New York,
1838–39. From Downing,
Landscape Gardening,
1841, fig. 49. University
of Delaware Library,
Newark

for country-seats, and will, at some future day, doubtless, be hauled within suburban distance by the iron hook of a railroad, and gemmed with villas." And yet at his own rural residence he wrote, "I thank God that the deep shades of ⌈Owaga Creek⌉ lie between my cottage and the track of both canal and railroad."[47]

Sunnyside stands today, a lovely gem. Unfortunately, Downing's equally Picturesque Highland Garden is gone. A rare photograph recalls what the nearly ninety-year-old house looked like during demolition in the 1920s (fig. 2.31). The view, taken from the driveway, shows the south and east fronts. The visiting Swedish writer Fredrika Bremer mistook the walls for "sepia-coloured sandstone," but they were actually stucco-covered brick, scored, in the manner popular in the day; as the poet J. R. Lowell spoofed such work, "people think it very gneiss." Perhaps the recipe was the same that Davis used at Blithewood: pure beach sand, Thomaston lime, and hydraulic cement, painted fawn color (burnt ocher pigment dissolved in sweet milk). Almost hidden by vines is the stair tower; the door to its left led from the big entrance hall onto the piazza, which in Downing's lifetime occupied the east façade only (Davis later extended it). Downing's office was originally upstairs at the south end of the house; below was the largest room in the building, the parlor. Its "Tudor arch" bay and "square-headed" window adjacent are seen in the only photograph known of the interior of the house, one hitherto unpublished (fig. 2.32).[48] The family spent summer months here, winter in the library at the west end of the dwelling, where Downing wrote at a table in front of a bay beneath busts of literary and scientific greats. These interiors were dark and full of brown wood—to the infatuated Bremer, just like "the man's own brown eyes." The office wing at left in figure 2.31 was added in 1851, after Vaux came to work for him, and Downing had his private study in the little windowed room visible between the projecting office porch (meant to be screened by plantings) and the parlor bay. He could enter and exit his study through the library by means of a door disguised as a bookcase.[49]

If we can think the pathetic ruination away, it is almost possible to imagine the life that the tastemaker once led here, the shy and silent son of a Newburgh nurseryman ambitiously emulating the habits of the English gentry he passionately admired. When Bremer came to stay in 1849 there were baskets of fruit and flowers on the table at breakfast, and quantities of coffee, tea, fish,

Figure 2.31.
Andrew J. Downing,
Highland Garden.
Piazza enlarged and
other alterations made by
Alexander Jackson Davis,
ca. 1852. Demolished
ca. 1920. Courtesy T. Kyle
and F. Kowsky

Figure 2.32.
Andrew J. Downing,
Highland Garden. Parlor
during demolition. Courtesy
T. Kyle and F. Kowsky

meat, buckwheat cakes, omelets, cornbread, and sweet potatoes. Visitor G. W. Curtis recalled "the roses and blossoming figs upon the green-house wall, and the music by moonlight, and reading of songs, and tales, and games upon the lawn, under the Warwick vase." One December "we all danced to a fiddle upon the marble pavement of the hall, by the light of rustic chandeliers wreathed with Christmas green, and under the antlers, and pikes, and helmets, and breastplates, and plumed hats of cavaliers, that hung upon the walls. The very genius of English Christmas ruled the revel." On the day the *Henry Clay* burned, friends "sat partly in the house and partly stood watching at the door and upon the piazza, waiting for news from the messengers who came constantly from the wreck. . . . In the afternoon, they brought him home, and laid him in his library."[50]

Downing was not alone in finding the Gothic and related styles richly associative. Like Irving, the wealthy Baltimore patron Robert Gilmor had visited Abbotsford, as well as Horace Walpole's Strawberry Hill (begun 1748), near London. Using these as models, Town and Davis built him the first Gothic-Revival villa in the United States, Glen Ellen—the first if we ignore Latrobe's much earlier, small-scale effort at Sedgeley (fig. 2.33). At this same time, the competition to design New York University was won by Dakin and Town with a Gothic proposal (fig. 2.12), and Davis assisted with the central room of the school—the chapel, "a specimen of the pointed architecture of the age of Henry VII," derived from English prints and books (fig. 2.34). These were major developments that helped establish a *nonclassical* architectural approach as sufficiently dignified and authentic-looking for the most important public and private buildings, pointing the way to the widespread popularity of Gothic for the remainder of the nineteenth century, throughout the period we associate with the reign of Victoria in England (1837–1901). In particular, the idea that Gothic was appropriate for libraries and colleges developed directly from the New York University building, as well as from Gore Hall library at Harvard (fig. 5.32). That medievalism was somehow inappropriate for a new, democratic country like the United States occurred to some—indeed, the decorations of the NYU chapel ceiling almost reflexively included "the arms of the [U.S.] nation"—but the tides of taste flowing from Britain proved unstoppable.[51]

An important aspect of the Picturesque—one suggested by Highland Garden and especially Sunnyside—is its stress on revivalist design, antiquarianism, and filiopiety. This helps explain the first stirrings that appear of historic preservation sentiment. By the middle of the period the Revolutionary generation was unmistakably passing away, as a series of events highlighted: the

THE ORIGINAL DESIGN

DWELLING, EXECUTED FOR ROBT. GILMOR ESQ: NEAR BALTIMORE,

Figure 2.33.
Ithiel Town and Alexander Jackson Davis, with Robert Gilmor, Glen Ellen, Towson, Maryland, 1832–33. Demolished 1929. A. J. Davis, "Glen Ellen" for Robert Gilmor III, Towson, Maryland; Town and Davis and Gilmore; Perspective, front elevation, and plan, watercolor, ink, and graphite on paper, 21¾ × 15⅝ in. (55.25 × 39.37 cm). The Metropolitan Museum of Art, Harris Brisbane Dick Fund [24.66.17]. Photograph © 1991 The Metropolitan Museum of Art

marquis de Lafayette's nostalgic tour (1824–25), the deaths of Jefferson and John Adams fifty years after the Declaration was signed (4 July 1826), the death of Monroe (4 July 1831), the one-hundredth anniversary of the birth of Washington (1832), the death of Madison (1836). A flurry of monument-building ensued, with Mills playing the lead role; for the cornerstone-laying of his De Kalb Monument in South Carolina, Lafayette was in attendance (fig. 5.22). During these same years, the surviving physical remains of the past suddenly seemed more valuable. In Philadelphia, the unregarded Old State House started to receive attention that would lead, by the 1840s, to its fame as "Independence Hall." In the process the building, then serving as a city hall, was restored to what contemporaries thought a colonial landmark ought to look like. The Assembly Room where the Continental Congress formerly met had been unsympathetically remodeled about 1815, an act that came to seem a desecration, and in 1830–31,

Figure 2.34.
Alexander Jackson Davis and James Dakin, Chapel, New York University, 1835. Demolished 1894. A. J. Davis, attrib., New York University Chapel Interior, *1837, watercolor. Davis Collection, The New-York Historical Society [30013]. Photograph © Collection of The New-York Historical Society*

Haviland was called upon to design a new interior. He had never known the old one, and his version (itself removed in 1961) was far more richly paneled than the colonial original.

Already Strickland had rebuilt the steeple (fig. 2.35). That of the 1750s had decayed during the Revolution and was pulled down in 1781, leaving only its 69-foot brick lower stories. (It is somewhat doubtful that the "Liberty Bell," which first became famous in the 1840s, ever rang in its rotten housing in 1776.) Strickland's new steeple at 164 feet was much taller than the original, which, according to a 1774 survey, rose "about one hundred and twenty feet" above the State House yard. The greater height was in response to the city fathers' demand for a tower big enough to house a clock and offer a grand symbol of civic pride. Travelers frequently remarked on the lack of towers in the city: "Philadelphia at a distance does not make much show"; "There is nothing striking in the appearance of Philadelphia when seen from the river. It stands on a flat surface, and presents no single object of beauty or grandeur to arrest the attention." New York increasingly rivaled the Quaker City, and its City Hall tower (fig. 1.37) was famously beautiful; this was the subtext to Strick-

land's orders to produce a steeple that would "contribute greatly to the ornament of our city, which is so deficient in embellishments, which in other cities are considered as indispensable." His first design called for raising the tower high in brick, but a storm of protest erupted in city council. Passing around an old print that showed the colonial steeple, some held that the new "shot tower" scheme violated Strickland's pietistic instructions to produce "a restoration of the spire originally erected with the building, and standing there on 4th July, 1776." The debate was lofty: "Our character is at stake, as men of taste, and as admirers of antiquity." Old-English ideas of nationalistic nostalgia and associationism had evidently permeated broadly by this date. In the end, Strickland produced a wooden tower, with clock, that was close in spirit to the eighteenth-century original, a remarkable early example of colonial-revival design.[52]

Figure 2.35.
William Strickland,
Tower of State House
("Independence Hall"),
Philadelphia, 1828.
Photograph, ca. 1918.
Independence National
Historical Park

Another instance of Picturesque antiquarianism is the house Bremo Recess, Fluvanna County, Virginia, as remodeled (1834–36) by its owner, John Hartwell Cocke, as a Jacobean-style cottage. A second Neo-Jacobean house followed at nearby Lower Bremo in 1839–40. Proud of his family tree, Cocke meant the buildings as homage to the seventeenth-century dwellings of Virginia, specifically "the well remembered, old Six-chimney House in Wmsburg once the property of the Custis Family — and Bacons Castle." The Custis house is long vanished, but Bacon's Castle (ca. 1665), Surry County, where Cocke spent his boyhood, still stands. His motivations recall those of Irving, who built Sunnyside in recollection of the old Dutch houses he had known in his youth. These were the sort of persons whom Downing later discussed as "belong[ing] rather to the past than the present — men to whom memory is dearer than hope — the bygone ages fuller of meaning than those in the future." These "natural conservatives" served a useful function in a democracy, "to steady the otherwise too impetuous and unsteady onward movements of those who, in their love for progress, would obliterate the past, even in its hold on the feelings and imaginations of our race. . . . these men, who love the past, [should] build houses in styles that re-

call the past." Cocke was aware of the villa books—his efforts seem to have owed as much to a certain nine-chimney Flemish (or "Scotch") scheme in Loudon's *Encyclopedia* as to any study of American colonial remains. Echoing villa-book authors, he actually tried to publish his Neo-Jacobean Bremo designs in the *Southern Planter*, urging its editor, "The dimensions & cheapness of this Building bring it within the means of any Gentleman who can afford to lay out $2500 or 3000 in a House—and its accommodations are sufficient for any family of temperate habits & moderate desires in a republican age & Country." Again, this pioneering effort at revivalism looked to American examples for inspiration but really stemmed from the historicizing English Picturesque.[53]

"Style" is not a monolithic concept. It implies something different in Federal America, with its subtle manipulations of English neoclassicism, than it does in the riotous eclecticism that took hold starting in the 1830s. Nationwide, styles became more pervasive as the period went on and reached their height after its conclusion. Many American buildings from before midcentury were in no particular style, just boxes perhaps adorned with simplified classical motifs, at their worst falling into what one critic called "the *barn* style—the main features of which seemed to be *squareness, hugeness*, and most *un-fig-leaved nakedness* of all external decoration." After midcentury, far more felt obliged to show some knowing reference to style. Catherine W. Bishir has documented the shift in North Carolina away from "traditional building practice" to more stylish, national modes. The reasons for these nationwide changes are complex but owed to rapidly increasing affluence, the new ease of travel and communication by railroad, greater awareness of styles through the expansion of print media, the ever-larger number of architect-designed public buildings that displayed the latest trends even in smaller towns (fig. 2.36), and the size and economies of those towns having reached a critical mass that caused citizens suddenly to entertain a rivalry with the cities. In urban centers experimentation in various styles had always been the case—although even there one saw surprisingly little deviance from Federal classicism before midcentury. At Providence, Rhode Island, in 1823–24, a series of buildings by John Holden Greene—Granite Block, Roger Williams Bank Building, and Franklin House Hotel—urbanistically transformed the area around the eighteenth-century Market House (fig. 2.37). They looked striking, and two of them employed the radically new granite-wall construction technique, but at the same time they cautiously followed the classicism of the older building. So did almost every

structure in town as late as the 1840s, to judge by the photograph. Stylistic change was even slower to permeate the countryside; an observer wrote of upstate New York in 1850, "The 'rural Gothic' and 'Elizabethan,' which have grown rapidly into favor about the suburbs of large towns, have scarcely as yet made any impression here."[54]

But given the vast size of the United States, it is perhaps more remarkable that styles were transmitted as quickly as they were. High styles, though sometimes slow to cross the Atlantic, then moved with great speed overland—Federal-style houses in Indiana, for example, are hardly less sophisticated than those on the eastern seaboard—and tastes spilled swiftly downward from rich to poor. William H. Pierson observes that "the specific way in which the Italian villa developed in this country . . . was very different from what happened in England. . . . It was more pervasive, touching every level of domestic architecture" and not restricted to the houses of the extremely wealthy. Social mobility meant that styles, and the sophistication they implied, were available to all. And indeed, today's vernacular specialists seem increasingly aware of the role of high-style "cultural exchanges that were much broader than community or region" as important factors in understanding even the most localized traditions.[55]

Even with surging immigration, a common architectural culture governed English-speaking America, and from Maine to Alabama there was surprising agreement about what constituted taste. America's strong tradition of education and vigorous social mobility meant that advanced ideas about architecture deeply permeated the culture. Notwithstanding the multiplication of styles, for architectural thought the years 1800 to 1850 were arguably the most homogeneous ones in United States history. The strong north-south dichotomies that marked the early colonial period had long since faded, replaced by a consistent Federalism that showed the way to the Greek Revival with its complete national sway. The Gothic cottage, when it came, was embraced in Massachusetts (fig. 3.12) as well as in California (fig. 3.10, prefabricated and sent west, and fig. 3.11). English ideas remained strong as midcentury approached, thanks to the steamship and steam press. The few professional architects were frequently British-trained, and the "builder's tradition" in architecture was conservative and attached itself strongly to prece-

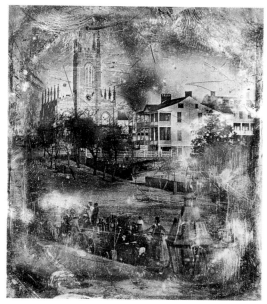

Figure 2.36.
Daguerreotype of
Wilmington, North
Carolina, ca. 1847. At
left, Thomas U. Walter,
Saint James Episcopal
Church, 1839–40. At
right, Burgwin-Wright
House, ca. 1770. Courtesy
Amon-Carter Museum,
Fort Worth, Texas
[P1981.65.28]

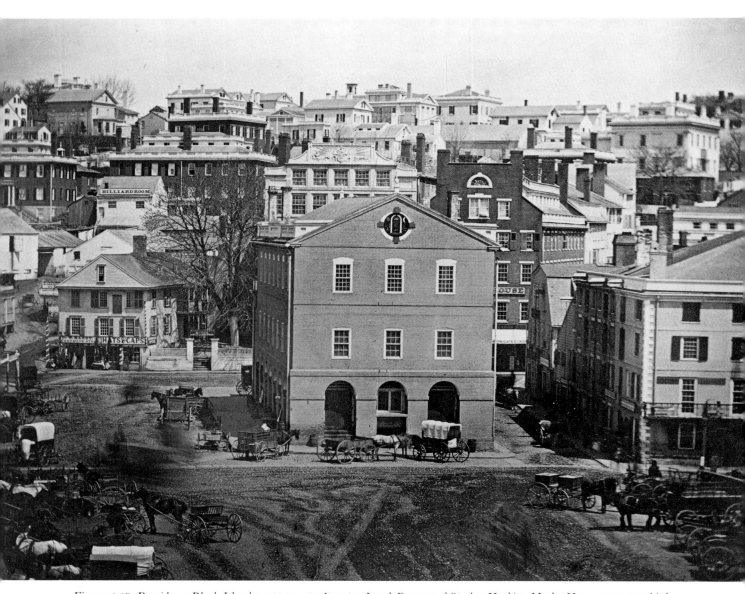

Figure 2.37. *Providence, Rhode Island, ca. 1844–49. At center, Joseph Brown and Stephen Hopkins, Market House, 1771–74, third story 1797. Behind it, John Holden Greene, Roger Williams Bank, 1823, demolished 1912; and Greene, Franklin House Hotel, 1823–24, mostly demolished 1930s. © 2001 The Rhode Island Historical Society. All rights reserved*

dents of classicism, borrowed from American pattern books that shamelessly plagiarized English ones—Walter's of 1846 consisting of two hundred plates literally duplicated by "anastatic press" from publications by Samuel H. Brooks, Francis Goodwin, J. C. Loudon, P. F. Robinson, Robert Lugar, James Thomson, John B. Papworth, and T. D. W. Dearn. All these conditions pro-

duced a unique moment at which it is possible to speak of a vigorous common culture of architectural thought, inspired by English example.[56]

American Rustic

The idea of the rustic—the radical refashioning of architecture through application of the forms of nature—was a vital component of the Picturesque, but its early flowering in America has seldom been examined. The subject is an important one, because rustic design played a major role in nineteenth-century American architecture as a whole, gaining momentum as the period went on. Like many Picturesque concepts, it had its origins in the classical past, where columns were sometimes given a rough, natural flavor through rustication, the leaving unfinished of the drums that compose the shaft. Renaissance architects embraced the idea, applying the notion of a rusticated "rural order" to barns and country houses. Palladianism helped bring the approach to England, where William Salmon (1734) defined "RUSTICK" as "a manner of building, rather in Imitation of Nature, than according to the Rules of Art. The Columns are encompassed with frequent Cinctures," or heavy blocks. With the coming of the villa and of greater informality in domestic architecture, rustic came to mean nature-based design in general: "RUSTIC, in *Architecture*, expresses a manner of building in imitation of simple or coarse nature, rather than according to the rules of art."[57]

The proving ground of the rustic was garden architecture of the eighteenth century. When the Continental rococo was imported to England as the colorfully named Sharawaggi style, rustic design caught on (along with the allied Chinese and Gothic) as a mode that offered refreshing freedom. New and experimental, it came to represent the most modern approaches, as suggested in the title of Charles Over's book *Ornamental Architecture in the Gothic, Chinese and Modern Taste* (London, 1758). He showed grottos, hermits' cells, arches, bridges, and banqueting rooms built from stones, roots and branches of trees, earth, thatch, and rushes. The rustic was sometimes called the "Fancy Style," as in Lugar's *Architectural Sketches for Cottages, Rural Dwellings, and Villas, in the Grecian, Gothic, and Fancy Styles* (London, 1823). It frequently was weird and whimsical, as in William Wrighte's *Grotesque Architecture, or Rural Amusement* with its hermitage floor of "sheeps marrow-bones placed upright." John Plaw wrote in 1795, "The grotesque or fancy character may be adopted, to commemorate some favourite animal for past services. The building supported by trunks of trees, forming naturally a rude pointed arch. The

skull of a horse may be placed over a mural tablet, where may be recorded the feats of that noble animal, and the water-trough may represent the sarcophagus." Wrighte's and Plaw's books were publicly available in the United States by 1798–1800.[58]

The building type called the hermitage was especially popular, the adoption of the hermit-philosopher guise allowing the leisure class to engage in outdoor recreation that otherwise might have seemed unjustifiable. Stowe, Buckinghamshire, in 1750 boasted "St. Augustine's Cave," "a Building of Roots of Trees and Moss. . . . In this Cave are a Straw Couch, a Wooden Chair, with Three Inscriptions in Monkish Latin Verse." A visitor to Deepdene, the Thomas Hope estate in Surrey, saw a hermitage on the grounds: "The house was not made for grandeur, but retirement (a noble hermitage); neat, elegant, and suitable to the modesty and solitude of the proprietor, a Christian philosopher, who, in this iron age, lives up to that of the primitive times." Another account called it "a hermitage, covered with moss, with all the humble requisites for a holy anchorite." As the rustic ideal filtered down to the middle class, an author of 1813 wrote of the appropriation of the Picturesque by "the plodding citizen, for adorning his box at Clapham," a London suburb. He is "endeavouring to realize those visions of retired enjoyment, which have so often cheered him in the toil of his counting-house" and so may be forgiven calling "his ditch a canal, his shrubbery a wood, and his summer-house an alcove." A contemporary spoofed the rustic embellishments of "a Common Councilman's retreat upon the Wandsworth road. They present a fantastic, and crowded groupe of Chinese pagodas, gothic ruins, immovable windmills, molehill-mounts, thirty grass patches, dry bridges, pigmy serpentines, cockleshell cascades, and stagnant duck-pools."[59]

The rustic was readily imported to America, where, as early as 1770, Jefferson considered calling his estate atop Little Mountain "Hermitage," before he chose "Monticello" (second version, fig. 2.38). The colorful new approach arrived in tandem with innovations in garden design. In his 1771 account book, he outlined an elaborate scheme for an English garden, including plans for "a Burying place" with "a small Gothic temple of antique appearance," as well as a "cascade" that falls "into a cistern under a temple"—the last to have a roof "Chinese, Grecian, or in the taste of the Lantern of Demosthenes at Athens," which, as Stuart and Revett had remarked in *Antiquities of Athens*, was supposedly "built by that great Orator, for a place of retirement and study" (fig. 5.8). Nearby would be "a cave or grotto. build up the sides and arch with stiff clay. cover this with moss. spangle it with translucent pebbles from Hanovertown, and beautiful shells from the shore at Burwell's ferry.

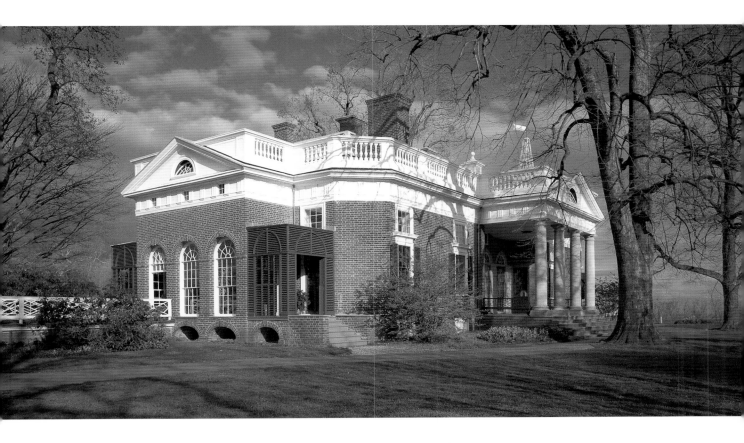

Figure 2.38.
*Thomas Jefferson,
Monticello, Albemarle
County, Virginia, second
version, 1793–1809.
Venetian porches
reconstructed 1998–99.
R. Lautmann/Monticello.
Thomas Jefferson
Memorial Foundation*

pave the floor with pebbles. let the spring enter at a corner of the grotto. . . . the [sleeping marble figure reclining on a marble slab, surrounded by turf] will be better placed in this. form a couch of moss."[60]

The rustic was on prominent display at Vaughan's Gardens near Philadelphia when Manasseh Cutler visited in July 1787: "There we were entertained with scenes romantic and delightful beyond the power of description. . . . this prodigy of art and nature [gave a] romantic and delightful effect. . . . During the whole of this romantic, rural scene, I fancied myself on enchanted ground, and could hardly help looking out for flying dragons, magic castles, little Fairies, Knight-errants, distressed Ladies, and all the apparatus of eastern fable." This landscape was fully in the Picturesque, irregular spirit of the English garden, "art so blended with *nature* as hardly to be distinguished." "The alleys were none of them straight, nor were there any two alike. At every end, side, and corner, there were *summer-houses*, arbors covered with vines or flowers, or shady bowers encircled with trees and flowering shrubs, each of which was formed in a different taste." There was "an antique building . . . built of large stones, very low and singular in its form, standing directly over the

The Role of Britain and the Picturesque [103

brook in the valley. It instantly struck me with the idea of a hermitage, and I found that so it was called." Near the river were "Grottoes wrought out of the sides of ledges of rocks, the entrance almost obscured by the shrubs and thickets that were placed before them, and the passage into them by a kind of labyrinth. There were several other hermitages, constructed in different forms; but the Grottoes and Hermitages were not yet completed, and some space of time will be necessary to give them that highly romantic air which they are capable of attaining."[61]

The rustic spirit evinced here was evidently catching, for William Hamilton employed it, too, at his estate, the Woodlands, just upstream. A visitor of 1788 saw near the riverbank "a charming spring, some part of the ground is hollowed out where Mr. Hamilton is going to form a grotto, he has already collected some shells." In 1806, Jefferson wished that Hamilton could visit Monticello to offer him some pointers, and he called the Woodlands "the only rival which I have known in America to what may be seen in England," that source of all excellence in garden design. These Philadelphia gardens lay in plain view of the main north-south road through the seaboard states. As such, they helped guarantee the dissemination of rustic ideas to a wide American audience.[62]

These places helped show the way to the rustic summerhouses and other structures in nineteenth-century American gardens. Downing described several, including a "rustic prospect-arbor, or tower" at André Parmentier's garden, Brooklyn, and Ravine Walk at Davis's Blithewood with its "rustic seats and pavilions." Hermitages appeared with some frequency. Latrobe designed a "little hermitage" in 1798 for the Frenchman C. F. Volney. The log-house "cottage" or "hut" of "The Hermit of the Falls" at Niagara was, somewhat paradoxically, a tourist attraction. Downing illustrated a "Hermit's Seat" and erected a "Hermitage" at his own Highland Garden, "a pretty, rural structure, neatly constructed of rough bark and logs."[63] The literary hermitage was a special type. Thoreau's friend Daniel Ricketson, a lawyer and gentleman farmer of New Bedford, Massachusetts, enjoyed "a quiet, peaceful, rural retirement" as "a sort of rustic" in his "rough board [and batten] shanty 12 x 14" (fig. 2.39). Thoreau was a self-described hermit, and his friend Bronson Alcott wrote of visiting him "at his hermitage on Walden." Together the two men built a rustic retreat for Emerson: "Went with Emerson and Thoreau to Walden and cut some hemlock for columns to the Summer House," Alcott wrote. "Began Emerson's arbour . . . H. Thoreau assisted me." It was to be a "poet's bower," Alcott explained; "I call this my style of building the 'Sylvan.'" Emerson wrote a friend, "Alcott (in whom do you know a Palladio was lost?)

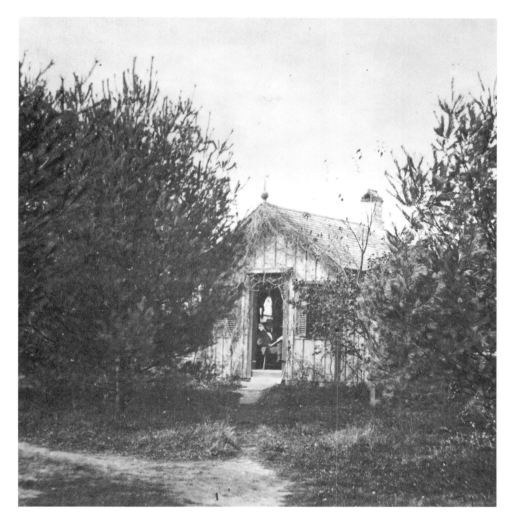

Figure 2.39.
Daniel Ricketson,
Shanty at Brooklawn,
New Bedford,
Massachusetts, 1854
replacement of original.
Demolished. Courtesy
Concord Free Public
Library

is building me (with Thoreau) a summerhouse of growing—alarming dimensions—peristyle gables, dormer windows, &c in the midst of my cornfield." During the slow process of construction, Alcott scoured the woods for crooked cedar with the bark on and confidently declared, "Men of taste [have always] preferred the natural curve" (fig. 2.40). Thoreau, bemused, remarked of the builder, "Ah, he is a crooked stick himself. He is getting on now so many *knots* an hour." The Yankee townsfolk scratched their heads at Alcott's display of the rustic: "It is odd"; "The strangest thing I ever saw"; "A log cabin"; "A whirligig."[64]

A crucial feature of the architectural rustic as imported to the United States was the column formed of a tree trunk. We associate this motif with Adirondack or New England summer camps of the late nineteenth century,

Figure 2.40.
*A. Bronson Alcott, with
Henry David Thoreau,
Summerhouse for Ralph
Waldo Emerson, Concord,
Massachusetts, 1847.
Demolished. Drawing
by May Alcott. Courtesy
Concord Free Public
Library*

but the idea was ultimately English of the eigh-teenth, with ancient and lively associations; Stu-art and Revett showed a French Capuchin friar in meditation beneath a rustic garden shed amid the ruins of classical Athens (fig. 5.8). Just as a Doric column is distinct from an Ionic, natural columns immediately identified a new "modern" style. Rob-ert and James Adam played a key role in the de-velopment of the rustic and in the popularization of its columns, a process well under way in the 1760s. David King points to their tea pavilion and cottage at Moor Park, Rickmansworth, Hertford-shire (ca. 1764–65): "If it was originally thatched, it was very likely the only one of numerous Adam designs for small thatched buildings that was ex-ecuted. . . . There is no sign now of the log col-umns, so the only rustic flavour today comes from the lattice windows." Rustic columns marked the Lodge at Kenwood, Hampstead (1767–69): "Noth-ing can equal the elegant simplicity of this en-chanting little building. . . . The rustic arcade, clothed with vines, is one of the happiest combinations of art and nature that can be imagined." These Adam innovations were taken up by the following generation: describing a house de-sign, John Soane said that "trunks of trees decorated with woodbines and honeysuckles would make the principal features of the porch." Nash worked in tandem with Humphry Repton from 1796 to about 1800, and their part-nership produced many thatch-roofed, rustic-columned designs. Nor did Nash's use of the rustic end with their breakup; the Swiss Cottage, Cahir Park, County Tipperary (1810–14), boasts elaborate rustic verandas.[65]

Associationism played a vital role in the ornamentation of the cottage ornée, particularly in the columns supporting the veranda. Robert Lugar once showed a veranda supported by fasces, painted green, a recollection of the classical past. In the wake of the 1790s primitive-hut conflation of "columns or trunks," nineteenth-century villa books abounded with rustic columns. James Malton in a design of 1802 called for "the pillars to be merely trunks of trees, in the rough." In place of "elegantly-formed pillars," Edmund Bartell promoted the "rustic colonnade or portico" with columns of tree trunks (fig. 2.41). Twining "ivy or the woodbine" would enhance the rusticity of "these natural columns." A rustic portico might consist of "trees of a proper size, in

their rough state, having only the bark taken off"; alternatively, Charles Middleton suggested "rude trunks of trees, as COLUMNS, and painted green." In 1838, Loudon gave an account of "a summer reading-room" in a garden, "a polygonal rustic structure" with nine pillars, each "a young fir tree," with capitals formed of a square four-inch board. The entablature was to be faced with four planks with the bark on. Inside, the floor was of broken bottles bedded in cement, or "flints, pebbles, bricks of different colours." In a long-standing English tradition, moss set within wooden strips would line the inner wall, and colored moss formed a star shape on the ceiling above a pinecone cornice. The construction here can be compared to a much earlier design for "an Ancient Hutt" in William and John Halfpenny's *Country Gentleman's Pocket Companion* (1753), which was to be "faced with Flints, or other rough Stones, and lined within with Billet of Wood and Moss." Architectural modernism with its quest for novelty has always ushered in new materials and new problems in their conservation, and rustic columns provide an early example, as architects sought means of protecting bark against decay. It "can be preserved for almost any length of time, by a proper varnish," T. D. W. Dearn assured his readers, but Malton was less sanguine, giving "a simple and rustic appearance" to a dwelling by incorporating "pillars" of "oak stumps . . . with the bark on, or, what is better, as the sap and bark will soon decay, they may be made of the heart of oak roughly carved in imitation of the bark of a tree, and painted so as to resemble it."[66]

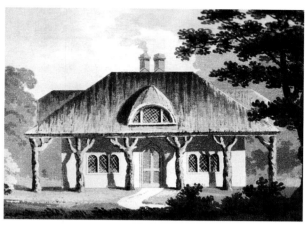

Figure 2.41. *"House with a Rustic Veranda." From Bartell,* Hints for Picturesque Improvements in Ornamented Cottages, *1804, pl. 5. University of Delaware Library, Newark*

These English columns formed the precedent for American experiments in the rustic, which included "a Rustic arbor curiously constructed of the crooked limbs of trees, in their rough state, covered with bark and moss" at Parmentier's garden in the 1820s. Donald G. Mitchell dismissed the "sneers" of "the grand architects" who asserted that the rustic was merely temporary: "It is quite true that rustic work will not last forever—neither will we; householders and architects [too] have the worms gnawing at our vitals, and the bark falling away, and the end coming swift." He recommended "a good, stanch tree trunk, cut in its best season (late autumn)." Ideal for holding their bark were sassafras, white ash, and pignut hickory, with oak and chestnut unacceptable. Beech, birch, maple, and sycamore would retain their bark if the ends and limb-stubs were coated with varnish. Cedar was the most popular wood for rustic work; "due precaution being taken, by coating of oil or var-

nish, against the ravages of the grubs (which have an uncommon appetite for the sapwood of cedar), it may hold its shaggy epidermis for a long time." In any event, "a wash of crude petroleum" could keep bugs away.[67]

In Davis's "American House" (or "American Cottage No. 1"), rustic columns were to be rendered of "cedar or hemlock boles" (fig. 1.4). Later Downing would call for a "rustic veranda and rustic trellises . . . of *cedar* poles, with the bark on" in his "Cottage for a Country Clergyman" and rustic columns in his "Bracketed Mode" of summerhouse, a "power"-filled fusion of Swiss and Greek precedents. He would have appreciated the rustic columns used many years before as temporary supports for the west portico at Monticello; an 1807 visitor, thinking of the primitive hut, admired these "stems of four tulip trees, which are really, when well grown, as beautiful as the fluted shafts of Corinthian pillars." A stone-colored wooden cottage built by Daniel Wadsworth near Hartford, Connecticut, had a five-foot-wide piazza recessed between two Gothic bays: "The columns are nine inches at the base, being trunks of trees, with the bark taken off, and their knots projecting a little, but smoothed, and painted the same color as the house, or a little lighter." Tree-trunks outlined the shape of the Gothic gables as well. "The ornaments of the front, and the pillars of the portico, of this cottage, made simply of trunks of small trees, give a beautiful rural finish to the building, and are trifling in expense."[68]

Rural cemeteries were highly appropriate places for rustic design. At Mount Auburn (begun 1831), Henry A. S. Dearborn designed a superintendent's house with a tree-trunk piazza. At Green-Wood, Brooklyn (1838), the Keeper's Lodge was "a cottage in the rustic, pointed style, with four gables. The sides are of plank uprights, battened with cedar poles, rough from the forest. Its whole exterior is unsmoothed and unpainted,—yet it is symmetrical and picturesque."[69]

In 1845, Lang promoted a "Childrens Cottage, or Play Room": "the roof, covered with hemlock bark, is supported at the corners by rough cedar posts, around which climbing roses and honeysuckles are prettily entwined." A rustic bower had a shingle roof painted black and rough cedar posts laced with Virginia creeper. Ranlett illustrated several rustic designs in his villa book of 1847–49. For his "Cottage-Villa, in the Rustic Style," he instructed that the "rafters, purlins, and columns of veranda, and the railing and filling to be cut from cedar or oak, and put up neatly with the bark left on." His $650 "substantial Cottage in the Rustic Style" was to be entirely built of "rude materials": "rough board sides, the joints feather-edged and lapped; the roof covered with boards same as sides and overlaid with bark slips 2 feet 6 in. long, 8 to

10 in. wide, the ends rounded and laid 12 in. to weather; the supports to the eaves and brackets, trunks of trees with the bark on" (fig. 2.42). The body of the house was to be painted "straw color," and the "undressed pillars, would be greatly improved, and present a truly elegant appearance with some kind of trailing vines, honey suckles, or climbing roses, trained up the rude posts." It was a weird fusion of English rustic and American clapboards. North of Cooperstown, New York, in 1848, N. P. Willis "noticed a peculiar style of ar-

Figure 2.42. *"Cottage in the Rustic Style." From Ranlett, The Architect, 1847–49, vol. 2, pl. 16. University of Delaware Library, Newark*

chitecture at one of the taverns—a colonnade formed of trees with simply the bark taken off, and about a foot's length of every branch and twig left projecting. While the body of the trees was carefully painted white, however, the projecting stumps [of the branches] were daintily colored green!"[70]

On the rustic porch, rustic furniture was fitting, and by midcentury the Messrs. Berrian, Broadway, were actively supplying it. Visiting the Bonaparte place near Bordentown, New Jersey, in the 1820s, John Fanning Watson noted rustic furniture arranged to take advantage of the "grand view": "Under some trees on the top of the precipitous banks, fronting the town upon the Delaware River are some very curious seats made out of crooked fragments of trees—so united by nails as to make seats." He visited Niagara Falls in summer 1827 and jotted in his memorandum book ideas for beautifying Goat Island: "This Island is capable of many grateful improvements for the enjoyment of Mr. Whitney's comp[an]y—Let him clear the underwood—open clearer paths, & make a few rural arbours for tea parties, &c— They must be *rustic* fabrics, or they will dissolve the charm." That same summer, Basil Hall engaged the proprietor of the island in a dialogue that suggested the clash of two current value systems, go-aheadism and the Picturesque, the latter ancestral to today's environmentalism. The owner "seemed unaffectedly desirous of rendering it an agreeable place of resort to strangers. He had been recommended, he told me, by many people, to trim and dress it; to clear away most of the woods; and by all means to extirpate every one of the crooked trees. I expressed my indignation at such a barbarous set of proposals, and tried hard to explain how repugnant they were to all our notions of taste in Europe. . . . this conversation may have contributed, in some degree, to the salvation of the most interesting spot in all America."[71]

The rustic movement in architecture emerged out of the naturalistic English garden, but for all its informality it was far from trivial in its implica-

tions. It represented a new, "modern" style, one of the first that promised to reform architecture by loosening traditional rules. The rustic column is one of its most distinctive features, the spread of which again demonstrates the permeation of the English Picturesque into the United States. The rustic proved enormously popular in late-nineteenth-century America and on into the twentieth. Rustic Construction Works on Fulton Street in New York, founded in 1875 by E. A. Pinckney, was still going strong in 1910, custom-designing structures for country estates: furniture, fences, bridges, teahouses, boathouses, and garages. The approach was familiar: "The basic element of most Rustic Work is the red-heart log cedar, with the bark on. . . . Superb effects are secured from the use of the silver birch, and other woods are used, it being quite possible, at times, to secure satisfactory results from the use of native material." They offered "Rustic Back Stops for Tennis Court" and a "Rustic Dog House." There was even "Andrew Jackson's Log Cabin. A Child's Play House. Size of room, 9 x 12 feet. Verandah, 3 x 12 feet." The uses of these items were modern, but the idea of the rustic was by then a venerable one. As a component of the Picturesque, the rustic offers a good measure of the spread of British architectural ideas to an American audience; like the Picturesque as a whole, it grew increasingly influential as the nineteenth century went on and still shaped United States architecture well into the twentieth century. It has been revived once more in recent decades, and today there is a booming market in rustic furniture. The architectural ideas of 1800–1850 are seldom remote and meaningless, then, but exerted an influence that extended well beyond those years and is palpable and exciting even in our time.[72]

3 : VILLA, COTTAGE, & LOG HOUSE

Take a weekend drive through the countryside almost anywhere in the United States, and you will be amazed and perhaps appalled by the ever-increasing number of houses in the landscape—1,335,000 new ones were built in 1999 alone. It is one of the most dramatic trends of modern times, with profound implications for our culture and environment. The ideal of the suburban house, so central to our society, reaches far back into the period we are considering, however, and there finds its essential roots. When a 1991 poll by *Architectural Record* demonstrated that its readers "think Fallingwater the most important building of the last 100 years," it was a testament to the genius of Frank Lloyd Wright, but also to the deeply ingrained enthusiasm that Americans have always had for what nineteenth-century writers called the suburban villa or cottage. Wright was born not long past the middle of that century, and he owed an enormous debt to its functionalist and Picturesque philosophies. Fallingwater was a seasonal home for a department-store magnate on the distant outskirts of Pittsburgh, a *beau ideal* of the suburban housing ethos of modern times—one that truly emerged in the years 1800–1850.[1]

At the end of that period, architect Samuel Sloan praised the "Suburban Mansion" as an embodiment of the middle state. Here the retired businessman "desires not the settled repose of country life, but is inclined to choose a suburban location. Here, all the conveniences to which he has been accustomed can be readily procured; and here, undisturbed by the discord of a thousand rumbling wheels, he can hear the merry chimes that his boyhood heard—enjoying an equilibrium between the stirring influences of a whirlwind of business and the slumber-inviting calm of a rural atmosphere." This concept of middle-state retirement was ultimately Roman but had been refined in England, where it offered an alternative to growing urban ills; Samuel Johnson treated it in the *Rambler*. Bamber Gascoigne has written of "that fascinating community which gave [London suburb] Twickenham in the eighteenth century such a special quality—a community of sophisticated urban people who seemed to be playing at country life, recreating in minia-

ture, indeed almost in parody form, the ways of the landed gentry." Considering the suburbanization of the Surrey countryside, John Timbs wrote in 1823, "In London, we admire the magnificence of the public buildings, as denoting fine taste, and bespeaking national importance; but who is there that would not exchange a cottage in the environs of Dorking for the proudest monument of human art? Who is there that would not prefer the salubrious breezes of the Surrey hills to the courtly and more tainted atmosphere of St. James's?"[2]

As this suburban, genteel mode of living was replicated in America, proper taste became a subject of widespread discussion. Though not precisely agreed upon, it was at least rooted in two universal standards, the classical and Gothic approaches that were considered to have derived from the study of nature itself. Thomas Cole defined "taste" as "the perception of the beautiful, and the knowledge of the principles on which nature works," and he would have regarded it as teachable, learnable, rational, and fundamental to a humanistic education. Happily, we can experience firsthand his idea of the tasteful suburban residence by visiting his home, Cedar Grove, which still stands on a hilltop at the edge of the town of Catskill, New York. The building has hardly changed, and a huge honey locust still graces the lawn, just as it did 150 years ago (fig. 3.1). Steeped in the ideals of the Picturesque, the expatriate English artist relished his life at this seat on the banks of the Hudson River. The opening of the nearby Mountain House resort inspired his first visits to the region in 1825 and 1826: "I am now in the Village of Catskill with the intention of spending the Summer here. Retired from the noise and bustle of N York and surrounded by the beauties of Nature" (fig. 4.24). He rented an outbuilding at Cedar Grove in summer 1834 and lived in the house permanently from 1836 on, having married the owner's niece. After the artist's sudden death in 1848, his former pupil Frederic Edwin Church paid a visit and sketched the property, making color notes (fig. 3.2). Cole, who painted *The Architect's Dream* and other famous pictures here (fig. 2.27), had designed the outhouse and studio himself, the latter with a jigsawed cornice. The scene, undeniably bucolic and inviting, recalls his enthusiastic account of "American Villa Architecture" in "Letter to the Publick on the Subject of Architecture," as well as his paean in "Essay on American Scenery" to "rural dwellings shaded by elms and garlanded by flowers—from yonder dark mass of foliage the village spire beams like a star." In this case, the village is down the hill to the right, as early as 1827 "a very neat respectable town, with a couple of great churches side by side, a broad street, a quarter of a mile long, gay shops, stages and hackney coaches, and all the apparatus of a thriving city."[3]

Figure 3.1. *J. A. Thomson-Thomas Cole House, "Cedar Grove," Catskill, New York, 1815. Charles Herbert Moore,* Thomas Cole National Historic Site, *1860, oil on canvas mounted on board, 10¼ × 7 in. (26.1 × 17.8 cm). Greene County Historical Society*

Cedar Grove, which eventually fell into some dilapidation but was handsomely restored in 2000, is a rare survival of an artist's house, but highly typical of the ideal suburban residence of the era. Two years after Cole's death, Fredrika Bremer visited the outskirts of Washington, D.C.: "When I stood with General Shield, and beheld from this spot the extensive view of the river-banks, scattered with hamlets and churches, and villas and cottages, amid their garden-grounds, he exclaimed as he pointed it out, 'See! This is America!' And so it is. The true life of the New World is not to be seen in great cities, with great palaces and dirty alleys, but in the abundance of its small communities, of its beautiful private dwellings, with their encircling fields and groves."[4]

Figure 3.2.
Frederic Edwin Church,
View of Cedar Grove,
October 1848, graphite on
paper. Olana State Historic
Site, New York State Office
of Parks, Recreation and
Historic Preservation

Such private homes were a transatlantic ideal. An emerging leisure class was eager to prove itself sophisticated in suburban house design, as Londoners evinced by the enormous attention they paid to the development of John Nash's Regent's Park. James Elmes's *Metropolitan Improvements; or London in the Nineteenth Century* (1827) began, inevitably, with a tour of it. The park was an irresistible blueprint for suburbia, contemporaries lauding "this terrestrial paradise" and "perfect Arcadia" and watching with interest the construction of its villas, of which twenty-six were planned. Nearby, Nash himself owned the lease on fifty more houses that he strung along a winding "Village Road" in Park Village East, backing up to Regent's Canal (fig. 3.3). Nash's sprawling experiment in rus in urbe became famous through publications but also by steamship travel; writers Cooper, Emerson, and William Cullen Bryant were just a few of the many American tourists who made sure to pay it a visit. A. J. Davis kept it in mind when designing Ravenswood (fig. 2.26). A pioneering experiment in quasi-suburban living, New Haven's Hillhouse Avenue reflected in microcosm the idea of Regent's Park, Downing calling it "remarkable for a neat display of Tuscan or Italian Suburban Villas." One by Davis was a literal copy (figs. 3.4, 3.5).[5]

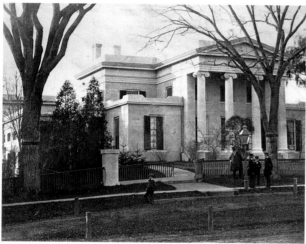

(top left)
Figure 3.3. *John Nash, Park Village East, Regent's Park, London, 1823–34. From Elmes,* Metropolitan Improvements, *1827, following p. 158. University of Delaware Library, Newark*

(top right)
Figure 3.4. *Decimus Burton, Greenough Villa, Regent's Park, London, 1822–24. From Elmes,* Metropolitan Improvements, *1827, facing p. 48. University of Delaware Library, Newark*

(bottom)
Figure 3.5. *Alexander Jackson Davis (with Ithiel Town?), Skinner-Trowbridge House, 46 Hillhouse Avenue, New Haven, Connecticut, 1830–34. Photograph before 1859 alterations by Henry Austin. New Haven Colony Historical Society*

In the heyday of the travel account, one did not have to visit England to comment upon domestic architecture; there were plenty of examples to be discovered and evaluated along America's rutted highways. In the vicinity of cities, the pleasurable Sunday drive became an institution, and rural residences were prime subjects of attention. New houses were meant to be appreciated by passersby, and it was a given that the "light" and "ornamental" cottage "cannot fail to attract the attention of tasteful observers."[6]

The prevailing habit of mobility played a major role in the intellectual response to the American house. "This restless, nervous, bustling, trivial Nineteenth Century," as Thoreau called it, was an unsettled era premonitory of our own; Catharine Beecher wrote of "this migratory and business Nation," and Bremer declared, "Nothing is so invariably a characteristic of life here as its incessant change from place to place. People, goods, thoughts and things, are in a perpetual state of movement." Cooper remarked that "Americans are thought to perform more journeys" than Europeans, owing to "the mental ac-

Villa, Cottage, and Log House [115

tivity of the people." The reader of Latrobe's letters and journals may feel sympathetically exhausted by his continual changes of residence and the many weeks each year spent on the move—the result of his difficult career as architect and engineer, but not atypical of the way many Americans then lived. With a rapidly growing population (which nearly doubled from 4.7 million to 9.6 million during Latrobe's years in America, 1796–1820), there were ever more opportunities for the person willing to travel in search of them. This fact combined with old English cultural traditions to shape an era in which hospitality was highly cherished and the home came to be seen as "an island of stability in an increasingly restless society."[7]

Again and again, the tasteful dwelling was equated with the clean, neat, welcoming home that promised shelter to the visitor. It followed the lead of the finer hotels, such as Mrs. Haviland's inn at Rye, New York, with "more the air of a gentleman's country-seat than a tavern. It is a large, well-built house, with a piazza extending the whole length of the front, well finished and elegantly furnished." Inns served what one historian calls the "subtle and complex process of cultural transmission that led to rural improvement" by which encouraging "new standards were disseminated." In turn, the architects of the great urban hotels worked to replicate a sense of "the quiet and retirement of a private residence," for example stuffing the partitions between the rooms at Tremont House (fig. 1.11) with horsehair to keep noise down.[8]

Tasteful homes and inns were all the more prized, given the abysmally low standards of the mass of such places, as Latrobe's unstinting accounts of nights at rural taverns and other lodgings attest—who can forget his description of the midnight scurry of rats "under the bed, around it, over the trunks, on the chair, among the things on the toilet" in a Virginia log house? Scholars have documented the extremely disordered condition of many American homes and dooryards, only gradually addressed by the movement toward positively "transforming the slovenly countryside." The affection that wandering contemporaries had for the rare tasteful home was expressed by Jacques P. B. de Warville, near Philadelphia in 1788: "No, never was I so much edified as in this house; it is the asylum of union, friendship, and hospitality. The beds were neat, the linen white, the covering elegant; the cabinets, desks, chairs, and tables, were of black walnut, well polished, and shining." Arriving in Boston in 1827, Margaret Hall wrote approvingly, "The outward appearance of the houses is so handsome that I feel a wish to go into each one as I pass, and those that I have been in do not fall short of what they promise on the outside."[9]

In Regency England, a historian writes, "nearly everyone wanted his house,

however small, to catch not only the eye of travellers, as Jane Austen said, but also of anyone living in the neighbourhood." Another speaks of the "uninvited audience" of passersby who commented on villas. In both Britain and the United States, the tasteful home glimpsed from the highway evinced the rising standard of living and, in a progress-obsessed age, signaled the general expansion of culture, opportunity, and wealth (fig. 3.6). Catching a glimpse was easy in America, where development was linear along highways. Cooper noted in 1828 that New England, notwithstanding the American reputation for being "a thinly populated, wooded" place, "appeared more populous" than any other landscape he had visited, excepting perhaps northern Italy, because "house and out-houses . . . are usually very near the public roads, and consequently in plain view of the traveller." Joseph Ingraham faulted planters of the South for not following northern farmers in building along the highways, for to do so would avoid "giving a solitary character to the road scenery, and detracting much from the general beauty of the country"—an exact inversion of today's familiar antisprawl arguments! Crossing the Allegheny Mountains on the Cumberland Road in 1830, Frances Trollope remarked, "Nor is there any danger that sameness should weary, for every three or four miles present a pretty little cottage, whose rustic colonnade generally contains a mingled group of black and white children to gaze at the daily show of the huge coach and four." The typical scheme was both linear and hierarchical, as Thoreau noted humorously in Concord: "The houses were so arranged as to make the most of the world and of mankind . . . fronting one another so that every traveller had to run the gauntlet. . . . Of course those who were stationed nearest to the head of the line, where they could most see and be seen . . . paid the highest prices for their places, and the few straggling inhabitants in the outskirts where long gaps in the line began to occur, where the traveller could get over walls and turn aside into cow paths, and so escape—paid a very slight ground or window tax."[10]

Without question, "the construction of country seats was a growing phenomenon in the decade after Downing's death," but these villas of the 1850s built upon a long-standing tradition of American rural residences that reached back into the eighteenth century and was celebrated by William Birch's *Country Seats of the United States of North America* as early as 1808: "The Fine Arts are, as to the American Nation at large, in their infancy; to promote them in propagating Taste with the habit of rural retirement, supported by the growing wealth of the Nation, will be to form the National character favourable to the civilization of this young country, and establish that respectability which will add to its strength" (fig. 3.7). Downing treated an identical theme, ra-

Figure 3.6.
Frances F. Palmer,
American Country Life:
October Afternoon,
*1855, Currier and Ives
lithograph, 16½ × 24 in.
(41.9 × 60.9 cm). The
Harry T. Peters Collection,
Museum of the City of
New York*

tionalizing and commodifying a villa movement that had gotten under way before his birth. He gave special attention to the problem of scale, suiting most of his designs to the generally modest dimensions of American homes. Our country seats had always been smaller than those of England, as Sunnyside (fig. 2.29) was a fraction of the size of Abbotsford; it has been noted that "some of Adam's and [James] Wyatt's clients spent more on a single country house than was involved in all the Bulfinch houses put together." Latrobe called Mount Vernon "by no means above what would be expected in a plain English Country Gentleman's house of £500 or £600 a Year. It is however a little above what I have hitherto seen in Virginia" (fig. 4.1). Having toured New Jersey, New York, Connecticut, and Rhode Island in 1817, Englishman Henry Bradshaw Fearon concluded, "All houses within sight from the road are farm-houses. The genuine country seat has not yet made its appearance in the four states which I have seen." The Rufus King home, Long Island, "a frame house, painted white, with green shutters . . . would class in England as a fourth-rate country seat." A lieutenant of the Royal Navy, visiting New York in 1826, "dined with an English merchant at his country-house, about four miles from the town. The environs are thickly interspersed with villas, the generality of which are constructed upon a very paltry scale." Along the Hudson he saw "numerous country houses; but how different in size and taste

from similar residences on our own picturesque Thames!" John Jay's home outside New York was "about on a level with a third rate English Country house, or a second rate French Chateau." Cooper wrote in 1828, "The villas and country seats are commonly pretty, without ever attaining much elegance or size. A better sort of American Country house, will cover, perhaps, sixty or seventy feet of ground in length, and from fifty to sixty in depth. There are some of twice this size, but I should say the first was a fair average. There are a great many a size smaller."[11]

Figure 3.7.
"Montibello the Seat of Genl. S. Smith Maryland." Built 1799. From Birch, Country Seats of the United States of North America, *1808.* Demolished 1907. *Courtesy The Winterthur Library: Printed Book and Periodical Collection*

If *country seat* seemed too pretentious a term for most American dwellings, *villa* perhaps served better. Despite its ancient, Latin-derived name, the modern villa was a new building type developed in eighteenth-century England. Damie Stillman has counted the number of country house designs described as *villas* in London architectural exhibition catalogs; there were only 6 in the 1760s but 144 in the years 1770–1800. Humphry Repton said in 1816, "In the neighborhood of every city or manufacturing town, new places, as villas, are daily springing up," being "useful to those who wish to enjoy the scenery of the country, without removing too far from active life." He added, "The essential characteristic of a *villa* near the metropolis consists in its *seclusion* and *privacy*." Elmes defined *villa* as "a rural mansion or retreat, for wealthy men" and in particular "such suburban structures as those which are rising around us," and Massachusetts architect William Brown called it any "country-house for the residence of an opulent person." A cottage was generally smaller— Downing charged fifty dollars to design the grounds of a villa, just thirty dollars for a cottage—but a large cottage ornée and a modest villa were easily confused, and an Englishman surveying the rural residences of Suffolk in 1827 could refer only to "the indefinite term of Villa." Like many contemporaries, architect William H. Ranlett was perplexed at what to call the new middle-class suburban home; *cottage* implied the habitation of "a poor rustic," hardly a fitting association for "the country residence of the man of business," and "Cottage *Ornèe* is a ridiculously affected term." In truth, "the small country houses which are now happily becoming so common, are neither Cottages nor Villas." A modern historian agrees: "a new type of house had arrived."[12]

The sharpest distinction was to be drawn not between the various tasteful house types of the affluent but between these together and the rural farmhouse, stolid and unpicturesque—"the more ornamented houses of country

Gentlemen" versus "the comfortable residences of substantial Yeomanry." In western Virginia in 1834, the usual houses were "log tenements erected in the rude style of the frontier settlements. Occasionally, however, there are handsome edifices, built in accordance with a more modern and refined taste," reassuring evidence of advancing civilization. If American country seats were smaller than England's, the average farmhouse was on the contrary "much larger than would be occupied by men of the same wealth in Europe." Not infrequent were two-story houses of forty-five by thirty-five feet, surrounded by two hundred acres and inhabited by men worth five to ten thousand dollars—"sturdy independent yeomen," or what Bernard L. Herman has termed the "model farmer." Abundant land and plentiful forests made such spacious dwellings possible, and in the democratic spirit of the times, pattern books aimed to improve them by taking cues from more refined homes, as in "a model for small Farm Houses, its exterior combin[ing] features of the modern Mansion and Merchant's Cottage." This campaign of improvement was much ballyhooed, for of all "human dwellings . . . none can compare in National importance and Philosophical interest with THE FARM HOUSE—The Homestead of our species."[13]

The emergence of a virtuous, enlightened middle class was the underlying theme of this noble architectural effort. Bremer, on the Hudson in 1849, saw "beautiful well-built little houses, with their orchards and grounds which lie like pearls set in the emerald green frame of the river! How much is contained in them of that which is most valuable in the life of the new world. . . . On the other side of the river a brick-maker has built himself a lovely villa. . . . Mr. Downing has called my attention to a beautiful little house, a frame-house, with green verandah and garden just in this neighbourhood. 'It belongs,' said he, 'to a man who in the day drives cart-loads of stone and rubbish for making the roads.'" In Cincinnati, merchants built many of the villas that climbed the slopes of Mount Adams above the town (fig. 3.8), but "even the grocer and the soap-boiler rid themselves of the cares of the shop, by spending their time upon their snug suburban grass plats," no doubt pursuing what Downing called "that velvet-like appearance so much admired in English lawns" and, like the suburban home itself, a Picturesque obsession passed down to our own day. Here was the new ideal, the affluent and the middle class living in proximity and sharing the same dignified manners and taste. But not all contemporaries enjoyed the spectacle of the laboring class self-consciously adopting the latest architectural fashions. Thoreau condemned it, and a traveler between Philadelphia and Trenton remarked skeptically, "I notice that it is a pretty general action of farmer residents, to alter their houses, from old

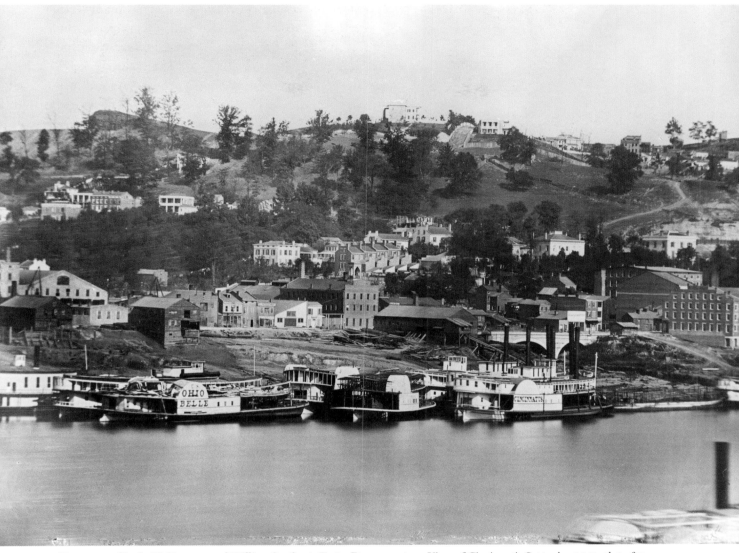

Figure 3.8. *Charles H. Fontayne and William Southgate Porter*, Daguerreotype View of Cincinnati, *September 1848, pl. 6 of 8. Atop Mount Adams is O. M. Mitchel, Observatory, 1843–45, demolished. From the Collection of The Public Library of Cincinnati and Hamilton County*

fashion, to new, so as to look more like Cottages—This no doubt to please Sons & daughters, & the public eye."[14]

Massachusetts architect Edward Shaw considered the "reasons why the beauties of ornamental architecture have, in our country, been so long neglected." He found the rapidly expanding American town "a city of shingle palaces, erected to endure but for a generation. But the spirit of the age is locomotive. The people of this age are a transient people, flitting from place to

Figure 3.9.
James Jackson, first dwelling at "Forks of Cypress," Lauderdale County, Alabama, ca. 1818. Photograph, 1936. HABS, Library of Congress

place; and each builds a hut for *himself*, not for his successors." In the unsettled modern world, adherence to the principles of the Picturesque promised at least the illusion of stability in the face of this kind of upheaval. Gervase Wheeler advocated stone in the American rural residence: "Stone, with its pleasant associations of moss and fretted surface, seems the material for a quiet, rustic home; there is something in its aspect, of appeal from the long, long past, and of promise of endurance in the future, that must make it especially sought after by those who preach a crusade against the ephemeral pretensions of the present day." Horace Greeley viewed Thoreau's lectures on his Walden Pond experiment in a similar light: "He has built him a house ten by fifteen feet in a piece of unfrequented woods by the side of a pleasant little lakelet, where he devotes his days to study and reflection. . . . If all our young men would but hear this lecture, we think some among them would feel less strongly impelled either to come to New-York or go to California."[15]

The idea of domestic architecture as a calming influence was applicable even in the Deep South, an area sometimes thought to have been insulated from the tides of contemporary taste. In 1851, agricultural reformer John Forsyth stood before the Chunnenuggee Horticultural Society in southeastern Alabama to declare that "the South is far behind the North" in taste as in most other things, with the culture of restlessness the chief culprit: "Is it not time to check this roving spirit? Is it not the experience of us all, that the great foe to local improvement in the South is, that *unsettled* feeling that lurks in almost every bosom? Did you ever know a farmer of Alabama or Georgia, who would not sell out and move, for *his* price on his land?" The appearance of the plantation house reflected this crisis; it was not "a substantial and comfortable dwelling, arranged with taste and care, and sparkling in clean white paint," nor with "Flora . . . festooning its porches with jasmine and woodbine." Instead, "The Planter's home is generally a rude, ungainly structure, made of logs, rough hewn from the forest [fig. 3.9]. . . . his yard is as barren as Zahara."[16]

Some architects sought to adapt the English cottage to the prevailing restlessness of the times. British practitioner J. C. Loudon called for "*Cooperative Ambulatory Cottages . . .* for those who have no occupation, and derive a great part of their enjoyment from visiting different parts of the country," and he

enumerated the benefits of "such a portable cottage as this on wheels." In America, N. P. Willis proposed "a tenement on wheels" that could be transported by railroad, an "ambulatory cottage" ancestral to that extraordinary modern-day phenomenon, the eight million mobile homes that together house more people than lived in the entire United States in 1840. Loudon had illustrated John Manning's "Portable Cottage," of which "a great number" were sold to emigrants bound for Australia. Gold Rush settlers in California needed instant housing, too, and a prefabrication boom ensued. John Frisbie's house was manufactured in the northeastern United States, dismantled, and shipped west by boat in 1849 (fig. 3.10). At least two others of the same design were also erected in California, Gothic cottages more than five thousand miles from the England that gave birth to the style—striking proof of how rapidly architectural fashions could spread in a restless, mobile world (fig. 3.11).[17]

Three Centers

Boston, New York, and Philadelphia were the chief centers of suburban development in the United States before 1850, as contemporary voices can attest in their own words. The first of these cities was an early and persistent locus. Carl Bridenbaugh has written, "One ordinarily thinks of the suburban movement of the [twentieth] century as being of recent origin, and it will come as a surprise to many that the flight from the city began in the first half of the eighteenth century. . . . The suburban movement at Boston was largely confined to members of the mercantile aristocracy who sought the kind of life that attached to every country gentleman in England or America. Many Bostonians established seats at Dorchester, Roxbury, Milton, Medford, and other nearby towns easily reached by carriage or boat." Such seats were common by century's end; William Strickland discovered "a multitude of elegant villas belonging to the inhabitants of Boston" as he approached the city from the west in 1794.[18]

Travelers lauded these residences at the outskirts of town: "The vicinity of Boston presents a succession of villages, probably not to be paralleled for beauty in the United States. They are generally the residence of a number of the most opulent citizens, during the pleasant seasons, and many of the buildings are fine and expensive. The grounds are also frequently laid out with great taste, and highly cultivated." Boston Harbor in 1830 was "studded with villas." Near Mount Auburn, "Country seats and cottages seen in various directions, and those on the elevated land at Watertown, especially, add much

Figure 3.10.
*Frisbie-Walsh House,
Benicia, Solano County,
California. Prefabricated
in eastern United States
and shipped, 1849. HABS,
Library of Congress*

Figure 3.11.
*General M. G. Vallejo
House, "Lachryma
Montis," Sonoma,
California, 1851–53.
Lithograph after painting
by S. W. Shaw. Courtesy
California History Section,
California State Library,
Sacramento*

to the picturesque effect of the scene." Downing said that "the environs of Boston" were "more highly cultivated than those of any other city in North America. There are here, whole rural neighborhoods of pretty cottages and villas"; "For that species of suburban cottage or villa residence which is most frequently within the reach of persons of moderate fortunes, the environs of Boston afford the finest examples in the Union"; "In the suburbs of Boston, rural cottages are springing up on all sides." These were epitomized by William Bailey Lang's "Highland Cottages," the designs for which were published just as Thoreau mortised his house frame a few miles away in the Walden woods (fig. 3.12). Lang intended his villa book "to assist in creating a taste for Rural Architecture," for "every year [is] bringing with it evidences of an increased taste for country life, and a better appreciation of natural scenery." His English-inspired designs featured wide eaves, Gothic gables with ornamented vergeboards, and the "rustic lean-to." Rustic was how Thoreau described his own house (fig. 1.3), which engaged in a complex dialogue with the lakeside villas popular around Boston; living in a clearing on the wooded shore of Walden he looked ahead with interest to the "villas which will one day be built here."[19]

New York State deserves careful attention, because its cultural influence was enormous on the United States as a whole. In 1850, one American in three lived there or in an adjoining state. The growth of New York City in particular was an extraordinary phenomenon: according to a modern reckoning, in 1800 it ranked only 106th in size among the cities of the world, but by 1850, when its population hit 645,000, it was seventh—and contemporaries, ignorant of the size of Chinese cities, held it to be fourth (after London, Paris, and Constantinople). Like America itself, New York had gone from small to enormous in just two generations (fig. 1.6). Appropriate to its size, it was ringed by the greatest number of suburban homes of any city on the continent, all in a diverse and attractive setting; Ranlett boasted in 1847, "Probably no portion of the globe, offers a greater variety of beautiful country seats than the vicinity of New-York."[20]

To homesick immigrants sailing into New York Harbor, Staten Island offered hopeful evidence that English taste prevailed in the New World. Leaning on a ship's rail in 1794, Strickland saw market-gardeners' homes on hillsides in the distance: "The Houses constructed of wood and neatly painted in various colors and in various fashions, are situated among orchards, and groves of trees, and fields of luxuriant verdure, like the ornamented grounds of Gentlemen in England." In the 1820s, Cooper observed, "The shores on both hands were . . . dotted with marine villas and farm-houses," and he would

Figure 3.12.
William Bailey Lang,
Glenn Cottage, Roxbury,
Massachusetts, ca. 1844.
From Lang, Views, with
Ground Plans, of the
Highland Cottages at
Roxbury, *1845. Courtesy*
The Winterthur Library:
Printed Book and
Periodical Collection

later write, "All that part of Staten Island, which lies nearest to the quarantine ground, has a marked resemblance to what we should term suburban English landscape." The island's "hills covered with wood, agreeably interspersed with villas and cottages," were approvingly noted by an Englishman from shipboard in 1830. A number of the houses on the island had tasteful English-style gardens; Downing visited the William H. Aspinwall residence and admired its "pretty, rustic moss-house." The popularity of suburban living on the island triggered a land boom; when Thoreau briefly lived there in 1843 and went "moping about the fields and woods . . . as I did in Concord," he was mistaken for "a surveyor,—an Eastern man inquiring narrowly into the condition and value of land . . . preparatory to an extensive speculation." Repeatedly it served as a proving ground for the new suburban ideal (fig. 3.13); for example, the town of New Brighton, for which a prospectus was published in 1836, was "one of the earliest American commuter suburbs laid out in a formal plan with particular attention to the natural beauty of the site." Two steamboats linked this planned community to Manhattan. English-born John Haviland may have played a role in its creation, drawing inspiration from an identically named resort suburb of Liverpool (ca. 1832). Later, Ranlett's offering (1847–49) of "the first published American design for a suburban village similar to English prototypes, incorporating detached, picturesquely landscaped villas" was for sixteen lots on the island.[21]

A culture of "marine residences" flourished and spread to the nearby coasts of Long Island and New Jersey. Davis's airy Grecian design for Ravenswood, Long Island (1836), was a good example of the trend (fig. 3.14). By 1849, Ranlett remarked, "Gentlemen who have sufficient means" had begun "to stud the shores of Rockaway and Long Branch with Marine Villas." One he illustrated exemplifies the phenomenon by which public buildings increasingly lent their forms to private ones, the seaside home of Philip Stockton closely resembling a contemporary description of Renshaw's Mansion House and Sears's, popular Long Branch resort hotels: "Both houses are 2 stories high— all white & with lead coloured roofs & long Piazzas to both stories." America's marine villas were descendants of those on England's south coast, including the "several marine residences, well placed in the most favorable situations," that an observer saw on the Isle of Wight in 1814.[22]

Figure 3.13.
F. and S. Palmer,
Elliottsville, Staten
Island, *ca. 1850,
lithograph, 11⅜ × 16¾ in.
(28.5 × 42.5 cm). The
Harry T. Peters Collection,
Gift of Natalie W. Peters,
Museum of the City of
New York*

"Country seats are rather numerous" on Long Island, a visitor remarked in 1817, and the greatest concentration surrounded burgeoning Brooklyn, a town that exploded from 5,700 persons in 1800 to 20,500 in 1830 and 138,900 in 1850 — going in fifty years from an inconsequential village to a city the size of Bristol or Sheffield, big enough to have ranked among the ten largest in the British Isles. In his account of Brooklyn as "the first commuter suburb," Kenneth T. Jackson has identified 1814 as marking the start of American suburbia, that being the year the first regular steam ferry service linked it to New York. Even earlier, however, the town was emerging as a commuter haven. "Just south of Brooklyn and overlooking the river is a small chain of hills, on which are the country houses of many wealthy New Yorkers [who] rent the houses and send their families there during the hot season. The men go to New York in the morning, and return to Brooklyn after the Stock Exchange closes." This account dates as early as the 1790s.[23]

Fifty years later, Brooklyn might have been described with the words a contemporary used for Lewisham, Kent, five and a half miles from London: "It consists of many handsome houses and detached villas, occupied by opulent merchants and retired citizens, attracted hither by the salubrity of the air and the beauties of the adjacent country." Bremer described suburban life as it was lived in Brooklyn in 1849:

Figure 3.14.
Alexander Jackson Davis,
Ravenswood, for
Charles H. Roach,
Long Island, New York,
*1836, watercolor, ink, and
graphite on paper, 16½ ×
12⅜ in. (41.9 × 31.7 cm).
Avery Architectural
and Fine Arts Library,
Columbia University in
the City of New York*

The friend with whom I am living, Marcus S., has his place of business in New York and his proper home here in Brooklyn, one of the very prettiest rural homes, by name "Rose Cottage," which he himself built, and around which he has himself planted trees, covered arbours with trailing vines, has sown the fields with maize, and other vegetables, so that the place has the united character of park and garden. From this place he drives every morning to New York, and hither he returns every evening, but not merely to sleep, but to rest, and enjoy himself with wife, children, and friends. Rose Cottage lies just on the outskirts . . . and the country, with wooded heights and green fields, may be seen there from on three sides. But houses are now building at various distances, and threaten soon to shut out the country. It may, however, be some years yet before Rose Cottage comes into the city.

Bremer extolled the pleasures of Brooklyn suburban life: "In the evening, at sunset, I went out for a solitary walk in the road, half town, half country. I

Figure 3.15.
*Henry Waring House,
Brooklyn, New York, form
of ca. 1836. William H.
Wallace*, The Old Waring
House, Fulton Street
near Johnson, *1853,
watercolor, 7⅝ × 11¾ in.
(19.5 × 29.9 cm). I. N.
Phelps Stokes Collection,
Miriam and Ira D. Wallach
Division of Art, Prints
and Photographs, The
New York Public Library,
Astor, Lenox and Tilden
Foundations [Deak 668]*

walked beneath the green trees. . . . The evening sky glowed, and cast its warm reflections over meadow and wooded height." But her description of July 1851 is full of astonishment at the rapidity of urbanization: "Great changes have taken place around Rose Cottage and its peaceful environs since I was last there, that is to say, since last year. Above a hundred houses, certainly, have sprung up around it in all directions, and a regular street runs now in front of its little park. When I first came to Rose Cottage it stood in the country, now it lies in the very middle of the city." In time, many estates were ruined by the creeping urbanism (fig. 3.15).[24]

In Manhattan, suburban values dominated in the rapidly expanding residential district out Broadway, where homeowners sought to establish a Picturesque, bucolic character, as captured in Fanny Kemble's description of the town upon her arrival in 1832: "The houses are almost all painted glaring white or red; the other favourite colours appear to be pale straw colour and grey. They have all green venetian shutters, which give an idea of coolness, and almost every house has a tree or trees in its vicinity, which looks pretty and garden-like." At an early date it was common for wealthy Manhattanites to retreat to the upper part of the island in summer. Augustus John Foster, visiting New York about 1807, arrived "at a season when many of the best families of the place were at their country houses." Passing south through Harlem in 1787, Manasseh Cutler reported, "Toward the city are a number of elegant country-seats, with large orchards, and the land highly cultivated, particularly their gardens." Later he saw from Long Island Sound near Hell

Gate "a number of country seats, very romantic." Riding north toward Fort Tryon, Strickland observed, "The woods have every where been cut down [during the Revolution], but large tracts are rising again. Every commanding eminence is occupied by Gentlemen's Houses, some of them most delightfully situated." Villas multiplied as the ranks of Manhattanites surged from 33,100 in 1790, to 60,500 in 1800, and 96,400 in 1810—the small-scale, mixed-income "walking city" of the eighteenth century beginning to transform into the sprawling, economically segregated modern metropolis.[25] Travelers saw "rich landscapes interspersed with rocks and slopes and numerous villas"; "the land on the York Island side well cultivated and spot[t]ed with Gentlemens villa's"; "scattered several country seats, belonging to the city merchants" along the East River; "summer residences of some gentlemen of the city command[ing] a fine prospect"; "beautiful country houses or farms, the mere aspect of which announced comfort and abundance." Once renowned for their refinement, these New York villas are today almost entirely gone, and with them a major chapter in the history of the American rural residence. A 1952 exhibition displayed pictures of one hundred Manhattan country houses built before 1860. Only five could still be found standing.[26]

The coming of the steamboat and later the railroad rapidly suburbanized the Hudson Valley north of New York: "There is a suburban look and character about all the villages of the Hudson which seems out of place among such scenery. They are suburbs; in fact, steam has destroyed the distance between them and the city." A historian has written of the lower Hudson as displaying "a suburban aspect unknown to the rest of America until long after the advent of the railroad age." Villas were preeminently on display and remarked by numerous tourists steaming up and down the river, who found the valley's tasteful homes and fertile fields emblematic of the ideal future development of the American countryside. In 1835, Freeman Hunt summarized the glories of the region "as adapted more particularly for villas and country-seats. . . . The day is not distant, when the entire banks of the Hudson will be dotted with villas of the refined and elegant . . . the eye of 'chaste and classic' taste could not select a more delicious and consummate position for the display of its elegant and graceful designs." The same year, Cole hailed the tasteful homes of the Hudson: "Its shores are not besprinkled with venerated ruins, or the palaces of princes; but there are flourishing towns, and neat villas, and the hand of taste has already been at work. Without any great stretch of the imagination we may anticipate the time when the ample waters shall reflect temple, and tower, and dome, in every variety of picturesqueness and magnificence." But as Washington Irving discovered at Sunnyside, the railroad that contributed

to the development of the district cut right in front of the villas on the eastern shore, proving both a convenience and a nuisance (fig. 3.16).[27]

Figure 3.16.
"The Mansion." From
Sloan, Model Architect,
1852, vol. 2, pl. 10.
University of Delaware
Library, Newark

Traveling upriver with Lafayette in the 1820s, Cooper wrote, "There is scarcely an eligible site for a dwelling that is not occupied by a villa, or one of the convenient and respectable looking farm-houses of the country." Westchester County in 1844 was marked by "a succession of beautifully situated country residences, looking out upon the river and across it to the Palisades." Dutchess County boasted "some delightful sites for country seats, where the wealthy and the refined may retire in the summer season, from the 'din and dust' of the city, and enjoy the magnificent, the soul-enlivening scenery." A visitor to Hyde Park declared, "No section of the country between New-York and Albany, excels this part of Dutchess county for the beauty of its country residences."[28] At Newburgh, "The country-houses, or boxes, for few could claim to be much more, were neat, well placed, and exceedingly numerous. The heights around the town . . . were fairly dotted with them . . . one Grecian temple . . . after another." Fishkill Landing, across from Newburgh, was "surrounded by delightful country residences." In the town of Hudson, "The houses are of brick and look good & comfortable; the country around it cleard & cultivated and many gentlemens villa's near it." Hills near Poughkeepsie were "studded with villas," and the town itself marked by "new streets and squares . . . being laid out and graded under the eye of the 'improvement party.'" By 1844 it had "1,000 dwelling houses, many of them tasty edifices," and was considered "the queen of villages in the Empire State," soon to see the construction of Downing-designed Springside (fig. 3.25).[29]

Bremer described Hudson Valley homes in 1849: "On the shores shone forth white country-houses and small farms. I observed a great variety in the style of building: many of the houses were in the gothic style, others like Grecian temples." Over time, the "river lined with" temples was becoming diversified by other styles, and with the midcentury rise in interest in German culture (on which Henry Adams would later remark), visitors came to compare the Hudson to the Rhine. By the 1850s, a steamboat traveler could report, "I found great changes, and for the better. The elegant summer residences of New Yorkers, peeping out from groves nestled in warm dells, or, most usually, crowning the highest points of the hills, now extend more than half-way to Albany. . . . Those Gothic, Tuscan, and Norman villas, with their air of com-

fort and home, give an attractive, human sentiment to the scenery; and I would not exchange them for the castles of the Rhine." John Zukowsky has explored the "Gothic architectural response to the literary image of the Hudson as the topographical equivalent of the Rhine" from the 1850s on.[30]

Farther south, the culture of summertime retirement was strong in fever-plagued Philadelphia. At nearby Germantown, which today advertises itself as "the first suburb in the United States," Johann David Schoepf in 1783 found "sundry neat and tasteful country-houses, although of a plan neither extensive nor durable. . . . many Philadelphians own land and houses here, and use the place as a resort for summer. By reason of its nearness also, excursions are often made hither; on Sundays the whole street is filled with the carts and coaches of pleasure-seeking Philadelphians." "During summer, the people that can make it convenient retire to country houses in the neighbourhood of the town," wrote a traveler in 1795. A visitor to the suburb of Frankfort a year earlier saw "pretty little houses, mostly stone, ornamented with doors and windows generally painted green, with blinds of the same color or gray. Little gardens and stretches of lawn give a sylvan air to this colony."[31]

Near Neshaminy Bridge, on the west bank of the Delaware, stood Springland Cot, home of William Birch, previously noted as the author of *Country Seats of the United States*. He had come to Philadelphia from England in 1794, bringing notions of the ideal villa with him. It was appropriate that a resident of the Philadelphia area should have written a book on America's tasteful suburban residences, for in his day that city was still the largest in North America—with 42,400 people in 1790, compared to 33,100 in New York. It was the most populous in the United States from about 1755, when it surpassed Boston, to 1810, when New York eclipsed it in turn. One often hears that in the eighteenth century, "Philadelphia, after London, was the largest English speaking city in the world," as Queen Elizabeth said when visiting there on 6 July 1976. But in fact, several cities in the United Kingdom were larger: even in 1800, a fast-growing Philadelphia (variously estimated at 61,500 to 68,000) lagged behind not only London but also Birmingham, Manchester, Glasgow, Liverpool, and Edinburgh.[32]

The villas of the Schuylkill formed one of the most Picturesque groupings of American rural residences. The combination of a winding stream with wooded hills and villas recalled the situation along the Thames above Windsor, with its many houses "peculiarly adapted for a summer retirement." From eminences all around, gentlemen's villas looked out at one another, the various houses forming pleasing objects in the others' prospects:

The beautiful banks of the Schuylkill are every where covered with elegant country houses; among others, those of Mr. [Thomas] Penn, the late proprietor, Mr. Hamilton, and Mr. Peters, late Secretary to the Board of War, are on the most delightful situations. The tasty little box [Belmont] of the last gentleman is on the most enchanting spot that nature can embellish, and besides the variegated beauties of the rural banks of the Schuylkill, commands the Delaware, and the shipping mounting and descending it. . . . From hence is the most romantic ride up the river to the Falls, in which the opposite bank is likewise seen beautifully interspersed with the country houses of the opulent citizens of the capital. On your arrival at the Falls, every little knowl or eminence is occupied by one of these charming retreats; among which General Mifflin's [Sedgeley] stands conspicuous, nor is the exterior belied by the neatness, the abundance, and hospitality which reign within.

In July 1787, Cutler enjoyed the obligatory pleasure drive "up the river several miles, and took a view of a number of Country-seats," including Robert Morris's the Hills: "His country-seat is not yet completed, but it will be superb. It is planned on a large scale, the gardens and walks are extensive, and the villa, situated on an eminence, has a commanding prospect."[33]

Kemble rode up the Schuylkill in 1832: "Turning between some rising banks, through a defile where the road wound up a hill, we caught a glimpse of a white house, standing on the sunny slope of a green rise. The undulating grounds around were all bathed in warm light, relieved only by the massy shadows of the thick woods that sheltered them. It was a bit of England." Appropriately, many of these villas had close ties to English precedent. William Hamilton intently studied English country seats in 1784–86 and, designs in hand, returned to undertake an Adamesque rebuilding of the Woodlands near Gray's Ferry in 1787–89. John Penn came from England in 1783 and erected Solitude the following year. Latrobe had been in the United States only three years when he designed Gothic Revival Sedgeley (1799). A picture of the Schuylkill villas at a moment in time is provided by the diary and sketchbooks of Englishman Joshua Rowley Watson, who visited Eaglesfield (1798) in 1816–17 (fig. 3.17). That house was by G. I. Parkyns, English landscape designer and author of a villa book, *Six Designs for Improving and Embellishing Grounds* (London, 1793). Thomas Jefferson had hoped to secure Parkyns's assistance with Monticello. On first traveling up the Schuylkill in June 1816, Watson wrote that "the road is prettily diversified by Country houses and small boxes laid out with good taste"; there were "innumerable

Figure 3.17.
*Joshua Rowley Watson,
"From the Piazza
[Eaglesfield] Looking
towards the Pavilion,"
21 May 1817. Demolished.
The Barra Foundation, Inc.*

gentlemens villas delightfully situated." Sweetbriar (1797), in particular, was "a pretty thing."[34]

The beauties of the Schuylkill were eventually spoiled as industry and the city encroached, however. The river was dammed in 1821, drowning the Picturesque falls, and by 1832 "the beautiful villas on the banks . . . are all either utterly deserted and half-ruinous, or let out by the proprietors to tavern-keepers," owing to "the fever and ague." Downing lamented the steady demise of Lemon Hill, built on what had been the Morris estate and notable for "geometric style" gardens, rare plants, waterworks, "hot-houses, curious grottoes and spring houses" (fig. 1.32). Annalist John Fanning Watson complained, "In our approach to Fairmount . . . how defaced & marred were all their former rural beauties, as country Seats or elevated grounds." Farther upstream, however, there were attractive stretches still; standing on a hill looking toward Norristown, "I thought it a most beautiful position for *a country seat!*"[35]

With time and the development of railroads, tasteful rural residences sprang up ever farther from the immediate suburbs of Philadelphia. An 1834 account of the new Philadelphia and Columbia Railroad observed ecstatically, "The country through which the road winds its way is unsurpassed in interest and beauty. The whole line of the rail road, and the Lancaster turnpike pursuing the same course . . . is for many miles richly studded with magnificent and imposing mansions, delightful villas, substantial farm houses and capacious barns and granaries, and for 20 miles present to the enraptured gaze the appearance of one extensive and continuous village, the abode of health, industry, and content, the home of the happy, the virtuous, and the frugal." Railroads did their part to spread a Picturesque ideal, even as they spoiled the

earliest suburban neighborhoods close to towns (fig. 2.22). Along the heavily traveled corridor between Baltimore and Philadelphia, station houses were, by the 1850s, Downingesque cottages of board and batten with vergeboards. That at Marcus Hook, Pennsylvania, even boasted a Picturesque vine-covered porch. And in its vicinity was more than one *cottage ornée* of 'the citizen who affects the country,' surrounded by ornamental buildings, shrubbery, and a blooming parterre."[36]

So far we have considered tasteful residences on the edges of major cities, but they were increasingly found outside smaller towns, too. They were numerous in antebellum Georgia and Alabama, for example: "Greek Revival houses, with columned porches and wide cool halls (frigid in winter), proliferated in the suburbs of most of the cities, and particularly in the small towns and in the countryside of the Georgia sand hills and piedmont." Bremer noted at Augusta in 1850, "Around it are many charming country-houses with their gardens." At Mobile she described a stroll on "Government-street, the principal street of the city, a broad, straight alley of beautiful villas, surrounded by trees and garden-plots." Ingraham offers a good account of rural residences in the old Southwest before 1835. The "suburbs" of New Orleans consisted of "a succession of isolated villas, encircled by slender columns and airy galleries, and surrounded by richly foliaged gardens." At Baton Rouge he admired "its colonnaded dwellings—its mingled town and rural scenery, and its pleasant suburbs." He singled out Natchez for praise, "whose suburbs are peculiarly rich in tasteful country seats" and the vicinity of which was marked by "white villas, not unfrequently large and elegant. . . . The general character of the scenery struck me as remarkably English." A 1979 study that focused on Mississippi reaffirmed the fact that pattern books played a major role in the development of southern villa architecture, with exterior and interior details from Asher Benjamin's *Practical House Carpenter* (1830) and *Practice of Architecture* (1833) being frequently copied.[37]

For all the handsome Greek Revival country homes still to be seen today in the Black Belt, there was a widespread feeling that the Deep South was lagging behind in the national campaign to improve the rural residence. A Georgian of 1853, having learned of Downing's death, expressed his embarrassment that, in the South, "Downing is not simply unread, but unknown." He called for his state to be "improved . . . upon the principles so clearly delineated by Downing—here a cottage peeping modestly out from behind a group of forest trees—and there the more commanding and costly country residence . . . made to meet the view of the traveller at every turn of the road." Reformer John Forsyth had recently urged Alabamians, "Let us cease to go

North, as thousands of our people annually do, in quest of the cultivated land-scapes, bright cottages and rural beauties which are so attractive in New-England. Let us have a civilization of our own."[38]

Sloan, the Philadelphia architect, was one of the northerners who provided designs for clients in a rapidly growing South, culminating in the extraordinary Longwood at Natchez (1854–61). In his 1852 villa book he described in detail the ideal southern home (fig 3.18). It should have a low, spreading form; wide eaves (protecting walls from heavy rains and keeping the sun out); large, often floor-length windows and wide doors; green venetian shutters; an encircling veranda; abundant bedrooms (for "the laws of hospitality"); kitchens detached, with slave housing above them; extensive gardens (land was abundant and labor inexpensive). He called the northern mansion "totally unfit" for conditions in the South—yet none of the "southern" features he described was original but, rather, a modification of established country-house design principles everywhere. Indeed, Daniel D. Reiff has found two faithfully copied examples of the main block of Sloan's "Southern Mansion" still standing today—in arctic upstate New York (1853, 1856). We must be careful not to exaggerate regional differences. At the end of a fifteen-year study of southern architecture, Mills Lane concluded, "The South's historic buildings show how the South participated far more fully in the mainstream of American life before the Civil War than has been generally appreciated. . . . As late as 1840 Northerners and Southerners were far more alike than they were different."[39]

Tasteful homes sprang up around the rapidly expanding towns and cities of the West, and period accounts suggest the surprise and delight such places occasioned in a region known mostly for stump-filled clearings. Founders of Marietta, Ohio, in 1788 lost no time exploring "a number of the hills back; fine prospect, most delightful for country-seats." In Cincinnati in July 1828, Frances Trollope "began to fear for our health, and determined to leave the city," settling upon the suburb of Mohawk and "a very pretty cottage. . . . it gave us all the privileges of rusticity." Here "we lived on terms of primaeval intimacy with our cow," who would wander over when Trollope was reading on the lawn. Life partook of a rustic flavor; the family used the nearby forest "as an extra drawing-room," and "sundry logs and stumps furnished our sofas and tables." She who had admired the rural residences of many parts of the United States now had the opportunity to enjoy the Picturesque delights of her own. Charles Dickens wrote of Pittsburgh in 1842, "The villas of the wealthier citizens sprinkled about the high grounds in the neighbourhood, are pretty enough," and at Cincinnati he praised "the varying styles" of the houses: "The disposition to ornament these pretty villas and render them at-

Figure 3.18.
"Southern Mansion."
From Sloan, Model
Architect, *1852, vol. 2,
pl. 47. University of
Delaware Library,
Newark*

tractive, leads to the culture of trees and flowers, and the laying out of well-kept gardens, the sight of which, to those who walk along the streets, is inexpressibly refreshing and agreeable. I was quite charmed with the appearance of the town, and its adjoining suburb of Mount Auburn." Visiting Chicago in 1850, Bremer stayed "in a pretty villa, built in the Italian style, with Corinthian pillars, surrounded by beautiful trees and flowers." Madison, Wisconsin, was "a pretty little town (mostly consisting of villas and gardens)." In Missouri, "Mr. A. drove me to part of the neighbourhood where the wealthy citizens of St. Louis built their villas. There are already upon the hills . . . and in the valleys, whole streets and groups of pretty country-houses, many of them really splendid, surrounded by trees, and flowers, and vines, and other creepers."[40]

In Cincinnati, "It has become quite a mania, of late, to possess a country residence; and the fruits of [this] well directed taste are being seen all around us, on the hill-tops and in the valleys" (fig. 3.8). A daguerreotype summarizes this theme of the western villa, fully as tasteful as anything back east (fig. 3.19). The family proudly poses on a bench brought out into the sunlight of the yard, the delights of their hilltop suburban-villa existence forming the larger subject. The neatness and pretension of their home is palpable—urns along the rooftop balustrade, a jigsawed parapet—but equally striking is the role played by the ornamented landscape in which a Negro gardener stands at the ready with his shovel. The genteel Twickenham life of England is here

Figure 3.19.
Charles H. Fontayne and
William Southgate Porter,
A Family Seated in Its
Garden [Cincinnati area],
1848–52, daguerreotype,
4¹⁵/₁₆ × 5¹⁵/₁₆ in. (12.6 ×
15.1 cm). The J. Paul Getty
Museum, Los Angeles

replicated, as much as possible, in the New World. A writer of 1843 almost seems to describe this scene when he writes of the cultural shift from clearing the native western forests to planting the grounds of the tasteful American home. With the coming of "the picturesque style," "the natural style of gardening is now universally approved. . . . On the lawn before the house, trees of unusual shape, or rich foliage, and flowers, can be sprinkled everywhere, taking care to avoid that formal regularity, which is never found in nature." The Cincinnati homeowner has got this idea down thoroughly. Perhaps in his youth he swung an ax to clear the forested hills around the city, but now he feels the impulse to taste and sophistication, and "a new sensibility is thus awakened." "Where, in former days, he saw nothing but fuel and timber, he

will find value, apart from domestic uses, in the expression of their forms. . . .
He will ascertain by experiment, where the rich velvet of the locust, the cheer-
ful green of the plane-tree, the autumnal scarlet of the maple, and the blood
red of the oak, can be set with the best effect. . . . Even if he gained nothing
for himself, but the satisfaction which it is sure to give, his children will grow
up with tastes and perceptions, to which his early days were strangers."[41]

In these accounts from across the nation, a common theme emerges: the
country seat that had, in the eighteenth century, been the pride of the very
wealthy increasingly came to be a middle-class expectation, the estates of the
landed gentry replicated in miniature on the modest suburban lot. It is an-
other example of the kind of trickle-down flow of taste that so often shaped
nineteenth-century architecture, as standards of living rapidly rose. As a re-
sult of this process, the groundwork was laid for modern suburban life. Today,
fully half of all the housing units in the United States are in suburbia—some
fifty-two million homes.

Blinds, Battens, and Brackets

By 1850 it was supposed that "there is no country in the world where more
houses are projected and built in the course of a year" than in America. Much
of this took place in newly settled areas, but there was enormous rebuilding
in established towns and cities as well. "I have been thinking over with Father
the old houses in this street," Thoreau wrote of Concord in 1855, and to-
gether they came up with a considerable list of seventeenth- and eighteenth-
century homes since replaced by modern ones. The newer houses were the
stylish kind he critiques in *Walden*, with "the improvements of centuries, spa-
cious apartments, clean paint and paper, Rumford fireplace, back plastering,
Venetian blinds, copper pump, spring lock, a commodious cellar." This steady
process of improvement was typical of long-settled areas everywhere.
Catherine W. Bishir discusses the great campaign of rebuilding that got
under way in North Carolina in the 1830s, as "demands for modern and styl-
ish architecture . . . swelled to a chorus. . . . Replication of national architec-
tural models was part of a package that usually incorporated railroad and in-
dustrial growth, temperance, genteel domestic life, public education, and
scientific farming as the means to prosperity and pride." Meditating upon the
scenery of the Hudson River, Cooper shared his contemporaries' opinion that
"the view of all the improvements of high civilization in rapid, healthful and
unequalled progress is cheering to philanthropy, while the countless villas,

country houses, and even Seats of reasonable pretension, are calculated to assure one that, amid the general abundance of life, its numberless refinements are not neglected."[42]

One up-to-date element shared by tasteful residences of whatever size or style was the green latticed shutter (fig. 1.9). "Venetian blind" refers today to a slatted interior window shade that can be pulled up and down, but in the early nineteenth century it more often referred to outside shutters: "For exterior wooden screens, the terms *blind* and *shutter* were nearly synonymous if they had louvered slats." These grew more common over time; in New York in 1794, a visitor saw solid shutters on lower windows (with crescents cut into them) but none "except on the ground floor"—and yet within a few years the slatted shutter would become commonplace on above-stairs windows in this and other cities. A painting shows that Tontine Crescent townhouses had both solid interior blinds and latticed exterior ones (fig. 2.6). Shutters were invariably painted green: "the green Venetian blind is universal," Willis reported from New Haven in 1840, and specifications for the William M. Bickford House in Worcester, Massachusetts, called for "the lower part of each blind to have movable shades or slats. Painted with four coats, the last two of Paris green." In Delaware today it is often remarked that old houses have white shutters on the ground floor, green above, but the reason has been forgotten: upstairs shutters were latticed, providing ventilation to the bedrooms, and latticed forms were conventionally green. That idea had been imported from England, where it was felt to suit the garden origins of the lattice and enhance its Eastern flavor; Venetian blinds, Downing wrote, were appropriate "where the architecture is lighter and more fanciful." There was an element of self-conscious luxury, too, because the verdigris (copper acetate) pigment used in green paint was fugitive, meaning that shutters had to be retouched frequently.[43]

Utile et dulce perfectly intersected in the blind, which had manifold functions: it protected expensive window-glass against wind and hail, provided ventilation to bedrooms ("mephitic air" being a worry), helped keep the appallingly abundant flies out, and guarded against light damage to valuable furnishings—even as it evoked the sprightly and appealing imagery of the Picturesque East. Its aesthetic was akin to that of the treillage popular in England and later here (fig. 1.22), and indeed a Massachusetts architect defined *trellice* as "a reticulated framing made of thin bars of wood, for screens; windows where air is required for the apartment, &c." In warmer climates, blinds were sometimes used, trellislike, to screen entire porches, as on a cottage in Alabama that was many-winged and raised high on brick piers for maximum

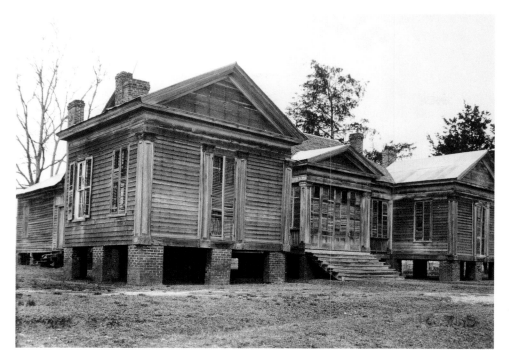

ventilation (fig. 3.20). Along the same lines were the little wooden rooms that Jefferson built just off his greenhouse-piazza at Monticello. These "Venetian porches," as he called them, disappeared generations ago but have been expertly reconstructed (fig. 2.38).[44]

Homesick in central Alabama in June 1838, Englishman Philip Henry Gosse observed, "We usually sleep with every window wide open, there being latticed blinds or shutters to prevent the intrusion of bats, birds, &c." In Washington, D.C., in July 1850, Bremer wrote, "It is very hot, but the sycamore-tree outside my window casts a shadow, and all is kept cool by the green Venetian shutters." At Cape May, New Jersey, a few weeks later, she "slept with my window open and the Venetian shutters closed, as people do here generally." Thoreau wrote in Concord, "How still the hot noon; people have retired behind blinds. . . . I see men and women through open windows—in white un-dress taking their Sunday afternoon nap—overcome with heat"; they listened "through open lattices" to orioles singing in the elms.[45]

Travelers constantly remarked on America's wooden houses with their distinctive paint scheme of white and green. An Englishman in 1817–18 saw houses outside New York "painted white, with green shutters," and churches and houses in Providence, Rhode Island (fig. 2.37), were "built of wood, painted white, with green Venetian shutters, presenting a neat elegance very

superior to our smoky brick buildings." Frances Wright described the "lovely villas" of Canandaigua, New York, in 1819: "The houses are all delicately painted, their windows with green Venetian blinds, peeping gaily through fine young trees, or standing forward more exposed on their little lawns, green and fresh as those of England." Cooper, in New England in the 1820s, wrote of "buildings, many white, relieved by venetian blinds in green." In describing the stark contrast in upstate New York between raw pioneer homesteads and dwellings of taste and pretension, Basil Hall found "green Venetian blinds" an emblem of the latter. Ranlett called for "blinds to have three coats bronze green" even as he commented (in 1847) that the white-and-green paint scheme was now less universal than formerly. Perhaps the most memorable expression was that of Dickens, outside Boston in 1842: "The suburbs are, if possible, even more unsubstantial-looking than the city. The white wooden houses (so white that it makes one wink to look at them), with their green jalousie blinds, are so sprinkled and dropped about in all directions, without seeming to have any root at all in the ground. . . . Every house is the whitest of the white; every Venetian blind the greenest of the green."[46]

Another tasteful feature of the country house was the floor-length window leading onto a piazza. In England, Barbara Hofland described the south front of the duke of Marlborough's White-Knights: "The glass doors by which we enter the hall (and indeed every other window) is level with the lawn." In 1827, Elmes summarized the ideal villa in Regent's Park: the windows of the "broad verandah . . . should all open as French sashes down to the floor." Verandas and long windows were so common in London's West End that Leigh Hunt was moved to censure them, complaining, "Windows down to the floor . . . let in draughts of air . . . so as to chill the feet." In America, such windows are often said to be peculiar to the South, but they were widely common (fig. 3.17). Shaw wrote in Boston, "The windows in modern houses are frequently brought down to the floor, in imitation of the French," and William Brown from nearby Lowell offered a Gothic cottage with a sitting room where the windows "may be brought down to the floor, and open like French casements, so as to admit of easy access to the piazza."[47]

A further element emblematic of taste was board-and-batten siding, introduced with the Gothic cottage popularized by Davis and Downing (fig. 1.25). Battens harmonized with the verticality of porch posts and suited the medieval "pointed style" that was of course "distinguished by the upward direction of its leading lines." Downing was the great popularizer of the new method. He wrote of "boards and battens," but more often termed it "the *vertical boarding.*" Davis, from whom he probably learned it, had called for "1¼

[inch] plank, tongued, grooved, and put on vertically, with a fillet chamfered at the edges, over the joint"; Downing echoed him in writing of "weatherboarding of sound inch or inch and a quarter pine, tongued and grooved at the edges, nailed on in the vertical manner, and covered with neat battens." Downing said that its advantages over customary horizontal weatherboarding were durability, economy, offering "an expression of strength and truthfulness" by suggesting the upright character of "the main timbers which enter into the frame of a wooden house," and "better express[ing] the picturesque" by being "a bolder mode of construction." Unlike traditional siding, which required "a great deal of labor . . . in planing and fitting up" in order to look "very highly finished and polished," vertical boarding was easy and forgiving—"more rustic and picturesque, than planed boards." Perhaps its greatest practical benefit was that it allowed the builder to avoid expensive hand planing entirely by taking advantage of the new availability of steam-planed boards that came readymade in tongue and groove. These were marketed for use as matched floorboards, but Downing promoted them for finished walls, with just a batten to cover the joints. Soft bricks inside would serve as insulation.[48]

The origins of board and batten remain obscure. It has been argued that Davis, who promoted the mode in *Rural Residences* (1837), borrowed it from "vernacular and practical" buildings in the American countryside and that it was ultimately "based on plank framing, a structural technique familiar in New England" and elsewhere. It should be noted, however, that neither Davis nor Downing mentioned these derivations—given their customary goal of achieving "a sense of something beyond mere utility," they typically had little good to say about vernacular buildings—and Downing's comments make it seem that the technique had come in abruptly with the new machine-cut boards. Whatever its roots, in the 1840s it suddenly flowered as a timely, ingenious method of rendering the half-timbered English cottage style in an affordable American material, scantling. Around 1800, Humphry Repton had helped pioneer the Old English (freely called Swiss) type of cottage ornée, with vertical half-timbering rising into a sharp-pointed, bargeboarded gable (fig. 3.21). In the years that followed, the type was widely imitated, and Loudon illustrated many variants on it, including a Swiss chalet–like dwelling with vertical boarding in the second story rather than the English half-timbering. In 1835 he published a "Cyclopean cottage" design that had recently been erected in Kent as an under-gardener's residence: "The effect, as contrasted with the numerous straight perpendicular lines formed by the studwork in the upper part of the walls, and with the horizontal lines of the

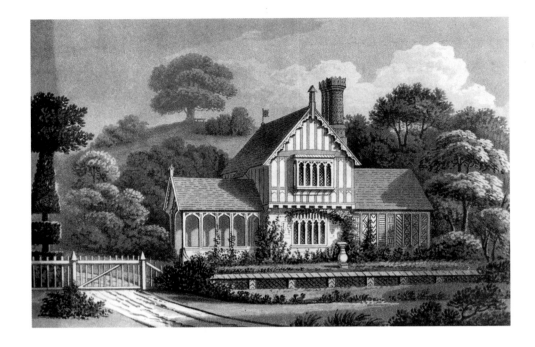

roof, is exceedingly good" (fig. 3.22). He specifically called for the substitution of wood shingles for roof tile "if this building were imitated in America." Imitated it would be, these vertical-studwork designs jumping off the pages at Davis and Downing as they sought an architecture appropriate for New World conditions. The very features that seemed drawbacks to Loudon—that the Swiss was good only for small buildings and wooden construction—were just what American builders needed. In such compositions, Vincent Scully has written, "the concepts of utility, wood structure, and the picturesque all come together, mingle, and produce a style."[49]

Davis remodeled a Federal-style house overlooking the Hudson for New York merchant Robert Donaldson, who called the place Blithewood (figs. 3.23 and 2.19). For Downing, this was "one of the most tasteful villa residences in the Union," and he illustrated it on the frontispiece to his first book. Among the earliest board-and-batten cottage designs built anywhere was Davis's Gatehouse there, entirely of wood, grained on the outside in imitation of oak and with hexagon-shaped roof shingles. When a larger Gatehouse was later erected, the first became a Gardener's House, described in 1846 as "in the Cottage Gothic style . . . with its pointed and projecting gables, and miniature porch, covered with honeysuckles and Boussault roses." It has been called "the prototype of the American Gothic cottage," and arguably "its impact on American architecture was enormous." A glance at the earlier designs by

Repton and Loudon will show, however, that it was highly derivative, the successful adaptation of English ideas to American conditions. And in particular, nearly every element—including the rustic porch and paired, ornamented chimneys—was copied from plates in P. F. Robinson's *Rural Architecture*, as was Davis's presentation of it in a bucolic landscape with a man trudging along the road in the foreground (fig. 3.24).[50]

Villa books helped spread the vertical-boarding construction widely in the 1850s, and Civil War photographs show it extensively in use. How a board-and-batten design could go from print to built reality is illustrated by Downing's construction of a gardener's cottage for Matthew Vassar at Poughkeepsie, New York (fig. 3.25). Vassar was a local ale-brewer who became wealthy and founded the college that bears his name. In mid-1850 he paid eight thousand dollars for Allen Farm, a hummocky tract on the edge of town, intending to found a rural cemetery. When this scheme failed to materialize, he transformed the place into a lovely Picturesque estate that by early 1852 he was calling "Springside." He himself lived in the Cottage in summertime, moving there permanently four years before his death in 1868.[51]

It was probably following his return from England in September 1850 that Downing designed Springside, both grounds and buildings. Even after he died two years later, the place continued to evolve in a compatible style. Perhaps from the hand of his associate Calvert Vaux came "the curious little building . . . at the corner of the garden," an apiary with a weathervane of "an enormous golden honey-bee swinging over a hive." Downing had derived the nearby Cottage from Design 3 in his recent *Architecture of Country Houses*, "Symmetrical Bracketed Cottage"—many of his published schemes being symmetrical, proof that the Picturesque need not be irregular (fig. 3.26). Design 3 was itself based on Loudon's "Cottage Villa in the Gothic Style." Most aspects of the Vassar Cottage obeyed Design 3, down to the distinctive slanting window-hoods "designed especially for this style of building." Downing could barely suppress his enthusiasm for Design 3, truly "a successful example of a rural cottage" and almost "a model." Part of its appeal was "the pretty little open porch, with its overhanging window and its seat, where, in the cooler hours of the day, the husband, the wife, and the children may sit and enjoy the fresh breath of morning or evening hours," and he diagrammed a

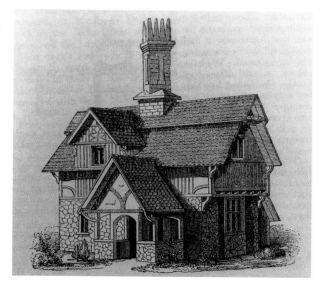

Figure 3.22.
William Wells, Cyclopean Cottage, Redleaf, Kent, England. In Architectural Magazine, *December 1835, 533–34. University of Delaware Library, Newark*

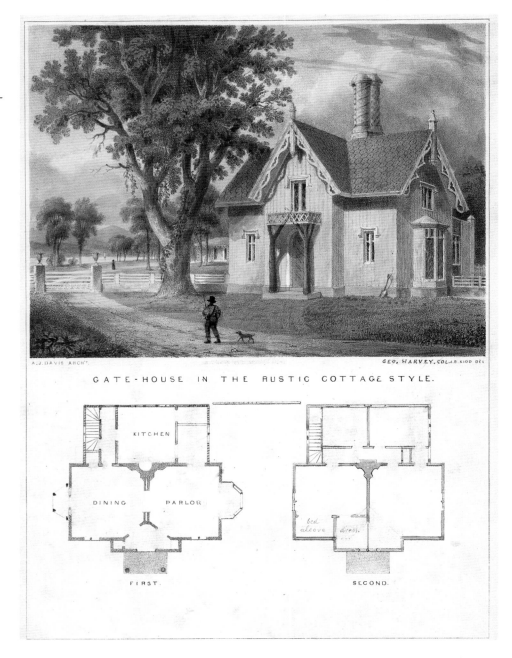

Figure 3.23.
*Alexander Jackson Davis,
"Gate-House in the
Rustic Cottage Style,"
Robert Donaldson estate,
Blithewood, Annandale-on-
Hudson, New York, 1836.
Demolished. Lithograph,
watercolored by George
Harvey, 13½ × 9⅝ in.
(34.3 × 24.2 cm). Avery
Architectural and Fine
Arts Library, Columbia
University in the City of
New York*

GATE-HOUSE IN THE RUSTIC COTTAGE STYLE.

section of this "novel" porch. He thought the bedroom that overhung it "would be a pretty apartment for the eldest daughter—where she would have an opportunity to arrange her little cottage boudoir to show her own taste." The Vassar Cottage had, in addition, a veranda on the back overlooking the valley garden with its scenic copses and ponds. The doubled chimneys of

Figure 3.24. *Cottage Gate Lodge for Sir Robert Vaughan. From Robinson,* Rural Architecture, *1823, Design no. 2. Courtesy The Winterthur Library: Printed Book and Periodical Collection*

Figure 3.25. *Andrew J. Downing, Cottage, Matthew Vassar estate, "Springside," Poughkeepsie, New York, ca. 1850–52. Demolished 1976. At left, Calvert Vaux, attrib., Apiary, after 1852. At far right, Greenhouse. S. L. Walker,* The Bee House, *photograph, ca. 1859. Special Collections, Vassar College Libraries*

Fig. 13

Figure 3.26.
Andrew J. Downing,
Design 3, "Symmetrical
Bracketed Cottage." From
Downing, Architecture,
1850, facing p. 83.
University of Delaware
Library, Newark

the Cottage had appeared in several designs in Downing's book and exhibited the careful proportions and base, shaft, capital arrangement that he advocated (fig. 1.26).[52]

From Design 7, "Symmetrical Cottage," came the vergeboards on front, side, and rear gables. These were tricky features, Downing attempting to avoid not only "a very ornate verge-board, which properly belongs to a villa," but on the other hand the kind cheaply "sawn out of thin board, so as to have a frippery and 'gingerbread' look." In *Architecture of Country Houses* he gave a detail of the tasteful vergeboard on the front of Design 7, "carefully carved in thick and solid" two-inch plank. By the rules of fitness, cottages should not have vergeboards at all, because they were "inconsistent and out of keeping" with the humility of the rustic state; but Downing made a single exception in the case of "cottages built as gate-lodges or gardeners' houses on gentlemen's estates," which of course is what Vassar's Cottage was. To that dwelling he added, finally, an element of Design 17, "Farm House in the English Rural Style"—the *truncated gables* (fig. 1.26). These "sources of beauty and picturesqueness" were meant to "give an air of rustic modesty . . . expressive of honest, homely, unaffected country character. United to a broad roof of this kind, they express an easy, unrestrained, unconventional comfort" akin to "the wide, shadowy straw-hat with which the farmer covers his head in the easiest and most comfortable manner." The Cottage, then, was the tangible realization of many of the ideas expounded in *Architecture of Country Houses,* an ensemble of traits that collectively suggested what Downing called those "'cottage homes of England,' so universally and so justly admired." Board and batten was part of the package, an American response to the vertical half-timbering or boarding of Swiss cottages and English gatehouses. Today only the foundation remains of the Cottage, although pieces of the façade exist in storage. "The only surviving domestic landscape design" by Downing, Springside in 2000 was abandoned and overgrown, although slowly undergoing restoration.[53]

In discussing porches and wide, bracketed eaves, many villa-book authors emphasized the aesthetic value of shadows, which could provide monumentality even to small buildings. The origins of the shadow cult lay in Picturesque theories of the landscape; the artist Edward Dayes, for example, repeatedly

stressed the role of shadows in his "Instructions for Drawing and Coloring Landscapes" (1805), and R. P. Knight held that "deep shadows near, / Will show the distant scene more bright and clear" and offer "a scale of magnitude and harmony." As often, painterly ideas were readily transferred to the architectural Picturesque. In his 1805 villa book, William Atkinson emphasized the importance "of light and shade . . . as it is on these principles, that the picturesque depends." William Wordsworth wrote of traditional cottages, "[In] the numerous recesses and projections in the walls and in the different stages of their roofs, are seen bold and harmonious effects of contrasted sunshine and shadow." In the cottage ornée, Robert Lugar observed, "deep recesses and bold projections are great assistants" toward "irregularity" and "the play of light and shadow." Francis Goodwin in 1834 noted how wide overhangs supported by rustic pillars would give "vigorous expression and relief, in consequence of the deep shadows thus produced."[54]

Shadows had special efficacy in the everyday, rather insipid landscape. This was a notion suggested by Papworth, who with a scheme for a cottage ornée had offered the comment, "This building is designed to harmonize with garden scenery, and to afford a degree of embellishment by its verandahs and the variety of shadow which they project, that would be greatly desirable where the landscape is not composed of very interesting features. The cottage roof is well fitted to assist in this endeavour, as its overhanging eaves produce a picturesque effect, and give a considerable shelter to the house. On the pleasing variety of shadow resulting from this design, its pretension to notice would principally depend, for the parts themselves are perfectly simple and unaffected" (cf. fig. 1.22). Deep shadows beneath broad eaves, then, could give character to a plain house in flat and unpicturesque scenery. This realization would prove significant in America, where travelers (Downing included) complained that the eastern seaboard was generally featureless and level. "There is a great sameness," said Latrobe in 1806, and "many of the most picturesque kinds of Scenery, frequent across the Atlantic are absolutely excluded." Even the most Picturesque sight in America, Niagara Falls, coexisted with a board-flat landscape that disappointed many tourists, including J. F. Watson in 1827—he was reminded, alas, of New Jersey—and Cole had a similar reaction when he visited the falls in 1829 as a kind of inoculation against the charms of foreign scenery before he sailed for Europe. It was probably to address this fundamental drawback of the indigenous eastern landscape—flatness—that Downing offered his broad-eaved, shadow-casting "Cottage-Villa, in the Bracketted Mode" as the desirable genesis of "an *American cottage style*" (fig. 3.27). Cole would ratify Downing's ideas: "The climate

Figure 3.27.
Andrew J. Downing,
"Cottage-Villa, in the
Bracketted Mode." From
Downing, Cottage
Residences, *1842,*
figs. 40, 41. University
of Delaware Library,
Newark

being more sunny than that of England more shade is required than is to be found in the English Cottage Style— Large Piazzas deep recesses projecting roofs greater breadth of style is demanded by the American Landscape & climate." Here lay the future basis of "American Villa Architecture—American Landscape is generally broad & grand & its architecture ought to harmonize with it."[55]

New York architect Ranlett agreed, hailing "Anglo-Italian Villas" with their "projecting eaves, so becoming in our sunny climate" and proposing to rename the style "American-Italian" (fig. 3.28). Later, Holly had much to say about the shadow-casting function of wide eaves. He recognized that "one great advantage architects possess in this country is the strong contrast of light and shade produced by our clear atmosphere. . . . light and shade are the happiest instruments of design, and most easily procured in our climate." Among the many schemes in *Holly's Country Seats* (1863) that display wide eaves, there is one in which "the decorated barge boards at the eaves produce shadows, relieve the walls, and serve as a protection to the sides of the house, thus forming a useful and ornamental appendage, often cheaper than brackets." Italianate villas with their wide overhangs enjoyed enormous popularity after 1840, Sloan estimating in 1852 that "nearly one-half of the suburban dwellings that have been erected in this country within the last ten years, are in this style."[56]

Not only houses could employ large brackets. Henry Austin's Union Station, New Haven, took the bracketed mode to a fantastic extreme in a public building, as seen in a rare photograph (fig. 3.29). Contemporaries called the 300-foot-long edifice "Italian" for its wide eaves and campanile tower, the first at an American station, but Austin (consulting Loudon's *Encyclopedia*) freely mixed Chinese, Indian, and Moorish motifs. The building cost forty thousand dollars; the 140-foot north tower had glass clock-faces 8 feet tall, illuminated by gas.[57]

Brackets beneath capacious eaves were highly symbolic of Picturesque functionalism. For Downing, "projecting roofs" casting deep shadows connoted *power*, a term employed by Dayes in his Picturesque drawing manual: "The shadows and middle tints being worked up to a sufficient degree of power." Some years before Ruskin's "Lamp of Power," Downing echoed the English villa books in writing, "Every thing that conveys the idea of strength

or force in attaining any agreeable form, adds to the picturesqueness of that form. For this reason, in picturesque architecture, the rude timbers which support the roof, are openly shown, and in others, bold brackets support the eaves, not only for actual support, but to suggest the idea of that support directly to the eye." "Beauty and force" were the rationale for the special sloping window-hoods he gave with Design 3 in *Architecture of Country Houses*, made tangible at the Cottage for Matthew Vassar, where on a sunny noon they cast long shadows down the walls (fig. 3.25). His illustrations show the support principle at work in the skeletal construction of bracketed verandas and the boldly bracketed eaves and heavy post-and-lintel chimney tops of villas (fig. 3.27). Of course, brackets and posts did not need to be *literally* functional so long as they suggested the idea of function; it was the visible expression of a Picturesque principle that mattered.[58]

Enamored of deep overhangs, the Picturesque looked at an early date to Swiss architecture for inspiration, even if the results were not especially authentic, and the chalet emerged as an essential type of rustic wooden construction. The Swiss Cottage in the grounds of the duke of Marlborough's White-Knights (illustrated in Hofland's book, which Downing owned) was Swiss only in name, although one key feature was present: capacious eaves. In this case, the thatch roof "project[ed] far enough from the building to form a piazza all round," supported by "rustic pillars" atop "large stones." The Swiss Cottage, Cahir Park, County Tipperary (1810–14), attributed to Nash, is an extant example of this Picturesque Swiss mania, which Ruskin would satirize in 1838 as being nothing like Switzerland.[59]

The rude Swiss cottage was the epitome of Picturesque "power," and so shaped brackets beneath wide eaves, beloved of Davis and Downing, were borrowed from Swiss precedent via Loudon. Downing's post-and-lintel chim-

(left)
Figure 3.28.
"Cottage Villa Italian Style." From Ranlett, Architect, *1847–49, vol. 2, pl. 45. University of Delaware Library, Newark*

(right)
Figure 3.29.
Henry Austin, Union Station, New Haven, Connecticut, 1848–49. Burned 1890s. New Haven Colony Historical Society

Villa, Cottage, and Log House ⎡ 151

ney tops, too, are Swiss. Cooper had a character say, "Nothing can be uglier, *per se*, than a Swiss cottage, or anything more beautiful under its precise circumstances"—and this remarkable type would long endure in America. Ranlett considered it "well fitted for building with wood, which is a common material with us, in all parts of the United States." In 1855, Henry W. Cleaveland and William Backus offered American audiences a house based on the Swiss cottage: "Its principal feature is the verandah or gallery covered by the projecting roof, and supported by the open framework. This is at once bold and simple, suggestive of summer enjoyment and of winter protection." The house was meant for a Picturesque site: "It would suit well the southern side of some steep and rugged hill," its grounds to be "left with their natural inequalities." A writer for *Picturesque America* (1872–74) observed at Watkins Glen, New York, that "the very picturesque Mountain House, built directly on the side of the rift, affords one of the few instances where, in this country, man has worked in harmony with Nature. This *chalet* is, in its own way, almost as attractive as the glen itself. Its balconies overhang the gorge, with trees jutting up through them from ledges in the rocks below." And it is to the Swiss chalet that we must look to understand the ostensibly novel and protomodernist, triangular form of the William G. Low House, Bristol, Rhode Island, by McKim, Mead and White (1886–87). Chalets often had triangular massing. To a large degree, the Shingle Style of the postbellum years descended from the pioneering Swiss cottages of the 1840s, such as one designed by a Mr. Penchard of Albany for E. P. Prentice and illustrated by Downing, its exterior "covered with *shingles*, the lower ends of which are cut before using them, so that they form a pleasing pattern. They . . . are much more picturesque in effect than planed boards or 'siding'" (fig. 3.30).[60]

Discovery of the Log House

In Virginia, Jefferson wrote, "The poorest people build huts of logs, laid horizontally in pens, stopping the interstices with mud." Having examined villas and cottages, we can now turn to this lowlier type of dwelling—for an analysis not of its construction but of its contemporary meanings to educated observers. As we have seen, there was no mistaking the outpouring of interest in rustic design before 1850. These same years saw the intellectual discovery of the American log cabin, too, and this was no coincidence. The log house is one of the most famous architectural types in America and has been the subject of considerable scholarly attention, but its prominent symbolic

role has been interpreted narrowly as political, based upon the part it played in William Henry Harrison's 1840 presidential campaign (fig. 3.31). His log cabin at North Bend, Ohio, became a rallying cry, even though he had long since enlarged and modernized the place into a fashionable, weatherboarded country house. Powerful new aesthetic values were at work, however, and the log house as an architectural type might have been little noticed or discussed were it not for the English tradition of the rustic (fig. 2.41). Informed contemporaries had absorbed the ideas of the Picturesque, as Thoreau (a reader of English theorists Uvedale Price and William Gilpin) eloquently expressed them:

> What of architectural beauty I now see, I know has gradually grown from within outward, out of the necessities and character of the indweller, who is the only builder,—out of some unconscious truthfulness, and nobleness, without ever a thought for the appearance; and whatever additional beauty of this kind is destined to be produced will be preceded by a like unconscious beauty of life. The most interesting dwellings in this country, as the painter knows, are the most unpretending, humble log huts and cottages of the poor commonly; it is the life of the inhabitants whose shells they are, and not any peculiarity in their surfaces merely, which makes them *picturesque;* and equally interesting will be the citizen's suburban box, when his life shall be as simple and as agreeable to the imagination, and there is as little straining after effect in the style of his dwelling.[61]

Figure 3.30.
G. J. Penchard, Swiss Cottage, Mount Hope, New York. From Downing, Architecture, *1850, facing p. 123. University of Delaware Library, Newark*

Thoreau's "humble log huts" were excitingly symbolic of the drama of settling the North American continent. Many observers were fascinated by the native recapitulation of the "primitive hut," those earliest stages of architecture as explicated by William Chambers and others; to Timothy Flint, it seemed a grand anthropological demonstration, this "transition from cabins to mansions, and from settlements to cities [which] has taken place under our own observation," and he wrote at length on the log houses of the West, intending to preserve a historical record of frontier building, "the modes and contrivances of a settler on the virgin soil," before advancing civilization obliterated all evidence. Travelers joined him in paying homage to America's

Figure 3.31.
"Old Tippecanoe has
come out in the West,"
*1840, colored lithograph,
12 × 14 in. (30.3 × 35.6
cm). The Library Company
of Philadelphia [Cartoons
1840 Old, P.2275.19]*

"hundred thousand log cabins." Latrobe sketched them often, attentive to their Picturesque irregularity and roughness. Venturing up the Hudson in 1817, H. B. Fearon itched to see a log house and was disappointed to find none between New York and Newburgh. Beyond Utica, Harriet Martineau "first saw a loghouse, and first felt myself admitted into the sanctuary of the forest." Cottage-minded, she enjoyed log architecture, writing approvingly of "a picturesque loghouse, peeping forth from a blossomy thicket." At White Sulphur Springs, Virginia, Frederick Marryat admired "little cottages, log-houses, and other picturesque buildings, sometimes in rows, and ornamented with verandahs." Log houses were more common in the South, wrote a Virginian from "Yankeeland" in 1834: "I have not seen a log house in New England; and nine-tenths of the ordinary farm houses are painted."[62]

That contemporaries would have enjoyed log houses is not surprising, given their interest in the rustic and the popularity of the Swiss, which, Ruskin explained, could consist of "a rude log hut, formed of unsquared pine trunks, notched into each other at the corners." Villa books sometimes illustrated buildings completely of logs, and John Plaw in 1795 had designed some "Shepherds' Huts" as log houses: "The façade is formed of rough trunks of trees." He also proposed a keeper's lodge: "The rustic columns are trunks of

trees in the rough," the walls made of trees "bedded in loam, &c." American log cabins were not infrequently conflated with English cottages—although, depending on the attitude of the observer, their inhabitants were either far more or far less impoverished and wretched than their counterparts overseas (fig. 1.24). In upstate New York in 1816, J. R. Watson saw many log cabins with piazzas: "The Country houses are in general built with wood, some in the Old style of Logs, placed over each other, & their ends locked in by a sort of mortice—they are plasterd inside or lined with plank and are found to be very durable and warm—the chimneys are built of stone or brick: they have most of them sheds or piazza's with platforms." Frances Wright, likewise in upstate New York, wrote of how, "During the summer nights, a log hut often presents a very singular appearance," owing to "the light streaming through [the] crevices" and revealing the happy family within: "Insensible were the heart that could pass without emotion this little scene of human industry and human happiness. The cotter's evening light is interesting everywhere, but doubly so when it shines in a world of solitude such as this." It was the cottagesque virtue of humility that made the log cabin of architectural interest: "even the log-hut, set in an indentation of the forest, with no works of art, save blackened stumps of trees around, figures to advantage, because it pretends to nothing."[63]

In a Cole painting the frontier log house is embellished with cottage attributes—cheerful tokens of dooryard activities, clinging vines, a rudimentary porch in the form of an overhang above the door (fig. 3.32). He paid homage to the rustic idea posited long before in William Cowper's famous wish, "Oh for a lodge in some vast wilderness"—lines that came to the mind of the lonely Gosse when he surveyed his schoolhouse in central Alabama in summer 1838: "My schoolroom is a funny little place, built wholly of round, unhewn logs, notched at the ends to receive each other, and the interstices filled with clay." A dogtrot log cabin at Rock River, Illinois, resembled an English cottage, sporting a spacious piazza (complete with hammock) and vine-covered posts.[64]

Several artists found inspiration in log houses. At Lake George about 1844, Charles Lanman made an oil sketch of "a neat log-cabin on a quiet lawn near the water, at whose threshold a couple of ragged but beautiful children were playing with a large dog, and from whose chimney ascended the blue smoke with a thousand fantastic evolutions," again evoking the English cottage. Susan Cooper eulogized "the log-cabin, such as are still seen to-day in the hills, or on the skirts of the woods: low, substantial, and rustic; when well put together, and inhabited by neat and thrifty people, they look very snug and

Figure 3.32.
Thomas Cole, Home
in the Woods, *1847,*
oil on canvas, 44×66 in.
(111.7×167.6 cm).
Reynolda House, Museum
of American Art, Winston-
Salem, North Carolina.
Gift of Barbara B.
Millhouse [1978.2.2]

comfortable, and decidedly picturesque, also." One that she knew "has as pleasant a cottage look as possible," with "a neat little yard," flowers, "balsam-firs before the door," and "hop-vines just within the fence." Another had "little windows . . . bright and clean, as though they belonged to a Dutch palace." But she was obliged to admit that some cabins "are wretched holes, full of disorder and filth." Visiting Illinois in 1843, Margaret Fuller agreed: "Sometimes they looked attractive, the little brown houses, the natural architecture of the country, in the edge of the timber," but "almost always" they displayed "slovenliness" up close. That was very much the appearance of a Virginia log house sketched by David Strother, "a specimen of rural architecture not noticed by Downing" (fig. 3.33).[65]

Not a few observers disliked log houses. Theodore Dwight complained of a certain "wretched log-hut," and Irving poked fun at the scenery at Ballston Springs, New York, where "after breakfast, every one chooses his amusement—some take a ride into the pine woods, and enjoy the varied and romantick scenery of burnt trees, post and rail fences, pine flats, potatoe patches,

and log huts" (fig. 3.34). For Timothy Dwight, these were "certainly no ornaments to the landscape." Alexander Wilson was repulsed by the sight of squatters' cabins in Kentucky, "miserable huts of human beings, lurking at the bottom of a gigantic growth of timber," but he recognized that the log house was a prime contributor to "the savage grandeur, and picturesque effect, of the scenery along the Ohio." He declared that "an engraved representation of one of their cabins would form a striking embellishment to the pages of the Port Folio, as a specimen of the *first* order of *American Architecture*."[66]

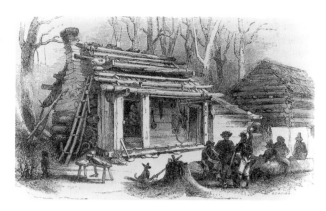

Figure 3.33.
"Thornhill's Cabin,"
Randolph County, Virginia,
seen in June 1853.
From Strother, Virginia
Illustrated, *1857, 20.*
University of Delaware
Library, Newark

Some log cabins housed an extraordinary race, the foresters. Their vulgarity was legendary, but Picturesque thinkers shared James Fenimore Cooper's admiration for their wild, uncompromising spirit in the face of advancing civilization, of which they were both avant garde and, ultimately, victims. Already in the East, C. F. Hoffman wrote, the "foresters . . . finding their ancient haunts . . . invaded by the pioneers of improvement, have fled to wilds beyond the Wisconsan." Their domain increasingly attracted the tourist; a certain "primitive swamp" was "visited, I believe, by few, except the hunters of these mountains; but it must at some day become a favorite resort with the lovers of the Picturesque."[67]

They would need to hurry, for civilization was rushing in, as Flint knew. Already in Kentucky "the whole state is studded with plantations. The buffaloes, bears, Indians, and the cane brake, the wild, and much of the naturally beautiful of the country is no more. The aged settlers look back to the period of this first settlement as a golden age. To them the earth seems to have been cursed with natural and moral degeneracy, deformity and sterility, in consequence of having been settled." On the frontier, "improvement" proceeded with amazing speed. Chastellux, who traveled widely in America in the early 1780s, commented, "Whatever mountains I have climbed, whatever forests I have traversed, whatever bye-paths I have followed, I have never travelled three miles without meeting with a new settlement." He explained the process by which the settler clears the forest, converting "immense oaks, or pines . . . the ancient lords of the territory" into "hideous skeleton[s]." For two years, crops are grown. "Then his dwelling, which at first was no better than a large hut formed by a square of the trunks of trees, placed one upon another, with the intervals filled by mud, changes into a handsome wooden house." Typically this process involved the covering of the old log house with plank

Figure 3.34.
W. J. Benjamin,
Burning Fallen Trees
in a Girdled Clearing,
1841, aquatint after a
watercolor by George
Harvey, 10⁷⁄₁₆ × 14 in.
(26.7 × 35.6 cm). Courtesy
The Winterthur Library:
Printed Book and
Periodical Collection

siding. A house built by a Scotsman who traded with the Cherokee Indians in Georgia, for example, was of log construction, with a later addition to the left; the entire dogtrot structure was eventually weatherboarded and given a porch—the owner reaching for a measure of comfort, if not quite gentility, amid hardscrabble surroundings (fig. 3.35). From 1808 to 1827 this was home

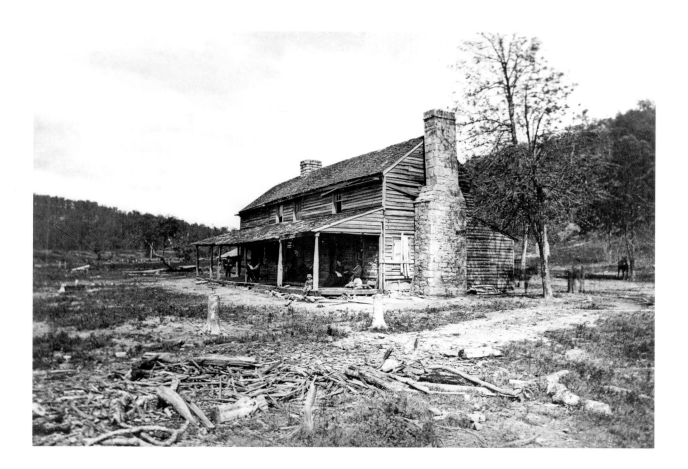

to John Ross, Cherokee chief, and it survives today as the oldest dwelling in northwest Georgia, its logs again exposed.[68]

The transformation from log cabin to frame house was a familiar one. As David S. Shields has discussed, contemporaries frequently remarked on the sharp dichotomy between the initial home erected for the purposes of mere shelter and the more imposing dwelling that took its place. The abandonment of log houses for more pretentious habitations sometimes seemed a disheartening rebuke to Picturesque values, as the humble, solid, and natural were supplanted by the gimcrack, flashy, and fashionable. Irving commented wryly in 1809 that the "Yankey farmer" is rarely satisfied with his "log hut," as *improvement* is his darling passion." In a typical case, "a huge palace of pine boards immediately springs up in the midst of the wilderness . . . so rickety and flimsy withal, that every blast gives it a fit of the ague." Irving's tale indicts the violation, even in the depths of the wilderness, of the Picturesque and of cottage values. The "mighty air castle" is never completed, funds being

Figure 3.35.
John McDonald–John Ross House, Rossville, Walker County, Georgia, begun ca. 1797. Photograph by G. K. Bernard, 1866. Library of Congress

Villa, Cottage, and Log House [159

insufficient, and the pioneers shiver in the drafty "aerial palace" while outside, ironically, "the humble log hut, which whilome nestled this *improving* family snugly within its narrow but comfortable walls, stands hard by in ignominious contrast, degraded into a cow house or pig stye."[69]

Observing the architecture of rural New York State in the 1840s, Susan Cooper outlined a progression similar to Irving's. "Next to the log-cabin, in our architectural history, comes its very opposite, the lank and lean style, the *shallow* order, which aimed at rising far above the lowly log-cottage; proud of a tall front and two stories." But in the place of snugness and comfort, the new building is a claptrap, drafty habitation. This replacement of log houses with frame dwellings proceeded inexorably. William Cobbett wrote in 1818 of prairie settlers he had known: "They began with a *shed*; then rose to a *log-house*; and next to a *frame-house*; all of their own building." An 1834 visitor to Red Sulphur Springs, Virginia, remarked, "Most of the log cabins have been exchanged for neat white cottages." In Alabama about that same time, prosperous horse-breeder James Jackson exchanged his log dwelling for a frame mansion, Forks of Cypress (fig. 5.21). The old "saddlebag" log house—two pens separated by a narrower hyphen—became quarters for his slaves (fig. 3.9). In eastern America the log school quickly became a thing of the past; an 1843 survey of the 9,368 common schools in New York State found that just 707 were of logs—compared to 7,685 frame.[70]

As log houses became rarer, a few were actually preserved for reasons of sentiment, instruction, or Picturesque aesthetics. Thomas Hulme, visiting Illinois in 1817, met up with a fellow Englishman who had settled near the Wabash. "At present his habitation is a cabin, the building of which cost only 20 dollars; this little hutch is near the spot where he is about to build his house. . . . I like [his] plan of keeping the old log-house; it reminds the grand children and their children's children of what their ancestor has done for their sake." During the log cabin frenzy of 1840, Daniel Webster told a crowd at Saratoga that he cherished the log house in which his parents had once lived in New Hampshire: "Its remains still exist. I make to it an annual visit. I carry my children to it, to teach them the hardships endured by the generations which have gone before them." At Hazelwood, on the Rock River in Illinois, in 1843, Fuller was gratified to discover a log house deliberately preserved. The owner had erected a larger dwelling, but "near it stands the log-cabin where its master lived while it was building, a very ornamental accessory." She was moved to write a poem to "this fair spot, / On which 'improvement' yet has made no blot." In an account of settlers in western New York, a writer of 1850 observed that the frontiersman in time "has put up a comfortable

block house, but has had too much reverence for his primitive dwelling to remove it."[71]

Preservation of log houses would long continue. At Portage Falls, New York, in 1872, "a rude log-cabin" that was supposed to be "an ancient Indian council-house" was moved twenty-two miles and reassembled as an ornament "upon the lawn that divides Glen-Iris Cottage from the brink of the precipice." Here it was "jealously guarded by its present owner, Mr. Letchworth, on whose lawn it stands." "In effecting this removal, great care was taken to place the building precisely as it originally stood, each stick occupying the same relative position to the others." In a Daniel Wise novel of 1876, a girl on a tour to the Saranac Lakes with her uncle complains that "'There isn't much comfort in a log-house,'" to which her elder replies, "'Not much to invite an elegant lounger, whose ideas of comfort were formed in a sumptuous home. . . . Nevertheless, a log-house is often the abode of more contentment and real happiness than are to be found in royal palaces and magnificent mansions.'"[72]

Fuller in 1843 visited Eagle's Nest, at Oregon, Illinois, "a double log cabin . . . to my eye, the model of a Western villa." About this time, log houses made their inevitable appearance in the villa books. Orson Squire Fowler commented that "the first oblong house, covered by a sloping roof, whether its walls were constructed of logs placed horizontally one above the other, in the American backwoods style, or of upright posts . . . contained the germ of the cottage, the mansion, and the villa of to-day." Design 15 in John W. Ritch's volume of 1847 was a log house to cost only $175 (his villas cost as much as $3,800). "To City Subscribers this design is new, perhaps picturesque. . . . To a sporting gentleman, desiring a modest and cheap hunting box in his own forest . . . this design is valuable." Vaux offered an upscale log house in *Villas and Cottages*, having already built one at Springside: "The style might be raised in character accordingly, without sacrificing in any way its primitive character." Such a house would be suitable for one of the upright, respectable pioneers who, it was thought, were frequently to be found in log houses on the frontier. Vaux wished that "such men would set the example of devoting some thought to the *beauty*, as well as to the *utility* of the homes they erect."[73]

A remarkable example of the log house reinterpreted as Picturesque villa was Hornby Lodge, built by Elisha Johnson, a contractor for the Genesee Valley Canal in western New York (fig. 3.36). Construction of the canal involved the blasting of a twelve-hundred-foot tunnel through a mountainside, so Johnson christened his nearby estate "Tunnel Park." The octagonal Hornby Lodge—"Mr. Johnson's castle"—stood a hundred feet above the tunnel mouth

Figure 3.36.
*Elisha Johnson,
Hornby Lodge, near
Portage Falls, Genesee,
New York, 1837–38.
Demolished 1849.
Drawing by Thomas Cole,
1839. Founders Society
Purchase, William H.
Murphy Fund. Photograph
© 2000 The Detroit
Institute of Arts*

"on the verge of the precipice, resembling an ancient chateau; its rude, gothic architecture in keeping with the wildness of the situation." Four stories tall with eighteen rooms, it was nominally "Swiss Gothic," with vergeboards and label moldings: "The ornaments of the lodge, over the doors and windows, and much of the furniture, are truly Gothic, being formed from the crookedest limbs of trees that could be found. . . . [The] saloon is in true 'log cabin' style. The trunk of [a] huge oak . . . with its shaggy bark covering, rises from the floor in the centre of the room as a pillar to support the ceiling. The furniture, chairs, sofas, &c., in this apartment are formed of the rough limbs of the forest."[74]

Hornby Lodge was truly "'a lodge' . . . in the 'wilderness.' The site selected is wild and picturesque in a high degree. . . . the grounds around [the house are] purposely kept as wild as nature herself has made them. . . . On the whole, it is a most picturesque establishment, standing alone in its rustic beauty, and looking out fearfully upon the confined deep. . . . Fortunately for visiters, as yet the scene has been thus far permitted by man to remain in a state of nature. It is therefore as wild and romantic as can be described." The villa was a celebrated destination for tourists, and Cole stayed there when he sketched the nearby gorge in August 1839. Blasting finally rendered the house uninhabitable, and it was demolished in 1849. The canal itself was

made obsolete by the railroad, so the tunnel went unfinished; today it is a sanctuary for swarms of bats.[75]

At Hornby Lodge, as at Davis's "American House," the English cottage merged with the log cabin. The same was true of the most famous and portentous log house of the nineteenth century, the fictional abode that lent its name to *Uncle Tom's Cabin*. Harriet Beecher Stowe, seeking to inspire support for abolitionism, shrewdly conflated southern slaves with the virtuous poor of English tradition:

Figure 3.37.
Title Page of Harriet Beecher Stowe, Uncle Tom's Cabin, *1852. Wood engraving by W. J. Baker after Hammatt Billings. University of Delaware Library, Newark*

> The cabin of Uncle Tom was a small log building, close adjoining to "the house," as the negro *par excellence* designates his master's dwelling. In front it had a neat garden-patch, where, every summer, strawberries, raspberries, and a variety of fruits and vegetables, flourished under careful tending. The whole front of it was covered by a large scarlet bignonia and a native multiflora rose, which, entwisting and interlacing, left scarce a vestige of the rough logs to be seen. Here, also, in summer, various brilliant annuals, such as marigolds, petunias, four-o'clocks, found an indulgent corner in which to unfold their splendors, and were the delight and pride of Aunt Chloe's heart.

This is classic cottage language, meant to garner sympathy for slaves by pleasant associations with Old English traits. Stowe's strategy was repeated on the title page in a picture by Hammatt Billings, an illustrator who was also a Boston architect (fig. 3.37). He presents a scene of cheerful domestic life at a viney dooryard, an instantly recognizable image of traditional English values. At the same time that Stowe was drawing this equation, Fowler attempted to tease the log cabin into closer conformity to the cottage ornée, writing, "Nowhere can the Virginia creeper, the ivy, the jasmine, the trumpet flower, the clematis, the climbing roses, etc., be more appropriately disposed than around the veranda, windows, and gables of a log cabin." And in an account of the typical log house of western New York, a contemporary wrote of the settler's wife, "She has a few marygolds, pinks, sweet williams, daffodills, sun flowers, hollyhocks; upon one side of the door, a hop vine, and upon the other a morning glory." With the fame of Stowe's book came replicas of Uncle Tom's Cabin, including, as alluded to previously, Vaux's double-pen "comfortable log house, covered with tiles" (ca. 1854) that housed the teamster at Springside.[76]

Figure 3.38. *C. C. Kuchel and E. Dresel*, Portland, Multnomah County, Oregon, *lithograph, 1858. I. N. Phelps Stokes Collection, Miriam and Ira D. Wallach Division of Art, Prints and Photographs, The New York Public Library, Astor, Lenox and Tilden Foundations*

From Cedar Grove to Hornby Lodge, the American residence was enormously varied and complex. It ran the gamut from small cottage to ostentatious villa, but most exciting to contemporaries was the emergence of the middle-state dwelling of the suburbs, derived from English examples and yet perfectly suited to social conditions in the United States. Tasteful homes showed regional variations, but far less than vernacular dwellings did, as owners sought to overcome parochialism and speak the widely accepted language of high culture. This is obvious in the explosive development of Pacific coast towns in the 1850s, as villa and cottage ideals shaped the development of their domestic architecture even on the furthest fringes of civilization. In 1845, two New Englanders laid out the streets of an Oregon settlement to be called Portland. Just thirteen years later it was a flourishing town, thriving on

the Gold Rush and the China trade, with more than forty buildings worth an artist's attention—including a crop of Picturesque houses (fig. 3.38). Like Americans everywhere, through architecture these homeowners hoped to advertise their status as persons of refinement and leisure. Nearly every one of their dwellings had a wide piazza in front, which leads naturally to the subject of the next chapter, the mania for the porch.[77]

4 : ON THE PIAZZA

When a starstruck Benjamin Henry Latrobe visited Mount Vernon in July 1796, he was greeted and entertained by George Washington and family on the portico. He made special note of the house, "A wooden building, painted to represent champhered rustic and sanded. . . . Along the other front is a portico supported by 8 square pillars, of good proportions and effect"—a great colonnade that looked across lawn and bluff to the wide Potomac River. Wishing to preserve a record of the remarkable encounter, Latrobe surreptitiously sketched the general's profile when he wasn't looking, and later he drew members of the Washington clan in an idealized group (fig. 4.1). The classical garb and stances of the figures suggestively connect this illustrious American porch—what Washington called "a long open Gallery in Front of my House"—with those of the ancient world. Within four years Washington was dead, and his home began a dispiriting decline; but even as a shambles, its portico endured as a nationally famous symbol of the hero and a quintessential emblem of the ideal American country house (fig. 4.2).[1]

Sixty-six summers after Latrobe's visit and some sixty miles away, in the aftermath of the bloody Civil War battle of Antietam, Union general George McClellan made a headquarters of a private home in Pleasant Valley, Maryland (fig. 4.3). In retrospect it seems a blunder that he failed to pursue the defeated rebel army as it fled south but instead allowed his men to recuperate, during which time "in the vine-clad porch the officers of the Staff whiled away many a pleasant October day." If the Mount Vernon portico suggested the classical tradition, this one was closer to the rustic cottage of England—two great intellectual sources of the American porch. Each was practical yet pleasant, each had its tempting delights.[2]

These two porches, at either end of our period, suggest how significant and enduring this form was as an element of American domestic architecture of the nineteenth century. Whatever the architectural style, the custom of enjoying what contemporaries often called the "piazza" was familiar and time-

Figure 4.1.
Benjamin Henry Latrobe,
"Sketch of a groupe for a
drawing of Mount Vernon,"
after 16 July 1796. The
Maryland Historical
Society, Baltimore

less. The porch seems simple in its structure—a sloping roof supported by posts and beams—but its very essentialness renders it complex: like some core grammatical unit it has emerged again and again in isolated places across the world, defying easy solutions as to its origins. Nor can porches readily be categorized; some are decidedly classical, others rustic, others Eastern or exotic, and some are vernacular and simple—but there are many intergrades. By the start of the period, the United States porch was already old and established, yet vital and ever changing. Without settling the question of its long-ago origins, we can point to some solutions that have been suggested and describe the stylistic streams that flowed together in "almost endless variants" to produce the porch as it was commonly met with in early nineteenth-century America.[3]

Some accounts imply that the porch of the private home is an architectural accessory virtually unique to America. This is an old idea, recalling A. J. Downing's claim that in England, "the veranda is a feature of little importance" owing to "the dampness of their climate." It is true that he added porches as needed when adapting English villa designs to American conditions, as in refashioning a plate in Francis Goodwin's book to serve as his own house at Newburgh, New York (fig. 2.30). Perhaps patriotism led him to emphasize and even overstate the exclusivity of the porch to the young nation; later, architect Henry Hudson Holly would proclaim, "The veranda in our climate has become a national feature." English immigrant Gervase Wheeler similarly wrote, "Were I asked what should be the feature most prominent in an American villa, I would say 'the veranda,' for to no portion of the house are perfect comfort and effective appearance attributable so much as to its provision for shade. In fact, this may be considered the element of the character of the design, and the 'veranda style' in this age of new nomenclature would be no unfit description of a class of house otherwise difficult to be placed in the list of recognised orders and styles."[4]

But the porch, novel and American as it sometimes seemed, had venerable antecedents in English architecture. Cottages often had small, boxlike porches around the door, and William Wordsworth reported "substantial porches" on rural dwellings of the Lake District. These traditional porches were transferred to the American colonies, as Henry H. Glassie has recognized in his study of Virginia folk housing: "The eighteenth-century porch was not dis-

Figure 4.2.
*George Washington,
Mount Vernon, Fairfax
County, Virginia, third
campaign, 1774–87.
Piazza, 1777, with
balustrade and side
porch added by Bushrod
Washington (d. 1829).
Photograph, 1850s.
Courtesy Mount Vernon
Ladies' Association*

Figure 4.3.
*Alexander Gardner,
"Scene in Pleasant Valley,
Maryland," 1862. From
Gardner's Photographic
Sketch Book of the
Civil War, 1866, pl. 24.
University of Delaware
Library, Newark*

similar in size and shape to the porches built onto seventeenth-century English houses, still to be seen in the English West Country and in Ireland." With the debut of Palladian classicism in the seventeenth century came a new source of the porch, one that enlarged its physical dimensions considerably. Two houses flanking Inigo Jones's Covent Garden church, London, by 1644

"had *porches* with balustrades, and must be among the earliest, if not the earliest, built in England," and porticos became a popular feature of the Palladian country houses that followed. In a more vernacular vein, the numerous coaching inns of London had always had multistory galleries in their courtyards, a tradition that probably reached back to medieval times and recalled Scandinavian traditions of building in wood. Several of these inns were built in the 1670s, following the Great Fire, and were recorded by nineteenth-century artists and photographers as venerable relics in the city (fig. 4.4).[5]

In the late eighteenth century, the rise of the villa as an architectural type ushered in the heyday of the English veranda-style porch. Damie Stillman has noted the "dramatic change" in the country house as builders set about "eliminating the rusticated bottom story and lowering the main rooms to ground level." This brought "increased horizontality and informality" and led to the proliferation of colonnades that functioned as covered walkways or as extensions of the main living areas. An attractive new house type was born, with the spreading veranda an essential feature of its design—a widely recognized emblem of taste, hospitality, and leisure.[6]

By the time the villa books came along after 1790, it was almost impossible to distinguish the lineages of the porches they illustrated. Cottage ornée enthusiasts, in their customary free-design spirit, gave the porch great formal diversity, achieved by borrowing from every existing tradition. Typically eclectic is T. D. W. Dearn's 1807 volume; in the course of fifteen designs, he illustrates no fewer than five porch types: rustic, cast-iron, treillage (trellis), Eastern-inspired veranda, and Grecian portico (fig. 1.22). Thomas Jefferson's Monticello, under construction at the same time and indeed resembling some of the little villas of English books, featured a similar diversity of porch forms: Doric porticos with masonry columns; the three-arched brick "piazza" facing southeast and used as a greenhouse; and the "Venetian porches" or "porticles" of green-painted lattice that the statesman must have used as sitting rooms in warm weather (fig. 2.38).[7]

The formal diversity given porches in the villa books was rooted in eclectic historical traditions in the English countryside and beyond. First, there was the vine-draped porch of the humble cottage. Second, there were the trellis and pergola of the English garden, their convergence in the porch reflecting the Picturesque desire to have plants close at hand, as witnessed by the increasing popularity of what one scholar calls the "Edenic domain" of the conservatory. These became so popular on private homes that A. W. N. Pugin was moved to ridicule them: "On one side of the house machicolated parapets, embrasures, bastions, and all the show of strong defence, and round the cor-

Figure 4.4.
Thomas H. Shepherd,
View of Black Lion
Inn, Whitefriars Street,
*ca. 1855, watercolor
on paper, 7½ × 9½ in.
(18 × 24.1 cm). Building
probably late seventeenth
century. Guildhall Library,
Corporation of London,
UK/Bridgeman Art
Library*

ner of the building a conservatory leading to the principal rooms, through which a whole company of horsemen might penetrate at one smash into the very heart of the mansion!—for who would hammer against nailed portals when he could kick his way through the greenhouse?" These conservatories often assumed the aspect of attenuated classicism, with graceful ironwork colonnades that invited echo by a delicate veranda. Third, there was the new mania for the architecture of the Orient. And finally, the modern piazza was rooted in the portico of antiquity, either in its traditional form or as reinterpreted as a rustic order in light of the Vitruvian primitive hut. Each of these traditions brought with it a host of meanings for those inclined toward the Picturesque, making the modern porch of Britain a complex thing indeed.[8]

John Nash, one of the most prolific and influential English architects in the years after 1800, did much to popularize the porch. His famous Cronkhill, Shropshire (1802), demonstrates the futility of sharply dividing the Picturesque from classicism, for here he skillfully combined both approaches. He took as his model an Italian villa as illustrated by the seventeenth-century painter Claude Lorrain, with a loggia of sandstone piers supporting arches. This loggia-porch was paired with wide eaves overhead held up by double brackets, these being a favorite Nash device; porch and bracketed eaves would

Figure 4.5.
*John Claudius Loudon,
Tew Lodge Farm,
Oxfordshire, England,
enlarged 1808–10.
Loudon,* Garden Front
of Tew Lodge, *pl. 11
from* Observations on
Laying Out Farms . . . ,
*London, 1812. Aquatint
with etching partly printed
in color with hand-coloring
added, 11¹⁵⁄₁₆ × 7½ in.
(28½ × 19 cm). Courtesy
of Hunt Institute for
Botanical Documentation,
Carnegie-Mellon
University, Pittsburgh,
Pennsylvania*

together prove enormously influential in England and later America. Quite close to the spirit in which the verandaed residence would develop in the nineteenth-century United States was Tew Lodge, Oxfordshire, designed by J. C. Loudon in 1808–11 (fig. 4.5). It exemplified the long, low, graceful style of house popularized by the early villa books, with bracketed eaves and slender columns wreathed with vines, the whole merging naturally with greenhouses and garden. Topographical prints, estate views, and travel accounts confirm that verandas like these were a common feature of the tasteful rural residence in England in the years around 1800. There were several verandaed homes along the Thames above London, including the much-illustrated Marble Hill Cottage, which received a vine-covered veranda by 1804.[9]

The eighteenth century had seen a wave of fascination with exoticism and the architecture of the East—of Islam, India, and China—a trend that legitimized and encouraged the use of the porch as a decorative feature. Its very oddity favored it. The new Indian style was typified by S. P. Cockerell's Sezincote (1803) and the metal verandas on the late-eighteenth-century ter-

race houses of Clifton and Bristol or the upscale West End of London. The word *veranda* seems to have been an Indian reformulation of the Portuguese *varanda*, balustrade or balcony; it entered the English language gradually during the eighteenth century. Primitivism was part of the veranda's exotic appeal; "the verandah is of Eastern and of very ancient origin," English architect J. B. Papworth explained, and its piquant resemblance to the tents of nomadic tribes could only have heightened its desirability for the contemporary builder. Verandas might literally be awnings: an English villa-book author of 1835 described a "veranda of wood, covered with canvass and painted green" (cf. fig. 4.6). Some placed the origins of the veranda even farther afield, Richard Brown offering a design for an "English rustic ornate cottage" with an "awning" supported by "trunks of unbarked trees, surmounted with a tasteful Chinese cornice above . . . from which those objects had their origin."[10]

This taste for Eastern verandas made its way to America (fig. 2.20). Davis's "Cottage Orné Designed for David Codwise" showed "an oriental character, from its veranda-like porch," with a tin roof painted bronze-green (fig. 1.23), and a southern homeowner of 1849 expressed his intention to build a "little Chinese verandah, 4 by 4." Philip Stockton's "marine villa" in New Jersey, illustrated by William Ranlett, had Chinese detailing. The most remarkable example of this fashion was to be seen at the home of P. T. Barnum near Bridgeport, Connecticut, which Downing decried as an ostentatious copy of "the minareted and domed residence of a Persian *Shah*" (fig. 4.7). Barnum had grown rich through his famous museum in New York, with its sensational displays of human and animal oddities—the Fejee Mermaid, a seven-year-old boy who weighed 257 pounds, a family of albinos (fig. 1.6). He wanted a country house overlooking Long Island Sound, but it needed to "be unique" and "serve as an advertisement of my Museum" to gawking passengers on the nearby railroad—the same reason that he had a turbaned employee plow a trackside field with an elephant. The irrepressible showman fell in love with Nash's Royal Pavilion, Brighton (1815–21): "It was the only specimen of Oriental architecture in England, and the style had not been introduced into America. I concluded to adopt it, and engaged a London architect to furnish me a set of drawings after the general plan of the Pavilion."[11]

American builders carried out the design while Barnum toured the United States and Cuba with General Tom Thumb. Architect Leopold Eidlitz later claimed that he himself had played the major role. "Iranistan" (the accent supposedly was on the third syllable) meant "Oriental Villa," and the place cost a staggering $150,000. Its furnishings were sumptuous, and guests trekked to the ninety-foot onion dome on top, sat on a circular divan big enough for forty-

five, and looked out at the landscape through diamond-shaped windows, each of which was a different color. The image of the house on Barnum's letterhead convinced the cautious Swedish singer Jenny Lind to sign up for an American tour with him (fig. 1.28); she assumed he must be successful and prosperous as a manager to be able to afford such a residence. Barnum commuted from Iranistan to Manhattan, but in a bankruptcy he lost the place, and just at it seemed that he would get it back in 1857, it burned.[12]

Contemporaries did not equate the veranda exclusively with India or China, however. Many recognized it as essentially southern European or Italian. An English architect explained that it originated with "those delightful awnings, spread in the streets of every Continental town," its "brilliant-coloured stripes" adding "to that gaiety in which our dwellings, both in town and country, are so deficient." It was Italy, not the East, that came to mind for P. F. Robinson when he complained in 1823 of the proliferation of verandas in England: the "ornamental chimney, the mullioned window, and thatched penthouse, are daily giving place to the Italian form, and crude verandah; features incompatible with the humble and retired residence of the cottager." In America, Ranlett was clear in placing the ultimate source of the piazza in Italy, writing that architecture in the New York region in its "prevailing form, or dominant tone, is very similar to the light, graceful and voluptuous architecture of Italy, but more particularly of the Venetian school, which is distinguished by its profusion of columns, arches, verandas, and pilasters" (fig. 3.28).[13]

Some authors tried to establish precise definitions for the various types of porches, but these efforts were overwhelmed by the perplexing diversity of porch forms and types. For New York architect John W. Ritch in 1847, a *porch* was an enclosed room before the front door, a *piazza* was long and open, a *veranda* had trellised posts. For Samuel Sloan, "The verandah differs from the porch principally in being of lighter construction, and in having greater length." Describing his Youle Cottage at Roxbury, Massachusetts, William Bailey Lang wrote variously of its *piazza*—or *porch*. At Natchez, Joseph Ingraham indiscriminately used *gallery* (a localism), *veranda*, *piazza*, and *portico*. William Brown fussily insisted that a *piazza* was "a square open space, surrounded by buildings. The term is very frequently, and very ignorantly, used to denote a walk under an arcade." But having said this, he proceeded to use

piazza and porch interchangeably and to conflate portico and veranda. For Sereno Todd, piazza was "used nearly synonymous with veranda, although the latter generally means a portion of a building that has a lean-to roof"; "there is a floor or rooms above a piazza, but never above a veranda; and a veranda is usually understood to be more secluded than a piazza." John Dix, describing a "beautiful residence" near Lowell, Massachusetts, wrote ambiguously of a "veranda, or rather piazza," and Donald G. Mitchell concluded that veranda was "but a long translation of porch." At Andalusia, the Biddle family called the huge wooden portico a piazza (fig. 5.18). Conflated terminologies even became the subject of humor, a visitor to Wolf Row at White Sulphur Springs, Virginia, reporting, "It is ornamented with two piazza's, or as a late Col. in the army used to say, it has a 'Pizarro' in front, and a 'Portorico' in the rear."[14]

By a quirk of etymology, the rarest word of their day has become the exclusive one now: porch. The decline of piazza after the end of the nineteenth

Figure 4.7.
Leopold Eidlitz, attrib., and others, Iranistan, P. T. Barnum House, Bridgeport, Connecticut, 1846–48. Burned 1857. Sarony and Major, Iranistan, an oriental ville . . . , 1852–54, lithograph, hand-colored [dimensions unknown]. Library of Congress

century was precipitous, perhaps because it savored of the detested Victorianism. By 1941, J. Frazer Smith could write of "the portico—porch—veranda—gallery—call it what you will," the once-ubiquitous word *piazza* never coming to mind.[15]

Emergence of the American Porch

So the porch and veranda of Britain derived from a whole host of sources. On one occasion, at least, a model was America itself: John Plaw reported in 1795 that Colonel John Montresor had built some "AMERICAN COTTAGES" near Faversham, Kent, their "extreme singularity" owing to the fact that "the East, West, and South aspects have a piazza round them." In these steep-roofed houses, one of which survives today, Montresor meant to commemorate his twenty-four years of military service in America (fig. 4.8). Contemporaries recognized, then, that there was a distinctively American type of porch, suited to a warm climate, that extended itself widely around several sides of the home.[16]

Where had this American porch come from? It has lately been a truism that it was, by one means or another, an import from the West Indies and even Africa. Writers have called the veranda "probably an indigenous American contribution to architectural history. . . . It may owe something to memories of Africa, and something to . . . the West Indies"; it should be seen as a "porch of West Indian origin"; "Following the example set by settlers in the West Indies, the early Southern English colonists modified the narrow stoops on their homes into spacious porches"; and there arose "an authentically New World hybrid of vernacular architecture: the Caribbean (ultimately African) tradition of the encircling porch married to the Georgian plan."[17] Not only southern porches have been linked to the Caribbean: we should "associate the West Indies with the verandah-girt houses of the Hudson Valley"; the "Quebec cottage" had a "porch or gallery, which may be an addition derived from the French colonial connection to the West Indies"; and there is likewise "a Caribbean connection" to the French houses of the Mississippi Valley.[18]

Some of these accounts are frankly multiculturalist in tone and grow increasingly self-assured, it seems, with every retelling: "The front porch . . . may be tallied as an African-derived trait. No antecedent for the front porch, as it is commonly found in the South, can be found in England or elsewhere in northern Europe. . . . For almost 250 years the southern front porch has owed its existence mainly to the adaptive genius of local carpenters acting on

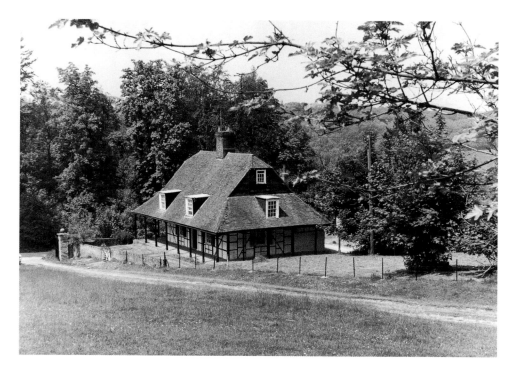

Figure 4.8.
John Montresor,
American Cottage,
Belmont Estate,
near Faversham, Kent,
England, ca. 1779–95.
Photograph courtesy
Jessie Poesch

African notions of good architectural form" (1986). "While Thomas Jefferson, George Washington, and their contemporaries were searching for a truly American architecture, African slaves and less prominent white emigrants from the West Indies were adapting the architecture of their homelands to the American milieu. The porches on classic southern buildings may have borrowed from ancient Greek porticos, but the front porch as extended living space almost surely owes a great debt to the experience in dealing with an inhospitably hot and humid climate, experience that Africans and West Indians brought with them to the American South" (1989). "The porch . . . was an African import that arrived in America in the 1730s [as] a startling innovation. . . . It proved to be one of Africa's most profound influences on American society" (1998).[19]

It is highly appealing to think of the porch as the invention of slaves, an architectural equivalent to their rich contributions in foodways or music. Realistically, however, it must be said that the matter is doubtful. As we have seen, porch traditions are always hard to disentangle, and the problem is made even more difficult by the fact that, "despite their remote proveniences, the domestic architectures of different European and African cultures came to look increasingly alike in the American tropics." There were spacious porches in Africa, the West Indies, and the American South, but to what extent were

these sensible, independent responses to warm climates? Africans had "experience in dealing with" hot weather, it is true, but so had English settlers as early as four centuries ago in sweltering Jamestown. Largely absent from the debate has been the fact that seventeenth-century Europeans brought to the South vigorous porch traditions of their own, as the galleried inns demonstrate (figs. 4.4, 4.19), and it was no great stretch for them to modify or enlarge these to suit the hot, humid American summers. Such a complicated question cannot be fully resolved here, but we should note, with Carl Lounsbury, that "from the time of settlement" in the seventeenth-century Upper South there were "small porches, squarish in plan," and "as early as the 1690s, a few buildings had completely open porches whose roofs were supported by columns or posts." A descendant of the latter was Holly Hill in Maryland, as shown in a rare painting (fig. 4.9). Here a ca. 1720s piazza was proposed (it may not have been finally built) far from the West Indies or Mississippi Valley, and there is no reason to think that it was anything other than a purely Anglo-American response to a warm climate and the abundance of wood—porches require ample timber for construction and, being highly exposed, for frequent repair.[20]

"The coincident first appearance of cottages with sitting porches throughout maritime North America, about 1740, is a delectable mystery," Roger G. Kennedy writes, but Holly Hill shows that there were porches earlier, and surely the mystery dissipates if we look to the midcentury emergence of an affluent transatlantic class of merchants and landowners and the fashionable Palladianism it embraced. Holly Hill's porch, like practically all high-style American porches of the eighteenth century, was classicizing, and it can be seen as part of a package of innovative features that swept the Anglo-American world before 1750—sash windows, Flemish-bond brickwork, hipped roofs, the modillion cornice—all of which spoke eloquently to passersby of taste and stylishness in a self-conscious mercantile world. The porch came to symbolize elegant living, especially in the country seat, and soon seemed indispensable on all kinds of houses. The term *piazza* distinguished this new porch from vernacular types; surveying early writings in Georgia, one historian writes that "from 1750 on, references to piazzas are numerous"; the word *piazza* "appears in South Carolina by the second quarter of the 18th century and slowly moves up the seaboard," gradually driving out *porch*. In 1771, artist John Singleton Copley discovered the benefits of "Peazas" during a stay in New York and wrote his half-brother in Boston, "I shall add a peazer when I return, which is much practiced here, and is very beautiful and convenient."[21]

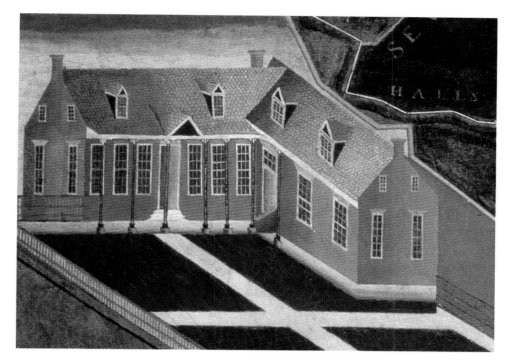

Figure 4.9.
Unknown, Holly Hill,
Samuel Harrison
Plantation, Anne
Arundel County,
Maryland, piazza
scheme, *ca. 1720, oil
on wood, 45¾ × 54⅝ in.
(108.6 × 138.4 cm).
Colonial Williamsburg
Foundation, Abby Aldrich
Rockefeller Folk Art
Museum, Williamsburg,
Virginia. Photograph
courtesy of Mr. and Mrs.
Brice Clagett*

Not all scholars have accorded the West Indies a primary role. Considering the architecture of Georgia, Frederick D. Nichols has written, "Although it has been said that the piazza came from the West Indies, its development seems to owe as much to Charleston and Savannah as to the islands"—these being cities in close communication with the ports of Britain and Europe. In "re-examining many old assumptions" about Charleston, Lounsbury writes, "Another long held but unexamined [one] is that the Charleston piazza derived from Caribbean sources. South Carolinians did construct open-sided porches or piazzas by the 1730s, but were they adopting a form developed by Caribbean settlers? . . . The question . . . begs closer scrutiny." Mills Lane described the raised, galleried houses of the late eighteenth century at Natchez; "it is not yet clear" whether these were French holdovers with ties to the West Indies, or new, purely indigenous and "spontaneous" responses to climate. Jessie Poesch and Barbara SoRelle Bacot have pointed out the similarity of Louisiana houses with galleries to Renaissance designs of Sebastiano Serlio—Palladio's older contemporary—and have noted "the region's reliance on a long Mediterranean tradition, both directly and by way of the Caribbean." For espousing this opinion, Poesch has been charged with being "determined to demonstrate the superiority of Western traditions," as if it were inconceivable that these could play the dominant role in Louisiana architecture.[22]

Palladianism, evolved in Italy, was a rational response to the hot southern climate. It was Italy, not the Indies, that came to the mind of the marquis de Chastellux when he stood before "Mr. Bannister's handsome country-house" near Petersburg, Virginia: "This house, which is really worth seeing . . . is decorated rather in the Italian, than the English or American style, having three porticos at the three principal entries, each of them supported by four columns." Chastellux's English translator added, "The Italian architecture, that of porticos in particular, is admirably adapted to all hot climates, and of course to the southern states of America." Augustus John Foster, in America in 1805–7, recognized the similarity of the weather in the two regions: "No other climate perhaps, unless it be that of the north of Italy, ha[s] the same heat as this during summer, with such excess of cold as is often experienced during winter." Palladianism, then, was a sensible approach, as the Italianate would be later; Sloan offered a verandaed "Southern Mansion" meant "to combine all the features desirable for a southern residence . . . [it] is of Italian origin" (fig. 3.18). As early as 1811–13, a visitor had observed, "As regards country houses, the Americans have for some time adopted the Italian style."[23]

A popular myth about antebellum porches is that they were almost exclusively a feature of *southern* architecture, an idea that had gained a firm hold by the 1890s: "The advent of the piazza as we know it to-day is a comparatively recent occurrence in the North. . . . The veranda and the 'piazza habit' were imported bodily, for both the veranda and the habit were evolved south of Mason and Dixon's line" (fig. 4.10). Southerners have enthusiastically promoted this notion, calling their region "the land of encircling verandahs" or giving books such titles as *Alabama: One Big Front Porch*. The ubiquity of porches in the South has led some to imply that they were rare elsewhere: "Until the mid-19th century, only in the South were dwellings—'big houses' on the great plantations, slave cabins, and everything in between—routinely equipped with sitting porches."[24]

But the porch had come to be seen as an essential emblem of the country seat years earlier—in William Birch's *Country Seats of the United States of North America* (1808), piazzas abound; of the buildings legibly illustrated, nearly all of them in the northern states, fifteen have piazzas and only two do not (fig. 3.7). There were tasteful homes with porches in the Middle Atlantic States (fig. 4.11), and Colonel Montresor's "American" cottage was listed in an 1801 bill of sale as "A House called New-York," a reference to its geographic origins—not in the West Indies, as one might think, but in verandaed eighteenth-century Hudson River houses such as Van Cortlandt Manor, Croton-on-Hudson. In a 2001 study, historian Jack Crowley emphasizes the

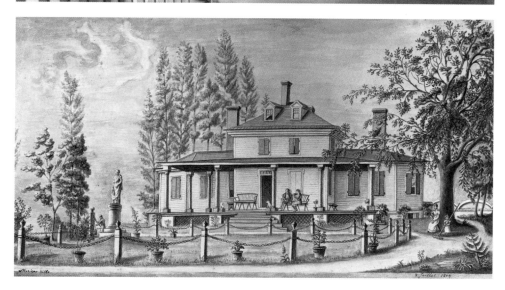

role that these Dutch houses in New York played in the development of the American porch. They were among the first to be used for "regular sociability," and they attracted widespread comment from travelers after 1750. He stresses, too, the importance of British military officers such as Montresor, who made use of the piazzas they had seen in their travels (and on army hospitals) on their own tasteful homes, including some in the vicinity of Wil-

mington, North Carolina, a flourishing early center of porch development (fig. 2.36).[25]

No one region could claim the porch as uniquely appropriate to its conditions; it was a flexible device remarkably well suited to all. New York architect William H. Willcox said that "broad, overhanging, bracketed roofs—sheltering thoroughly the walls from the weather—and pleasing piazzas" constituted a design "well adapted to our northern climate"—yes, *northern.* This almost universal applicability of the porch was one reason that Ranlett could acknowledge in the 1840s, "There is but little difference discernible now in the houses of the Northern and the Southern States." By the time of Fredrika Bremer's visit at midcentury, the piazza had become essential to the ideal American house, "a small human habitation. It is neither large or splendid; but its style of architecture is ornamental, it speaks of taste and convenience; [it displays] a veranda or piazza formed of lovely trellis-work, up which clamber vines and the fragrant clematis. . . . You see *the home* of North America; the home with its characteristic features, as it is found in all the States, as well on the heights of Massachusetts and Minnesota, as in the fragrant forest-meadows of South Carolina, and on the prairie-land of the far West."[26]

A brief survey confirms that Bremer was correct in speaking of the wide geographical range of the early-nineteenth-century porch. To start at the North, colonnades were "regarded as desirable in the climate of New England," a contemporary wrote, and piazzas were to be found rather frequently. They were common at Nahant and other seaside resorts, but the tourist Charles Dickens wrote of the New England interior, too, with "its clean white houses and their cool piazzas"; Worcester, Massachusetts, had "clean cardboard colonnades." The only surviving photograph of American soldiers departing for the Mexican War shows porches in the streets of Exeter, New Hampshire (fig. 4.12). As we have seen, Copley built porches on his Boston house, a sketch showing two of them ten feet wide with Chinese railings; such "Peazas are so cool in Sumer and in Winter break off the storms so much that I think I should not be able to like an house without." Years later, Charles Bulfinch's Colonnade (1810–12), nineteen identical dwellings on Tremont Street facing Boston Common, was a city landmark. Piazzas became more common as one entered New York State. Long Island seemed to Margaret Hall in 1827 to be "quite the garden of New York. . . . I did not see a single stone or brick house, all were of wood, and so clean and nice they looked, with little verandahs in front, and sometimes all round." The estate "Calendar" on the Hudson was "like all the country houses I have yet seen on this side of the

Figure 4.12.
*Mexican War volunteers,
Exeter, New Hampshire,
ca. 1846. Daguerreotype.
Courtesy Amon-Carter
Museum, Fort Worth,
Texas [P1979.33]*

Atlantic, of wood with a wide verandah in front." In 1828, James Fenimore Cooper described the country house of John Jay near New York: "As is usual here with most of the better sort of dwellings, it was painted, and having a comfortable and spacious piazza along its *façade*, another common practice in this climate, it is not without some pretension externally."[27]

Porches were common in upstate New York, having been, as suggested earlier, a favorite feature of country houses in Dutch colonial times. Historian Benson J. Lossing commented on the "rickety piazza or *stoop* on the river front" of the Hasbrouck House, Newburgh (1694–1712). Joshua Rowley Watson wrote, "The Country houses are in general built with wood . . . they have most of them sheds or piazza's with platforms" (fig. 4.13). Frances Wright visited the home of a Mr. Hopkinson near Geneseo in 1819: "Entering the house, the shade of its broad piazzas and Venetian blinds, through which the evening breeze played sweetly, refreshed us much after the fatigues and heats of the day." Basil Hall traveled extensively upstate in 1827: "In the more cleared and longer settled parts . . . we saw many detached houses, which might almost be called villas, very neatly got up, with rows of wooden colum[n]s in front, shaded by trees and tall shrubs running round and across the garden"—a succinct description of the tasteful country house everywhere in the Anglo-American world. Ascending the Hudson toward Albany in 1837

Figure 4.13.
*Joshua Rowley Watson,
"Cottages in the Northern
parts of [the] State of
New York," 31 July 1816.
© Collection of The New-
York Historical Society
[70805]*

at the heyday of the Greek Revival, the ever-caustic Frederick Marryat complained, "The country seats, which fringe the whole line of shore, all are built in the same, and very bad, style. Every house or tenement, be it a palace or a cottage, has its porticos and pillars—a string of petty Parthenons which tire you by their uniformity and pretence." Even in Canada, piazzas were to be seen. In New Market in 1827, Hall visited a cottage with the desired attributes of taste: "A most agreeable house, surrounded by a large flower garden, intersected in all directions by well-shaded gravel and turf walks. In one of the rooms stood a piano-forte, and plenty of comfortable and handsome furniture, chiefly of the bird's eye maple. From this apartment a single step placed us in a verandah, as wide as the room itself, bounded in front and at both ends by trellis work . . . thickly twined with hop vines."[28]

Moving south, we find that Cutler saw many porches at Bergentown, New Jersey, in 1787: "The houses are mostly built with stone, and in the Dutch style. . . . Every house has a piazza in front, and some of them extended round the whole house." Frances Wright observed "neat white dwellings . . . shaded by projecting piazzas" in New Jersey and on Long Island in 1818. Piazzas were ubiquitous along the Schuylkill above Philadelphia; Belmont, "like all the Country houses, has a Piazza in front." At Latrobe's Sedgeley "there [was] a Piazza on two sides," as later at Eaglesfield (fig. 3.17).[29]

Of course the piazza was most common in the South, where it was subject to distinctive localisms, so that the side-piazza houses of Charleston differed from inland homes that sometimes had Palladian double porches (fig. 4.14) or the hipped-roof cottages with encircling galleries of French New Orleans. Whatever its form, the porch came to be seen early on as symbolic of a special southern regional culture. Bremer wrote upon her departure, "Farewell thou beautiful, flowery South, the garden of North America! Thou hast warmed and refreshed me deliciously! farewell to thy piazzas covered with blossoming creepers shading pale beauties." Dickens visited a "planter's house

Figure 4.14.
*Mount Nebo, near
Milledgeville, Georgia,
1817–20. Demolished.
Photograph, 1934.
HABS, Library of
Congress*

. . . an airy rustic dwelling" across the James River from Richmond in 1842: "The day was very warm, but the blinds being all closed, and the windows and doors set wide open, a shady coolness rustled through the rooms, which was exquisitely refreshing after the glare and heat without. Before the windows was an open piazza, where, in what they call the hot weather — whatever that may be — they sling hammocks, and drink and doze luxuriously." "In these latitudes" the favored piazza drinks were "mounds of ices and . . . bowls of mint-julep and sherry-cobbler." Still further south, Edenton, North Carolina, was described in the 1780s as "consisting of not more than 100 framed houses, all standing apart and surrounded with galleries or piazzas." Hall visited South Carolina in 1828: "What gives Charleston its peculiar character . . . is the verandah, or piazza, which embraces most of the houses on their southern side, and frequently, also, on those which face the east and west [fig. 4.15]. These are not clumsily put on, but constructed in a light Oriental style, extending from the ground to the very top, so that the rooms on each story enjoy the advantage of a shady, open walk."[30]

Ingraham, an immigrant from the North, described the piazzas he encountered in the Old Southwest before 1835. A certain "dwelling, like most in Mississippi, was a long, wooden, cottage-like edifice, with a long piazza, or gallery, projecting from the roof, and extending along the front and rear of the building." Arriving in Mobile in May 1838, English naturalist Philip Henry

Figure 4.15.
South Battery, Charleston,
South Carolina. Left to
right, Colonel John Ashe
House, ca. 1782, piazza
three stories in 1850;
James E. Spear House,
ca. 1860; George Cook
House, 1860; Edward C.
Jones, Colonel J. A. S. Ashe
House, ca. 1853. Photo-
graph by Jack Boucher.
HABS, Library of Congress

Gosse "was struck by an unusual character, a certain something of a foreign appearance, which was forcibly evident" and which owed in part "to the almost universality of open verandas, beneath which the inhabitants were sitting to enjoy the cool breath of evening."[31]

West of the Ohio, Federal and Greek Revival houses had porches of a sophistication to equal those in longer-settled regions, evidence of the rapid spread of taste throughout the nation. Writing of her own Mohawk Cottage near Cincinnati, Frances Trollope did not fail to mention its porch, a common feature of rural residences in the developing West: "Our cottage had an ample piazza, (a luxury almost universal in the country houses of America), which, shaded by a group of acacias, made a delightful sitting-room." At the far fringe of European settlement were the ubiquitous porches of California, which have proven hard to classify; are they "a hybrid of American and Hispanic design ideas," as long thought, or fundamentally Mexican, as recently argued? Their overall form suggests Mexico, but the detailing of the posts is American, lacking the customary Hispanic *zapata*, or bracketlike capital. Here was a mingling of two Euro-American architectural streams, English and Spanish, in both of which the porch played an important role. Once again the porch, as simple as it may appear, proves surprisingly complex and resistant to easy analysis.[32]

From Public to Private

How did the porch come to be so widespread in the nineteenth century? This owed in part to its great usefulness but also to its pleasing connotations of taste and pleasure—of relaxation, luxury, and ample time for talk and entertaining. The porch of the private home must be seen in the context of public colonnades and porticos, which helped the form gain wide appeal. In eighteenth-century England, these were familiar sights wherever crowds congregated. Town marketplaces traditionally had piazzas; in London there were long Doric colonnades and arcades in granite at Hungerford Market (1831–33); and Covent Garden Market (1829–30) had no fewer than 116 columns. English theaters had porticos before the door. The strongest suggestions of pleasure were at English public gardens such as Vauxhall, with its series of dining colonnades, one of them five hundred feet long (fig. 2.21). It was understood that the association of the portico with the congregation of fashionable pleasure-seekers had obtained ever since Roman times: "The *portico of Pompey*, annexed to his theatre, was supported by 100 marble columns; it opened on both sides into groves of plane trees, and was refreshed by fountains and streams, and in summer time it was the favourite resort of the young, the gay, and the gallant," just like Vauxhall. Colonnades were popular in France as well—the Palais Royal, Paris, being a splendid example—where they seem to have been enjoyed not just for their utility or classical allusions but for their Picturesque aesthetics, the flicker of light and shade down their long treelike rows.[33]

The tradition of the marketplace portico was transferred to eighteenth-century America. "For beef, veal and mutton the big market of Philadelphia is only second to that of London-hall. . . . It is built of brick with three hundred posts, in such a way that air circulates freely in all directions." More fashionable were the indoor "Arcade" shopping complexes of the 1820s, based on Samuel Ware's Burlington Arcade, London (1815–19). John Haviland's Arcades in Philadelphia (1825–28) and New York (1826–27) were imitated in the Providence Arcade with its two seventy-four-foot-wide "Colonades" each composed of "six Grecin Ionic columns of 3 feet diameter," twenty-one feet high with Ilissus Ionic capitals (fig. 4.16). Inside this attractive building, which narrowly escaped demolition in 1944, shops face each other across an enclosed yet streetlike space that hearkens back to ancient Roman markets and forward to the modern indoor mall (fig. 4.17). Exchanges in Europe often had porticos, so Latrobe included them in his first design for the Baltimore

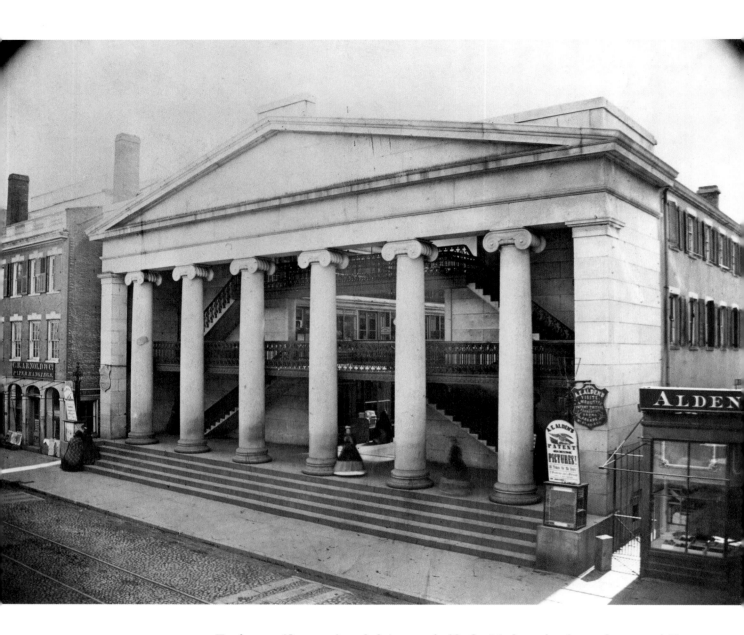

Figure 4.16.
*James C. Bucklin and
Russell Warren, Providence
Arcade, Rhode Island,
1828. Photograph, ca.
1865. © 2001 The Rhode
Island Historical Society.
All rights reserved*

Exchange (fig. 1.29): at left is seen half of a U-shaped colonnade around Exchange Walk; toward the right is an interior courtyard similarly colonnaded; and the Gay Street front of the building was to have a long piazza with some thirty columns. All of these porches were to employ the order of the Tower of the Winds, Athens.[34]

In associating the porch with convivial public life and pleasure, inns and resorts played a leading role and must be viewed as crucial generators of taste (fig. 4.18). In the history of societal conventions, the public amenities of one

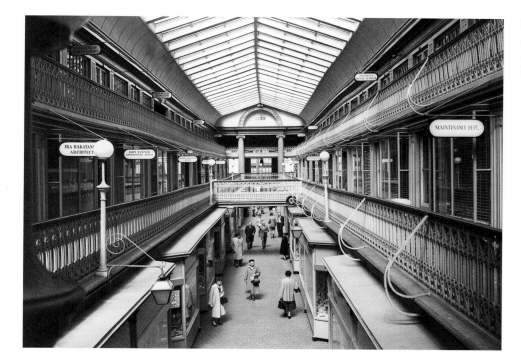

Figure 4.17.
*Providence Arcade interior.
Photograph, 1958. HABS,
Library of Congress*

generation frequently become the private ones of the next; moving pictures were a public form of entertainment in the 1920s, but television made such pictures private and domestic by the 1950s, and more recently the computer has undergone a similar shift. In a somewhat analogous way, the piazzas of inns and other public places were increasingly transferred to private dwellings in the nineteenth century as the porch caught on widely. "What shall we say . . . of inn porches?" asked Mitchell. "Does anybody doubt their fitness?" Inns and hotels incorporated piazzas that took advantage of the view and sheltered arriving travelers from the rain but at the same time communicated hospitality and pleasure. Chastellux's translator observed in the 1780s that, in America, "Every tavern or inn is provided with a covered portico for the convenience of its guests." As we have seen, much the same was true in Britain, where, with taste and travel increasingly linked, innkeepers thrived on tourists seeking a retreat from the cities and wishing to enjoy Picturesque scenes. Humphry Repton wrote in 1816 of the Reindeer Tavern, Essex, which was "appropriated to the Sunday visits of those who made holiday, fancying they enjoyed solitude in a forest, amidst the crowd of *'felicity hunters,'* who came here to forget the cares of London."[35]

This custom of weekend visits to country inns was easily transported overseas. In 1780, Chastellux stayed at Benezet's at Bristol, Pennsylvania: "His inn

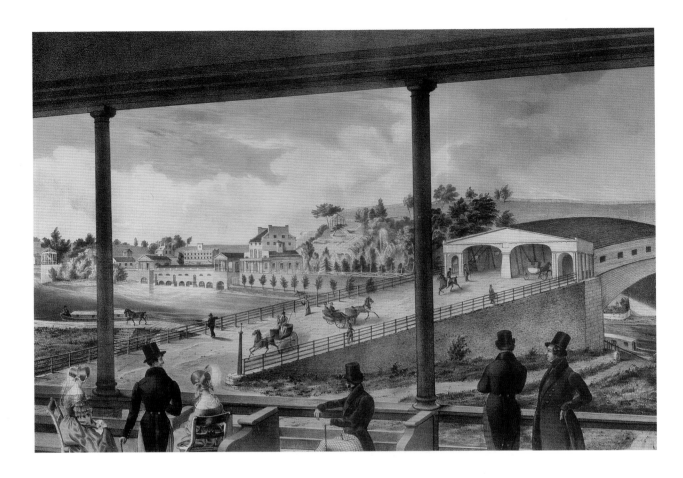

Figure 4.18.
John T. Bowen, The
View of Fairmount
and the Waterworks . . .
Taken from the Veranda
of Harding's Hotel,
Schuylkill, *Philadelphia,
1838, colored lithograph,
15 × 21¾ in. (38 × 55.5
cm). At right, Lewis
Wernwag and Robert
Mills, Colossus Bridge,
1812, burned 1838. At left,
Fairmount Waterworks.
The Historical Society
of Pennsylvania
[Bc 88 B7681]*

is handsome, the windows look upon the Delaware, and the view from them is superb; for this river is nearly a mile broad, and flows through a very delightful country." The translator of his book had stayed at the same place, commenting, "This landlord, like his [English] brethren at Richmond and Shooter's-hill, makes his guests pay for the prospect, and he has the same temptations; the ride from Philadelphia here on parties of pleasure being very common in summer." Cutler described Benezet's in July 1787: it "has a most delightful piazza on the side next the river, which extends the whole length of the house, and is entirely over the water, affording a most beautiful prospect." He also enjoyed the view at Samuel Vaughan's inn at Gray's Ferry: "We went into a piazza one story high, next the street, very pleasant, as it is in full view of the river. Here we breakfasted." The owner of a tavern nearby added a two-story porch to keep up with evolving fashion; this was always one of the most common nineteenth-century alterations to eighteenth-century buildings (fig. 2.22). Some of these American inns had galleried courtyards that

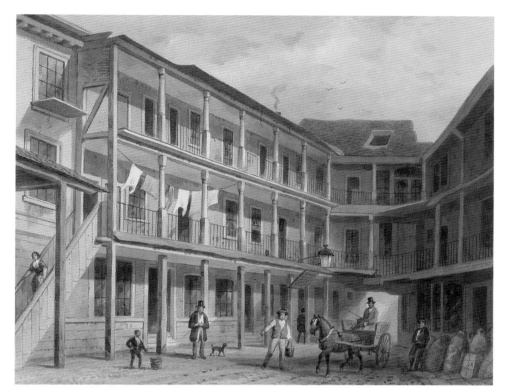

Figure 4.19.
Thomas Hosmer Shepherd,
View of Blue Boar Inn,
no. 30 Aldgate, *ca. 1850,*
watercolor on paper,
8 × 9½ in. (20.3 × 24.4 cm).
Building probably late
seventeenth century.
Guildhall Library,
Corporation of London,
UK/Bridgeman Art
Library

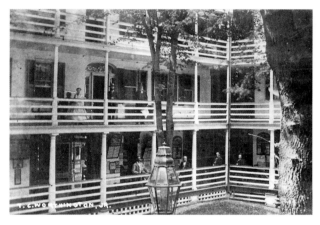

Figure 4.20. *Fountain Inn, Baltimore, ca. 1800. Demolished.*
Photograph by T. C. Worthington. The Maryland Historical
Society, Baltimore

were derived not from the architecture of the Caribbean, as some might suppose, but from seventeenth- and eighteenth-century London (figs. 4.19, 4.20).[36]

Cooper would write in commendation of his town of "Templeton," "Its inns were of respectable size, well piazzaed." Such piazzas were recognized symbols of hospitality. Travelers near White Sulphur Springs in the 1830s stopped at a tavern: "We entered the white pailings through a wicket gate,

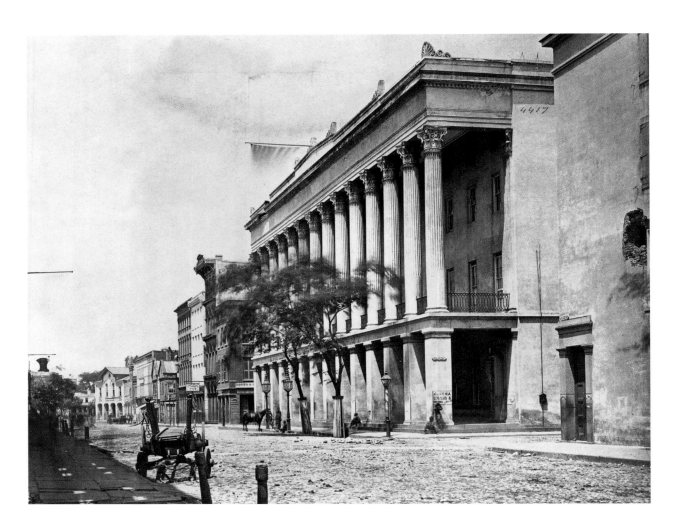

Figure 4.21.
Charles F. Reichardt,
Charleston Hotel, 1837–39.
Demolished 1960.
Photograph, ca. 1865.
Library of Congress

and were met on the piazza by Mr. Crow, quite portly, and good natured in appearance. . . . He promised us all we required, and brought us a frozen imperial to refresh us." As advertisements of welcome and of luxurious appointment, hotel porches would come to vie with one another for sheer size. Fourteen Choragic Monument columns marched across the colonnade of the Charleston Hotel (fig. 4.21), and James Dakin's Rockaway Marine Pavilion, Long Island (1833–34), had a 230-foot colonnaded front of square Doric piers. Neither building survives today. But even small towns had inn porches that promised sumptuous welcome: in *Walden,* Thoreau took aim at the Middlesex House in his native Concord, its "almost innumerable apartments" and "huge halls" being "extravagantly large for their inhabitants," the whole a needlessly grandiose backdrop to the occasional timid mice that "come creeping out over the piazza" (fig. 4.22).[37]

The piazzas of oceanfront inns offered unique pleasures. At Cape May, New Jersey, in July 1834, John Fanning Watson remarked that "all the boarding houses have galleries & Piazzas." There were novelties to be experienced at the shore— ladies venturing into the waves "timid & delighted & shouting," and the painful discovery of the "sun scald," a "new desease to us." At the hotel, "some pitch Quoits," others "walk the Piazza—& converse" or play a porch game of trying to walk blindfolded to an assigned point. At Tucker's Beach in 1823, he recorded a curious porch custom: "When you enter this piazza you are struck with the display of *names* cut into the boards of the house by the summer visiters—& probably 100 clams are nailed up, of large size, having names inscribed on them—I see many Philad[elphia] names—and have cut my name as at Horner's over the Door." Bremer reported her own experience on a porch at Cape May in August 1850: "When it gets dark . . . I walk backwards and forwards in the upper piazza, which runs round our hotel—the Columbia House—and contemplate the glorious spectacle produced by the lightning."[38]

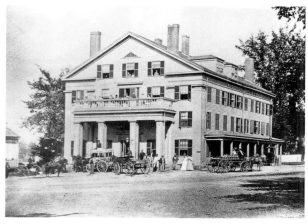

Figure 4.22. *Middlesex Hotel, Concord, Massachusetts, as rebuilt 1846. Demolished 1900. Photograph, ca. 1870. Courtesy Concord Free Public Library*

A good example of a hotel as generator of taste may be found in the development of the ironwork balconies of New Orleans. In Regency England, green was "the colour used to adorn the ironwork of newly fashionable verandahs and conservatories," a habit that may have owed something to "the Neo-Classical predilection for a 'bronzed' effect." This taste was imported to America, as could be seen in James and Charles Dakin's Verandah Hotel, New Orleans (1836–39, burned 1855), with its two-story Corinthian veranda of cast iron stretching around two street façades. A newspaper announced, "The Verandah will be constructed on iron columns and have beautiful trellis work—the whole painted green." One historian has identified this veranda as "a prototype of the iron balconies New Orleans is noted for, that is, those which cover the entire sidewalk and are roofed over. . . . Of course, there had been iron balconies for years in the French Quarter, but . . . there were none earlier than this one which covered the sidewalk completely and was supported from below by iron columns." It likely was "the inspiration for the rash of iron gallery construction" on private homes throughout the city after 1850, which has given the place its unforgettable appearance today.[39]

A famed concentration of inn piazzas was to be found at Saratoga Springs, New York. Congress Hall was "200 feet in length. . . . In front of the hall is a

spacious piazza, extending the whole length of the building, 20 feet in width, with a canopy from the roof, supported by 17 massy columns, each of which is gracefully intwined with woodbine. There is also a back piazza" (fig. 4.23). On these porches the five hundred guests in their best clothes would "pace to and fro for an hour" following tea, and "young ladies walk[ed] arm in arm under the portico." Basil Hall counted his steps as he strolled along: eighty paces. Not far away, the United States Hotel had "broad piazzas" overlooking "a row of forest trees extending the whole length of the building"; the Pavilion had a "handsome portico in front, sustained by delicate colonnades"; and Union Hall was "ornamented in front by 10 columns, which rise to nearly the height of the building, and support the roof of a spacious piazza." At nearby Ballston Springs, the largest hotel was Sans Souci (1803), with a 156-foot piazza. The long-colonnade format of these springs hotels was replicated in a spectacular setting at the Catskill Mountain House, one of the great tourist destinations of the age (fig. 4.24).[40]

The mineral springs of western Virginia deserve special attention for their numerous porches. Six thousand travelers visited them every summer in the 1830s, living in colonnaded hotels or in rows of cabins with verandas. At Warm Springs, an arriving guest reported, "We were weighed in the patent scale that stands in the colonnade, which runs the whole length of the main building here, somewhat after the fashion of the hotels at Saratoga." At Hot Springs, "The piazzas of the hotels were filled with invalids." Sweet Springs—

Figure 4.24.
*Catskill Mountain House,
Pine Orchard, Greene
County, New York, begun
1824–25, piazza rebuilt
1844–45. Ruins burned
1963. John Rubens,*
Catskill Mountain-
House, *1830, colored
aquatint, 16⁷⁄₁₆ × 13¼ in.
(41.7 × 33.6 cm). Print
Collection, Miriam and
Ira D. Wallach Division
of Art, Prints and
Photographs, The New
York Public Library,
Astor, Lenox and Tilden
Foundations* [Deak 376]

hailed in 1839 as "among the most ancient and celebrated watering places in the United States"—consisted of "a large green area, having on each side rows of white rustic-looking cottages. . . . The spring is under the piazza of the bath house." At Blue Sulphur, "In front of the main brick building, is a handsome three storied piazza, forming a fine promenade, before which you have an extensive level plain, laid out in walks . . . and ornamented with groves of the sugar maple, and several rows of pretty cabins."[41]

Figure 4.25.
White Sulphur Springs,
Greenbrier County, (West)
Virginia. Edward Beyer,
White Sulphur Springs,
Virginia, *1853, oil*
on canvas, 26 × 50 in.
(66 × 127 cm). Courtesy
The Greenbrier

White Sulphur was the most famous of the Virginia springs (fig. 4.25). There were cabins here as early as 1786, a hotel was built in 1808, and growth was rapid after 1818. Six hundred guests could be accommodated by the late 1830s in this prototype of the new suburban layout: "At present each family or party reside in a separate cabin, being lords of their own castles for the time being, which is perhaps the most preferable mode of living." Cabins were arranged in rows, named Paradise, Spring, Alabama, Georgia, Carolina, Virginia, and Wolf; Colonnade Row was added in 1849. A visitor reported in the late 1830s, "A new row of six ornamental veranda cottages has lately been erected on a line with Paradise Row." Wolf Row was "reserved for bachelors, amateurs and philosophers" and was adorned with hunting trophies. A female visitor reported frequent use of a piazza: "We are four in our cabin; C. and I. occupying one room, and having our front room to receive visitors, and our piazza for our music saloon. . . . After breakfast this morning, we returned to our cabins, and remained on the piazza chatting with our neighbours, and watching the departure of the gentlemen for the hunt."[42]

It has become a truism that the portico "spread through the South after various Southern planters had passed through Charlottesville on their way to spend the summer holidays in the cool mountains among the spas of Virginia. After they had seen the colonnades and the porticos at the University [of Virginia] they went home and added such to their own houses." Probably this

places too much importance on the university. It is not unlikely, however, that the spas themselves exerted an influence on southern domestic design; a summer spent living in a verandaed cottage could well have convinced a planter to build a porch on his home.[43]

A Piazzaed University

At the University of Virginia, piazzas form an integral part of the design (fig. 4.26). The modern fame of this complex owes mostly to twentieth-century factors: the democratic apotheosis of Jefferson as genius and polymath, our partiality for leafy suburbanism, the centrality of universities in today's cultural pantheon, the eloquence and enthusiasm of a series of "UVA" scholars from Fiske Kimball on, and the excellent state of preservation of the school when so many contemporaneous places have been grossly altered or destroyed. In recent decades, preservationists have tried to bring us ever closer to the precise forms of Jefferson's conception. The attempted re-creation of his interior of the Rotunda (as we saw, it burned in 1895) was highly controversial, involving as it did the destruction of the handsome McKim, Mead and White room that had replaced it. A painstaking, four-decade campaign is gradually restoring the pavilions to something like their original state.

No history of this period would be complete without attention to Jefferson's university, which the American Institute of Architects has declared "the proudest achievement of American architecture" of the past two hundred years and "the most important architectural ensemble in America." This is one of the few monuments of the nineteenth-century United States that has achieved an international reputation; in 1987, UNESCO named the Lawn a World Heritage Site. Such boundless adulation makes it difficult to evaluate the school properly, being far out of proportion to its perceived importance at the time, when it lay far from the major centers of architectural and cultural influence. As famous as the university has become today, it is surprising to realize that no photograph seems to have been taken of it until 1868 (many schools were photographed in the 1850s), and it must be admitted that "until the 1890s, it had little discernible effect on the planning of other colleges," with William Nichols's University of Alabama (1828) a rare exception.[44]

Jefferson's almost forty-year dream of founding a public university in Virginia was at last made possible by legislative action in 1816. In spring of the following year, he wrote to William Thornton and Latrobe for help with the design, and both offered aid. Latrobe's role was especially important, though

Figure 4.26.
Thomas Jefferson, with Benjamin Henry Latrobe, University of Virginia, Charlottesville. Lawn, 1817–22; Rotunda, 1822–26. Extending left of Rotunda is Robert Mills, Annex, 1851–53, burned 1895. Foreground, Jefferson, Anatomical Theater, 1826–27, demolished 1939. E. Sachse & Co., View of the University of Virginia, Charlottesville and Monticello Taken from Lewis Mountain, 1856, lithograph, 17¾ × 26⅝ in. (45.1 × 67.3 cm). Albert and Shirley Small Special Collections Library, University of Virginia

difficult to evaluate, given that the drawings he sent are lost; but it seems from his letter of 24 July 1817 that to him should go the credit for monumental pavilions that break forward of the piazzas and for the Rotunda. Jefferson often stated that the ten pavilions, no two alike, were to provide chaste classical models for instructing students about architecture, but they were also aimed directly at an English audience, for he explicitly intended to create an impressive architectural statement (complete with capitals imported at great expense from Carrara, Italy) that would entice Oxford and Cambridge graduates to teach on his faculty. Perhaps he hoped for the kind of attention that William Wilkins's neo-Greek design for Downing College, Cambridge, had received (1804), dramatically raising the profile of universities as architectural showpieces. "By the distinguished scale of its structure and preparation" he meant to lure the best foreign minds; "Had we built a barn for a college, and log huts for accommodations, should we ever have had the assurance to propose to an European professor of that character to come to it?" Six of his seven instructors were foreign-born, mostly English. The Latrobe and Jefferson Rotunda recalls the long-standing English fondness for domes, such as the garden Rotunda at Chiswick that Jefferson admired as early as the 1770s;

the Rotunda of Vauxhall Gardens (fig. 2.21); John Plaw's "Circular House" (fig. 4.27), illustrated in *Rural Architecture* (1802); or James Wyatt's great dome inside the Pantheon, London (1769–72).[45]

Jefferson's school is the last work of an elderly amateur architect self-trained in the third and fourth quarters of the eighteenth century—by a number of years he is the earliest-born American architect featured in the present book, two decades older than Bulfinch, even—so the *retardataire* Palladianism of its detailing should not surprise us. It looks back to a bygone Neoclassical movement and ignores the

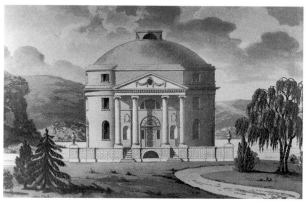

Figure 4.27.
John Plaw, "The Circular House, on the great Island, in the Lake of Windandermere." From Plaw, Rural Architecture, *1796.* University of Delaware Library, Newark

Greek Revival that produced Strickland's Second Bank at exactly the same time (fig. 5.6). And yet the results were not dissimilar to the scenographic, piazzaed urbanism that was transforming British cities during the Regency. Nash in 1811 had proposed Regent's Park with neoclassical villas and terraces in and about an open green-space, and that celebrated park was under construction simultaneously with Jefferson's much smaller college. Both are strongly Romanist and show a marked stylophily; both integrate architecture with nature and stress the Picturesque idea of variety within unity. The way Chester Terrace, in particular, had a series of "pavilion-like houses which project" beyond the long arcades of its nearly one-thousand-foot front is suggestive of the Lawn, which it postdates. Robert Mills found the university urbanistic: "The foliage of the trees fronting the buildings on the lawn, and the distance they are apart, separate them to the eye, and associate the idea of a city street, decorated according to individual taste." And like the university, Regent's Park had a focal point in a copy of the Pantheon—in this case, Decimus Burton's Greek Revival Colosseum (1824–27).[46]

The plan of the university was less distinctive than is sometimes supposed; already in 1805, South Carolina College had "two ranges" and, "as occasion may require, other buildings, such as the dining hall and professors houses are expected to be built fronting each other, and ranging in a line with the first mentioned long buildings." As early as May 1802, Mills had submitted a scheme for the inaugural building of that college, which featured an arcade at the rear allowing a dry passage from room to room. These prototypes at an American college have not dissuaded Jeffersonian historians from looking farther afield, however, and over the years an extraordinary number of sources have been proposed for his university: Palladian palazzos; ancient Greek academies; the French royal retreat at Marly-le-Roi; French and English hospitals

(it strongly resembles some of the latter); Palace Green in Williamsburg; La-trobe's hospital and school plans; Ramée's Union College, Schenectady, New York; Hôtel de Salm, Paris; Ledoux's saltworks; a Carthusian monastery in Italy; and the writings of Henry Home, Lord Kames. In this context, perhaps worth reexamining is the university's relationship to the Virginia springs, seventy-five miles away. Charlottesville lay on the main road from the north and so was bound up with the springs culture. Jefferson himself visited them, including White Sulphur; his favorite cabin at Warm Springs was pointed out to visitors in the 1830s. Notice how descriptions of the "hollow square" arrangement of White Sulphur with its "ranges," including one "entirely of brick and extend[ing] for several hundred yards" suggests a similarity to the University of Virginia:

> The grounds are laid out very prettily with gravel walks intersecting the green lawns, and the area is bordered on all sides by rows of neat cabins, some of them of a very attractive appearance. The whole looks like a well laid out little town. . . . On the front square stands a large frame building containing the dining room, the public room, and the offices. A portico runs the whole length of this edifice, forming a fine promenade in wet weather. . . . Immediately in front of these, on the acclivity of the hill, which overlooks the plain, and sweeping round before you, is Alabama Row, which extends as far as the large centre building, where it is joined by Par-adise Row, which has a similar range. The cabins which form these ranges are all built of brick, with little piazzas in front.[47]

Ordinarily the springs are considered to postdate the university, several of whose workmen they shared. This account is from the 1830s, long after the University was completed. But the distinctive arrangement followed by the various springs may have already been established by the time Jefferson began tentatively planning his campus in 1805, writing, "A plain small house for the school & lodging of each professor is best. These connected by covered ways out of which the rooms of the students should open would be best. These may then be built only as they shall be wanting. in fact an University should not be an house but a village." In 1810 he again called for "a small and separate lodge for each separate professorship, with only a hall below for his class, and two chambers above for himself; joining these lodges by barracks for a certain portion of the students opening into a covered way to give a dry communication between all the schools the whole of these arranged around an open square of grass and trees would make it, what it should be in fact, an academical village, instead of a large & common den of noise, of filth, & of

fetid air. . . . These separate buildings too might be erected successively & occasionally." Healthfulness was a major factor in Jefferson's thinking, as he envisioned Central College as replacing the venerable College of William and Mary, located in the fever-prone Tidewater. All the problems Jefferson foresaw in the university were already being addressed by the springs, which had evolved to handle large crowds every summer and grew organically to meet increased demand. Buildings were small and separate, which fostered a familial atmosphere and kept healthy and sick patrons apart; connecting piazzas provided a dry passageway back and forth, enclosed a villagelike green, and looked out at the scenic mountain landscape of western Virginia; a large central building provided focus and a common meeting place; new rows were added as needed. Whether the springs derived from the university, as is now assumed, or whether Jefferson derived the university partly from them, will depend on clarification of the sketchy chronology of those mountain resorts.[48]

The school soon outgrew Jefferson's conception of it—as indeed it has continued to do, so that today the original dormitory rooms on the Lawn house only a minute fraction of the university's students (about fifty of eighteen thousand). "The great increase of students to the University and the want of suitable rooms for their exercises" led Mills to build a 150-foot-long Annex onto the Rotunda in 1851–53, as shown prominently in Edward Sachse's famous lithograph that views the grounds from the side in order to showcase this addition (figs. 4.28 and 4.26). It was the last commission for an architect who had started his career as a twenty-one-year-old apprentice at Monticello in 1802–3, bringing our half-century full circle. The Annex has been much maligned but was a sensitive and well-proportioned attempt to harmonize with Jefferson's fabric while providing classroom space and a lecture hall that could seat twelve hundred. Faulty electrical wiring in the ceiling above the hall caused the 1895 fire that destroyed both Annex and Rotunda in spite of a math professor's reckless expedient of hurling dynamite down onto the portico linking the two buildings (fig. 4.29). The Annex itself was unfairly blamed for the conflagration, its reputation mud ever since. It will never be rebuilt, of course, but great attention is currently being lavished on the Jeffersonian portions of the school, including the extensive piazzas. Two water-damaged piazza columns were experimentally restored in 1997–99: thick layers of white paint and the stucco underneath were removed from the brick core; then new stucco was applied using the original recipe. The resulting stone-colored shafts give a quite different visual look from the long-familiar whitewash and promise gradually to transform the appearance of the famous Lawn.[49]

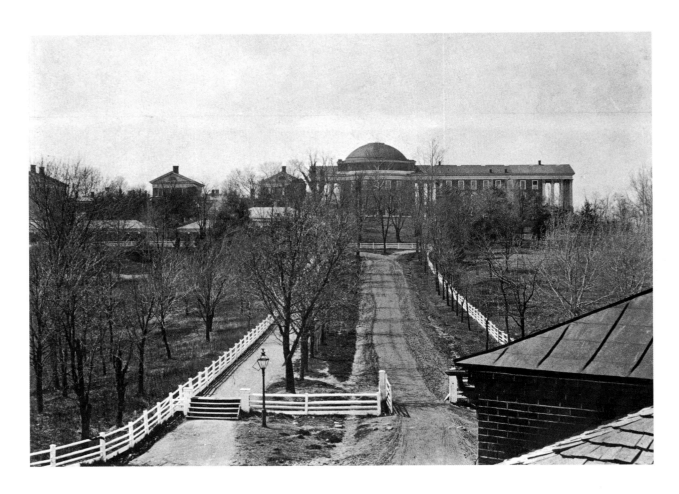

Figure 4.28.
*Pavilions, Rotunda, and
Annex from Temperance
Hall (built 1855–56,
demolished 1913),
University of Virginia.
Photograph, ca. 1890.
Holsinger Studio Collection,
Special Collections Division,
University of Virginia
Library*

Shelter and Shade

A dystopian country house forms the centerpiece of Cooper's novel *Home
as Found* (1838): "The Wigwam had none of the more familiar features of a
modern American dwelling of its class. There was not a column about it,
whether Grecian, Roman, or Egyptian; no Venetian blinds; no veranda or pi-
azza; no outside paint, nor gay blending of colors." Here the author summons
up a familiar type of "modern American dwelling" in the countryside, with
the porch a key feature. This sort of place had been developing for genera-
tions, and notwithstanding the regional differences we often choose to stress,
there was great uniformity in intention and design. From Maine to Alabama
there existed a common mental image of what a country house should be, and
a porch was fundamental to it. As Ranlett argued in 1847, "Verandas, piazzas
and porches are very expressive of purpose, and a dwelling should always

have one or more of them." They served many functions: shelter, a locus for work and activities both private and social, and as aesthetic features of considerable subtlety. Mitchell summarized some of these various uses in an 1867 "Talk about Porches": "The least office of a porch is that of affording protection against the rain-beat and the sun-beat. It is an interpreter of character; it humanizes bald walls and windows; it emphasizes architectural tone; it gives hint of hospitality; it is a hand stretched out . . . from the world within to the world without."[50]

On both sides of the Atlantic, verandas were useful for shelter and shade in all seasons. In summer they served, as W. F. Pocock wrote in his villa book, "to shade the aspect from the beams of a south-west sun," and in winter they provided "a convenient ambulatory in the wet seasons." The English had long sought sheltered places in which to walk out of the glare or drizzle. In 1734, William Salmon discussed "a long kind of Galleries, or Walking-places" in his account of "Piazza's" or "Cloysters," and the poet William Cowper praised the former use of porches in England and deplored their abandonment: "A length of colonnade / Invites us . . . Our fathers knew the value of a screen / From sultry suns." There was classical precedent for the porch as a shelter, "porticos" being defined as "numerous buildings erected in Rome for the convenience of the public in sultry or inclement weather." At Vauxhall, "Almost all the pavilions and boxes have colonnades in front, seven feet broad, which effectually shelter them from rain." Porticoed walkways of just this kind were employed, as we have seen, by Jefferson in his University: "The whole of the pavilions and dormitories to be united by a colonnade in front of the height of the lower story of the pavilions, under which [the students] may go dry from school to school." In many ways, the spirit of Vauxhall lived on in Jefferson's schemes.[51]

In England, Loudon confirmed that the veranda was everywhere useful against the weather: "When it does not obstruct light or impede ventilation, [it] is a great source of comfort and enjoyment in all countries; it excludes rain and cold in the north, and a burning sun in the south." Those who claimed there was no use for it in England "appear not only to forget that the sun does sometimes actually unveil his face to us, and that shade is desirable during some portion of the year, even in this formidable climate." The colonnade of-

Figure 4.29.
Thomas Jefferson and Benjamin Henry Latrobe, Rotunda, 1822–26. Burned 1895. Holsinger Studio Collection (#9872), Special Collections Division, University of Virginia Library

fered "both advantages . . . shade in summer, when the sun is high; and shelter in winter," and he concluded, "*a Porch, or Portico*, can never be dispensed with in a country-house." But these pronouncements notwithstanding, verandas were scarcer in England than America. English traveler J. R. Watson wrote of a retreat on the Schuylkill, "Bellmont house is old, but is well built of stone and like all the Country houses, has a Piazza in front. I don't see why those in England should not have the same, which would secure a fine airy walk in all weathers, besides being ornamental to the building."[52]

American porches were invaluable for providing shelter and shade in all seasons. Arriving at Eaglesfield in June 1816, Watson wrote, "The front windows of the eating & drawing rooms reach from near the top of the room to the floor, and open out on a spacious Piazza 46 ft long and 13 ft wide supported by 6 pillars, the whole front of the house. This is a delightful place, and affords shelter in the summer from the intense heat, and in rainy weather and winter, from damp and extreme cold" (fig. 3.17). Sloan wrote of a room "entirely surrounded by the arched veranda . . . equally sheltered from the storms of winter and the intense heat of summer." Downing commented that the American porch would "serve to keep the entrance dry and warm in inclement weather" and "shelters the entrance-door, and affords an agreeable place both for walking in damp or unpleasant weather, and to enjoy a cool shaded seat in the hotter portion of the season." In his allusion to the porch as a walkway, he echoed Loudon's formulation that a veranda "will keep the house warmer in winter, and cooler in summer, and will afford a dry walk during rain." Even in Canada, Basil Hall observed, a piazza was useful to keep out "the blazing glare of a red hot sky" in summer.[53]

"Glaring light & hot air" were vexatious problems in the domestic interior, Latrobe agreed. Accordingly, piazzas helped keep houses cool and dim—as indeed they did in England: "The colonnade, while it contributes to the embellishment of the front, serves also to subdue the glare of light to the study." Bremer complained of the resulting darkness of the American interior. Visiting Blithewood in 1849, she wrote, "Here, as in many other places, I observed how they exclude the daylight from the rooms. This troubles me, who am accustomed to our light rooms in Sweden, and who love the light. But they say that the heat of the sun is too powerful here for the greater part of the year, and that they are obliged as much as possible to exclude its light from the rooms" (fig. 4.30).[54]

Verandas for coolness were especially appropriate in the sweltering American South, travelers confirmed. At Mount Vernon about 1805, "The bedrooms were miserably small and of course dreadfully hot, tho' the portico

being to the south east, sitting under it was pleasant of an evening." In New Orleans, "large verandahs remind[ed] us that the windows required protection from the sun's heat." At a southern mansion, a piazza protected the "inner walls" from "the effect of either sun or rain," keeping "the spacious apartments . . . both cool and dry." "You admire the lofty, cool rooms, with their green blinds, and the width of the piazzas on both sides the house, built to compensate for the want of shade from trees, which cannot be allowed near the dwelling for fear of moschetoes."[55]

Figure 4.30.
"View in the Grounds at Blithewood, Dutchess Co., N.Y." Demolished. Engraving after drawing by Alexander Jackson Davis, frontispiece of Downing, Landscape Gardening, *1841. University of Delaware Library, Newark*

Frances Trollope visited the cottage of a woodcutter at Mohawk, Ohio: "His pretty house, which was admirably constructed, [had] an ample portico, that kept it always cool." In a health-conscious age that was still largely ignorant of the true causes of disease, such porticos seemed to serve a vital function—for in America, Trollope noted, "Nothing is considered more dangerous than exposure to mid-day heat, except exposure to evening damp." A southern writer on "Rural Homes" outlined the ideal residence: "Give it the graceful colonnade and airy porch for our hot summers." In the South, Ingraham was attentive to the hammocks and other appurtenances that made porches pleasant in the heat. Approaching New Orleans by steamboat, he saw a plantation "with Venetian blinds, and latticed verandas, supported by slender and graceful pillars, running round every side of the dwelling." A dark green curtain was lowered to shield the porch, "inviting the inmates to a cool and refreshing *siesta*, in some of the half dozen net-work hammocks." At an estate near Natchez, "A hammock, suspended between an iron hook driven into the side of the house and one of the slender columns" was the favorite retreat of a fourteen-year-old boy who slept while "a strapping negress, stood by the hammock, waving over the sleeper a long plume of gorgeous feathers of the pea-fowl."[56]

Workplace

For Downing, the porch was vital precisely because it was *not* an essential feature of a house but an extra that "indicates the constant means of enjoyment for the inmates—something in their daily life besides ministering to the necessities." Nevertheless, many porches served as workplaces, especially rear

porches, which were plainer and more utilitarian than front ones (fig. 1.9). Writers on the English cottage emphasized this, as when a rustic character "sate / Upon the long stone-seat beneath the eaves / Of his old cottage . . . Employed in winter's work. Upon the stone / His wife sate near him, teasing matted wool." Wordsworth's pleasant conceit was transferred to America, as in Washington Irving's loving description of the Van Tassel farmhouse at Sleepy Hollow, half-imaginary predecessor to his own Sunnyside (fig. 2.29): "The low, projecting eaves formed a piazza along the front, capable of being closed up in bad weather. Under this were hung flails, harness, various utensils of husbandry, and nets for fishing in the neighboring river. Benches were built along the sides for summer use; and a great spinning wheel at one end, and a churn at the other, showed the various uses to which this important porch might be devoted."[57]

Similarly, Ingraham was struck by the extraordinary usefulness of the southern porch as a workplace. He marveled at "the piazzas, over which were strewed saddles, whips, horse blankets, and the motley paraphernalia with which planters love to lumber their galleries. On nearly every piazza in Mississippi may be found a wash-stand, bowl, pitcher, towel, and water-bucket, for general accommodation. But the southern gallery is not constructed, like those at the north, for ornament or ostentation, but for use. Here they wash, lounge, often sleep, and take their meals." Lest such accounts seem quaint, it is well to remember that the work that took place on porches was often difficult and, in some cases, involuntary; double porches common on two-story brick urban outbuildings in Richmond, Virginia, were workplaces for slaves.[58]

The popularity of the porch as work environment benefited women, who otherwise might have been housebound. American wives and daughters were extraordinarily cloistered, travelers agreed: "They devote almost their whole existence to the management of the household. . . . They generally live much retired." In his daily walks along country roads, Thoreau constantly saw men and boys but rarely a woman, except in huckleberry season. Basil Hall, visiting the annual fair and cattle show at Brighton, Massachusetts, in 1827, was astonished to discover a "most unwonted separation of the sexes": "Literally and truly, amongst several thousand persons, I counted, during the whole day, only nine females!" Martineau described "the horror of the Americans at the idea of women being employed in outdoor labour," a sentiment voiced by many. Cooper in 1828 said that a woman was hardly ever seen working in the fields, save "in the emergency of some passing shower" that threatened the hay crop; instead she was expected always to remain "retired within the sacred precincts of her own abode." Bremer visited "a newly married couple, a

physician and his little wife," in Uxbridge, Massachusetts: "They had built their house according to one of Mr. Downing's designs, and laid out their garden also after his plan; and here they lived without a servant, the wife herself performing all the in-doors work. This is very much the custom in the small homes of the New England states." Given this cloistered existence, porches were beneficial in allowing women to enjoy fresh air while working. Many took advantage of the chance; Martineau noted as she rode along a highway in New York State, "The women looked up from their work in the piazzas as we passed," and in the South she reported that her hostess was "engaged . . . in the piazza behind the house, cutting out clothes for her slaves."[59]

Sometimes pattern-book authors explicitly incorporated the utilitarian porch concept into their designs, as when Loudon set aside part of a porch for beekeeping. Goodwin wrote in 1834 of his "Small Villa in the Old English Cottage Style": "A viranda of the kind here shown . . . is a most pleasant accessory to a drawing room in summer time, and may almost be said to take the room itself out abroad, for when rendered so attractive as it may be made here, it would frequently seduce the work-table or the reading-table into its own neutral ground, between the house and the open air." As the years passed, people found ever more uses for porches. Calvert Vaux's "veranda-porch" on a designer log house could serve as entrance in summer, wood-storage facility in winter. Wheeler noted that sections of a veranda might be enclosed, seasonally, for reception of guests or as a sleeping porch. He referred to the useful "carriage porch," a feature later added to A. J. Davis's Lyndhurst, Tarrytown, New York, in 1865–67. Porte cocheres were nothing new, having been put forward by Loudon in 1833. Both these and sleeping porches would flourish on American homes of the later nineteenth century.[60]

Meditations and Sociability

The piazza of the rural residence could serve a subtle, private function, one essential to the purposes of the Picturesque: as a locus for meditation, reflection, and reverie. Irving adored his piazza at Sunnyside: "I am never tired of sitting there in my old Voltaire chair, of a long summer morning, with a book in my hand, sometimes reading, sometimes musing on the landscape, and sometimes dozing and mixing all up in a pleasant dream." "I sat down in the Piazza to meditate on things past," a contemporary wrote in Philadelphia. Similar purposes were envisioned by pattern-book author Fowler when he remarked (in his usual expansive way) of an octagonal house design, "Only

one other thing remains to complete the most perfect dwelling ever created—
A PIAZZA ALL AROUND, AT EVERY STORY." There he could do no less than "re-
tire within my own soul, and draw near to my Maker, imbibe his spirit, bask
in the smiles of his love, and open my soul to the influx of divine ideas and
feelings."[61]

Fowler was not alone in making high claims for the porch as a quasi-
spiritual realm. Harriet Martineau's mind was on the greatness of Washing-
ton as she approached Mount Vernon in 1835: "I cared far less for any of the
things that were shown me within the house than to stay in the piazza next
the garden, and fancy how he here walked in meditation, or stood looking
abroad over the beautiful river, and pleasing his eye with a far different spec-
tacle from that of camps and conventions." Such was the extraordinary pre-
eminence the Picturesque could give to the porch, a place sometimes more in-
teresting than the house itself. For Martineau, it was the moral heart of the
dwelling—as, indeed, a reverential Latrobe implied in his sketches of the
Washington family at leisure here, some forty years before (fig. 4.1). He and
Martineau "read" Mount Vernon in the same way, understanding it to be
meaningful as the scene of the modern Cincinnatus's rest and retirement after
years of heroism, the spacious porch as eloquent backdrop to the final, rural
phase of Washington's life.[62]

On the piazza, private and public functions merged. The rest, relaxation,
and reverie that the individual could enjoy might be shared by friends and
family (fig. 4.31), as architect Richard Brown indicated of his scheme for a
"projecting rustic porch" on an "English rustic ornate cottage": "The awning
. . . is designed for a shady piazza, or shelter against the summer heat; here the
occupant may take his exercise, read, and meditate quietly, or with his family
sit on rustic seats and enjoy the beauties of nature." Loudon discussed the ar-
chitecture of "warm countries, where it is desirable to sit, and even to dine, or
receive visiters, under the veranda." Such domestic benefits made the porch,
for Downing, a key to making the home "the place dearest to our hearts a
sunny spot, where the social sympathies take shelter securely under the shad-
owy eaves." In America, the porch "during a considerable part of the year fre-
quently becomes the lounging apartment of the family," where (as he says of
fig. 3.26) "in the cooler hours of the day, the husband, the wife, and the chil-
dren may sit and enjoy the fresh breath of morning or evening hours."[63]

A guest at the country house "Stonington," near the Great Falls in Mary-
land, relished "entering the cool and moonlit portico [for] the well-iced san-
garee, or still more refreshing coffee." Visiting Riceborough, Georgia, Mar-
garet Hall wrote, "We have dined, and I am now seated in the piazza writing

whilst Basil makes a sketch with the *camera* [*lucida*] [fig. 4.32] and Eliza is looking after her favourites, the pigs, and a large black bear which is chained in the court yard." A visitor to the home of author R. H. Dana reported in 1854, "We take chairs and seat ourselves under the broad piazza. Our talk is of old times, and modern times." Along these lines of sociability, in "Sleepy Hollow" Irving had portrayed old Van Tassel and friends "smoking at one end of the piazza, gossiping over former times." When he later transformed the model of that fictive house into Sunnyside, he incorporated two kinds of porch, both for social functions: "The state entrance is by the porch at the south end [fig. 4.33]; the household exit is from the drawing-room, across the piazza [fig. 2.29], to the lawn on the east or river front. It is on this side of the cottage that the family chat or read the news of the great world, away, on summer days and nights." The photograph shows Irving under the

Figure 4.31.
*C. H. Brainerd and
L. H. Bradford*, American
Independence, *1859,
lithograph, 16½ × 21½ in.
(41.9 × 54.6 cm). Harry T.
Peters, "America on Stone"
Lithography Collection,
National Museum of
American History, Behring
Center, Smithsonian
Institution [60.2622]*

(left)
Figure 4.32. *Basil Hall, "Village of Riceborough in the State of Georgia." From Hall,* Forty Etchings, *1829, no. 21. University of Delaware Library, Newark*

(right)
Figure 4.33. *Washington Irving at Sunnyside. Photograph by Frederick Langenheim, 1856. Historic Hudson Valley, Tarrytown, New York*

wisteria-draped front porch as if waiting for guests to arrive, sitting beside a cast-iron Gothic bench he had designed with George Harvey in 1836 and had cast at Cold Spring foundry.[64]

Porches were places to entertain, especially in the evening, when floor-length windows or French doors were thrown open to make the piazza an extension of the parlor. Bremer wrote from a house on Lynch Street, Charleston, in April 1850, "Lovely sprays of white roses, and of the scarlet honeysuckle, fling themselves over the piazza, and form the most exquisite verandah. Here I often walk, especially in the early morning and in the evening, inhaling the delicious air, and looking abroad over the country. . . . The principal apartments which are on the first story open upon the piazza, where people assemble or walk about in the evening, when there is generally company." Whenever the rhythms of daily life turned to recreation, the porch was involved. "After breakfast all go out on the piazza for a little while, the children leap about and chase one another through the garden." In the evening the family gathered "in the beautiful drawing-rooms"; "Later, people go out on the piazza, where they walk about, or sit and talk, but I prefer rather quietly to enjoy the fragrant night-air, and to glance through the open doors into the room where the handsome children are skipping about in the joy of youth."[65]

Ingraham recounted the manifold uses of porches in Mississippi, where the "gallery is in all country-houses, in the summer, the lounging room, reception

room, promenade and dining room." Already the porch was synonymous with southern hospitality: "Here will the stranger or visiter be invited to take a chair, or recline upon a sofa, settee, or form, as the taste and ability of the host may have furnished this important portion of a planter's house." Informality was the watchword. Approaching a rural residence outside Natchez, he reported, "The planter was sitting upon the gallery, divested of coat, vest, and shoes, with his feet on the railing."[66]

Porches were usually open to all, without reference to gender or age. Peter Kalm wrote from Albany as early as 1749, "In the evening the verandas are full of people of both sexes." Ingraham gave an account of a steamboat ride above New Orleans: "A glimpse through the trees now and then, as we move rapidly past the numerous villas, detects the piazzas, filled with the young, beautiful, and aged of the family, enjoying the rich beauty of the evening." Martineau said that in the South "the afternoon is spent in the piazza, where coffee is served. There the ladies sit, whisking their feather fans." But sometimes women abandoned the piazza to the men. Cutler approached the Woodlands, William Hamilton's home near Philadelphia, in November 1803: "In the front, which commands an extensive and most enchanting prospect, is a piazza, supported on large pillars, and furnished with chairs and sofas, like an elegant room. Here we found Mr. H., at his ease, smoking his cigar." Thomas Hamilton remarked at Saratoga, New York, in 1831, "The whole company, as usual, dine in an enormous saloon, after which the gentlemen lounge about the balconies, smoking cigars, while the ladies within read, net purses, or endeavour to extract music from a jingling piano." At Nahant resort in Massachusetts in 1835, Hawthorne saw "gentlemen smoking round the piazza." And later Donald G. Mitchell would have his cottage-seeking Mr. Lackland say, "Half the charm of a country place, to my notion, lies in the possession of some sunny porch . . . where I can smoke my pipe, basking in the yellow light, as I watch the shadows chasing over the grass."[67]

The social and personal functions of the piazza did not strike all contemporaries as essential. Sternly committed to "the science of domestic economy," Catharine Beecher could not justify needless outlay: "Piazzas and porticos are very expensive appendages, and would secure far more comfort, if turned into additional accommodations, such as closets, drawers, shelves, and kitchen conveniences. The money demanded for the cheapest kind of portico, would pay for enlarging the house, so as to admit another room of convenient size." But even she gave designs for piazzas, including "a latticed portico, which is cheap, and answers all the purposes of a more expensive one. It should be solid, overhead, to shed the rain, and creepers should be trained over it."[68]

Beecher's dissents aside, it would be hard to exaggerate the importance given nineteenth-century porches as generators of positive social and domestic feeling and as places of congregation and interaction. Increasingly, the ideal dwelling was a suburban one—the detached house on a large lot—with the family sitting out prominently in the porch in the evening, attempting perhaps to recoup the sociability lost by the decreased density of the new suburban life. Basil Hall was enthralled by a Massachusetts town at dusk in 1827, one that seemed to consist "entirely . . . of gentlemen's houses, almost hid in the foliage. . . . Troops of people were sitting before their doors, or in their gardens; all the windows were thrown open; and we could see quite through the houses."[69]

Signs and Expressions

As a protected viewing-place close to nature, the piazza was indispensable for the purposes of the Picturesque—in Downing's words, "affording . . . shelter, prospect, and an agreeable promenade," foreshadowing Jay Appleton's "prospect and refuge" thesis of our own day. As usual, these ideas were imported from England, where a visitor to "the tasteful *cottage-orné* of Mrs. Bolton, eligibly placed on a knoll, and commanding picturesque views in every direction" across Surrey, described how "the back is fitted up with a viranda, communicating with a small flower-garden" and offering "a fine view of the Norbury Hills." This obsession with views was brought to America early on. Kalm wrote of New York in 1748, "Many of the houses had a balcony on the roof, on which the people used to sit evenings in the summer season; and from thence they had a pleasant view." Views were a major appeal of the scores of porticoed villas that sprang up along the Hudson, including the Cold Spring house of George P. Morris, editor of the *New-York Mirror:* "This is one of the most magnificent sites for a summer residence in the United States. . . . The drawing-rooms and saloon front the river, and the ever-moving panorama of the Hudson is right before them, while on a moonlight evening the portico is one of the pleasantest stations to be conceived." At these villas, eave and posts literally framed a "Picturesque" view—as shown by William Birch or later by Davis in his sketch of the piazza at Blithewood, the landscape as seen through the uprights neatly dividing into a series of painterly compositions (fig. 4.34).[70]

The aesthetic functions that the porch served were preceded by the basic facts of construction. Contrary to modern assumptions that the Picturesque

was mostly cheapness, villa books called for porches to be well built and sturdy. For the Hudson Valley piazzas he designed, John W. Ritch demanded that "the floor [be] laid with planed, tongued and grooved white pine plank. The roof to be covered with common H. tin, soldered and warranted tight. Piazza to be ceiled with tongued, grooved, and beaded narrow ⅞ inch boards, well nailed." Specifications for the William M. Bickford House in Worcester, Massachusetts, called for porticos floored with "Georgia pine, one inch and a half thick, and four inches wide." "Decay speedily begins" on exposed porches, Sloan warned, and he specified floors of "white pine one inch thick, grooved together with white lead in the joints."[71]

In Britain, the elegant simplicity of Regency verandas supported by slender cast-iron columns must have done much to accustom the public to the aesthetics of iron long before the great greenhouses and Crystal Palace. American porches were mostly supported by wooden columns, not metal, but the occasional use of iron seemed to point in a bold new direction, as in the fireproof "piazzas" on William Strickland's United States Naval Asylum in Phil-

Figure 4.34.
Alexander Jackson Davis, "View N. W. at Blithewood," Annandale-on-Hudson, New York, ca. 1841, watercolor, ink, and graphite on paper, 7⅞ × 9¹⁵⁄₁₆ in. (20 × 25.3 cm). Avery Architectural and Fine Arts Library, Columbia University in the City of New York

adelphia (figs. 4.35, 4.36). The asylum was the national home for old sailors, equivalent to Greenwich Hospital in England, and was built in a town where the climate was supposedly salubrious, free from "the harsh breezes which assail the northern cities during the winter, as well as the severe bilious fevers which prevail during the summer and autumn in the South." The central building, with refectory, chapel, and administrative offices, boasted a gray Pennsylvania marble portico with eight Ilissus Ionic columns. The wings, with basement of granite and walls of marble, housed four hundred men in 180 rooms, with piazzas for healthfulness and domesticity. The entire structure was fireproof, right up to the copper roof of the main building and the slate roof of the wings, and so the eighty-eight columns of the piazzas were cast-iron on granite piers. The total cost was $220,000, "a less sum than is required to build and fit out a frigate."[72]

Porch aesthetics was a complex subject, with ground-hugging *lowness* and upspringing *lightness* jockeying for preeminence. Wheeler wrote ambiguously, "The broad veranda seems like a base to the building, and gives massiveness and apparent firmness to its foothold upon the ground, equally as it imparts lightness and variety to its outline." The duality owed to the fact, of course, that porches are post-and-beam, both horizontal and vertical in nature. Often the vertical was emphasized: in 1782, Jefferson found little to praise in Virginia's architecture, save for the Capitol at Williamsburg, "a light

Figure 4.36.
*William Strickland,
Naval Asylum, detail.
HABS, Library of
Congress*

and airy structure, with a portico in front of two orders . . . on the whole, it is the most pleasing piece of architecture we have." It was the lightness of the portico that distinguished the building from the "brick-kiln" of a College that faced it down Duke of Gloucester Street, and he made sure to give his Richmond Capitol a tall portico, too (fig. 2.9). For J. R. Watson at Landsdowne on the Schuylkill (1777), "The Piazza has a hanging gallery from the Bed rooms—and tho convenient does not add to the lightness," as it should have. In western Virginia in the 1830s, the hotel at Red Sulphur Springs had "a light and airy piazza connected with each story." Planters' houses at Natchez always had a gallery, "which furnishes a fine promenade and dining-room in the warm season, and adds much to the lightness and beauty of the edifice."[73]

The presence of a porch was a vital indicator of taste in the inhabitants of a house, as William Birch remarked at Mount Vernon: "The additions of a piazza to the water front, and of a drawing room, are proofs of the legitimacy of the General's taste." John Dix, visiting from England in the 1840s, commented similarly on the role of porches; Lexington, Massachusetts, and other New England towns showed "white and glittering . . . pretty cottages, with their cheerful-looking green blinds. . . . There is so much taste displayed in their construction that every one of them, with its pillars and veranda . . . seems intended as a model for exhibition." Porches would readily have been numbered among the domestic features that were, a contemporary argued,

Figure 4.37.
*American house,
location unknown,
ca. 1851. Daguerreotype.
The J. Paul Getty
Museum, Los Angeles
[84.XT.269.18]*

"beautiful always, and everywhere, not simply as ornaments, but as signs and expressions of the refinement and grace of life" (fig. 4.37).[74]

With Picturesque *utile et dulce* in full sway, porches and eaves were valued not only for actually providing shelter but for communicating it as a moral value. Approaching Philadelphia from the north in July 1787, Cutler wrote, "At almost every house the farmers and their wives were sitting in their cool entries, or under the piazzas and shady trees about their doors. I observed the men generally wore fine Holland shirts, with the sleeves plaited, the women in clean, cool, white dresses, enjoying the ease and pleasures of domestic life,

with few cares, less labor, and abounding in plenty." Holly noted that the presence of wide eaves "at once gives to the cottage a pleasant expression of shelter." The suggestion of taste and refinement was a serious matter; along America's country highways, Mitchell said, houses with porches showed "an air of modest grace," whereas those without one were "naked, vulgar-looking dwellings" that exhibited the "indecorous exposure of a wanton."[75]

In the late 1840s, Susan Cooper chronicled the gradual improvement in architecture in upstate New York as the Picturesque caught on. Porches and eaves played a role, as the Scylla of the "common *shallow*" style (the claptrap house that succeeded the log cabin in her scheme of architectural history) and the Charybdis of the "*shallow-ornate*" ("a starved Grecian edifice") were at last answered with a new, better type. Rural residences now showed "the elevation . . . lower, the roof projects farther, the cornices and all parts of the framework are more substantial, the porch or verandah is in better proportions, and the whole has a look of more finished workmanship." There were dangers to the approach, however. Lately "this substantial school has been somewhat abused. You see here and there new wooden cottages, which, in the anxiety of the architect to escape the shallow, err in the opposite extreme, and look oppressively heavy, as though the roof must weigh upon the spirits of those it covers. The cornices and door-frames of these small cottages would often suit buildings of twice their size, and, altogether, they belong to the ponderous style"—erring on the side of lowness, and deficient in lightness. A delicate piazza might have helped.[76]

For Downing there was no mistaking that "a broad shady veranda suggests ideas of comfort, and is highly expressive of purpose" and that the ideal home would always have "an air of taste lurking about it, and breathing out from vine-covered porch." So distinctive of the Picturesque was the piazza that it was one of the first "Victorian" architectural features twentieth-century modernists would assault. A writer in *Architectural Record* in 1910 commented approvingly upon architects' having "declared war upon the old piazzas which deprived the best living-rooms of direct light, and made any propriety of exterior effect impossible." Indeed, Loudon had warned as early as 1838 that the veranda made ground-floor rooms gloomy. For much of the rest of the twentieth century, the piazza would remain in eclipse, as epitomized by the decay of the celebrated porch of the Catskill Mountain House into a latter-day ruin of Baalbek by 1961, huge rotting columns leaning drunkenly against its warped walls.[77]

In more recent times, however, the porch has been widely revived, from the streets of suburbia to Andres Duany and Elizabeth Plater-Zyberk's Seaside,

Florida (begun 1983), as new generations rediscover its Picturesque pleasures—all the more reason, then, to understand its historical origins and to appreciate the rich variety of meanings ascribed to it by its formal and philosophical fashioners in the nineteenth century. Porches or piazzas are a beloved leitmotiv of our culture—they "seem to embody everyone's fond memories of the past: visits to Grandma, summer nights, the house we knew as children. Porches evoke much that was wonderful and is now lost." Pleasing sentimentalities aside, the evidence does not support the idea that porches are an indigenous American invention. Whatever the contributions of Africa or the West Indies, the porch of the high-style dwelling was essentially an old, European feature of complex derivation that found new life in the United States. In countryside and suburb it evolved to suit the climate and social conditions of the New World, until it seemed entirely native—for generations, a cherished and indispensable part of the American home.[78]

5 : GREEK REVIVAL & BEYOND

From a ridge top one mile west of Gettysburg, Lutheran Theological Seminary enjoys sweeping views of rolling Pennsylvania farmland and distant blue mountains. Civil War enthusiasts will immediately recognize its green-domed cupola, from which generals nervously watched the fortunes of their armies in July 1863. As famous as the building is, little attention has been paid to its architecture, which is of a rather ordinary variety, the normative Federal style that could be found in public buildings throughout the country in the 1830s, before the Greek Revival took hold. It is marked by a stolid, foursquare, red brick and white trim aesthetic, slightly enlivened by tripartite windows and lunettes and parapets rising above the roof (fig. 5.1). Greece is evident only in the column capitals of the porch. Even with its Flemish-bond brickwork on front and sides, it was handsome but not elegant, a distant echo of the old Adamesque Federalism of Charles Bulfinch and contemporaries (fig. 2.1). This is a building rightly renowned more for its historical role on Seminary Ridge than for its artistic design.[1]

One can appreciate what a great aesthetic advance the Greek Revival must have seemed by looking at Pennsylvania College, built a half-mile north just three years after the seminary was finished (fig. 5.2). Here across the fields and in plain view of the older building was a new nobility and monumentality, imparted by whitewashed brick walls, low-pitched roof, tholos-like cupola, and especially the imposing Doric portico. The local building committee— anti-Masonic politician and future "Scourge of the South" Thaddeus Stevens prominent among them—hired a pupil of William Strickland's as architect, John C. Trautwine, who made sure that his portico was "of the same order of architecture as the [Second] Bank of U.S. in Philadelphia" (fig. 5.6) and affirmed that "Mr. Strickland approves entirely of the plans." The young architect was aghast at the suggestion of omitting the finishing paint job as an economy measure: "Respecting the leaving of the exterior *red* instead of *white*, it would entirely destroy all architectural beauty." The chasteness of white Grecian walls would set the tone for the developing Pennsylvania College

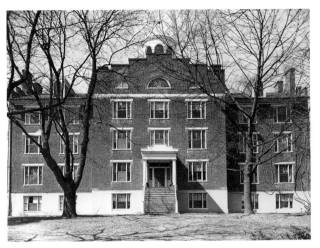

(left)
Figure 5.1.
Nicholas Pierce,
Lutheran Theological
Seminary, Gettysburg,
Pennsylvania, 1830–32.
HABS, *Library of*
Congress

(right)
Figure 5.2.
John C. Trautwine,
Pennsylvania College,
Gettysburg, 1835–37.
At left are President's
House, 1860, and Herman
Haupt, Linnaean Hall,
1846–47, demolished 1942.
Photograph by Tyson
brothers, ca. April 1862.
Beltzhover Album, Special
Collections/Musselman
Library, Gettysburg
College

campus as the school evolved into the spacious, greenswarded ensemble typical of many American colleges, with a temple-form home for a scientific society (there were supposed to be two of these, recalling Whig and Cliosophic Halls at Princeton of 1837–38) and a piazzaed Italianate villa for the president. This was the bucolic place as it was when suddenly overrun by the Confederate army in 1863 and made a hospital for seven hundred casualties. An eyewitness recalled that "the moans, prayers and shrieks of the wounded and dying were heard everywhere" in Trautwine's college hall.[2]

Federal-style Lutheran Theological Seminary and Greek Revival Pennsylvania College show a shift in taste that took place all over the country in the years after 1830 (fig. 1.19). Where did this Greek Revival come from, what motivated it, and what did it symbolize? Many answers have been put forward over the generations, not all of them satisfactory. Indeed, few phases of American architecture have been more discussed—or more misunderstood—than the Greek Revival. Part of the confusion comes from its transitional nature, in some ways emblematic of the progress-minded nineteenth century and yet deeply rooted in aesthetic philosophies of the eighteenth. Its newness fulfilled the contemporary desire for innovation in a time of rapid change, yet its classical heritage obeyed the traditional Renaissance demand that architectural forms be conservative. The Greek Revival spread rapidly throughout the nation in the decades that new settlement was most intensive in the South and Midwest and as architectural conditions improved in the East. In an age obsessed with measuring and commodification, the details of Greek architecture offered a barometer of rising taste as proper Grecian forms began "to appear in every village," and the enduring cultural image of the white temple gleam-

ing in solitary splendor in the arcadian landscape perfectly summarized the American effort to domesticate and civilize a continent. This sober aesthetic of whiteness and purity dovetailed with the national manner of building in wood, by which even ordinary structures happened to take on temple-like appearance in the raw countryside (fig. 5.3). To foursquare, white-painted frame buildings the application of Greek details was a straightforward exercise that instantly leant refinement.[3]

The term *Greek Revival* suggests a new, autonomous movement, but really the revival marked another phase of classicism, the universal heritage of Western architecture for centuries, and it emerged gradually in England during the half-century that followed the publication of the first volume of James Stuart and Nicholas Revett's *Antiquities of Athens* (1762). Not until the opening decade of the nineteenth century did the revival really blossom in England (volumes 2 and 3 of *Antiquities* appeared in 1789 and 1794, others in 1816 and 1830). As approaches to architecture became more scientific, learned, and anthropological, theorists increasingly emphasized the preeminence of Greek architecture of the fifth century B.C. as the first flowering of classicism, purer and more austerely beautiful than the corruptions introduced later by the Romans. The Greek Revival owed little to attitudes toward modern Greece but rather stemmed from the classical emphasis of liberal education—whole generations taught, as A. J. Downing said, to "hang upon the skirts of Greece and Rome"—and the eighteenth-century fondness for archaeological neoclassicism. It was frequently bookish, with Stuart and Revett its Bible, but there is no need to be put off by its historicisms, for its decorative forms were fresh and natural and were conjoined with a fully modern emphasis on technological progress. Greek Revival buildings with their antique flavor were often the most advanced of the day in construction and plan.[4]

Talbot Hamlin, an architect and librarian of the Avery Architectural Library, Columbia University, New York (1934–46), stressed in his landmark *Greek Revival Architecture in America* (1944) that the movement never really revived ancient architecture but instead adapted classical forms to modern conditions. Often these were no more than a few ornamental motifs belatedly applied. Nor was the Greek Revival exclusively "Greek"; historians recognized as early as the 1890s that bookish forms had in fact been "blended with the Free-Classic of Georgian work and the vernacular of the native builder" to produce something synthetic and new. "Free-Classic" suggests the creative reinterpretations undertaken by Rome and the Renaissance, and the influence of these periods is palpable in the Greek Revival, the word *Grecian* being used more often than *Greek* at the time and implying classicism in general. For

Archibald Alison, whose associationist philosophies appeared just as the revival gained momentum in England, Grecian architecture was consonant with Antiquity and was the product of "countries" and "nations" in the plural, not merely of Greece. As we have seen, the "bigotted Greek" Latrobe was clear that the aesthetic cutoff for him was the death of *Roman* emperor Hadrian in A.D. 138. Robert Mills said of Latrobe's House of Representatives, "It is purely Grecian in its design and decorations," yet the semidomed ceiling was assuredly not Greek but stylishly up-to-date in the manner of contemporary English and especially French design (fig. 2.14). Minard Lafever's Sailor's Snug Harbor, Staten Island, New York (1831–33), with its eight Ilissus Ionic columns, epitomizes the Greek Revival, but "it is apparent that [its] design resulted from a combination of Georgian and Regency features" plus Grecian, all drawn from English books. And John Notman's North Lodge at Laurel Hill Cemetery, Philadelphia, was erected at the height of the revival (1836) but is Roman Doric, with affinities to the British work of John Nash as well as that of William H. Playfair, in whose office Notman had worked before immigrating in 1831 (fig. 2.23). Playfair used both Greek and Roman modes, and "far from being simply an architect of the Greek Revival, [he] was one of the

greatest exponents of the Picturesque which was the dominant aesthetic of Georgian England." British-derived "Roman Revival" would be an accurate term at Laurel Hill, which ultimately was eclectic and Picturesque—like many places in the "Greek" Revival.[5]

The Lions of Philadelphia

Some of the most famous and influential Greek Revival buildings were the so-called lions of Philadelphia, the major public edifices of that city renowned for its relatively high level of aesthetic development. "To see the lions" was an old expression in London, where actual lions at the Tower were once a tourist attraction, and over time it came to refer to the must-see sights in major cities. The American Greek Revival got its tentative start in Philadelphia with Latrobe's Bank of Pennsylvania, a composition often said to have been inspired by Jefferson's Virginia Capitol (figs. 5.4 and 2.9). But Latrobe probably learned little he did not already know from that building, unfinished when he first saw it, its bare brick columns partly whitewashed, devoid of entasis, and rising up to tops without capitals. A contemporary called it "a clumsy ill shapen pile . . . ugly and ill contrived." Instead, the origins of Latrobe's assured and graceful bank more nearly lie in his own career in England. Drawing upon a long tradition of temple-form garden structures, he employed strikingly similar massing to his bank in designs for a garden bath pavilion (ca. 1791–93) before he ever saw Richmond.[6]

The customary idea of the bank as a "temple" should not be taken too far—after all, Latrobe himself argued that "the *forms*, and the *distribution* of the Roman and Greek buildings which remain, are in general inapplicable to the objects and uses of our public buildings." Fundamentally, it was a small, double-porticoed Neoclassical structure (53 by 148 feet) designed to fit a narrow lot in Philadelphia's oldest, densest section. Notwithstanding Hamlin's contention that it was "unlike any English prototype," it can perhaps best be understood as a freestanding piece of a larger British composition, as if one of the porticoed pavilions of Robert Taylor's Bank of England (finished 1790) were made to stand on its own, or perhaps a rectangular, Ionic, domed pavilion from Soane's project for the House of Lords (1794–96). The bank's large porticos were Latrobe's attempt to invest the little building with dignity in spite of its limited size. Without question the architect borrowed freely from Soane's Bank of England, under construction during Latrobe's last years in Britain, reassembling certain of its elements into a miniaturized composition:

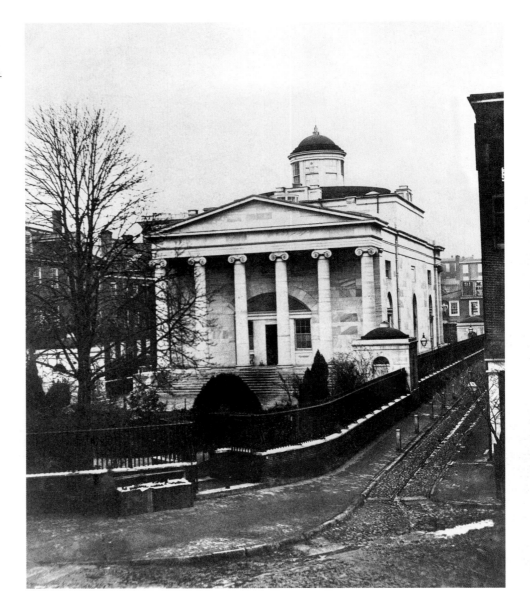

Figure 5.4.
Benjamin Henry Latrobe,
Bank of Pennsylvania,
Philadelphia, 1798–1800.
Rear (west) façade, 1855.
The Historical Society of
Pennsylvania [Penrose
Small B.4]

he closely based his Hall with its "flat Dome" upon Soane's Rotunda, and the adjacent, apsidal Stockholders' Room imitated the bank's Vestibule. He employed many Soanian motifs, including the lantern and the long rectangular panel behind the east portico (seen partly disassembled in fig. 5.5), which takes a hint from the wall treatment in Soane's Bank Stock Office. Having courses of stone alternate thick-thin was an archaeological touch and suggested Soanian banding. The Ionic order of the Erechtheum was one Latrobe had previously used at Ashdown House, Sussex (ca. 1793–95). The immi-

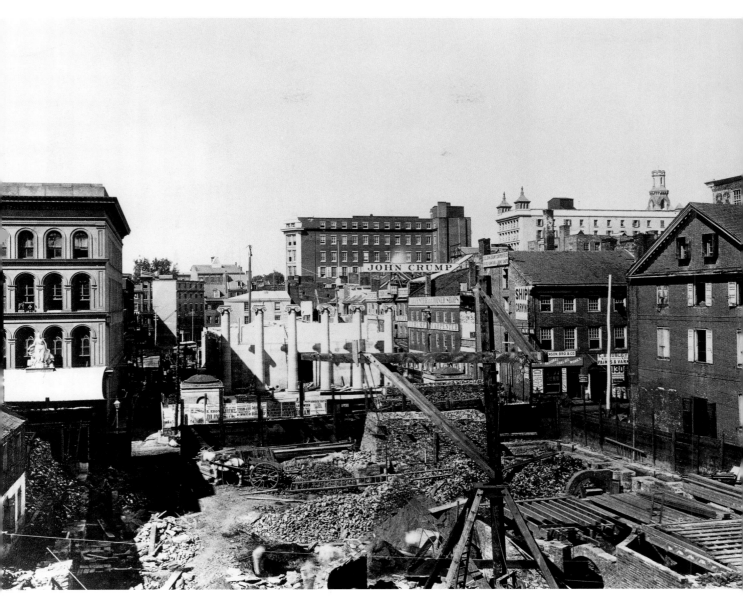

grant architect had thus created a building thoroughly in the tradition of the Advanced Neoclassicism of 1790s Britain, transplanted 3,500 miles away to the shores of America. Rare photographs of its demolition provide an invaluable record of this once highly regarded, lost structure (figs. 2.2, 2.3).[7]

Twenty years after the Pennsylvania Bank, Latrobe designed what was more literally a temple, for the competition for the Second Bank of the United States, to be built just a few blocks away. He was defeated by his former pupil, Strickland, who submitted a scheme very similar to his own: a Parthenon

Figure 5.5.
Benjamin Henry Latrobe,
Bank of Pennsylvania,
demolition in 1867.
Photograph by John Moran.
The Historical Society of
Pennsylvania [Penrose
Small B.4]

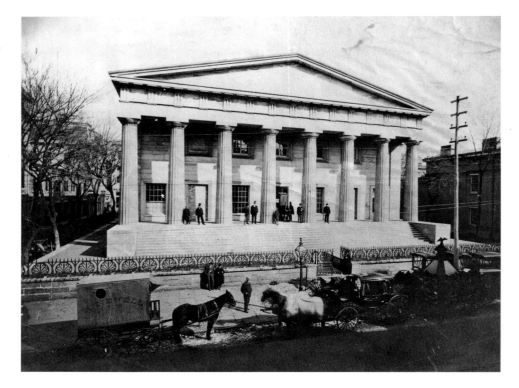

in miniature (fig. 5.6). This seemed boldly innovative for the United States, but it had been two decades since Robert Smirke's Covent Garden Theater (1808–9) had introduced the Doric of the Parthenon to the London cityscape, and by now the Greek mania was in full swing in Britain. Strickland's bank was instantly famous: "The most faultless monument of its size in the United States [and] of the purest Doric, classic in its proportions, and severely chaste and simple." This was, of course, the structure that Trautwine made sure to mention to the building committee at Pennsylvania College as a ticket to high aesthetic esteem.[8]

The bank's fame should not cause us to forget, however, that the Doric order it employed was by no means the only one used in the Greek Revival, notwithstanding the modern psychosexual idea of the movement as having been burly, masculine, and phallocentric. Viewing the revival as a whole, it would appear that the Doric occurred relatively less often than it had in colonial times, when the hard-to-fashion Ionic and Corinthian were rare. The Greek Revival brought a tremendous expansion of the use of the light and elegant Ionic of the Temple on the Ilissus (fig. 4.16), Ionic of the Erechtheum ("Minerva Polias"), or Corinthian of the Choragic Monument of Lysicrates ("Lantern of Demosthenes," fig. 5.7), all illustrated by Stuart and Revett

Figure 5.7.
*William Strickland,
Merchants' Exchange,
Philadelphia, 1831–33.
Column with signature by
Peter and Philip Bardi on
band below capital. Upper
right, dedicatory inscription
to Strickland and mason
J. Struthers. Photograph by
Jack Boucher, November
1964. Independence
National Historical Park*

(fig. 5.8). Strickland used Erechtheum Ionic in the attractive, barrel-vaulted Banking Room inside the Second Bank. Here, as often, the Greek Revival was graceful and lyrical and resembled Roman or Renaissance classicism in all but a few decorative details.

The Second Bank stood at the vanguard of the new Grecian taste that swept the United States in the 1820s and 1830s. Illustrated in every modern history of American architecture, it was noted at the time for its aesthetic excellence as well as for being the epicenter of financial activity in the nation during the years that culminated in the notorious "Bank War" between the Andrew Jackson administration and bank enthusiasts. It is all too easy to think of it as a static mass entirely of marble, but a surviving ledger suggests the great variety of materials that were employed during the highly dynamic construction process. The 41,500 cubic feet of stone were cut at Hitner's Quarry in Montgomery County, Pennsylvania ("expenses at quarry, saw blades"; "making, mending & sharpening marble masons tools, repairing jacks, dressing wedges, &c"), and fashioned by prisoners ("porterage of marble from Centre square & prison"). Great effort was involved in "fluting &

Figure 5.8. *Choragic Monument of Lysicrates, late fourth century B.C., in the garden of the Capuchins, Athens. From Stuart and Revett,* Antiquities of Athens, *1762. University of Delaware Library, Newark*

rubbing" the column drums and hoisting them. In addition to the stone there were many other materials paid for, suggestive of the complexity of a building project of this size: three million bricks, 17.5 tons of copper in 1,485 sheets for the roof, white pine and sweet red gum boards, "cut nails & spikes," "Rope, hooks, thimbles," "oil, candles, brushes," "10-¾ cords upland Hickory & cordage," "20 bu[shels] of coal," "250 bu. of plastering hair," "400 bu. white sand," "175 loads of gravel," "soap stone jambs, plinths for counters, Gate setts," "2 gilt platinum lightning rods," and "737 ft mahogany for desks & furniture of banking room."[9]

Strickland described the building as "arched in a bomb-proof manner from the cellar to the roof . . . as the only safe-guard against the ravages of the incendiary"—he well knew that banks were unpopular—and restoration work in 1964 revealed sophisticated brick arches even under the marble steps and inverted ones beneath the heavy portico columns (fig. 5.9). These hidden details were likely laid by master bricklayer Joseph Walter and his son Thomas, later a famous architect in his own right. For further fireproofing and security, Strickland made sure there was an avenue on each side "to insulate the building from the surrounding objects," and he raised the structure upon a terrace to heighten the classical feel: "It is on this terrace that the building is reared, and from it derives a great portion of its effect." These ideas owed much to Latrobe, who had essayed them to a considerable degree at the Bank of Pennsylvania and in his own design for the Second Bank, which he was sure Strickland had cribbed. The freestanding gracefulness of the marble

Figure 5.9.
*William Strickland,
Second Bank of the
United States. Chestnut
Street (north) front with
marble steps removed for
restoration. Photograph by
Jack Boucher, June 1964.
Independence National
Historical Park*

bank as seen from crowded Chestnut Street, one of the most visited thoroughfares in America, ensured an appreciative audience and helped set the Greek Revival fully in motion here—not to mention created an indelible image of what a reputable bank should look like. With bank president Nicholas Biddle's encouragement, branch banks throughout the country followed suit in employing the Grecian style.[10]

When Trautwine sought his mentor Strickland's advice on the Pennsylvania College designs, he had only to stroll from his office in Room 24 Merchants' Exchange to Strickland's in Room 31. The Exchange was designed as a place for merchants to assemble and do business, with offices let out to a variety of concerns, including a bank, insurance companies, and the chamber of commerce (figs. 1.21, 5.10). The post office, on the ground floor on the Dock Street side, was among the first to distribute postage stamps, a contemporary innovation (1845). Construction had been rapid: the cornerstone-laying took place amid the pomp of the grand civic procession marking "the hundredth anniversary of the birth-day of the illustrious Washington" in 1832, and already in November 1833 a banquet was held at Tontine Coffee House celebrating the completion. Among those invited were 140 artisans, and spirited toasts were given. The building contained 1.15 million bricks and 28,000 cubic feet of marble "hewn and fitted to give brilliance and beauty to our edifice for untold ages," and it had a gleaming roof of copper. The large Ex-

Figure 5.10.
*William Strickland,
Merchants' Exchange,
Philadelphia, 1831–33.
Distant right, Samuel
Blodget, Jr., First Bank
of the United States,
1795–97. Photograph by
John Moran, ca. 1860s.
The Library Company
of Philadelphia
[1322.F(6).97a,#2]*

change room on the second floor was warmed by a basement furnace, "the heat from which passes through a hollow Iron Column . . . into the room covered by a marble curb and a brass revolving ventilator." The room's curving wall offered a dramatic, elevated view of Dock Street. Peter and Philip Bardi were brought over from Carrara, Italy, to carve the capitals of the columns just outside the windows, which they proudly signed in Latin on the necking-band (fig. 5.7). Strickland toasted these sculptors at the Tontine: "The excellence of their art will be a lasting model for our American chissels."[11]

The crown of the Exchange was the "circular Lantern of wood 40 ft. high, neatly finished outside with 8 columns of wood & Carved Capitols"—a replica of the Choragic Monument of Lysicrates, copied out of the pages of Stuart and Revett. It was a lovely design, if not as daringly original as has sometimes been said: exchanges in Britain and America regularly had towers; the Choragic Monument was a favorite plaything of English architects; and the combination of tholos and curving colonnade was popular for corner sites in the contemporary London of Nash. Years earlier, Strickland's mentor Latrobe

had speculated to Jefferson, "The lanthern of Demosthenes than which nothing of the kind can be more beautiful, would not be the less beautiful if mounted upon a ma[gn]ificent Mass of architecture harmonizing with it in character and style."[12]

As we have seen, elsewhere in Philadelphia stood another of the great landmarks of the Greek Revival, Girard College by Thomas U. Walter, only twenty-eight years old when he won the competition in 1833 (fig. 1.1). Its Lysicrates Corinthian order is Greek, evidently inspired by Strickland's just-completed Merchants' Exchange as well as the long, elegant Ionic portico of his Naval Asylum (fig. 4.35); but the design history of the building suggests how many non-Hellenic influences could readily be brought to bear on a "Greek" structure. Walter's inflexible client was, literally, a dead man, and the architect struggled to come up with a design that would satisfy a building committee bound by the conditions of Girard's will, which called for four rooms per floor, each fifty feet square, and descended into such minutia as the precise rise and tread depth of the stairs. As for aesthetics, it demanded marble but otherwise gave little clue, other than calling for "avoiding needless ornament." Walter's first design blatantly copied French precedent, with Alexandre Pierre Vignon's scheme for the Madeleine (1807–42) at center and two flankers copied from Ange Jacques Gabriel's Place de la Concorde (1755). This stage-set evocation of Paris was doubtless meant to match Girard's French origins; born near Bordeaux, he had come to Philadelphia as a young man in 1776, and in applying the word *college* to a grammar school he had used the word in its French sense. Walter probably also had an eye to William Wilkins's enormous, ten-column Corinthian portico at University College, London (1827–28). Hellenophile trustee Biddle, who had visited Greece in 1806, saw that the final design was properly chaste, but still it resembled the Roman Temple of Zeus at Athens more than any Greek building and surely rivaled what Latrobe once praised as "the *immense size*, the bold *plans and arrangements* of the buildings of the Romans." Downing, disapproving of its ostentation, called it "a superb marble temple, like that of Jupiter Olympius," meaning Zeus at Athens. Again, the term "Greek Revival" seems somewhat restrictive when applied to this modern, multifarious, classicizing design.[13]

As a classroom building, Girard College proved an instant failure—its thirty-eight thousand square feet of shiny marble floor-tile with vaulted ceilings above shimmered maddeningly with echoes—but it survives today as the symbolic heart of the school and one of the most extraordinary monuments of antebellum American architecture. The whole building is elevated on a gigantic podium of blue Montgomery County marble eleven steps high, so that

one stands on the sidewalk and looks *up* to the bottom of the column bases (fig. 1.2). These bases are truly huge, each a disc more than nine feet wide, nearly waist-high, and costing $1,454 apiece, as much as a trained marble cutter could expect to earn in salary for three years' arduous labor—and there are thirty-four in all. Each column weighs 103 tons, as much as fifty automobiles. Standing on the peristyle at the side of the building, one looks down an awesome enfilade of eleven of these monstrous shafts. Craning one's neck, the ceiling is seen high above, "composed entirely of cast iron, enriched with deep sunken panels, and painted and sanded in imitation of marble," only the paint peeled off long ago. As splendid as the exterior columns are, it is easy to forget that there are forty-eight more columns in the stair halls inside the building, Ionic and Corinthian, all of them monolithic.[14]

The school's twentieth-century preservation record was dismal—between 1926 and 1973 it demolished at least nine nineteenth-century buildings, and Founder's Hall, as it had come to be known, was allowed to languish. When Hamlin visited this "forgotten masterpiece" he was appalled to find the "magnificent upper rooms with their sweeping domes and bold arches" to be "dirty and forgotten" and strewn with dead birds and pigeon droppings. "What a disgraceful fate for one of the most important *tours de force* of American constructive genius of a century ago!" He was ecstatic about the capitals of the colonnade, "impeccable," of "rich lightness," and a "glory," but not long after his visit—about 1950, that awful nadir for historic architecture—all but one of their 136 curlicue volutes were knocked off to save the maintenance trouble. These capitals that had together cost $146,370 to fashion—and that Victorian admirers once made a journey to see—have ever since stood mutilated.[15]

A 1997 study points to several reasons that the Greek Revival blossomed in Philadelphia—the presence of the classics-minded Franklin Institute (housed after 1826 in John Haviland's takeoff on the Choragic Monument of Thrasyllus); the drawing school that it ran, where leading architects taught the beauties of the Greek orders; the Grecophile advocacy of Biddle and the journal he briefly edited (1812–14), the *Port Folio*. The public responded enthusiastically, it would seem, for Girard College and the other "lions" of Philadelphia became central to the rituals of contemporary tourism. Omnibuses that departed from the Dock Street front of the Merchants' Exchange conveniently allowed a tour of all the architectural landmarks. In half an hour one could be exploring the Waterworks (fig. 1.32); buses to Girard College left every fifteen minutes and cost 6¼ cents. Thoreau's visit in fall 1854 was typical of many: from New York by railroad and Camden ferry to "Jones's Exchange Hotel, 77 Dock Street . . . Looked from the cupola of the State-House,

where the Declaration of Independence was declared [fig. 2.35]. The best view of the city I got [fig. 1.20] . . . Fine view from Fairmount water-works" before arriving at Girard. All of these architectural showpieces were featured in the remarkable "Views in North America" series of Talbotype photographs by William and Frederick Langenheim in summer 1850, in a distinctive circular format. The immense popularity of these places is further evidence of the great public esteem in which architecture was held in the day and the pride that was taken in Greek Revival buildings as expressions of civic and national achievement.[16]

Stone

Like all the best public buildings in England and America, those of Philadelphia were at least partly faced in stone—not a rough ledgestone found on the site and sometimes employed in basements, but expensive marbles imported from some distance. This marked a great advance over the usual eighteenth-century practice, when the fancier stones were a great luxury, confined to steps, lintels, and chimneypieces. In accordance with precedents going back to ancient times, stone had enormous prestige over brick, and to build in stone was a ticket to civic esteem—but the United States lagged far behind England, where the excellent Bath and Portland freestones, among others, had long been widely available. The young Republic was eager to show itself sophisticated, and it ambitiously erected buildings of stone before quarrying or craftsmanship could quite meet the challenge. In Philadelphia the First Bank of the United States, of Montgomery County marble on the front façade only (fig. 5.10), was almost touchingly naive in the miscellaneous dimensions of the column drums. Progress was rapid, however, and Latrobe's Bank of Pennsylvania was masterfully fabricated, with thick and thin courses of stone alternating as in ancient Greek work, as a precious few columns survive to show (fig. 5.11). Its fully vaulted interior was a milestone in permanence and fireproofing. In Washington before 1840 the President's House, Capitol (fig. 2.13), Patent Office, and Treasury Building were all erected of stone at enormous expense but of the substandard Aquia freestone, "a sandstone of faulty character, with many blemishes and iron stains" and riddled with clay holes. Early on, both President's House and Capitol were painted white to conceal this poor material. It is myth that the "White House" received its familiar color only after its walls were blackened by British arson in 1814; the building had already gotten its nickname by the time of Jeffer-

Figure 5.11.
Benjamin Henry Latrobe,
Bank of Pennsylvania,
Philadelphia, 1798–1800,
column shaft and base as
reincorporated into Soldiers
and Sailors Monument,
Wilmington, Delaware,
1871

son's tenure, having been whitewashed in the 1790s. It was coated with lead white in linseed oil after the fire, the first of thirty or more layers of such paint that were stripped off in a late-twentieth-century restoration and repainting.[17]

"New materials may make new forms possible, and even call for new forms," said Nikolaus Pevsner, and in the Greek Revival the architect marched side by side with the quarryman. "The Quincy stone seems indeed particularly appropriate to the order of architecture, to which the improved taste of late years has given the preference," wrote a commentator on Greek Revival Tremont House (fig. 1.11). Canals, and later railroads, demanded huge quantities of stone for their construction, spurring the development of quarries that in turn got their products to wider markets by the new means of transportation. More quarries meant more stone-faced buildings, which then boosted the demand for yet more quarries. Sheldons and Slason's Marble Quarry, West Rutland, Vermont, underwent expansion at the time the railroad reached it about 1850. A Scotland-born artist, James Hope, showed all stages of the quarrying process, from cutters at work in the pit at left, to the new steam-powered mill at center where stone was sawed into shape, to finished products shipped to market at right (fig. 5.12). The big block rising from the quarry is labeled "Washington Monument," apparently the Vermont contribution to the 1849 call for a stone from every state to form part of Mills's obelisk rising in the District of Columbia (fig. 5.26). Vermont increasingly played a dominant role in the United States stone industry, as symbolized by the massive Barre granite columns of its Greek Revival State House, which even a disastrous fire could not destroy (fig. 5.13).[18]

Baltimore, a wood-and-brick city initially, shows the explosive development of stone quarrying and distribution from localized and limited circumstances around 1800. Latrobe's Baltimore Cathedral was ambitious in its extensive use of stone—not crude ledge-stone from the immediate surroundings but ashlar (square-cut) stone quarried ten miles west in Ellicott City (fig. 5.14). The material was undistinguished, a mottled gray granite, and the size of the blocks was kept small, because they had to be transported over rough roads by nine-ox teams. Change came rapidly, however. By 1815, Mills's Washing-

Figure 5.12. *James Hope,* A Marble Quarry, *1851, oil on canvas, 18 × 24 in. (45.7 × 92.1 cm). Gift of Maxim Karolik for the M. and M. Karolik Collection of American Paintings, 1815–1865. Courtesy Museum of Fine Arts, Boston. Reproduced with permission.* © 2000 Museum of Fine Arts, Boston. All rights reserved [62.275]

ton Monument a few blocks away was rising in gleaming white marble from recently opened quarries at Cockeysville, Maryland, and some of its pieces were very large indeed. For the statue on top, hoisted in 1829, a stone was cut from the quarry walls as a single block seventeen feet long—considered an extraordinary achievement, even though it ultimately had to be sawed up. And yet this same quarry could provide, thirty years later, no fewer than 108 monolithic columns each twenty-six feet tall for Walter's additions to the United States Capitol! Such single-shaft columns of enormous size belonged

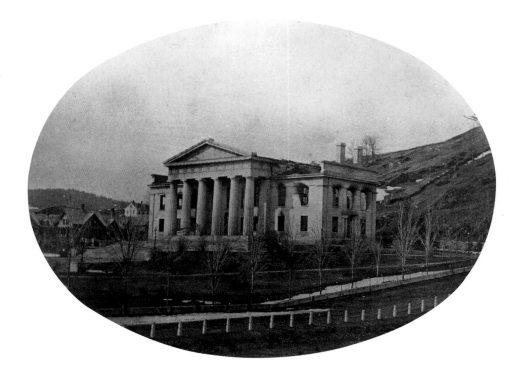

Figure 5.13.
Ammi B. Young,
Vermont State House,
Montpelier, 1834–38.
Burned 1857; rebuilt using
original portico. Vermont
Historical Society

to a proud tradition that went back to Roman times, where the nearly thirty-nine-foot columns of the Pantheon were imported from Egypt in a gesture that symbolized the imperial might and technological sophistication of the state. These parallels were seldom far from Americans' minds. By using a beautiful breccia stone for the columns of the House of Representatives, Latrobe felt that he had earned the right to brag, "Cedite Romani"—yield to me, Romans. And Strickland was toasted upon the completion of his Merchants' Exchange, "He will realize the boast of the ancient emperor—He found us living in a city of brick, and he will leave us a city of marble."[19]

Steam made a difference in the stone revolution, providing power to saws, hoisting engines, and railroads (fig. 2.22 shows "stone cars" of a somewhat later era). When construction began on Girard College in 1833, the site was linked to its West Chester, Pennsylvania, quarry by miles of horse-drawn railroad, but three years later, steam locomotives came into use on the line (along with marble from Egremont, Massachusetts, West Chester stone was used for the finer parts of the building). In the transport of stone, distance was quickly annihilated. James Gallier, Sr., described his Municipal Hall, New Orleans (1845–50): "The portico and ashlar of the front are of white marble, procured from quarries near New York; the basement and steps are of gran-

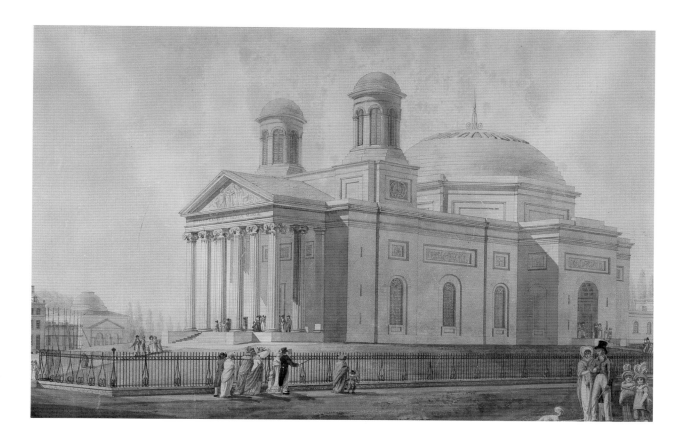

ite, the style of the architecture is Grecian Ionic, and the portico is considered as a very chaste and highly-finished example of that style."[20]

Boston was transformed by quarrying technology during the age of the Greek Revival. The granite beds of Quincy were an easy boat ride across the harbor but had to await the coming of improved technology to be exploited. The moment arrived suddenly; a writer of 1825 could look back just eight years to when "the stores in Market Street were the first erected on granite pillars, a thing now so common." From the debut of this practice it was not long until Alexander Parris's Quincy Market (1823–26), with its extensive use of hammered granite and huge, monolithic stone columns. It was a far cry from colonial times when the Quincy town fathers worried that the entire supply of granite boulders—then the only practicable source of stone—would run out in the construction of a single building, King's Chapel, Boston (fig. 1.17).[21]

The explosion in the use of Quincy granite owed to the indefatigable efforts of Solomon Willard, one of those self-made men of whom the era was proud. He had worked as a carpenter on Asher Benjamin's huge Exchange

Figure 5.14.
Benjamin Henry Latrobe,
Baltimore Cathedral,
1804–18. Latrobe, Roman
Catholic Cathedral,
Baltimore, Maryland,
pencil, pen, ink, and
watercolor on paper
[dimensions unknown].
The Maryland Historical
Society, Baltimore
[1897.1.3]

Coffee House, Boston (1808, burned 1818), and went on to carve capitals, eagles, figureheads, and an architectural model of the U.S. Capitol for Bulfinch. Eventually he specialized in detailed carving in stone, when he was not perfecting an innovative hot-air furnace he had designed, and by 1822 he was active as an architect. What was needed, Willard thought, was a dramatic reduction in the price of granite in order to stimulate demand. He wrote in 1831, "The high price demanded for granite for fifteen years past, and particularly for blocks of large dimensions, has had a tendency to discourage the use of it; and my object in engaging in the stone business was not to make money, but to make experiments in order to remove the obstructions to the extensive use of granite as a building material." His opportunity came with the proposal to erect an enormous Revolutionary War monument on Bunker Hill (fig. 5.15). Who exactly designed the obelisk has always been a matter of debate, but Willard executed it and insisted that it be entirely of granite, not with a brick core like the "cheap construction" of Mills's Washington Monument, Baltimore. The large scale of Willard's operation successfully triggered a revolution in the availability of granite as a building stone, with profound effects on the Greek Revival.[22]

The monument company bought a rocky ledge in Quincy in 1825, and Willard supervised a quarrying operation on a scale never before seen in America, with 6,600 tons taken out and carefully shaped into hundreds of blocks—a great challenge, because few of them could be conveniently rectangular in an edifice that tapered. The stones were cut and finished on-site before being shipped to Bunker Hill for raising, the work organized with an eye to efficiency into five departments: quarrymen, hammerers, carriers, hoisters, and masons. The ledge was a crowded place, with roads, boardinghouse, blacksmith shop, stonecutters' sheds, and a timber run by which the blocks were brought down from the quarry walls. Laborers were all native-born and free, unlike the prisoners who had cut the stone of Tremont House (or of New York University, of Sing Sing marble, fig. 2.12). Technological innovations were everywhere to be seen, for example in the improved "wrought iron and cast steel" lifting jack; Holmes's Hoisting Apparatus; and steam power to raise the higher courses of stone (after 1841). Such advances allowed three splitters and three capstan men to cut and run down 291 blocks, more than 100 of which weighed six tons each, in only 108 days in 1827. The two miles from the ledge to Devens's wharf, where boats ferried the stone to Bunker Hill, were traversed by a horse-drawn railroad, widely hailed as the first in America, although Latrobe had used one on the abortive Chesapeake and Delaware Canal project in Maryland of 1804.[23]

The cost of the 221-foot monument was enormous, and by a grotesque irony its completion could be financed only by the sale to developers (in 1839) of three-quarters of the surrounding sacred battlefield it commemorated. It was finally dedicated in 1843, with President Tyler and 110 Revolutionary veterans on hand, including one Phineas Johnson, who had been alive in the 1740s. The long years of the monument's construction had seen the annihilation of distance by the locomotive, so that the New Yorkers who now attended the ceremony missed only one day of work by doing so. Daniel Webster had spoken at the cornerstone-laying ceremony back in 1825, in the presence of Lafayette; much had changed in the life of America since then, and his address at the dedication made pointed mention of the perils of disunion.

In Boston, the architectural fruits of the Quincy granite were to be seen on all sides. Willard wrote of his initial desire of "improving the style of building, and the taste in architecture, by the introduction of a building material not before in use; and showing that it can be worked into any moulded or ornamental form required," and indeed "a strongly marked improvement in taste, and in construction, immediately followed the commencement of this work." He could point to many fine buildings of Quincy granite with which he had been involved, including Isaiah Rogers's Merchants' Exchange, New York (1836–42), with its nearly twenty monolithic fluted columns each thirty-three feet tall and weighing more than thirty tons, which took two years to extract from Quincy's Wigwam Quarry and finish at a cost of $5,200 apiece. Larger still were the corner pilasters of Rogers's Merchants' Exchange, Boston, each six feet wide, forty-two feet high, and weighing an astonishing fifty-five tons—the Greek Revival at its most elephantine (fig. 5.16).[24]

But of course not all Greek Revival buildings were of stone. The $34,000 Albany Female Academy had forty-foot columns of marble, but their bases were cast-iron and the walls were stuccoed brick (fig. 5.17). The Greek style

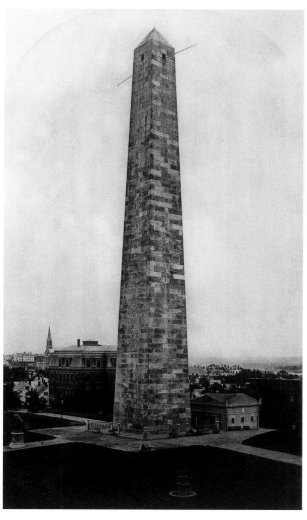

Figure 5.15.
Solomon Willard and others, Bunker Hill Monument, Charlestown, Massachusetts, 1825–43. At right, George A. Parker, Lodge, extant 1857–1901. Photograph, ca. 1890. Collection of Richard Creaser, BOST archives, Boston National Historical Park

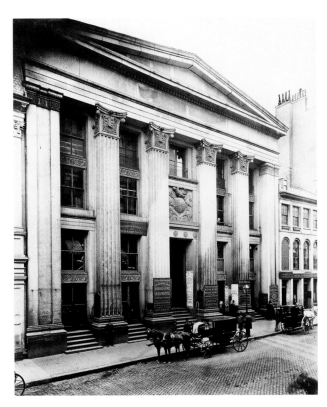

(left)
Figure 5.16.
Isaiah Rogers,
Merchants' Exchange,
Boston, 1840–42.
Demolished 1891.
Courtesy The Bostonian
Society/Old State House

(right)
Figure 5.17.
Jonathan Lyman,
Albany Female Academy,
New York, 1833–34.
Photograph, 1863.
Demolished after 1890.
Female Academy,
North Pearl Street,
Albany, *photograph.*
Albany Institute of History
and Art Library, series 14,
box 1, photo 4

was easily adaptable to wooden construction and was thus applied to homes nationwide. The same architects who promoted its use in public buildings also employed it in domestic design, and as a result the major monuments of the revival in Philadelphia and other cities exerted a powerful influence on American architecture as a whole. A famous example is Andalusia, commissioned by Biddle from Walter at the same time that they were collaborating on Girard College (fig. 5.18). Biddle had grown rich on the fortunes of the Second Bank, and a detractor wrote of him, "He possesses a beautiful seat on the banks of the Delaware, where there is a miniature facsimile of the monster's marble den in Chestnut Street." This was indeed an apt description of the massive riverfront façade, which copied in wood the heavy forms of Greek Doric and even had a wooden checkerboard floor imitating stone pavement. Walter remodeled an earlier house by Latrobe, and the cost (including an enlarged billiard room on the lawn and a Gothic-ruin grotto) was $14,660 — actually far less than Biddle spent on his graperies and extensive agricultural improvements, all part of the seasonal, country-gentleman life in which he reveled.[25]

The career of architect William Nichols likewise exemplifies the spread of

Greek Revival ideas from public to private, from cities to rural locations. He immigrated from Bath, England, about 1800 and practiced architecture in North Carolina, Alabama, Louisiana, and Mississippi, following the trajectory of western migration as the Old Southwest was settled. His important commissions in Tuscaloosa—the State Capitol, Christ Church (1829–30), and Lyceum and Rotunda at the University of Alabama (1828), "all now gone, may have owed at least as much to [his] English background and training as to American precedent." The Capitol exterior (figs. 5.19, 5.20) was derived in part from a plate in Peter Nicholson's *Architectural Dictionary* (London, 1819), and its House of Representatives was based on Latrobe's in Washington (fig. 2.14). It was all a sophisticated essay, particularly given the newness of this settlement. There had been a Creek Indian village here until 1813, and Alabama achieved statehood only in 1819. Governor Gabriel Moore addressed the legislature in Nichols's new building in 1829: "And what, may I ask, was this much favored spot only a short time anterior to our admission into the union? a mere wilderness, the resort of savages and wild beasts only. What an exchange of tenements is now presented! In the place of those humble huts, then occupied by the Black Warrior or Tuscaloosa chief and his followers . . .

Figure 5.18.
*Thomas U. Walter,
enlargement of* Nicholas
Biddle house, Andalusia,
near Philadelphia,
*1835–36, watercolor,
13 × 20 in. (33 × 50.8 cm).
Andalusia. Photograph
by Will Brown*

Greek Revival and Beyond [241

Figure 5.19.
William Nichols,
Alabama State Capitol,
Tuscaloosa, 1828–30.
Burned 1923. Photograph
by J. R. Kennedy. Courtesy
Alabama Historical
Commission

we now behold a Capitol, emphatically a Capitol, and University, which when completed will be inferior to none in elegance, in taste, or in usefulness."[26]

The Greek Revival in a grand southern home is exemplified by the handsome Forks of Cypress, which Nichols may have designed (fig. 5.21). It belonged to Ulster-born James Jackson, a noted horse-breeder who operated a racetrack on his farm and whose way of life must have been, in most aspects, not unlike Biddle's at Andalusia, though year-round. He had bought the property from Cherokee chief Double Head, whose wigwam stood not far from where Jackson built his original log house (fig. 3.9). With increased prosperity, Jackson desired far grander quarters, so he erected a large frame dwelling and gave his log house over to his slaves. Above a stone foundation the body

Figure 5.20. *Alabama State Capitol, south portico. Photograph by J. R. Kennedy. Courtesy Alabama Historical Commission*

Figure 5.21. *William Nichols, attrib., "Forks of Cypress," James Jackson house, Lauderdale County, Alabama, ca. 1830. Photograph by Dan Glenn, 1964. Burned 1966. Courtesy Alabama Historical Commission*

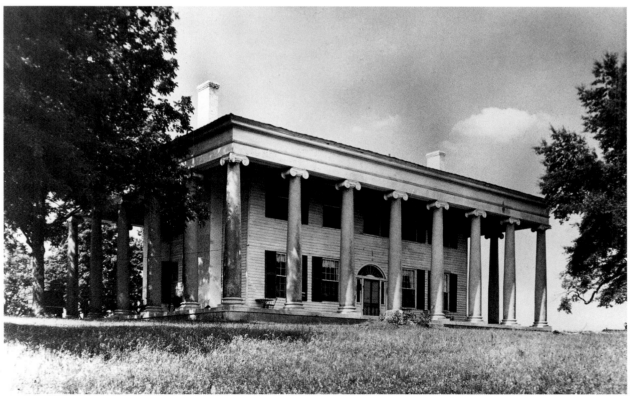

of Forks was frame, including the heavy timbers of the attic that supported the cypress-shingle roof (fig. 1.10), and the exterior was sheathed in tulip-poplar weatherboards. But what made the design memorable were the twenty-four massive columns of radial brick covered with stucco mixed with sand to resemble stone. Each shaft was topped with a hand-carved tulip-poplar capital.

Part of the Greek Revival's appeal was that it was distinctly new and stylish and yet had evolved harmoniously from the long-popular Palladian and Federal modes—as suggested by the transitional work of Mills in the 1820s (fig. 5.22). The buildings of Nichols are likewise useful in showing the shift, for they have one foot in the eighteenth-century, Chambers-esque classical architecture of Bath and another in the new Grecian style (fig. 5.20). The Forks's massive columns suggest the Greek Revival, but its fanlight and interior trim recalled the older Federalism (fig. 2.3). The great peristyle colonnade may seem like a southern feature, but it is the only one known in Alabama, and perhaps alone in the United States in using the Ionic order. Jackson had ties to New Orleans and may have been thinking of the galleried plantation houses of the lower Mississippi Valley; but on the other hand, his architect may have been responding to a contemporaneous transatlantic interest in peripteral design (fig. 3.14). The precise influences that shaped "the great pillared plantation manor of the cotton belt" have long proven difficult to trace.[27]

Americanness

When twentieth-century historians sought to demonstrate that American architecture had always been boldly independent and innovative—worthy of the greatness of the world-straddling nation of their day—their favorite example was the Greek Revival. They argued that this nineteenth-century movement was unique to America and expressed peculiarly democratic meanings. These ideas do not seem to have obtained in the 1890s, when the revival was still understood to have been an English import. But by 1926, when American art and antiques suddenly seemed valuable, Howard Major would call the revival "An American Style for Americans. . . . It is the only thoroughly American architecture" and was our "national style, our independent creation." The temple-form house, in particular, "was independent of contemporaneous European influence." Lewis E. Crook agreed: such a house "had no counterpart in Europe. The direct classicism of the revivalist in the temple

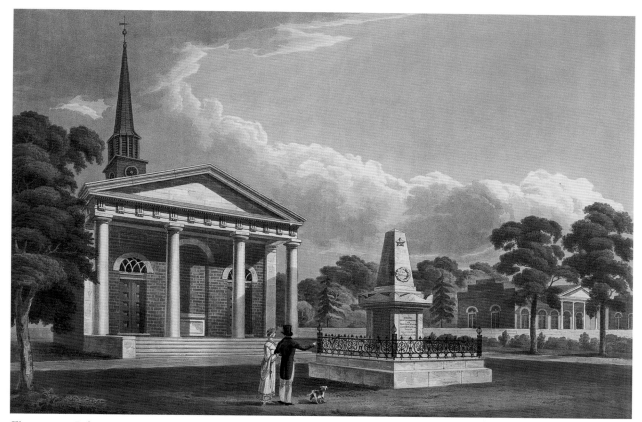

Figure 5.22. Robert Mills, Bethesda Presbyterian Church, Camden, South Carolina, 1820–21, and Mills, Johann De Kalb Monument, 1824–27. John Hill (after Robert Mills), The Monument to De Kalb, 1827, colored aquatint. Print Collection, Miriam and Ira D. Wallach Division of Art, Prints and Photographs, The New York Public Library, Astor, Lenox and Tilden Foundations [Deak 353]

form of architecture first gained a foothold in the South and produced our own great national style in architecture—America's independent contribution to the art." Joseph Jackson titled his 1926 chapter on the Greek Revival, "Beginnings of a National Architecture," and promoted the Americanness theme: Strickland's Second Bank "certainly . . . was not flavored with any British influence," and his Merchants' Exchange showed how "American Architecture had released itself from British tradition." Leopold Arnaud, introducing Hamlin's *Greek Revival Architecture*, wrote, "The word 'Revival' is an unfortunate misnomer, for this style was only a revival in that its decorative vocabulary was based upon classic Greek detail. In all other respects it was typically of America. Never before or since has there been less influence from Europe." Arnaud's comments show the cast of the times; when he writes of "a conscious separation from Europe and a fierce will to be American," he refers

Figure 5.23.
*Historic American
Buildings Survey team,
16 March 1934, measuring
portico of Francis Costigan,
School for the Blind,
Louisville, Kentucky, 1855.
Demolished 1967. HABS,
Library of Congress*

to the 1830s but could easily be describing the 1930s, years of crisis and intense patriotism in which interest in Greek Revival architecture surged (fig. 5.23). Hamlin's book, born at the very moment of U.S. world ascendancy, made the architectural-Americanness idea gospel for the rest of the century. In vain did Nikolaus Pevsner protest against his "contention . . . that the Greek Revival is the first national American style. I fail to see that."[28]

As Pevsner knew, the Greek Revival was really an international phenomenon, with many of its greatest American monuments inspired by British examples. As for the temple-form house, abundant wood allowed Grecian porticos to multiply here, but they were far from uncommon in England (fig. 3.4). Among public buildings, the Patent Office at Washington owed much to Smirke's General Post Office in London but was even closer kin to the Doric monuments of Edinburgh by William Burn, Thomas Hamilton, and Playfair, and would actually seem to be derived from Burn's John Watson's School (figs. 5.24, 5.25). The Treasury Department has been called "distinctively American" but actually shows close affinities to Nash's stylophilic redevelopment of the western districts of London (fig. 5.26). An obvious parallel is his Carlton House Terrace (begun 1827), which has thirty-two columns in a row, all topped by a balustrade; twenty columns form a freestanding screen like the

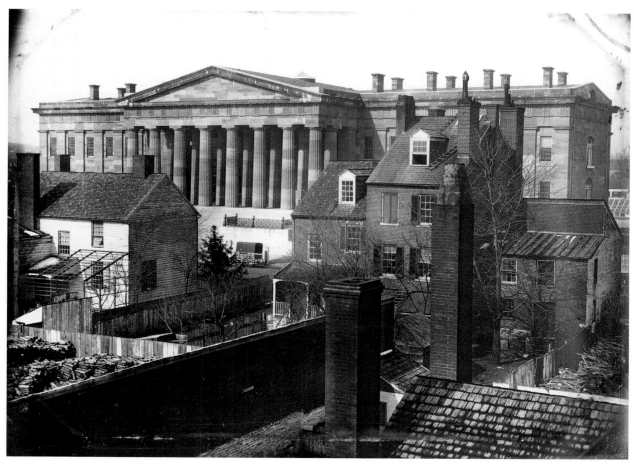

Figure 5.24. *Robert Mills, following Ithiel Town and William P. Eliot, Patent Office, Washington, D.C., 1836–40. Enlarged 1849–67. Photograph by John Plumbe, ca. 1846. Library of Congress*

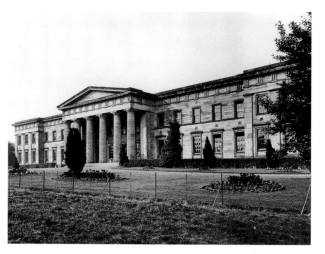

Figure 5.25. *William Burn, John Watson's School, Edinburgh, 1825. Crown Copyright: Royal Commission on the Ancient and Historical Monuments of Scotland*

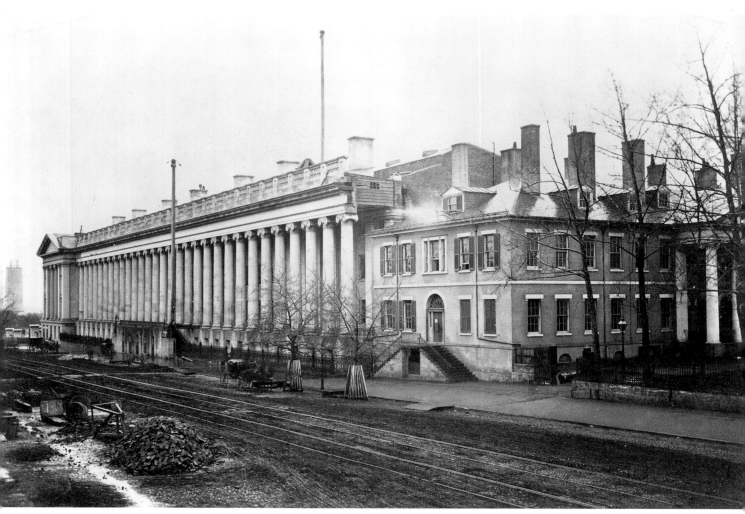

Figure 5.26. *Robert Mills, Treasury Department, Washington, D.C., 1836–42. Colonnade rebuilt 1908–9. At right, James Hoban (following 1798 design of George Hadfield), State Department, 1818–20, demolished 1860s. At far left, Mills, Washington Monument, as begun 1848–54. Library of Congress*

thirty-column one at the Treasury. And, appropriately enough, Mills's building is exceedingly similar to London's "New Treasury," Soane's Board of Trade, Whitehall (fig. 5.27). This last comparison underscores the generally retardataire character of American architecture; the Greek Revival had crested in London in the late 1820s and was fast transforming into the Italianate by the mid-1830s, yet American architects in appropriating Nash and Soane's grandiose urbanism largely persisted in clothing it in Greek, not Roman, garb. Mills used Erechtheum Ionic on the Treasury in a recollection of the lessons he had learned from his master Latrobe and the Bank of Penn-

sylvania of thirty-seven years before. When called upon to defend his design to a congressional committee, however (political enemies charged him with construction delays and design flaws), he mentioned only *French* buildings as precedents for a long colonnade—the Louvre and Alexandre Theodore Brongniart's Bourse, Paris (1808–13), the Bourse being "the most magnificent of modern structures." Perhaps it would have been foolhardy to talk of England to already irate American politicians.[29]

Figure 5.27. *John Soane, Board of Trade, Whitehall, London, 1824–26. From Elmes,* Metropolitan Improvements, *1827, facing p. 148. University of Delaware Library, Newark*

Political conditions unique to America are one thing, but architectural taste is another entirely. Taste during these years was a truly international language, and the Greek Revival, far from being an American revolt against British cultural hegemony, was if anything an eager—one could almost say servile—acquiescence to foreign preferences. As we saw earlier, Americans were almost desperate in their desire to be considered tasteful by English standards, recoiling in anguish at the "spleen . . . sneers and self-complacency" of Mrs. Trollope and others and redoubling their efforts to conform. Margaret Hall wrote of the Americans, "Their desire for our approbation exceeds anything I could have conceived . . . their whole minds seem to be bent in seeming quite English in their manners and customs, but a lurking suspicion that they are not quite what they ought to be makes them seek to have their opinion confirmed by those who they think qualified to judge." Political rivalries aside, in aesthetic matters England was not considered a foreign culture, but nurturing parent to America's. Architect William H. Ranlett wrote in the 1840s, "It has often been made a reproach to our national character that we imitate all other people in our architecture, while we have nothing that we can claim as our own. But so far from this being a reproach, it is rather a credit, that having a knowledge of the old world's experience we have the intelligence to avail ourselves of the wisdom of our ancestors."[30]

An English writer on the Picturesque once expected that a gentleman landscaper "will be checked from exceeding the boundaries which good sense prescribes, by that powerful species of restraint, the fear of ridicule"—and this fear was a powerful motivator driving the improvement of American architecture and pushing it in the direction of archaeological correctness. Restraint and discipline lay at the heart of the ancient Greek achievement, as the marquis de Chastellux wrote James Madison in 1783: "The remedy against the caprices of the fashion is the study of the arts, the knowledge of abstract

beauty, the perfection of taste. . . . do you not see that the Greeks, who had some how acquired very early, such just notions of the arts and taste; do you not see, I say, that they never varied in their modes?"[31]

The only way to avoid architectural solecisms was to obey classical taste rigidly. Accordingly, Americans became more than ordinarily obsessed with the rules and with building by the book, which helped give the U.S. Greek Revival its frequently literal and temple-form cast. Virginia lawyer and man of letters George Tucker, writing in the *Port Folio*, understood that Americans, like all moderns, would inevitably "remain slavish imitators in architecture" even though "national vanity may spurn at a perpetual servitude of imagination" to the precedent of Greece. In his pioneering *History of the Rise and Progress of the Arts of Design in the United States* (1834), William Dunlap acknowledged that his compatriots, as with the English, "have no standard of beauty, but that which is derived from the country of Homer and Phidias," and Tucker had agreed that "all the most civilized nations of the earth unite in considering the Grecian architecture as the standard of excellence." Massachusetts architect Edward Shaw, who once asked a traveling friend to measure the Parthenon for him—a modest request!—wrote of architecture, "If this science were more generally studied throughout the United States, we should be exempt from those architectural abortions which now so often disgrace our cities and villages." The writer N. P. Willis quoted a commentator on the Albany State House who stressed its failure to obey the norms: "The rules of architecture, whether Egyptian, Hindoo, Chinese, Grecian, Roman, Saracenic, Gothic, or Composite, have been violated" (fig. 5.28). James Fenimore Cooper has a character complain, "The classical taste of our architects is anything but rigid"; his companion dissents, however, observing, "The fault just now is perhaps to consult the books too rigidly, and to trust too little to invention." And Tucker wrote of that "technical pride, which cherishes and perpetuates much of the pedantry of all professional men, who are content to be thought ostentatious of their learning, rather than be supposed not to have acquired it"—a major factor in giving the Greek Revival a distinctive pedantry all its own, what one scholar calls "a rather priggishly genteel accent."[32]

As we have seen, Americans dutifully educated themselves in the high standards of European architectural aesthetics and took pride in their ability to pronounce and find fault. Their descriptive abilities were remarkably well developed, a product of the intimate connection between Greek Revival architecture and the ideal of literate, classical education as the basis of liberal culture. As with many travel writers, Anne Royall made a point to include comments on architecture that would demonstrate her own high level of aes-

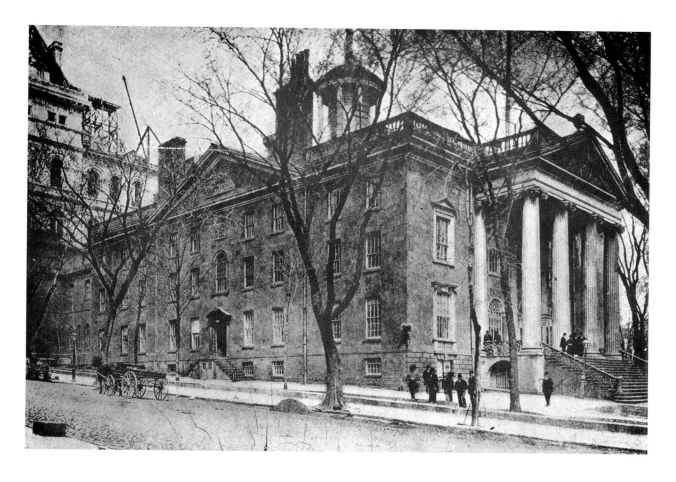

thetic refinement; she noted eruditely, for example, that the portico of the Al-
bany State House was "of the Ionic style, *tetrastyle*." In 1836, Freeman Hunt
described the Female Academy in that town as "really a beautiful and classi-
cal edifice. . . . The front faces to the east, and is ornamented with a beautiful
Hexastyle portico of the Ionic order, which for sublimity of effect, and taste in
arrangement, is not surpassed by any in the United States. The proportions
of the columns, capitals, bases, and entablature, are taken from the temple on
the *Ilissus*, the most beautiful example of the Ionic among the remains of an-
tiquity. . . . The angles are finished with antae; and the ceiling of the pronaos
or vestibule formed into a single panel, surrounded with an appropriate
entablature" (fig. 5.17). In language similarly sophisticated he described the
chapel inside: "The antaes and entablature with which this room is orna-
mented, are in imitation of those of the *Erectheum*, and cannot fail to attract
particular attention. They exhibit a highly finished specimen of the Grecian
Ionic, and display a judicious use of ornament without profusion."[33]

Figure 5.28.
*Philip Hooker, New York
State Capitol, Albany,
1806–8. Demolished 1883.
Far left, H. H. Richardson,
New Capitol, 1875–86.*
Old State Capitol, New
State Capitol Being Built
in Rear, *photograph.
Albany Institute of History
and Art Library, series 1,
box 1, photo 11*

These contemporaries were typical of the educated public at whom Greek Revival architects aimed their efforts. In a bookish gesture familiar in the day, Rogers's Tremont House (fig. 1.11) borrowed ornamental motifs from a range of classical buildings, mostly illustrated in *Antiquities of Athens:* entranceway from the Portico at Athens; ceilings from the Propylaea at Eleusis; interior columns from the Choragic Monument, Temple on the Ilissus, and Temple of Minerva Polias—and even a skylight design derived from frescoes in the Baths of Titus. These references would be entirely lost on a modern observer, but at the time they spoke the language of high architectural taste and seemed to demonstrate that civilization and refinement were confidently marching westward. America was not breaking away from Europe but applying the lessons of its greatest architectural achievements to the needs of modern life in the New World.[34]

Politics and Economics

Following the strains of the Pied Piper of (Talbot) Hamlin, it is often said that the Greek Revival was profoundly political in nature and made deliberate, prodemocratic reference to the glories of ancient Periclean Athens or the Greek War for Independence (1821–30). Arnaud wrote, "The fact that decorative detail was based upon classic precedent, and especially the Greek precedent, was due not merely to an increasing interest in archaeology, but more especially to the enthusiasm which the whole Western World, and particularly the new republic, showed for the struggles of Greece during her wars of independence." Others have reiterated the theme: the popularity of the revival was "due in large part to the Americans' enthusiasm for the Greek fight for independence from the Turks"; it "symbolically linked the new democracy of the United States with its spiritual forebear, the Athenian democracy of the fifth century B.C."; it symbolized "liberty" of various kinds; and Mills's Treasury represented an exercise in "retaining a visual association between American and Greek democracy." In other words, we tend to read the Greek Revival as a "polemical and political" phenomenon.[35]

Many Americans were indeed proud of the connections between their society and the democratic principles of ancient Greece, and sometimes they did draw an equation between the greatness of Greek art and their own cultural potential and political preferences. Latrobe called for "adapting our architecture to the age of our society and of our institutions, and exhibiting in our public edifices that republican simplicity which we profess," following not the

"indifferent taste" of the Roman Revival First Bank but instead the Bank of Pennsylvania's model of "a pure specimen of Grecian simplicity in design, and Grecian permanence in execution." In the matter of the fine arts, he hoped that "the days of Greece may be revived in the woods of America, and Philadelphia become the Athens of the Western world." Mills praised Latrobe's employment of Greek forms at the Bank of Pennsylvania: "It was fortunate that this style was so early introduced into our country, both on the ground of economy and of correct taste, as it exactly suited the character of our political institutions and pecuniary means."[36]

But the historical record offers scant evidence that nineteenth-century Americans viewed the Greek Revival primarily in political terms, and the endlessly quoted linkage with the Greek War for Independence seems to be based on little or no documentation. Perhaps the "Greek Fever" that swept the country during the years of the revolt against the Turks heightened some Americans' receptivity to Grecian taste, but the Greek Revival as described by contemporaries was overwhelmingly about aesthetics and cultural sophistication, not a distant war. Typically, when John Kane dedicated the cornerstone of the Exchange in Philadelphia—the apogee of the Greek Revival in the heart of the self-proclaimed "Athens of America"—he did not refer to politics but looked ahead 150 years to "when the building which we have founded shall stand among the relics of antiquity, another memorial to posterity of the skill of its architect,—and proof of the liberal spirit, and cultivated taste, which, in our days, distinguish the mercantile community"—a cogent summary of the aesthetic and symbolic role public architecture was expected to play. The watchword was taste, not politics.[37]

The specific political context of slavery is often called upon to explain the South's legendary fondness for the Greek Revival: "Many apologists for southern civilization saw the South as a society of traditions and unchanging principles, and an architecture that rested on precedent seemed to echo that unvarying order"; "That the South's 'peculiar institution' could be exonerated through association with classical antiquity was the message of [Greek Revival] plantation architecture"; the revival "flourished especially in the Deep South of the slaveowners." But there is in fact little evidence that links southern attitudes on slavery with architectural tastes; and if the Greek Revival justified slavery so effectively, one might wonder why the style waned in the South (as elsewhere) in the 1850s just as the slavery issue became most urgent and, as Robert Gamble writes, "at the very time when Southern nationalism was gaining momentum." That slavery and architectural taste had little real connection is suggested by the remarks of a Georgia writer who urged

new obedience to the dictates of the *northern* architect Downing so that "the prevailing style of building with massy Doric columns and Corinthian capitals, to private residences, will rapidly disappear." This was in 1853, in a Deep South inflamed by *Uncle Tom's Cabin* and with slavery on everyone's mind. During this same period, master builder Abner Cook designed temple-form Greek Revival mansions for wealthy citizens of Austin, Texas. As historian Kenneth Hafertepe has shown, however, many of the owners were born outside the South, owned few slaves, and opposed secession; only one went on to fight for the Confederacy. He concludes, "The association of white-columned mansions with Southern secession or Southern nationalism does not hold up."[38]

In accounting for the southerner's choice of Greek Revival as a domestic style (fig. 2.17), one historian finds that "aesthetic erudition was far less important than the heroic ideals of democratic Athens and Republican Rome, whose venerable political systems had been based on slave labor"; but in fact the opposite was probably true—the display of proper taste was much more significant than political associations. If insecurity about taste accounts for the literalism of the Greek Revival in America at large, the situation must have been especially acute in the South, which has always fretted about its backwardness. Lamenting that "the South is far behind the North," John Forsyth called upon the people of the Ridge of Chunnenuggee to reform their architecture and thereby "rescue your Alabama, a part of our loved sunny South, from the reproach now cast upon it by every traveller, of being behind the civilization of the age in the refinements and elegancies of rural life."[39]

The South is a land of legends, and historical commentary on its Greek Revival architecture has frequently been marked by creative speculation. Over the years, however, some have worked to disentangle the web of "pallid myth" that has grown up around the subject. In 1945, James C. Bonner first tried to overturn the white-column notion of "the Greek Revival as the traditional rural house of the plantation South." He identified Greek Revival homes as primarily an urbane phenomenon of "towns and villages. . . . It is too often forgotten that before 1860 it was there, and not on the plantation, that they achieved their highest perfection in the Lower South." In the 1970s, Gamble made a bold assertion: "There seems to be little evidence that Southerners on the eve of the Civil War associated neoclassical architecture and the classic-style portico with the virtues of a peculiarly Southern way of life." And Mills Lane more recently reminded us, "The Greek Revival was neither particularly American nor particularly Southern."[40]

If politics is an imperfect and limited explanation for the Greek Revival,

economics may be a better one. From its first application in America, the Grecian was considered a frugal means of building, as it had been in Britain; J. C. Loudon held that the best new houses were Greek "from its greater compactness, and from its having comparatively few ornaments." Strickland's Second Bank exemplified economy-minded planning, having been designed in response to an advertisement that read, "In this edifice, the Directors are desirous of exhibiting a chaste imitation of Grecian Architecture, in its simplest and least expensive form." The Greek Revival accommodated the financial constraints of the homebuilder, Mills wrote: "The natural good taste and the unprejudiced eye of our citizens required only a few examples of the Greek style to convince them of its superiority over the Roman for public structures, and its simplicity recommended its introduction into their private dwellings."[41]

Advertising his services as an architect in a New York newspaper in 1825, Ithiel Town stressed the Grecian's universality, chasteness, and economy:

> It will be the subscriber's endeavour, to introduce, generally, the taste and style of the Grecian Architecture, which from its simplicity, elegance, and grandeur, is evidently gaining the confidence and admiration of all who possess a true and classic taste, throughout the civilized world; and while the Grecian Architecture or even the general spirit and taste of it possesses this important advantage over the trifling, unmeaning innumerable little parts, in the prevailing modern taste in building, it is, *very fortunately* at the same time, a much more permanent and economical style for general use, both in public and private buildings.

One will notice the absence of any reference to politics, republicanism, or uniquely American conditions; on the contrary, Greek is appropriate "throughout the civilized world." Later Louisa Tuthill, too, equated Greek with economy, not political circumstances: "It is as easy to plan a city, a village, or a building, in good taste, as in bad taste, and *as cheap too*, since that is an all-important consideration. Simplicity of style in architecture is in itself a beauty. A Doric temple is perfectly simple, yet what object of art is more imposing and beautiful?"[42]

The word constantly applied to the Greek Revival was *chaste*, which at once connoted beauty achieved with economy. As Tucker wrote, the greatness of Greek lay in "*utility* and convenience," "*utility*" and "*beauty*," as ancient architects "seem always to have hit the happy mean between too much and too little variety." Chasteness went hand in hand with the middle-state ethos that perfectly suited antebellum America—a strong economic rationale for the Greek Revival.[43]

The Doric Cabin

A much-illustrated design from Davis's *Rural Residences* is the "American House" or "American Cottage No. 1" (fig. 1.4). In spite of its name, it was not altogether American but was borrowed from T. D. W. Dearn's rustic-columned, prostyle "Design for Two Cottages for Labourers" in his *Sketches in Architecture* (London, 1807). Still, Davis adapted it to suit a distinctive type of American construction: "The Log House is peculiar to America; and it may take a classical form with propriety and the closest attention to economy." The pediments at front and rear were left open to admit light to dormitories within, giving very much the character of the early Greek temples of wood. "This house might easily be constructed in a woodland region, with a saw-mill near, and would consist of cedar or hemlock boles, and axe hewn timber." It was never built, but its form (though not its materials) found echo in Davis's Smith Hall, University of North Carolina, Chapel Hill (1850–52). The American House introduces an important but seldom-discussed subject, the Picturesque connections between the Greek Revival and the rustic, including the role of the so-called Doric Cabin.[44]

The basis for Davis's design is what Joseph Rykwert and other scholars have termed the "primitive hut," the first shelters of humankind as adduced by eighteenth- and nineteenth-century theorists and mentioned frequently in the villa books as a first-principles standard for efforts at architectural reform and as the theoretical basis for rustic design. The ultimate account of the origins of architecture was the ancient Roman writer Vitruvius, whose thoughts were reinterpreted by Laugier in France and by William Chambers in *A Treatise on the Decorative Part of Civil Architecture*. Richard Payne Knight (*The Progress of Civil Society*, 1796) and others followed Chambers in their accounts.[45]

Chambers's interest was stimulated in part by the rustic Doric temples in English gardens, such as the grotto illustrated in *Vitruvius Britannicus* (1736), and he designed one himself—probably for a gardener's cottage at Kew Gardens—an essay that was later actually built on an Irish estate and inhabited until the 1980s. Daniel Malthus, father of the political economist, erected "a rustic temple" at the Rookery, Surrey (ca. 1759–68): "The pediment is supported by columns covered with bark, so as to resemble the trunks of trees; and the sides are formed of laths filled in with moss." Utile et dulce was the rule: "The back of this curious edifice proves to be a *cow-house!*" William Wrighte illustrated a rustic design meant "to represent the primitive state of the Dorick Order." The Doric-rustic connection was raised also by Loudon,

who faulted a certain rustic portico for lacking capitals or plinths for its rough log posts; these would "have also the great advantage of calling forth the associations which belong to them, as parts of the orders of Grecian Architecture. It ought to be the maxim of all architectural improvisers, never to neglect an established association." Francis Goodwin, in his "Villa, in the Cottage Style," placed a Tuscan-like capital atop rustic posts. A visitor to Jeffrey Wyatt's Endsleigh Cottage, Devonshire (1810), noted the "rustic verandas . . . supported by trunks of oak trees as columns, in the order, as may be supposed, of the primitive Doric."[46]

The primitive hut would shape thought in the United States, too, where it seemed particularly interesting given the rapid progress Americans were making in launching their culture to higher stages of development. Asher Benjamin plagiarized Chambers in *American Builder's Companion;* Downing wrote of "shelter" as the "first necessity" in architecture; and Tuthill referred to Chambers's caves and hollow trees in her account of the origins of building. Edward Shaw quoted Chambers at length and regretted that we know so little of primitive architecture, because of course "that awful visitation of the Almighty, the universal deluge, obliterated almost every mark of previous habitation." In *Elinor Fulton,* Hannah Lee has a young architect instruct the heroine on "the first kind of houses that people lived in," not log houses but rather "caves and the hollow of rocks; and God was the first great Architect. Then, as families multiplied, they wanted separate habitations, and they formed something like what the Indians call wigwams; that is, they took groups of trees, and cut out the centre ones, then twisted the tops of the outer trees together, and so made themselves a shelter from sun and rain."[47]

So broadly were these ideas disseminated, a children's primer on architecture could ask, "What are the buildings of savage nations? Describe one of their rude huts. . . . Describe the second kind of primitive huts." And so familiar was the primitive hut in villa literature, American architect John Bullock could spoof it in his pattern book of 1854. The first design he offered was "THE TERRA DEL FUEGO COTTAGE," a miserable hovel with one advantage only: it "costs no money" at all. Bullock chuckled, "We do not presume that any of our readers will adopt the cottage of the Fuegans." When Lowell, Massachusetts, architect William Brown sat down to write about the "Origin of Architecture" in 1847—"caverns and holes of the rocks," "tents," "low huts, or wigwams . . . reeds, canes, the leaves, bark and boughs of trees were employed"—Thoreau was living just a few miles away at Walden Pond (fig. 1.3). Thoreau's fascination with the primitive hut explains some long-mysterious passages concerning his Walden dwelling, including his fantasy "of a larger

and more populous house, standing in a golden age, of enduring materials, and without ginger-bread work, which shall still consist of only one room, a vast, rude, substantial, primitive hall." This building of the future, developed out of his Walden model, recalls the Greek Doric temple of the past, the glory of a Periclean Golden Age—a succinct expression of the neoclassical "first principles" approach to architecture.[48]

The basis of much of this contemporary thought was the understanding that Greek temples had originally been wooden, a "Doric cabin" ancestral to the beauties of the Parthenon (fig. 5.29). This was not speculation, but actually attested to by ancient writers; as late as A.D. 173 a wooden column still stood at the Temple of Hera, Olympia, the rest of them having been gradually replaced with stone over centuries. Edmund Aikin wrote in 1808 of "the extreme simplicity of their construction" among the Greeks: "The system of decoration is not separated from that of construction, but forms an essential part of it. The wooden hut is the model of both, the post and lintel are transmuted into the column and entablature, and the cabin into a temple." Americans, too, showed their interest in the Doric cabin. Brown expounded upon "the hut as a symbol of columnar architecture, which is identical with the Grecian." Benjamin (parroting Chambers) explained the wooden origins of the Doric: "The Doric order . . . being the most ancient of all the orders . . . retains more of the structure of the primitive huts, in its form, than any of the rest; having triglyphs in the frieze, to represent the ends of joists; and mutules in its cornice, to represent rafters," and so forth.[49]

To associationist-minded (and patriotic) contemporaries, the Doric cabin immediately suggested the forms of the American log house—the primitive hut of the New World. Nathaniel Hawthorne argued in his journal that, "as the architecture of a country always follows the earliest structures, American architecture should be a refinement of the log-house. The Egyptian is so of the cavern and mound; the Chinese, of the tent; the Gothic, of overarching trees; the Greek, of a cabin." Perhaps Hornby Lodge was an exercise along such lines (fig. 3.36). Tuthill held that "the most splendid Grecian temple is only an ornamented copy of the oblong house with its upright posts. Log cabins were used, thousands of years before they were built by American backwoodsmen." She illustrated her point with a proto-Doric hut that decidedly resembled a log cabin (fig. 5.30). Likewise enthusiastic about what he called "The Ancient Log Cabin" was Orson Squire Fowler, who gushed, "The inventor of the rectangular log-house should have been immortalized." He wrote of "THE COTTAGE OR DORIC STYLE" as an architectural type—not an American innovation, however, since Loudon had already illustrated a Doric-

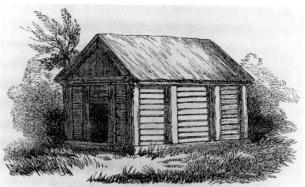

style cottage. Fowler—the erstwhile author of the women's health manual *Tight-Lacing, or The Evils of Compressing the Organs of Animal Life* (1844)—knew a thing or two about inventing new architectural geometries, having promoted the octagonal house in America, with considerable success.[50]

As early as 1814, Tucker discovered "in our own rustic porches . . . the germ of the Grecian column and vestibule" and predicted that, left to themselves, Americans would have invented "Greek" forms on their own, an argument borrowed by a writer in *Putnam's Monthly* in 1853 to defend the Customs House in New York (Town and Davis, 1833–41) against those who complained that it was merely a copy of a Greek temple: "The Parthenon was only the expanded idea of a log cabin, and we have quite as good a right to an expanded log cabin in New-York as ever they had in Athens, for we have had a good many more of the primitive types of the Greek temple in our country than there ever were in Greece. Our meridian is very nearly the same as that of Athens, and the climatic requirements of both cities are similar. We think it is quite probable that our architects would have planned just such buildings as our so-called Greek Custom-House, if a copy of Stuart and Revett had never crossed the Atlantic, or Athens never existed." This argument is untenable, of course, and slights the profound and continuing American reliance upon British precedent and British books. It suggests again the gnawing insecurity that some contemporaries felt about the nation's ability to shape its own architectural destiny. Typically, however, the writer argues that United States architecture, if left alone, would not have produced *novel* forms but would have exactly recapitulated Greece—Europe's highest standard.[51]

The stimulating connection between log architecture and the Doric would remain alive in the American mind long after the Greek Revival was extinct and log houses were in short supply, as the story of the Abraham Lincoln

Birthplace Memorial illustrates (fig. 5.31). Lincoln was born in 1809 in a log cabin at Sinking Spring, Kentucky, where he lived for his first two and a half years. The house was removed to a nearby farm in 1860, returned in 1894, and then taken on a nationwide tour by railroad from 1897 to 1906, when it was at last purchased by an association that sought to preserve it as a memorial. With coins from schoolchildren the organizers built an enormous shrine of Connecticut pink granite and Tennessee marble, the first museum by young John Russell Pope, who would go on to design many others, including the National Gallery of Art, Washington, D.C., in a similarly heroic classicism. Fifty-six steps symbolized each year of Lincoln's life. The place has been called "a bizarre confrontation between container and contained"—a juxtaposition that seems less odd when one recognizes the continuing influence of the pre-1850 log house–Doric temple equation.[52]

*Figure 5.31.
Early-nineteenth-century
log cabin housed in John
Russell Pope, Abraham
Lincoln Birthplace
Memorial, Hodgenville,
Kentucky, 1909–11.
Courtesy National Park
Service*

The Reaction

Tucker believed that adherence to Greek forms was proof against architectural faddism and "the luxuriant wanderings of taste." But it can be argued that, on the contrary, the Greek Revival itself was a kind of fad and not so politically or socially profound as is usually supposed. After all, in most places it came and went with great suddenness, and even in those situations where it ought to have been most zealously retained, succeeding styles quickly deposed it. Walter, high priest of the Greek Revival in the 1830s, abandoned it in his Renaissance Revival additions to the United States Capitol designed in 1850–51, and far more completely than would have been necessary to harmonize with the earlier, Chambers-style classicism. At Pennsylvania College, the first two campus buildings were Greek, but that mode was so unfashionable by 1860 that the third structure was built in Italianate (fig. 5.2). (No one would ascribe the choice of Italianate to Americans' political affinities to Italy, by the way.) This and other nineteenth-century campuses—Princeton's is a particularly striking example—comprised a merry parade of architectural styles that freely changed their garb every few decades in the entirely human urge to keep up with fashion. Harvard by 1857 boasted buildings in a

variety of styles, and they showed a typical progression: Federal-style classicism to the 1820s, Greek and Gothic debuting in the 1830s, Italianate in the 1840s, Romanesque in the 1850s (fig. 5.32). As James O'Gorman points out, the rock-faced Romanesque walls of Boylston Hall were erected during the undergraduate years (1856–59) of a young Louisianan who had come to study engineering but, perhaps inspired by watching the construction on campus, decided to become an architect. This was Henry Hobson Richardson, who would dominate the American profession with his bold interpretations of the Romanesque after 1870 (fig. 5.28).[53]

Contemporaries remarked on the faddish nature of the Greek Revival. A similar mania had already swept through the world of women's fashion; Latrobe in a public address of 1811 called for the application of Grecian principles in architecture just as "the fair part of this assembly once did in adopting the Grecian dress" — all of this long before the Greek War for Independence. Discussing the larger classical mania in England, Alison was clear that it was a mere fad: in his lifetime he had seen Chinese taste in furniture, followed by Gothic, "which had become fashionable in the world from many beautiful compositions both in prose and verse. The taste which now reigns is that of the ANTIQUE. Every thing we now use, is made in imitation of those models which have been lately discovered in Italy; and they serve in the same manner to occupy our imagination." One trend merely follows on another, the latest owing to little more than "those recollections of Grecian or Roman taste, which have so much the possession of our minds, from the studies and amusements of our youth." In America, Cooper saw the Greek revival as trendy, making a character in *Home as Found* (1838) say, "An extraordinary taste is afflicting this country in the way of architecture . . . nothing but a Grecian temple being now deemed a suitable residence for a man in these classical times." His companion replies, "The malady has affected the whole nation . . . like the spirit of speculation. We are passing from one extreme to the other, in this as in other things." Tuthill wrote of the "perfect mania for the Grecian orders," the "Grecian mania" with which Americans were for many years "rabid" until "the Gothic and Elizabethan mania . . . seized them," with none of these crazes more significant than the others.[54]

In a similar vein, a writer of 1855 who gave a knowledgeable capsule history of the Greek Revival saw it as a mere episode of fashion, one that gave way in turn to other episodes:

The prevalence of the national taste for Athenian architecture, which, a few years since overspread the whole country, may be traced to the erection of

Figure 5.32. *Harvard College, 1857. Main view, from far left, Paul Schulze, Boylston Hall, 1857; Richard Bond, Gore Hall (Library), 1838, demolished 1913; Charles Bulfinch, University Hall, 1813; Schulze, Appleton Chapel, 1856, demolished 1931. Harvard Yard beyond. Far right building, Richard Bond, Lawrence Hall (Scientific School), 1847, burned 1970. Middle three insets, Isaiah Rogers, Observatory, 1843–51, partly demolished 1954–60; Dane Hall (Law School), 1832, 1844, burned 1918; Solomon Willard and Thomas Sumner, Divinity Hall, 1825. Julius Hermann Kummer,* Bird's Eye View of Harvard College, and Old Cambridge, *1858, tinted lithograph, hand coloring. I. N. Phelps Stokes Collection, Miriam and Ira D. Wallach Division of Art, Prints and Photographs, The New York Public Library, Astor, Lenox and Tilden Foundations* [Deak 731]

the Bank of the United States, in Philadelphia, as the revival of Gothic architecture in England may be attributed to Horace Walpole's "pie-crust battlements" at Strawberry Hill, near London. Nicholas Biddle said, in one of his letters to the public, that there were two great truths in the world, one was the Bible, and Greek architecture the other. As the United States Bank was in full feather at the time, and as Mr. Biddle was its manager, the people regarded him as an oracle, and put a Grecian portico in every thing they built, whether it were a church, a bank, a dwelling-house, a post office, a city hall, or hencoop. But the Bank of the United States came to nought

in process of time, and, though the Greek temple it inhabited, still stands in its naked majesty, in Chesnut street, yet Greek architecture went out of fashion, and was succeeded by a taste for the Gothic.

Here are few of the deep patriotic or political significances modern writers have ascribed to the Greek Revival. Architect D. H. Arnot observed in 1849, "The fancy for temples is . . . declining, and has now almost expired, either from the strong voice of censure and ridicule, or the desire for something more novel and *distingué*." Like several other contemporary accounts, this one suggests that historian Thomas Tallmadge may have been close to the mark in his iconoclastic opinion, voiced in the 1920s, that "the Greek Revival in America was a fad pure and simple."[55]

As with its origins, there was nothing uniquely American about the decline of the Greek Revival, which in its trajectory paralleled the situation in England: "slow gestation, explosive popularity and sudden eclipse," with a few practitioners holding out surprisingly long. As late as 1854, Shaw's *Modern Architect* promoted the Greek Revival enthusiastically, and in some places the style lingered into the 1860s or even beyond. Many factors were involved in its decline, but most came down to a desire for greater choice—even in so basic an area as building stones. As the expansion of quarrying continued unabated, so, too, increased the desire to use stone more freely, especially the brownstones abundant in Connecticut and New Jersey that were only with some incongruity applied to the Greek Revival, which really demanded white marble or gray granite. The new materials favored a change to Gothic or Italianate. By 1847 the committee in charge of building the Smithsonian Institution in Washington had a wide range of stones to choose from, all of which they subjected in progress-minded fashion to a laboratory test for weathering abilities: Virginia sandstone; Maryland sandstone, marble, and granite; Pennsylvania limestone and marble; New Jersey sandstone; New York marble; Connecticut sandstone; and Nova Scotia sandstone. A lilac gray–tinted Virginia sandstone from Bull Run quarry in the Seneca Creek formation was selected (fig. 2.8). In the matter of building stones—as in taste overall—the wish was for more options after years of Greek Revival stringency.[56]

Greater choice was made possible too by the increasing sophistication of stone carvers, who proved themselves adequate to the challenge of rendering the intricate details of Gothic architecture once the softer stones became widely available. As New York's architectural prestige gradually eclipsed Philadelphia's after 1840, all eyes were on Richard Upjohn's Gothic Revival Trinity Church (fig. 1.6), the first nonclassical building to garner the kind of

nationwide adulation that Girard College, say, had received previously. Up-john was an English architectural carpenter who came to America in 1829 and became a designer of churches. For Trinity, he employed the red sandstone of Little Falls, near Newark, New Jersey, and thereby triggered the brownstone boom that would indelibly shape the appearance of nineteenth-century New York. The young diarist George Templeton Strong followed the construction of Trinity with pride and hoped for a swift end to an era "when churches are modelled after Parthenons—even to the bulls' heads and sacrificial emblems on the frieze." (Technology fascinated him, too; he noted that the "steam engine shows its true value now that the stone has to rise 140 feet.") Like many educated Americans he had fallen under the spell of English theorist A. W. N. Pugin, who condemned Greek and promoted a nationalist Gothic in his widely read books *Contrasts* (1836) and *The True Principles of Pointed or Christian Architecture* (1841). Visiting Green-Wood Cemetery, Brooklyn, in 1844, Strong breathed a sigh of relief: "I'm glad to see that what Pugin calls the 'revived Pagan style' doesn't prevail very extensively there."[57]

Trinity was part of a sudden turn toward archaeological medievalism, fostered by the efforts of the Cambridge Camden Society in England to shape American church design. George Washington Doane, Episcopal bishop of New Jersey, visited England in 1841, the year the society began publishing the *Ecclesiologist*, and the first number announced that he had been elected a member. On his return home he hired John Notman, who had already built in Gothic at Laurel Hill (fig. 2.24), to design a chapel for a girls' school. The window over the altar copied one at Stanton Saint John, Oxfordshire, and was "possibly the first . . . exact reproduction of an English medieval detail in an American church" (fig. 5.33). More ambitious still was Doane's commissioning of Upjohn to build a large parish church, Saint Mary's, working from published drawings of a medieval building at Shottesbrook, Berkshire (fig. 5.34). The Cambridge Camden Society disapproved of this particular English church as a model, but a march toward greater literalism was nonetheless under way. It culminated with Saint James the Less, Philadelphia (1846–48), erected from drawings of Saint Michael's, Long Stanton, that had been directly supplied by the society. The result was a stone-built replica of an English medieval structure on United States soil.[58]

During these years, Downing was leading a campaign against the Greek Revival for its failure to adhere faithfully to the principles of the Picturesque and especially to fitness and humility. He followed the lead of Loudon and other British writers in voicing what was in fact a rather old complaint; years earlier Edmund Bartell had warned in a villa book that a Grecian portico with

"elegantly-formed pillars and pilasters" was "an entrance proper for a mansion" and could hardly be applied to a modest home; "a Grecian portico attached to a clay-walled cottage" was an absurdity. "In designing a mansion, or a villa, the architect should bear in mind the models of Palladio, the temples of Greece, or the palaces of Rome; but if the cottage partake of these, it is pedantic." Taking aim at the temple-form literalness that marked the domestic Greek Revival in America, Downing deplored house designs "in the form of Greek temples, sacrificing thereby the beauty of variety, much convenience, and all the comfort of low and shady verandas, to the ambitious display of a portico of stately columns." Already Davis had called "the Greek Temple form . . . inappropriate for country residences." This conviction was taken up by the novelist Cooper, likewise part of the Hudson River intelligentsia, who spread them to a vast audience. He has a character complain of the villas at Newburgh, "Many of these buildings are obviously disproportioned, and

(left)
Figure 5.33.
John Notman, Chapel of the Holy Innocents, Burlington, New Jersey, 1845–46. Lithograph, 1869. Library of Congress

(right)
Figure 5.34.
Richard Upjohn, Saint Mary's, Burlington, New Jersey, 1846–48. Interior rebuilt after fire, 1976. HABS, Library of Congress

Greek Revival and Beyond ⌈ 265

then, like vulgar pretension of any sort, Grecian architecture produces less pleasure than even Dutch"; "Of all abortions of this sort, to my taste, a Grecian abortion is the worst." It was devastating when America's most popular author wrote, "One such temple well placed in a wood, might be a pleasant object enough; but to see a river lined with them, with children trundling hoops before their doors, beef carried into their kitchens, and smoke issuing, moreover, from those unclassical objects, chimneys, is too much even for a high taste."[59]

In a series of publications around 1840—a moment when the stream press was becoming extremely prolific—authors condemned the Greek Revival in architecture and manners as out of touch with contemporary life. Harriet Martineau declared that the Greek town names in New York were irreverent to the essential dignity and formality of the Antique tradition, a "mischief which has been done by boys fresh from their smattering of the classics, who have gone into the forest to hew out towns and villages." She felt troubled when "speculating sometimes on what the classical conceptions can be in the minds of youths who hear every day, in the most sordid connexion, of Rome, Utica, Carthage, Athens, Palmyra, and Troy." Frederick Marryat wrote of Syracuse in 1837, "I do detest these old names vamped up. Why do not the Americans take Indian names?" Similarly, for a writer of 1855, the "Tiber" at Washington seemed a cognomen fashioned by "some pompous donkey." In the privacy of his diary, Strong dared question the very value of a classical education, wondering was it right "to poison the minds of boys of fourteen with Ovid." Encountering such comments, those who argue that the Greek Revival flourished as a cultural symbol of American democracy ought to wonder how things Grecian came so swiftly to be seen as quite the opposite—as exemplars of "an obsolete form of government, and a widely different state of society from our own." Downing, too, used a metaphor from language: "If we talk pure Greek, and build a Grecian temple for a dwelling, we shall be . . . laughed at by our neighbors. . . . Let us rather be more sensible, though not less graceful in our architectural utterance, and express a pleasant, every-day language in an old English mansion, a Rural Gothic cottage, or an Italian villa."[60]

As in Britain, the same arguments from fitness that had been used to promote the Greek Revival were eventually used to bring it down. As Greek-style public buildings proliferated in the United States, they were eventually faulted for being costly and pretentious, violating the dictum that a structure should only be as elaborate as use demands. In this regard, Girard College was especially blamed. Fredrika Bremer, evaluating in 1850 "the fancy which the Americans have for the temple-style in their buildings," concluded that

"the use of the colonnade and other ornaments is sometimes carried to an excess, not accordance with the idea of the building, particularly as regards private houses." James Stirling condemned the Classical-style Orphans' Hospital in Charleston (Jones and Lee, 1853–55) as a "palatial anomaly," an "imposing edifice" of "massive grandeur . . . conspicuous among the wooden shanties with which it is surrounded"; "it was absurd to take children from log-huts, rear them in a palace, and return them as apprentices to wooden shanties." In Philadelphia, John Fanning Watson lamented that "the increased style of elegance of all public edifices is strikingly manifest since the year 1830. Every thing now goes upon a scale of *magnificence*. Such is our exchange, our banks, our poor house, our prisons, hotels, theatres, market houses, colleges, churches, mint, water works, Girard college, &c., &c. Every thing is now as manifestly made for ornament as for use. This is sufficiently proved in the palace-like appearance of the two great asylums provided for the poor upon the banks of the Schuylkill." The Renaissance public buildings to come would be even more sumptuous and showy; but for observers around 1850, Greek architecture suddenly seemed costly and lavish—and, in its rigid rectilinearity, ill-suited to complex modern purposes.[61]

Tuthill wrote, "There has been for many years in our country a perfect mania for the Grecian orders. Every building, from the shop of the tradesman to the church and the capitol, must be Grecian." The revival had come to be faulted for its very profusion, its indiscriminate application to every kind of structure—the same arguments that had been raised in England by the late 1830s and voiced by Pugin with withering effect. Cooper in 1838 decried "one town in the interior that has actually a market-house on the plan of the Parthenon!"—and five years later an American writer could moan about "these times, when every thing is so desperately Grecian. . . . Every one is weary of the eternal Grecian." At that time, all kinds of buildings were Greek Revival, including many train stations, the quietude of Greece incongruously paired with the screeching of the locomotive. At Nahant, Massachusetts, stood "a very ornamental little building, in the Grecian style, which contains billiard rooms," and a resort on an island in Boston Harbor mimicked a peripteral temple (fig. 5.35). (Andalusia, too, had a "little temple" billiard room.) These surprising conjunctions may have inspired one critic's jibe against "reerecting the eternal temples of the tropics, in timber and plaster imitations on the bleak shores of New England." A miniature, cast-iron Grecian tholos served as a lighthouse in Maine until 1943, poised against thundering surf in a setting far removed from ancient Athens or Rome (fig. 5.36). This toy has been thought to derive from the Choragic Monument (in spite of its Roman order),

but in fact it copies Hamilton's Robert Burns Monument, Edinburgh (finished 1830), with portholes in lieu of laurel wreaths.[62]

All of these American buildings were of course wildly at variance with the original uses of Grecian architecture, the nineteenth-century multiplication of building types having gotten far ahead of aesthetic developments, so that, from a modernist perspective, at least, contemporary functions collided awkwardly with archaeological literalism. An English architect visiting New York in 1834 commented, "The Greek mania here is at its height, as you may infer from the fact that every thing is a Greek temple, from the privies in the back court, through the various grades of prison, theatre, church, custom-house, and state-house." It was really too much to see "Greek temples, dedicated to Cloacina . . . placed immediately over the cesspool." No one style could fit all uses, and to attempt such a thing was in itself a denial of the rule of fitness. When the Greek Revival came to be applied to everything—to "a church, a bank, and a hall of justice," "a post office, a city hall, or hencoop"— its demise was surely inevitable.[63]

Figure 5.36.
*Portland Breakwater
Lighthouse, South
Portland, Maine, 1855.
Photograph, 1962.
HABS, Library of
Congress*

Alternatives

Robert Dale Owen's *Hints on Public Architecture* (1849) was one of several essays in its decade to call for a turn from Greek Revival. In an attack on classicism based on the values of fitness and economy, Owen promoted "Arch Architecture" as inherently more flexible than the rigid Greek. The tall new commercial buildings on the major thoroughfares in New York and other cities especially seemed to demand a round-arched aesthetic. Already Rundbogenstil was arriving, a brick Renaissance Revival mode popular in central Europe. Vienna-trained Leopold Eidlitz came to work for Upjohn in 1843, and both men played key roles in introducing this new approach. The precocious twenty-one-year-old Rhode Islander Thomas A. Tefft shaped the future direction of industrial architecture with his brick interpretations of the mode starting in 1847. His work in Lombard Romanesque style impressed even the gimlet eye of Thoreau: "Was struck with the Providence depot, its towers and great length of brick" (fig. 5.37). At 750 feet long it was America's largest sta-

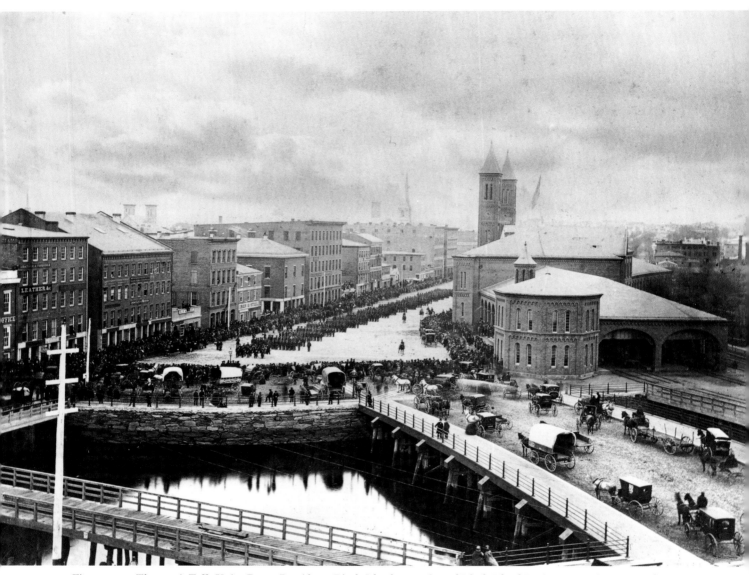

Figure 5.37. *Thomas A. Tefft, Union Depot, Providence, Rhode Island, 1847. Second Rhode Island Regiment on review, 20 April 1861. Depot burned 1890s.* © 2001 Rhode Island Historical Society. All rights reserved

tion. Tefft looked to Friedrich von Gärtner in Munich, but England was a major source of the American round-arched style, too; Norman architecture was much discussed in Loudon's *Architectural Magazine* from the moment of that journal's debut in 1834, and already British railroad stations employed long arcades.[64]

Some highly successful commercial buildings were designed in the Greek manner, such as the Brazer's Building, Boston (1842), but the mode was re-

strictive, lacking, as Samuel Sloan put it, "the great pliability of design" that arched medieval styles afforded. "Doric and plate-glass have a natural antipathy, which no ingenuity can overcome," said Boston architect Arthur D. Gilman—and in the end plate glass triumphed. Gilman called *Antiquities of Athens* "that inexhaustible quarry of bad taste" and led the fight for Renaissance Revival. As Hamlin succinctly said in a 1952 lecture, "eclecticism" replaced the Greek Revival for two main reasons, "the desire for a more complete freedom in planning and exterior form" and "the new problems—like those of the business buildings—which an emerging industrialized culture and a growing city produced." The granite verticalism on display at the Brazer's Building was doomed to extinction, despite its clean functionalism that led architect John Mead Howells to comment in 1931, "This building shows somewhat the vertical simplicity of some of the most modern European buildings."[65]

The Quincy granite so emblematic of the Greek Revival could be taught new tricks, especially as enormous quantities were shipped south. Philadelphia and Wilmington were defended by the thick walls of Fort Delaware (1849–59), partly of Quincy blocks that are virtually unweathered even today, and the ubiquitous vertical-stone storefronts of Boston were copied in the Quaker City by the 1840s, William L. Johnston's Jayne Building being especially daring in its design (fig. 5.38). Johnston died of consumption at age thirty-eight and Walter completed the building, which showed Venetian Gothic detailing in Quincy granite on the Chestnut Street front (fig. 5.39), brick on sides and rear (fig. 5.40 is a hitherto-unremarked early view). Mortars and pestles (not finally installed) referred to Jayne's lucrative patent medicine business, and a tower soared above the roofline. Bundled colonnettes were a stylish solution to the new problem of great building height, more elegant than simply punching holes in stark brick walls, as was done elsewhere in Philadelphia at the seven-story Pennsylvania Steam Sugar Refinery (fig. 5.41). As early as 1834 there was an eleven-story refinery in town—the kind of great height that would begin to become common only after Elisha Graves Otis's invention of the safety elevator in New York in 1852.[66]

The Historic American Buildings Survey was the brainchild of preservation architect Charles E. Peterson in November 1933. In 1951, Peterson voiced a thesis that the Jayne, an "ante-bellum skyscraper," had inspired the vertical, functionalist tall-building façades of Louis Sullivan and deserved to be seen as one of the most significant buildings of the period we are considering. He pointed out that it stood across Chestnut Street from the fourth-floor architectural offices of Furness and Hewitt, where an impressionable

seventeen-year-old Sullivan apprenticed in the summer of 1873, just before economic downturn forced him on to Chicago and eventual fame as a pioneer of architectural modernism. Surely the Jayne's association with an icon of American architecture should have been enough to save the building, which was bought by the National Park Service as part of its urban renewal campaign around Independence Hall. Whether the old and underused structure should stay or go became one of the liveliest preservation debates of the 1950s. Peterson, Henry-Russell Hitchcock, Philip Johnson, and others lobbied on its behalf, but they could not sway the czar of the renewal campaign, Judge Edwin O. Lewis, who viewed the gray, sooty commercial building as an eyesore no different from many others that sat empty in the blighted district; he held that it detracted from the park's mission of telling the story of 1776 and was too expensive to use for any modern function. Growing tired of the preservation debate that swirled around the building, in December 1956 he urged the director of the National Park Service to "speed up the demolitions in the National Park area, including the Jayne Building and the remaining properties on Dock Street, so that we can have some planting installed."

Figure 5.40.
*Jayne Building,
detail of fig. 5.5.
Photograph, 1867.
Historical Society
of Pennsylvania
[Penrose Small B.4]*

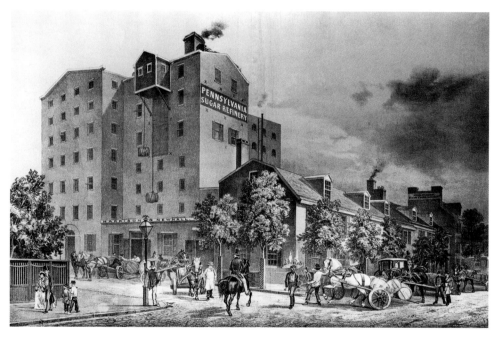

Figure 5.41.
*Harrison and Newhall's
Pennsylvania Steam Sugar
Refinery, Philadelphia.
Lithograph, 1856.
The Historical Society
of Pennsylvania
[Bc35 H324]*

Within months the landmark was gone, the demolition permit listing under "Justification," "This building is not of historic interest or practical use" (fig. 5.42). In 2000, the long-lived Peterson still spoke forcefully of the "crime" that was the demolition of the Jayne Building.[67]

In this light, it is ironic to look back to 1867, when the shining, sixteen-year-old Jayne Building stood proudly a block away from the scene of the de-

struction not only of Latrobe's lovely bank but, in the foreground, a building one hundred years older than that, the Slate Roof House (1687–99), where William Penn once lived (fig. 5.5). Surging commercialism as symbolized by the massive Jayne (and suggested by the proliferation of signage in the few years between figs. 5.4 and 2.2) had transformed the neighborhood and doomed its early landmarks. From their day to ours, cityscapes are continually evolving, remorselessly grinding down the good along with the bad.

The wiry look of the Jayne façade was unusual, but the arched mode became widespread after 1850 for commercial structures in American cities (fig. 5.5), and Gothic and especially Renaissance schemes flourished. Old Greek Revival buildings were sometimes retrofitted to be round arched, as happened to the rear elevations of the Treasury Department, shown in a rarely seen photograph (fig. 5.43). Mills's cornice remains, but the rest of the entablature has been altered everywhere except for a piece on the north (left) wall—the view showing the "ineffective" detailing of the ends and "the abrupt termination" of the colonnade that Walter complained about in 1838 (Mills had assumed that there would be additions). These larger windows were an attempt

Figure 5.43. *Robert Mills, Treasury Department, east and center wings, Washington, D.C., 1836–42. Entablature and roofline of these rear elevations altered ca. 1859–64. In foreground, A. B. Mullett, Treasury Department north wing under construction. Photograph, ca. 1867. Library of Congress*

to bring light to the upper story, which Walter in his critique found oppressively dark. The growth of the Treasury Department into the 1860s, as seen in the picture, is suggestive of the steady expansion of bureaucracies and looks ahead to the huge office buildings of the late nineteenth century, when these would become one of the most important of all architectural types.[68]

In the matter of new Renaissance and round-arched design, the Boston architect Gilman was highly appreciative of English advances, praising Charles Barry's Italianate Travellers' (1829) and Reform Clubs (1837–41), London, in 1844: "The picturesque and striking beauty, of the manner which he had chosen, have, beyond question, greatly conduced to form a growing taste for the *palazzo* style among the architects of 'the great metropolis.'" He hoped that this taste would soon spread to America and snuff out the tiresome Greek Revival, and indeed there almost immediately followed the Boston Museum by Hammatt and Joseph E. Billings, young brothers still in their twenties who had worked as draftsmen for Ammi B. Young on the sternly Greek Boston Custom House. The combination museum-playhouse was built for Moses Kimball, the Boston showman who had once provided his friend P. T. Barnum with the wildly popular "Fejee Mermaid," a grotesque stitchery of monkey and fish. The Billings coaxed Quincy granite into the forms of the Venetian Renaissance and adorned it with graceful balconies and gaslights sparkling all down the façade (fig. 5.44). Inside, Corinthian Hall with its twenty columns housed the museum collections (fig. 5.45). Greece was fast surrendering to Italy, as at the A. T. Stewart Store, a white-marble palazzo in New York (1845–46), or at John Notman's Athenaeum, Philadelphia, of Newark brownstone outside and with handsome interiors that survive in impeccable condition today. Abandoning the Greek Revival, American architecture had found a Renaissance Revival direction it would follow as a leading approach right through the rest of the nineteenth century, to McKim, Mead and White and beyond.[69]

The themes treated in this book do not end in 1850. In a sense, the story only begins then, for the Picturesque ideas we associate with Downing did not fully take hold until after his death in 1852, and alternatives to Greek were then just beginning to spread. In domestic design, it took years for architects and builders to develop the themes first broached before 1850, such as the villa as an expression of the owner's personality; associative medievalism; and deliberate variation of surface treatments, including board and batten (all seen in fig. 5.46). These were years of prosperity (despite some downturns) and explosive growth; between 1850 and 1860 the population of the United

States grew 35 percent, from 23.2 to 31.4 million. By every measure, including number of buildings constructed in city and countryside, it was a time of phenomenal change. Modern towns that have no structures at all surviving from the 1840s or earlier will often have several from the 1850s. Politically, the growing pains of these years led directly to the debacle that was the Civil War; aesthetically, they trended toward the extraordinary showiness and flamboyance that marked American architecture of the Lincoln and Grant age.

One can see the results of the demographic and economic expansion of the 1850s by looking once more at Gettysburg. Studying photographs taken at the time of the battle, it is remarkable to think that the town had been laid out just eighty-three years earlier, almost within the memory of its oldest citizens. Growth had not been steady and incremental, however, but came in surges, with considerable rebuildings and a surprising number of demolitions along the way. A wood engraving of 1843 shows four cupolas and steeples rising over the village; of these, only one still stood in 1863 (Christ Lutheran Church of 1835–36, which even today is framed by its original linden trees on Chambersburg Street). Many old Gettysburg landmarks were swept away

Figure 5.46.
*Alexander Jackson
Davis*, Wildmont, near
Llewellyn Park, New
Jersey, *1856–59, enlarged
1878. Burned 1884.
Watercolor, ink, and
graphite on paper, 15⁷⁄₁₆ ×
19¾ in. (39.3 × 50.2 cm).
Avery Architectural
and Fine Arts Library,
Columbia University in
the City of New York*

in the great rebuilding of the 1850s, and of the seven towers that punctuated the skyline in 1863, virtually all were the result of this phase: Saint James Lutheran Church, 1848; German Reformed Church, 1851; Saint Francis Xavier Church, 1852–53; Public School, 1857–58; Gettysburg Railroad Depot, 1858; and Adams County Courthouse, 1859. One finds a similar situation nationwide, as the 1850s brought unprecedented construction and, for the first time in most towns, stylish architectural innovations other than Greek. Gothic and Italianate motifs appeared in Gettysburg in the 1850s, jigsaw work and board and batten became popular, and suddenly no pretentious house could be without elaborate brackets at the cornice (see fig. 5.2). Thus the published ideas of the 1840s really made themselves broadly felt only after the end of our period. Gettysburg as seen from Seminary Ridge in 1863 retained the basic form of pre-1850, but surprisingly many of its prominent

buildings were new, and they were more self-consciously stylish than their plainspoken Federal predecessors.[70]

So 1850 is not a conclusion but another moment of transformation in the complex and fascinating course of nineteenth-century American architecture. This book began with Walter and Thoreau, as well as Davis, so it is fitting to glance at them one last time before ending. Thoreau did not survive long enough to see the great changes that the postbellum period brought nor, thankfully, the amusement park that was built on the shores of Walden Pond in 1866. But Walter lived on, watching his Philadelphia grow and transform, right into the age of the skyscraper. Ruined by bankruptcy in 1873, the old man came out of retirement to work as a consultant on the Philadelphia City Hall, an anticlimactic end to the career of this great Greek Revival architect who had, in what must have seemed some other lifetime, enlarged the United States Capitol and erected its splendid dome. In 1884 he was recalled to Girard College, where he delighted in making a thorough inspection, finding the forty-year-old building in excellent condition, only he thought the roof had gotten damaged by all those tourists walking on it.[71]

Meanwhile, in New York his old critic Davis still lived, ruminating on a bygone world and crankily scribbling papers on "Abuses in Society" and "Abuses in Architecture." He loved to tell stories of his long-ago acquaintance with Cooper, Irving, Cole, Bryant, and other luminaries of early America. When his Gothic Revival summer house Wildmont (fig. 5.46) was destroyed by fire, he set about designing a replacement, his shaky pencil recollecting the forms of the Picturesque architecture he had begun to study in 1826.[72] As he sat drawing in a quiet room of his son's home, out in Chicago, Frank Lloyd Wright was making sketches for the Charnley House. But Davis's eye was on the past, not the future, and as he worked his thoughts must have wandered back to the New York Custom House and Ravenswood; to "American Cottage No. 1" and Blithewood Gatehouse; to his compatriots Town and Downing, recalling as best he could their faces and voices across the gulf of forty years. But Wildmont in its Picturesque splendor would never be rebuilt. Death put a stop to Davis's pencil, on the very threshold of the modern age—just nine years before the start of the twentieth century.

NOTES

Chapter 1:
Building the Young Republic

1. *Philadelphia as It Is in 1852*, 119. Will of Stephen Girard, 1830, in *1848–1898*, 129.

2. *Philadelphia as It Is in 1852*, 119–23; see also Arey, *Girard College*, 44–52. Bruce Laverty, "The Great Work: Thomas Ustick Walter and the Building of Girard College," in Laverty, *Monument*, 87–117.

3. Thoreau, *Walden*, 40.

4. Thoreau, *Walden*, 100.

5. Stowe, *Uncle Tom's Cabin*, 122–25. Cable, *Lost New Orleans*, 116–20.

6. Burchard and Bush-Brown, *Architecture of America*, 71. "Catskill Mountains," 353. Cooper, *Notions*, 58.

7. McPherson, *Ordeal by Fire*, 9. Entry, 4 September 1851, in Thoreau, *Year*, 199. Entry, 5 December 1856, in Thoreau, *Journal* [1906], 9:160. Hanson, "Democracy," 72, 75. Pfanz, *Gettysburg*, 293. Ritch, *American Architect*, no. 3. Chastellux to James Madison, 12 January 1783, in Chastellux, *Travels*, 382.

8. Kalm, *Travels*, 1:153.

9. Hall, *Travels*, 1:266. "Scruffy" in Cantor, "New England Landscape," 52. Entry, 25 March 1837, in Strong, *Diary*, 8. Trollope, *Domestic Manners*, 105.

10. Ritch, *American Architect*, no. 3. McPherson, *Ordeal by Fire*, 10. Carroll in Hall, *Travels*, 2:101. "Corner Stone," 128. *Philadelphia as It Is in 1852*, 15, 18–19.

11. Mary Corbin Sies, "Toward a Performance Theory of the Suburban Ideal, 1877–1917," in Carter and Herman, *Perspectives*, 239 n. 4. Woodforde, *Georgian Houses*, 145. Chandler, *Urban Growth*, 527. *Leigh's New Picture*, 27.

12. "Waiting for . . . Urban Renaissance," 53.

13. [Hunt], *Letters*, 191. Downing, "A Few Words on Rural Architecture," 9.

14. Hall, *Travels*, 1:78. Cooper, *Home as Found*, 127. Bremer, *Homes*, 2:182.

15. Liscombe, "New Era," 14. Ross, "Street Houses," 490. [Eliot], *Tremont House*, 17. Bulfinch, 1822, in Scott, *Temple*, 61.

16. Barnard, *School Architecture*, 17. Fred W. Peterson, "Anglo-American Wooden Frame Farmhouses in the Mid-west, 1830–1900: Origins of Balloon Frame Construction," in McMurry and Adams, *People, Power, Places*, 3–16. "Baloon" in Robinson, "Cheap Farm-House," 57. Whiffen, *American Architecture*, n. 8:3 (following p. 207). Peterson, *Homes*, 24.

17. See Dell Upton, "Traditional Timber Framing," in Hindle, *Wooden Age*, 35–93. Entry, 23 August 1851, in Thoreau, *Year*, 174.

18. "Topographical and Historical Description," 3:273. Jefferson, *Notes*, 257–58. Downing, *Cottage Residences*, 7. Sloan, *Model Architect*, 2:99–100.

19. Ward, "Notes," 112. Barnard, *School Architecture*, 17. Peabody, "Rural Homes," 253.

20. Jarvis, personal correspondence. Meeks, *Railroad Station*, 50–54.

21. Gary Stanton, "'Alarmed by the Cry of Fire': How Fire Changed Fredericksburg, Virginia," in Hudgins and Cromley, *Shaping Communities*, 122–34. Ross, "Street Houses," 490. "Tenements" in Fay, *Views in New-York*, 39. [Eliot], *Tremont House*, 14. Tucker, *Massachusetts Historical Society*, 44–48.

22. Douglas E. Evelyn, "The Washington Years: The U.S. Patent Office," in Bryan, *Mills*, 107–40. On fireproofing, see Wermiel, *Fireproof*, chs. 1–2.

23. Mills, *Specifications*.

24. Ware, *Georgian Period*, 1:iii. Howells, *Lost Examples*, n.p.

25. Cooledge, *Sloan* (disregarding the "Unknown" and lumping "Unknown—believed Demolished" with "Demolished").

26. Prothro, "Virginia State Capitol." Jackson, *Development*, 206.

27. Gallier, *Autobiography*, 17–20. William Strickland, autobiographical sketch, ca. 1825, John K. Kane Papers, American Philosophical Society, in Cohen, "Building a Discipline," 144. See Rilling, *Making Houses*, ch. 3.

28. "Remarks on the Progress," 372–73. Schimmelman, *Architectural Books*, 181–83. Quinan, "Asher Benjamin," 244. For Lafever, see Shepherd, "Sailor's Snug Harbor."

29. Susanne Brendel-Pandich, "From Cottages to Castles," in Peck, *Davis*, 65. Downing, *Architecture*, 109. See also Reiff, *Houses from Books*.

30. Sloan, *Model Architect*, 1:103, 7.

31. Ritch, *American Architect*, no. 4. Downing, "On Simple Rural Cottages," 107. Maynard, "Thoreau's House." On the villa books, see Archer, *Literature*; Crowley, "Happier Mansions"; McMordie, "Picturesque Pattern Books"; Schuyler, "English and American Cottages"; and Upton, "Pattern Books." On Downing, see Major, *To Live in the New World*; Schuyler, *Apostle of Taste*; and Tatum and MacDougall, eds., *Prophet with Honor*. See also Peck, "Cult of the Rustic."

32. Marx, *Machine*. Bartell, *Hints*, 5, 26. Bushman, *Refinement*, 193, 203. Wirt, *British Spy*, 73. Downing, *Cottage Residences*, vii. Downing, *Architecture*, 109. Brown, *Carpenter's Assistant*, 55.

33. Irving, *History*, 500. Downing, *Architecture*, 145, 164. On hot summers, see Downing, "Wheeler's Rural Homes," 569 n. Loudon, *Suburban*, 115; see also Loudon, *Encyclopedia*, 198.

34. Bremer, *Homes*, 1:22. Downing, "Wheeler's Rural Homes." *Arbiter:* addressed to Robert Donaldson in book dedication, Downing, *Cottage Residences*. On Wheeler, see Tatman and Moss, *Biographical Dictionary*, 849–50.

35. Willis, *Rural Letters*, 218. [Lee], *Three Experiments*, 42, 45, 94, 96.

36. Latrobe, "Anniversary Oration to the Society of Artists," 8 May 1811, in Latrobe, *Correspondence*, 3:69. [Peabody], "Downing," 5. "Tie up" in Elliott, *Cottages*, vi. Ranlett, *Architect*, 2:30.

37. Combe, *Notes*, 1:32–33. Cooper, *Notions*, 80.

38. Hitchcock, *Architectural Books*, vii–viii. Latrobe to John Wickham, 26 April 1811, in Zimmer and Scott, "Wickham House," 207.

39. Gallier, *Autobiography*, 18. Z., "Emigration," 384. On contracts, see Catherine W. Bishir, "Good and Sufficient Language for Building," in Carter and Herman, *Perspectives*, 48.

40. Hall, *Series*, 4. On the role of pattern books, see Guter and Foster, *Building*.

41. Ritch, *American Architect*, no. 16. Lang, *Views*, n.p. J. Ritchie Garrison, "Carpentry in Northfield, Massachusetts: The Domestic Architecture of Calvin Stearns and Sons, 1799–1856," in Carter and Herman, *Perspectives*, 13.

42. Malton, *Essay*, 27. Pugin, *True Principles*, 52. [Peacock], *Nutshells*, 77–78.

43. Downing, *Architecture*, 261. Loudon, *Encyclopedia*, 214. Ward, "Notes," 109. Downing, *Architecture*, 43. Knight, *Landscape*, 54.

44. Ritch, *American Architect*, no. 2. Bremer, *Homes*, 3:377. Downing, *Architecture*, 8.

45. Greenough, *Form and Function*. Neil, *Toward a National Taste*, 152. Ward, "Notes," 110–12; see also Shaffer, "Emerson and His Circle," 17–20. Thoreau, *Walden*, 242.

46. Downing, *Architecture*, 51, 138. Wheeler, *Rural Homes*, 73–74. Owen, *Hints*, 12.

47. *Picturesque Pocket Companion*, 83. Butler, *Journal*, 2:129. Linden-Ward, *Silent City*, 261.

48. Hamlin, *Latrobe*, 495. "Memoir to Congress," 1818, in Latrobe, *Correspondence*, 3:1015. John H. B. Latrobe, 1832, in Latrobe, *Architectural Drawings*, 2, pt. 2:646. See also Reinberger, "Baltimore Exchange," 136–41, 225–49.

49. Will of Stephen Girard, 1830, in *1848–1898*, 130–31. Arey, *Girard*, 49.

50. Latrobe, *Architectural Drawings*, 2, pt. 1:227–31.

51. Gibson, *Fairmount*. "Fifty prints" in Snyder, *Mirror of America*.

52. Hitchcock, *Architecture*, 183.

53. *Laing Stores*.

54. Gayle and Gayle, *Cast-Iron*, 96–102, 223. See also David G. Wright, "The Sun Iron Building," in Dilts and Black, *Baltimore's Cast-Iron*, 23–32, and Lee, "Cast Iron District," ch. 2.

55. [Royall], *Sketches*, 244. [Eliot], *Tremont House*, 17–19. See also Knowles, "Luxury Hotels," 122–33. Linden-Ward, *Silent City*, 187.

56. Gray, *National Waterway*, xvii, 66, 83. *Niles Weekly Register*, 70. See also [Davison], *Fashionable Tour*, 55. No two accounts agree on the dimensions of Summit Bridge. The replacement span was built 1865–66; the photograph of the two bridges predates June 1867, when it was reproduced as an engraving on a stock certificate. "10,000" in Raymond E. Wilson, "Twenty Different Ways to Build a Covered Bridge," in *American Wooden Bridges*, 129.

57. McPherson, *Ordeal by Fire*, 5–6. Ellet, *Popular Notice*, 8.

58. Lewis, *Ellet*. See also Lee H. Nelson, "The Colossus of Philadelphia," in Hindle, *Wooden Age*, 159–83.

59. J. M., 11 May 1834, 190.

Chapter 2:
The Role of Britain and the Picturesque

1. Wiebenson, *Picturesque Garden*, 120.

2. "1794–97" in Prime, *Arts and Crafts*, 290–95. Tatman and Moss, *Biographical Dictionary*.

3. Withey and Withey, *Biographical Dictionary.*

4. Meeks, "Henry Austin," 146. Kirker and Kirker, *Bulfinch's Boston,* 64–70. Benjamin, *Practice,* iii. *Massachusetts Magazine* (February 1794), in Kirker and Kirker, *Bulfinch's Boston,* pl. 8. "Purifying" in "Topographical and Historical Description," 3:250. Weld, *Travels,* 1:39. See also Damie Stillman, "City Living, Federal Style," in Hutchins, *Everyday Life,* 159–61.

5. *Missouri Argus,* 11 June 1841, and *St. Louis Weekly Reveille,* 8 October 1848, in Dosch, *Old Courthouse,* 25–32.

6. Holly, *Country Seats,* 26. Downing, "A Few Words on Our Progress in Building," 250. Owen, *Hints,* 2–8, 109.

7. Pevsner, "Address," 5–6.

8. Entry, 19 March 1851, in Thoreau, *Year,* 25. Pierson, *Colonial and Neoclassical,* 297. Severens, *Southern Architecture,* 87. Gelernter, *American Architecture,* 115. "No other" in Lay, *Jefferson Country,* 1. On the Virginia Capitol, see Damie Stillman, "From the Ancient Roman Republic . . . ," in Kennon, *Republic,* 273–81.

9. Worsley, *Classical Architecture,* 54–56, 286. See also Friedman, *Gibbs,* 58–61. Jefferson, *Notes,* 254. On Clérisseau, see Poffenberger, "Jefferson's Design."

10. Strout, *American Image,* 63, 85. Reps, *Making of Urban America,* 325.

11. Strickland, *Journal,* 63. St. Méry, *American Journey,* 267.

12. Hawthorne, *Blithedale Romance,* 195. Thoreau to Emerson, 12 January 1848, in Thoreau, *Correspondence,* 203. Hall, *Travels,* 1:85, 228.

13. Willis, *Rural Letters,* 146, 152. Marryat, *Diary,* 75. Lyell, *Travels,* 1:5. Lyell, *Second Visit,* 1:164. Lyell, *Travels,* 1:65. "English Traits," in Emerson, *Portable,* 387, 354. Watson, *Annals,* 1:195.

14. Latrobe to William Waln, 26 March 1805, in Latrobe, *Correspondence,* 2:35. Yarmolinsky, *Svinin,* 39. Cooper, *Notions,* 134, 81. Butler, *Journal,* 2:129, 153.

15. Maynard, review. Ranlett, *Architect,* 2:40. Downing, *Cottage Residences,* ix. Sloan, *Model Architect,* 2:99. Bullock, *History,* iii.

16. [Cleveland], "On the Rise," 3. Alison, *Essays,* 287.

17. Foster, *Jeffersonian,* 12. [Hamilton], *Men and Manners,* 1:144–45, 162, 259–60.

18. Neil, *National Taste,* 144. [Dwight], *Things as They Are,* 76. Greenough, *Yankee Stonecutter,* 23–24. Halleck, *Fanny,* 22. J. M., *Philadelphia,* 190. Downing, "A Few Words on Rural Architecture," 9. [Cooper], *Rural Hours,* 385.

19. Entry, 16 October 1844, in Strong, *Diary,* 40. Wilson to Lawson, 4 and 28 April 1810, in Wilson, *Life and Letters,* 332, 343. Chambers, *Treatise,* 63. Cooper, *Pioneers,* 50. [Cleveland], "On the Rise," 3–4. Cooper, *Notions,* 355, 118. Marryat, *Diary,* 64, 174; see also Callow, *Kindred Spirits,* 196–97. [Ingraham], *South-West,* 2:37. [Jacques], *House,* 25. Cole to William A. Adams, December 1839, in Noble, *Cole,* xxxviii. Sedgwick in *Homes of American Authors,* 2:170.

20. Ross, "Street Houses," 493. Shaw, *Modern Architect,* 57, 60. [Gilman], "Architecture," 437–49. Davis in Cutler, "Girard College," 183. Walter to Levi Lincoln, 29 January 1838, in "New Treasury," 15.

21. Hamlin, *Greek Revival.*

22. Scott, *Temple,* xiv. Jeffrey A. Cohen, "Forms into Architecture," in Kennon, *Capitol,* 45–46. Mills, "Unpublished Diary," 192–93.

23. Scott, *Temple,* 5. Latrobe to Thomas Jefferson, 21 May 1807, in Latrobe, *Correspondence,* 2:428. Scott, *Temple,* 56–60, 85.

24. Latrobe to Mary Elizabeth Latrobe, 17 April 1815, in Latrobe, *Correspondence,* 3:644. Latrobe to Thomas Jefferson, 12 July 1815, in ibid., 670. Latrobe to Abner Lacock, 24 September 1814, in ibid., 575.

25. "Chalgrin" in Scott, *Temple,* 88. "Brittle" in Latrobe to Commissioners, 2 May 1815, in Latrobe, *Correspondence,* 3:661. Latrobe to Commissioners, 8 August 1815, in ibid., 681–82. "100 Men" in Latrobe to Thomas Jefferson, 28 June 1817, in ibid., 905. Latrobe, *Architectural Drawings 2,* pt. 2:591.

26. Kloss, *Morse,* 68–79.

27. Scott, *Temple,* 97. "American School" in Baird, *Impressions,* 283; see also Owen, *Hints,* 9–10. On corn orders see Downing, *Architecture,* 362; Brownell, "American Style," 129–31; Damie Stillman, "From the Ancient Roman Republic . . . ," in Kennon, *Republic,* 287–91; Allcott, "Scholarly Books"; and Taylor, "Building for Democracy," 297–98.

28. McAlester, *Field Guide.* "Floodgates" in Burchard and Bush-Brown, *Architecture of America,* 99. "Patronizing" in Early, *Romanticism,* 51. Longstreth, "Architectural History," 327. Upton, review of McAlester, 211. The first style guide was Whiffen, *American Architecture Since 1780.* For a critique, see Noble, *Wood, Brick, and Stone,* 130.

29. Pevsner, *Outline,* xix. Loudon, "On the Means," 52. Downing, *Architecture,* 8.

30. Patrick, *Architecture in Tennessee,* 120–21.

31. Morrison to Jackson.

32. "Mills" in Liscombe, *Altogether American*, 185–86. Downing, [Introductory essay], 9.

33. Copley and Garside, *Politics*, 1. Hornor, *Description*, 38. On the Picturesque in Britain, see Andrews, *Picturesque*; Watkin, *English Vision*; Summerson, *Architecture in Britain*; Hussey, *Picturesque*; Ackerman, *Villa*, 213–27; Stillman, *English Neo-Classical Architecture*, 2:497–523; Bermingham, *Landscape and Ideology*, 57–85; Crook, *Dilemma of Style*; and Simo, *Loudon*. In America: Pierson, *Technology and the Picturesque*; Whiffen, *American Architecture*, 179–80; Gowans, *Styles and Types*; and Kornwolf, "The Picturesque in the American Garden and Landscape Before 1800," in Maccubbin and Martin, *Gardens*, 93–106.

34. Hussey, *Picturesque*. "Spiry" in Downing, *Cottage Residences*, 47. Downing's final trip in Cook, "Late A. J. Downing," 380. On the Mall, see David Schuyler, "The Washington Park and Downing's Legacy to Public Landscape Design," in Tatum and MacDougall, *Prophet*, 291–312; George B. Tatum, "Nature's Gardener," in ibid., 43–80; Schuyler, *New Urban Landscape*, 68–74; Therese O'Malley, "'A Public Museum of Trees': Mid-Nineteenth-Century Plans for the Mall," in Longstreth, *Mall*, 61–76; and Kowsky, *Country*, 45–48. On urns, see Downing, *Cottage Residences*, 149.

35. Hamlin, *Greek Revival*, 332–33. Latrobe, "An Essay on Landscape, Explained in Tinted Drawings" (1798–99), 2 vols., in Latrobe, *Virginia Journals*, 2:467–531. See Latrobe, *Architectural Drawings*, 2, pt. 1:3–34; and Maynard, "'Best, Lowliest.'"

36. Early, *Romanticism*, 51. Meeks, *Railroad Station*, 3. O'Gorman, *Three American Architects*. For pirating, see *How to Build*. Maynard, "Picturesque," 1:15.

37. Davis, *Rural Residences*, n.p. Downing, "A Few Words on Our Progress in Building," 251. Foulston in Crook, *Greek Revival*, 110–11.

38. Baigell, "Haviland," 82, 93–94. On Eastern State, see Johnston, *Eastern State*. "The Pagoda." See also Eberlein and Hubbard, "Vauxhall," and Baigell, "Haviland," 144–47.

39. Cutler, *Life*, 1:274–78. See also Lancaster, *Japanese Influence*, 42–45.

40. Dickey, *Laurel Hill*, 7. Downing in "Talk about Public Parks," 157.

41. Smith, *Laurel Hill*, 108; see also *Guide to Laurel Hill*, 38. On Scotland-born John Struthers, see Gilchrist, "Philadelphia Exchange," 92 n. 39, and Tatman and Moss, *Biographical Dictionary*, 771.

42. Dickey, *Laurel Hill*, 7. [Cleveland], "On the Rise," 16.

43. Parry, *Cole*, 216, 242–46.

44. Baird, *Impressions*, 280. Plan of the National Gallery, 1844–49, in Christman, *1846*, 52.

45. Irving to George Harvey, 23 November 1835, in Aderman, *Irving*, 844–45. See also Butler, *Sunnyside*, and Maynard, "'Best, Lowliest.'"

46. [Richards], "Sunnyside," 9, 7. [Cleveland], "On the Rise," 18. Toole, "American Cottage Ornée," 69.

47. [Richards], "Sunnyside," 7, 9. Willis, *Rural Letters*, 322–23, 108.

48. Bremer, *Homes*, 1:19. Lowell, "Rural Cot," 254. "Tudor arch" in Downing, *Architecture*, 383; fig. 178 shows a parlor very similar to this one.

49. Bremer, *Homes*, 1:19–20. "Farm and Villa," 90. See also [Cook], "Home of the Late A. J. Downing"; Kowsky, *Country*, 23–26; and Downs, "Newburgh Villa."

50. Bremer, *Homes*, 1:27. G. W. Curtis, in Downing, *Rural Essays*, li, xlvi, lvi–lvii.

51. Susanne Brendel-Pandich, "From Cottages to Castles," in Peck, *Davis*, 70–71. NYU in Francis R. Kowsky, "Simplicity and Dignity," in ibid., 50. *New York American*, 27 May 1837, in Scully, *Dakin*, 21.

52. "Description of the State-House," 2. Entry, 29 June 1816, in Foster and Finkel, *Watson's Travels*, 296. "Nothing striking" in [Hamilton], *Men and Manners*, 1:336. Hazard, ed., *The Register of Pennsylvania* 1, no. 10 (28 February 1828): 152–54, in "Independence Hall/ 19th Cent."

53. Cocke to Botts; see also Brownell, *Making of Virginia Architecture*, 258. Downing, *Architecture*, 265–66. See also Loth and Sadler, *Only Proper Style*, 71–72. From Loudon, *Encyclopedia*, 216–24, Cocke evidently followed the "Scotch style" (or Flemish) dwelling, using the second of eight gable alternatives.

54. N. H., "Architecture of Country Houses," 139. Catherine W. Bishir, "A Spirit of Improvement: Changes in Building Practice, 1830–1860," in Bishir, *Architects and Builders*, 142. [Cooper], *Rural Hours*, 382–84.

55. Peat, *Indiana*, ch. 2. Pierson, "Upjohn," 232. J. Ritchie Garrison, "Carpentry in Northfield, Massachusetts: The Domestic Architecture of Calvin Stearns and Sons, 1799–1856," in Carter and Herman, *Perspectives*, 20.

56. Walter and Smith, *Two Hundred Designs*.

57. Salmon, *Palladio Londinensis*. Rees, *Cyclopaedia*, vol. 32. On the rustic, see Peck, "Cult of the Rustic."

58. Wrighte, *Grotesque*, 5. Plaw, *Ferme Ornée*, 3–4. Schimmelman, *Architectural Books*, 183.

59. Bickham, *Beauties*, n.p. Mr. Aubrey, in Timbs, *Picturesque Promenade*, 263. "Anchorite" in *Ambulator*, 89. On Deepdene (demolished 1969), see Nairn and Pevsner, *Surrey*, 191–94. The year 1813 in Hornor, *Description*, 58. Anonymous translator of Chastellux, *Travels*, 215 n.

60. Betts, *Garden Book*, 18 n. 2, 25–27. "Orator" in Stuart and Revett, *Antiquities of Athens*, 1:27.

61. Cutler, *Life*, 1:274–78.

62. L. G. to Eliza, June 1788, "Woodlands," Society Miscellaneous Collection, Historical Society of Pennsylvania, in Betts, "Woodlands," 217. Jefferson to William Hamilton, July 1806, in Betts, *Garden Book*, 323.

63. Downing, *Treatise* [1841], 388. "Farm and Villa," 89. Latrobe to Giambattista Scandella, 22 February 1798, in Latrobe, *Journals*, 2:357. Peck's, 93. Downing, *Treatise* [1844], 480. [Cook], "Home of the Late A. J. Downing."

64. Ricketson and Ricketson, *Ricketson*, 26–28. Entry, 16 March 1847, in Alcott, *Journal*, 196–97. To Margaret Fuller, 29 August 1847, in Emerson, *Letters*, 3:413. To Emerson, 14 November 1847, in Thoreau, *Correspondence*, 189. November 1847 in Alcott, *Journal*, 197. See also Harding, *Days*, 216–19.

65. On camps, see Kaiser, *Great Camps;* Dietz, "Home in the Woods"; and Maynard, "Ideal Life." King, *Complete Works*, 347. Kenwood in *Ambulator*, 62. Soane, *Sketches*, "Explanations of the Plates," i. Temple, *Repton's Pavilion Notebook*. Mansbridge, *Nash*, 212–13.

66. Lugar, *Architectural Sketches.* "Columns or trunks" in Plaw, *Ferme Ornée*, 4. Malton, *Collection*, 33. Bartell, *Hints*, 24. Middleton, *Picturesque and Architectural*, 2. Loudon, *Suburban*, 393–94. Halfpenny, *Pocket Companion*, 9. Dearn, *Sketches*, 2. Malton, *Essay*, 22.

67. "Suburban Gardens," 189. [Mitchell], *Rural Studies*, 107–9.

68. Davis, *Rural Residences*, n.p. Downing, *Cottage Residences*, 167–68. Downing, *Treatise* [1859], 339. August 1807, in Foster, *Jeffersonian America*, 144. Beecher, *Domestic Economy*, 291.

69. Linden-Ward, *Silent City*, 190. Cleaveland, *Green-Wood*, 10.

70. Lang, *Highland Cottages*, n.p. Ranlett, *Architect*, 2:8, 27, 24. Willis, *Rural Letters*, 326–27.

71. "Berrian" in Wheeler, *Rural Homes*, 89. On rustic furniture, see Kylloe, *Rustic Traditions*, and Stephenson, *Rustic Furniture.* Watson, "Trip to the Sea Shore." Watson, "Itinerary," 72. Hall, *Travels*, 1:102–3.

72. *Rustic Work*, n.p.

Chapter 3:
Villa, Cottage, and Log House

1. Anderson, "Century Club," 137.

2. Sloan, *City and Suburban*, 84. No. 46 (25 August 1750), in Johnson, *Rambler*, 1:249–50. Gascoigne and Ditchburn, *Twickenham*, 12. Timbs, *Dorking*, 284.

3. Cole, "Essay on American Scenery," 100. Cole to Daniel Wadsworth, 6 July 1826, in McNulty, *Correspondence*, 1. Cole, "Letter to the Publick." Cole, "Essay on American Scenery," 109. Hall, *Travels*, 1:52. See Maynard, "Cole Drawing."

4. Bremer, *Homes*, 2:93.

5. Elmes, *Metropolitan*, 24, 86. Mansbridge, *Nash*, 256–57. Archer, "Country and City," 148–49. Downing, *Treatise*, 1841, 313 n.

6. Ritch, *American Architect*, no. 12.

7. Thoreau, *Walden*, 329. See also Larkin, *Reshaping*, 204–31. Beecher, *Treatise*, 267. Bremer, *Homes*, 2:146. Cooper, *Notions*, 59. Clifford E. Clark, Jr., "Domestic Architecture as an Index to Social History . . . ," in St. George, *Material Life*, 538.

8. Cutler, *Life*, 1:225. Jack Larkin, "From 'Country Mediocrity' to 'Rural Improvement' . . . ," in Hutchins, *Everyday Life*, 190–91. [Eliot], *Tremont*, 17.

9. Entry, 22 August 1806, in Latrobe, *Journals*, 3:80. Jack Larkin, "From 'Country Mediocrity' to 'Rural Improvement' . . . ," in Hutchins, *Everyday Life*, 175–200. Warville, *On America*, 186. Hall, *Aristocratic*, 87.

10. Woodforde, *Georgian Houses*, 142. Julius Bryant, "Villa Views and the Uninvited Audience," in Arnold, *Georgian Villa*, 11–24. Cooper, *Notions*, 59. [Ingraham], *South-West*, 2:80. Trollope, *Domestic Manners*, 200 n. 4. Shanley, *Making of Walden*, 185.

11. Francis R. Kowsky, "The Architectural Legacy of Andrew Jackson Downing," in Tatum and MacDougall, *Prophet*, 278. Birch, *Country Seats*, n.p. Kirker and Kirker, *Bulfinch's Boston*, 38. Entry, 19 July 1796, in Latrobe, *Journal*, 1:164–65. Fearon, *Sketches*, 98, 63. "Lieutenant" in de Roos, *Personal Narrative*, 48–49, 81. Cooper, *Notions*, 80, 356.

12. Damie Stillman, "The Neo-Classical Transformation of the English Country House," in Jackson-Stops, *Fashioning*, 75. Repton, *Landscape Gardening*, 469–70. Elmes, *Metropolitan*, 26. Brown, *Carpenter's Assistant*, 140. "$50" in George B. Tatum, "Nature's Gardener," in Tatum and MacDougall, *Prophet with Honor*, 71. Davy, *Views*,

account of Plashwood, n.p. Ranlett, *Architect*, 2:20–22. Woodforde, *Georgian Houses*, 141.

13. Strickland, *Journal*, 183. "Visit to the Virginia Springs . . . No. II," 544. Cooper, *Notions*, 355. Bernard L. Herman, "The Model Farmer and the Organization of the Countryside," in Hutchins, *Everyday Life*, 35–60. Ritch, *American Architect*, nos. 11 and 3.

14. Bremer, *Homes*, 1:49. Sylvanus, "Random Notes," 223. Downing, *Cottage Residences*, 101. Watson, "Tour to New England."

15. Shaw, *Modern Architect*, 58–59. Wheeler, *Rural Homes*, 35. Horace Greeley, *New York Tribune*, 2 April 1849, in Harding, *Days*, 239.

16. Forsyth, "Address," 125.

17. Loudon, *Encyclopedia*, 257. Willis, *Rural Letters*, 109. On Manning, see Herbert, "Portable Colonial Cottage."

18. Bridenbaugh, *Cities*, 24–25; see also 144, 338. Strickland, *Journal*, 213. See also Hammond, " 'Where the Arts.' "

19. *Northern Traveller*, 289–90. [Hamilton], *Men and Manners*, 1:159. *Picturesque Pocket Companion*, 22. Downing, *Treatise* [1859], 36. Downing, "Hints to Rural Improvers," 11–12. Downing, "A Few Words on Our Progress in Building," 249. Lang, *Views*, n.p. Thoreau, *Walden*, 180.

20. Chandler, *Four Thousand*, 486, 490. Ranlett, *Architect*, 1:19.

21. Strickland, *Journal*, 41. Cooper, *Notions*, 38. James Fenimore Cooper, "American and European Scenery Compared," in *Home Book of the Picturesque*, 53. [Hamilton], *Men and Manners*, 1:10. Downing, *Treatise* [1859], 36. To Mrs. John Thoreau, 6 August 1843, in Thoreau, *Correspondence*, 132. Archer, "Country and City," 150–52.

22. Susanne Brendel-Pandich, "From Cottages to Castles . . . ," in Peck, *Davis*, 67. Ranlett, *Architect*, 2:19. Watson, "Trip to the Sea Shore." Cooke and Cooke, *Southern Coast*, 2:n.p. See also Lindsay Boynton, "The Marine Villa," in Arnold, *Georgian Villa*, 118–29.

23. Fearon, *Sketches*, 73. Shupe, *New York*, 201. Mitchell, *Statistics*, 26–27. Jackson, *Crabgrass Frontier*, 25–30. St. Méry, *American Journey*, 170.

24. *Kidd's London Ambulator*, 26. Bremer, *Homes*, 1:53–54, 75–76, 3:367.

25. Butler, *Journal*, 1:48. Foster, *Jeffersonian*, 300. Cutler, *Life*, 1:228, 325. Strickland, *Journal*, 89. Populations in Shupe, *New York*, 201. Betsy Blackmar, "Rewalking the 'Walking City' . . . ," in St. George, *Material Life*, 371–84.

26. Foster, *Jeffersonian*, 306. Diary, 23 July 1816, in Foster and Finkel, *Watson's Travels*, 307. Fearon, *Sketches*,

92. Wright, *Views*, 14. Levasseur, *Lafayette*, 1:83. "Still Unidentified," 24.

27. "Catskill Mountains"; see also Willis, *American Scenery*, 3:106. Van Zandt, *Catskill Mountain House*, 9. [Hunt], *Letters*, 108–9. Cole, "Essay on American Scenery," 106.

28. Cooper, *Notions*, 176. *Northern Traveller* [1844], 8. Dutchess Co. in [Hunt], *Letters*, 156. *Northern Traveller* [1844], 24.

29. Cooper, *Home as Found*, 117. *Northern Traveller* [1844], 21. "Hudson" in diary, 25 July 1816, in Foster and Finkel, *Watson's Travels*, 309. [Hunt], *Letters*, 17, 151. *Northern Traveller* [1844], 23.

30. Bremer, *Homes*, 1:19. "Lined with" in Cooper, *Home as Found*, 113. Bayard Taylor, "Travels at Home," ca. 1850s, in Rockwell, *Catskill Mountains*, 252–53. Zukowsky, "Castles," 73.

31. Schoepf, *Travels*, 1:121–22. Weld, *Travels*, 1:24. St. Méry, *American Journey*, 97.

32. On Birch, see *Birch's Views*, and catalogue entry by Kimberly Kroeger in Nygren, *Views and Visions*, 240–41. *Century of Population Growth*, 11–12.

33. Robertson, *Topographical Survey*, pt. 1, 88. Anonymous translator of Chastellux, *Travels*, 141 n. Cutler, *Life*, 1:256–57.

34. Butler, *Journal*, 1:163. Betts, "Woodlands." On Parkyns, see catalogue entry by Judith Ann Hughes in Nygren, *Views and Visions*, 276–77. Jefferson to William Hamilton, July 1806, in Betts, *Garden Book*, 323. Diary, 13–21 June 1816, in Foster and Finkel, *Watson's Travels*, 290–94.

35. Butler, *Journal*, 1:164 n. Downing, *Treatise* [1841], 24. July 1835, in Watson, "To Note & Observe." Watson, "Summer Excursions."

36. *Philadelphia as It Is* [1834], 115. Dare, *Railroad Guide*, 102.

37. Linley, *Georgia Catalogue*, 96. Bremer, *Homes*, 1:381, 3:19–20. [Ingraham], *South-West* 1:230, 253, 2:96, 1:79–80. Crocker, "Benjamin," 266–70.

38. Rusticus, "Fruits, Flowers," 404. Forsyth, "Address," 125.

39. Sloan, *Model Architect*, 1:55–56, 81. Reiff, *Houses from Books*, 74–75. Lane, *Old South*, 9.

40. Cutler, *Life*, 1:415. Trollope, *Domestic Manners*, 84, 95–96. Dickens, *American Notes*, 200, 207. Bremer, *Homes*, 2:202, 236, 351.

41. Sylvanus, "Random Notes," 223. [Peabody], "Downing on Rural Architecture," 12–14.

42. Sloan, *Model Architect*, 2:99. Entry, 21 October 1855, in Thoreau, *Journal* [1906], 7:505. Thoreau, *Walden*, 31. Catherine W. Bishir, "A Spirit of Improvement: Changes in Building Practice, 1830–1860," in Bishir, *Architects and Builders*, 134. Cooper, *Notions*, 177–78.

43. Lounsbury, *Glossary*, s.v. "blind," 34; see also "Venetian blind," 388–89. St. Méry, *American Journey*, 147. Willis, *American Scenery*, 2:9. Brown, *Carpenter's Assistant*, 131. Downing, *Cottage Residences*, 58.

44. Brown, *Carpenter's Assistant*, 140. Beiswanger, "Jefferson and the Art."

45. Gosse, *Letters*, 69. Bremer, *Homes*, 2:75, 124. Entry, 29 May 1853, in Thoreau, *Journal* [Princeton], 6:158–59. Entry, 29 December 1853, in Thoreau, *Journal* [1906], 6:32.

46. Fearon, *Sketches*, 23, 100. Wright, *Views*, 95–96. Cooper, *Notions*, 62. Hall, *Travels*, 1:74. Ranlett, *Architect*, 1:25, 2:50. Dickens, *American Notes*, 76, 119.

47. [Hofland], *White-Knights*, 30. Elmes, *Metropolitan*, 55–56. *Leigh Hunt's London Journal*, August 1834, in "General Notices," 314. Shaw, *Modern Architect*, 64. Brown, *Carpenter's Assistant*, 62.

48. "Upward direction" in Wheeler, *Rural Homes*, 32. Downing, *Architecture*, 52, 50. Davis, *Rural Residences*, n.p. Downing, *Architecture*, 51–52, 75–76.

49. Jensen, "Board and Batten," 41 n. 6. Upton, "Pattern Books," 150; see also Dell Upton, "Traditional Timber Framing," in Hindle, *Wooden Age*, 45–48. Downing, *Architecture*, 73. [Loudon], "Perspective View." Scully, *Shingle Style*, xliv.

50. Downing, *Treatise* [1841], 23. "Farm and Villa," 89. "Prototype" in Jane B. Davies, "Davis and Downing: Collaborators in the Picturesque," in Tatum and MacDougall, *Prophet*, 82. Pierson, *Technology and the Picturesque*, 304.

51. On Springside, see Toole, "Springside," 20–39; Harvey K. Flad, "Matthew Vassar's Springside . . . ," in Tatum and MacDougall, *Prophet*, 219–57; and Schuyler, *Apostle*, 164–69.

52. Lossing, *Vassar*, 74. Loudon, *Encyclopedia*, 844. Downing, *Architecture*, 83–92.

53. Downing, *Architecture*, 104–5, 42, 160. Downing, *Cottage Residences*, ix. *Springside* newsletter.

54. Dayes, *Works*, 279–311. Knight, *Landscape*, 53. Atkinson, *Views*. Wordsworth, *Guide to the Lakes*, 62. Lugar, *Architectural Sketches*, 14. Goodwin, *Domestic Architecture*, no. 6.

55. Papworth, *Rural Residences*, 57. Entry, 10 August 1806, in Latrobe, *Journals*, 3:65–66. Watson, "Itinerary."

56. Noble, *Cole*, 72–73. "*American cottage*" in Downing, *Cottage Residences*, 89. Cole, "Letter to the Publick."

56. Ranlett, *Architect*, 2:13–14. Holly, *Country Seats*, 46–47. Sloan, *Model Architect*, 2:63. See Meeks, "Austin and the Italian Villa."

57. Meeks, *Railroad Station*, 52–54.

58. Dayes, *Works*, 302. Downing, *Architecture*, 113.

59. [Hofland], *White-Knights*, 93. Mansbridge, *Nash*, 212–13. Ruskin, "Poetry of Architecture," 56–63.

60. Cooper, *Home as Found*, 113. Ranlett, *Architect*, 1:52. Cleaveland, *Villa and Farm Cottages*, 92. Bryant, *Picturesque America*, 1:245–46. Downing, "Design for a Swiss Cottage," 287.

61. Jefferson, *Notes*, 253. On the log house, see Weslager, *Log Cabin*; Hutslar, "Log Architecture"; Hutslar, *Architecture of Migration*; and Noble, *Wood, Brick, and Stone*, 110–18. Thoreau, *Walden*, 47.

62. Flint, *History and Geography*, 1:182–83. Fearon, *Sketches*, 83. Martineau, *Retrospect*, 1:83, 216. Marryat, *Diary in America*, 271. "Letters from New England," 85–86.

63. Ruskin, "Poetry of Architecture," 58. Plaw, *Ferme Ornée*, 6, 9. Diary, 30 July 1816, in Foster and Finkel, *Watson's Travels*, 313. Wright, *Views*, 105. [Peabody], "Downing on Rural Architecture," 4.

64. *The Task*, book 2, in Cowper, *Poetical Works*, 207. Gosse, *Letters*, 45, 43. Fuller, *Summer*, 58.

65. Lanman, *Letters*, 86–87. [Cooper], *Rural Hours*, 381–82. Fuller, *Summer*, 46. Strother, *Virginia*, 19–20.

66. [Dwight], *Things as They Are*, 107. The year 1807, in Irving, *History*, 290. Dwight, *Travels*, 2:127. Wilson to Alexander Lawson, 4 April 1810, in Wilson, *Life and Letters*, 332.

67. Hoffman, *Wild Scenes*, 1:29, 36–37.

68. Flint, *History*, 1:348. Chastellux, *Travels*, 34–35.

69. David S. Shields, "Reading the Landscape of Federal America," in Hutchins, *Everyday Life*, 119–36. Irving, *History*, 498–99.

70. [Cooper], *Rural Hours*, 382. William Cobbett to Morris Birkbeck, 10 December 1818, in Cobbett, *Year's Residence*, 292. "Visit to the Virginia Springs . . . No. II," 546. Barnard, *School Architecture*, 17.

71. Thomas Hulme, Journal, 1817, in Cobbett, *Year's Residence*, 261. Entry, 19 August 1840, in Webster, *Works*, 2:30; see also Watson, "Speech." Fuller, *Summer*, 45, 48. Turner, *Pioneer History*, 565.

72. Bryant, *Picturesque America*, 2:356–58. Wise, *Summer Days*, 282–83.

73. Fuller, *Summer*, 58. [Fowler], *House*, 11. Ritch, *American Architect*, no. 15. Vaux, *Villas and Cottages*, 124–25.

74. Barber and Howe, *Historical Collections . . . New York*, 63–65. See also Merritt, *To Walk*, 42, and Parry, *Cole*, 221–24.

75. Barber and Howe, *Historical Collections . . . New York*, 64–65.

76. Stowe, *Uncle Tom's Cabin*, 11. On Billings, see O'Gorman, *Accomplished*. [Fowler], *New Illustrated*, 46. Turner, *Pioneer History*, 564. Lossing, *Vassar*, 72; see also Kowsky, *Country*, 74–75.

77. Deák, *Picturing America*, 1:503.

Chapter 4:
On the Piazza

1. Entry, 19 July 1796, in Latrobe, *Journals*, 1:163. To William Hamilton, 15 January 1784, in Washington, *Papers*, 1:48.

2. Gardner, *Photographic Sketch Book*, pl. 24.

3. "Variants" in Michael W. Fazio and Patrick A. Snadon, s.v. "Greek Revival Architecture," in Wilson and Ferris, *Encyclopedia*, 78. On the porch, see Perry, "Front Porch"; on early American porches, see Poesch, *Art of the Old South*, 53–58.

4. Downing, *Architecture*, 120. Downing, *Cottage Residences*, 43. Holly, *Country Seats*, 42. Wheeler, *Rural Homes*, 110–11.

5. Wordsworth, *Guide to the Lakes*, 62. Glassie, *Folk Housing*, 137. Downs, "Covent Garden," 19. Eberlein and Richardson, *English Inn*, ch. 4.

6. Damie Stillman, "The Neo-Classical Transformation of the English Country House," in Jackson-Stops, *Fashioning and Functioning*, 82.

7. Beiswanger, "Jefferson and the Art."

8. Waters, "Conservatory," 279. Pugin, *True Principles*, 49.

9. Mansbridge, *Nash*, 101, 92. Gascoigne and Ditchburn, *Twickenham*, 32–33; see also pls. 81–91.

10. Papworth, *Rural Residences*, 104. Thomson, *Retreats*, 3. Brown, *Domestic Architecture*, 256.

11. Davis, *Rural Residences*, n.p. G. S. G., "Plan." Ranlett, *Architect*, 2:19. Downing, "A Few Words on Our Progress in Building," 251. Barnum, *Struggles*, 179.

12. Saxon, *Barnum*, 372 n. 4, 157. On Lind, see Werner, *Barnum*, 117.

13. Varden, "Design," 472. Robinson, *Rural Architecture*, n.p. Ranlett, *Architect*, 2:29.

14. Ritch, *American Architect*. Sloan, *Model Architect*, 2:70. Lang, *Views*, n.p. [Ingraham], *South-West* 2:43–44. Brown, *Carpenter's Assistant*, 139. Todd, *Country Homes*, 28. [Dix], *Local Loiterings*, 138. [Mitchell], *Rural Studies*, 100. Wainwright, "Andalusia." Strother, *White Sulphur*, 143.

15. Smith, *Plantation Houses*, 235.

16. Plaw, *Ferme Ornée*, 7.

17. Kennedy, *Architecture*, 61. Kahn and Meagher, *Preserving Porches*, 1. Gammon, *South*, 6. Foster and Finkel, *Watson's Travels*, 45.

18. Kennedy, *Architecture*, 60. Noble, *Wood, Brick, and Stone*, 13, 91.

19. John Michael Vlach, "Afro-Americans," in Upton, *America's Architectural Roots*, 45. Sue Bridwell Beckham, s.v. "Porches," in Wilson and Ferris, *Encyclopedia of Southern Culture*, 515. Kaye, *Bed in the Piano*, 101.

20. Edwards, "Origins of Creole," 189. Lounsbury, *Glossary*, s.v. "porch," 285.

21. Kennedy, *Architecture*, 61. "Georgia" in Nichols, *Early Architecture*, 48. Lounsbury, *Glossary*, s.v. "piazza," 269, "porch," 285. Entry, 14 July 1771, in Copley and Pelham, *Letters and Papers*, 131; see also Poesch, "British Officer," 77.

22. Nichols, *Early Architecture*, 48. Carl Lounsbury, "The Dynamics of Architectural Design in Eighteenth-Century Charleston and the Lowcountry," in Adams and McMurry, *Perspectives*, 60. Lane, *Mississippi and Alabama*, 18. Poesch and Bacot, *Louisiana*, 98. Ward, review, 85.

23. Chastellux, *Travels*, 272. Foster, *Jeffersonian*, 240. Sloan, *Model Architect*, 1:56. Yarmolinsky, *Svinin*, 40.

24. Ware, *Georgian Period*, 1:210. Leicester B. Holland, "Foreword," in Smith, *Plantation Houses*, n.p. Windham, *Alabama*. Sue Bridwell Beckham, s.v. "Porches," in Wilson and Ferris, *Encyclopedia*, 515. On myths of the southern porch, see Poesch, *Art of the Old South*, 335–36.

25. Poesch, "British Officer." Crowley, *Invention*, 245.

26. William H. Willcox, in Bullock, *American Cottage Builder*, 220. Ranlett, *Architect*, 2:70. Bremer, *Homes*, 2:399.

27. [Peabody], "Downing on Rural Architecture," 9. Dickens, *American Notes*, 113, 120. Entry, 3 August 1771, in Copley and Pelham, *Letters and Papers*, 137; see also Poesch, "British Officer," 79. Brown, "First Residential." Hall, *Aristocratic Journey*, 28–29, 32. Cooper, *Notions*, 80–81.

28. Lossing, *Pictorial Field-Book*, 1:667. Diary, 30 July

1816, in Foster and Finkel, *Watson's Travels*, 313. Wright, *Views*, 103. Hall, *Travels*, 1:71. Marryat, *Diary*, 89. Hall, *Travels*, 1:139. On Canada, see Crowley, *Invention*, 250–52.

29. Cutler, *Life*, 1:242. Wright, *Views of Society*, 14. Diary, 29 June 1816, in Foster and Finkel, *Watson's Travels*, 292–93, 296.

30. Bremer, *Homes*, 1:405. Dickens, *American Notes*, 182–83. Schoepf, *Travels*, 2:111. Hall, *Travels*, 2:190.

31. [Ingraham], *South-West*, 2:81. Gosse, *Letters*, 26.

32. Roos, "Ohio," 5; see also Peat, *Indiana Houses*, chs. 2–3. Trollope, *Domestic Manners*, 105. Mark L. Brack, "Domestic Architecture in Hispanic California: The Monterey Style Reconsidered," in Carter and Herman, *Perspectives*, 163.

33. Rees, *Cyclopaedia*, s.v. "portico," vol. 24. Wiebenson, *Picturesque Garden*, 119.

34. St. Méry, *American Journey*, 316. Russell Warren to William Staples, 1843, in Alexander, "Arcade," 13. See also Geist, *Arcades*. Latrobe, *Architectural Drawings*, 2, pt. 2:637–61.

35. [Mitchell], *Rural Studies*, 100. Chastellux, *Travels*, 272 n. Repton, *Landscape Gardening*, 475.

36. Chastellux, *Travels*, 88. Cutler, *Life*, 1:251, 274.

37. Cooper, *Home as Found*, 128. Strother, *White Sulphur*, 46. Severens, *Charleston*, 100–105. Scully, *Dakin*, 9. Thoreau, *Walden*, 140.

38. Watson, "To Note & Observe." Watson, "Trip to the Sea Shore." Bremer, *Homes*, 2:129.

39. Parissien, *Regency Style*, 72. *Louisiana Courier*, New Orleans, 7 February 1837, p. 3, in Scully, *Dakin*, 53.

40. [Hunt], *Letters*, 206. Willis, *American Scenery*, 1:21. Willis, "Vacation," 45. Hall, *Travels*, 1:230. [Hunt], *Letters*, 206–7. *Northern Traveller* [1826], 140; see also *Northern Traveller* [1844], 56.

41. Strother, *White Sulphur*, 18, 21, 51, 49, 65.

42. Dates in MacCorkle, *White Sulphur*, 51–53. Strother, *White Sulphur*, 24–25, 83–86.

43. Smith, *Architecture of the United States*, xx.

44. Hogan, *Lawn*, 12. Hitchcock, *University of Virginia*, 217. Turner, *Campus*, 87.

45. Role of Latrobe in Latrobe, *Correspondence*, 899–901. Jefferson to Joseph C. Cabell, 28 December 1822, in Patricia C. Sherwood and Joseph Michael Lasala, "Education and Architecture: The Evolution of the University of Virginia's Academical Village," in Wilson, *Jefferson's Academical Village*, 43. "Chiswick" in Brownell, "Laying the Groundwork . . . ," in Brownell, *Making of Virginia Archi-*

tecture, 49. On the Circular House, see Stillman, *English Neo-Classical Architecture*, 1:154; and Pevsner, *Cumberland and Westmorland*, 37, 228–29.

46. Elmes, *Metropolitan*, 67. Mills, "Architecture in Virginia," 40.

47. *Repertory* (Boston), 10 February 1804, and Edward Hooker, Diary, 6 November 1805, both in Bryan, *South Carolina College*, 37, 29. For UVA design sources, see Woods, "Jefferson and the University," 268–69 n. 14; Hogan, *Lawn*, 38; Hafertepe, "Inquiry," 227; and Richard Guy Wilson, "Jefferson's Lawn: Perceptions, Interpretations, Meanings," in Wilson, *Jefferson's Academical Village*, 62–64. Favorite cabin in Strother, *White Sulphur*, 19–20. "Visit to the Virginia Springs . . . No. 1," 475–76. Strother, *White Sulphur*, 24–25.

48. Jefferson to L. W. Tazewell, 5 January 1805, and Jefferson to the Trustees for the Lottery of East Tennessee College, 6 May 1810, both in Woods, "Jefferson and the University," 283.

49. Mills, "Architecture in Virginia," 41. Howard, personal correspondence, 2 July 2001.

50. Cooper, *Home as Found*, 151. Ranlett, *Architect*, 1:21. [Mitchell], *Rural Studies*, 99.

51. Pocock, *Architectural Designs*, 9. "Builder's Dictionary," s.v. "architrave," in Salmon, *Palladio Londinensis*. *The Task*, book 1, "The Sofa," in Cowper, *Poetical Works*, 194. Rees, *Cyclopaedia*, s.v. "portico," vol. 24. "Vauxhall" in *Ambulator*, 278. Jefferson to William Thornton, 9 May 1817, in Wilson, *Jefferson's Academical Village*, 17.

52. Loudon, *Encyclopedia*, 71, 782. Diary, 17 June 1816, in Foster and Finkel, *Watson's Travels*, 292–93.

53. Diary, 13 June 1816, in Foster and Finkel, *Watson's Travels*, 98. Sloan, *City and Suburban*, 98. Downing, *Cottage Residences*, 13, 29. Loudon, *Suburban Gardener*, 114. Hall, *Travels*, 1:139–40.

54. Latrobe to John Wickham, 26 April 1811, in Zimmer and Scott, "Wickham House," 207. Thomson, *Retreats*, 10–11. Bremer, *Homes*, 1:36.

55. Foster, *Jeffersonian America*, 115–16. Lyell, *Second Visit*, 2:111. Power, *Impressions*, 2:128. Martineau, *Retrospect*, 1:219.

56. Trollope, *Domestic Manners*, 120, 176. Peabody, "Rural Homes," 253. [Ingraham], *South-West*, 1:80–81, 2:99.

57. Downing, *Architecture*, 47. Wordsworth, "Brothers," lines 16–21. Irving, *History*, 1068.

58. [Ingraham], *South-West*, 2:98. Gregg D. Kimball, "African-Virginians and the Vernacular Building Tradition

in Richmond City, 1790–1860," in Carter and Herman, *Perspectives*, 125–26.

59. Levasseur, *Lafayette in America*, 1:126. Hall, *Travels*, 1:294. Martineau, *Retrospect*, 1:218. Cooper, *Notions*, 95–96. Bremer, *Homes*, 1:114. Martineau, *Retrospect*, 1:215.

60. Goodwin, *Domestic Architecture*, no. 16. Vaux, *Villas and Cottages*, 124. Wheeler, *Rural Homes*, 114–15. Loudon, *Encyclopedia*, 892.

61. Irving to Sarah Storrow, 23 August 1847, in Irving, *Letters*, 4:144. Watson, "Summer Excursions." Fowler, *Home for All*, 72.

62. Martineau, *Retrospect*, 1:187.

63. Brown, *Domestic Architecture*, 256. Loudon, *Encyclopedia*, 78. Downing, *Cottage Residences*, ix, 13. Downing, *Architecture*, 84.

64. Trollope, *Domestic Manners*, 239. Hall, *Aristocratic Journey*, 234. *Homes of American Authors*, 2:111. Irving, *History*, 1077. [Richards], "Sunnyside," 11.

65. Bremer, *Homes*, 1:286, 288–89.

66. [Ingraham], *South-West*, 2:81, 98.

67. Kalm, *Travels*, 1:341. [Ingraham], *South-West*, 1:246. Martineau, *Retrospect*, 1:221. Cutler, *Life*, 2:144. [Hamilton], *Men and Manners*, 2:378. Journal, 31 August 1835, in Hawthorne, *American Notebooks*, 8. [Mitchell], *Rural Studies*, 48–49.

68. Beecher, *Treatise*, 338, 271, 294–95.

69. Hall, *Travels*, 1:59–60.

70. Downing, *Cottage Residences*, 43. Appleton, *Experience of Landscape*; see also Appleton, "Prospect, Refuge." Timbs, *Dorking*, 35. Kalm, *Travels*, 1:132. [Hunt], *Letters*, 105–7.

71. Ritch, *American Architect*, no. 14. Brown, *Carpenter's Assistant*, 130. Sloan, *Model Architect*, 2:70, 1:14.

72. "Piazzas" on Strickland's plan in Cutler, "Girard College," fig. 84. [Naval Asylum, Philadelphia], newspaper clipping.

73. Wheeler, *Rural Homes*, 71. Jefferson, *Notes*, 254. Diary, 10 July 1816, in Foster and Finkel, *Watson's Travels*, 299. "Visit to the Virginia Springs . . . No. II," 546. [Ingraham], *South-West*, 2:44.

74. Birch, *Country Seats*, n.p. [Dix], *Local Loiterings*, 38. [Peabody], "Downing on Rural Architecture," 9.

75. Cutler, *Life*, 1:252. Holly, *Country Seats*, 42. [Mitchell], *Rural Studies*, 101.

76. [Cooper], *Rural Hours*, 383–84.

77. Downing, *Cottage Residences*, 13, 80. "Work of Messrs. Carrère & Hastings," 87. Loudon, *Suburban Gardener*, 114. Van Zandt, *Catskill Mountain House*.

78. Kahn and Meagher, *Preserving Porches*, x.

Chapter 5:
Greek Revival and Beyond

1. Wentz, *Seminary*, 1:150–56.

2. J. C. Trautwine to David Gilbert, 20 October 1835, 9 December 1835, and 5 January 1836, and to Michael Colver, 1902, all in Glatfelter, *Salutary Influence* 1:62, 67, 186. On American campuses, see Turner, *Campus*.

3. [Cleveland], "On the Rise," 5.

4. Downing, "A Few Words on Our Progress in Building," 250.

5. Ware, *Georgian Period*, 1:255. Alison, *Essays*, 285. Latrobe to Thomas Jefferson, 21 May 1807, in Latrobe, *Correspondence*, 2:428. Mills, *Guide to the Capitol*, 32. Shepherd, "Sailor's Snug Harbor," 117–18. Ian Gow, "William Henry Playfair," in *Scottish Pioneers*, 50.

6. *Lions of Philadelphia*. May 1796, in Weld, *Travels*, 1:189–90. Latrobe, *Architectural Drawings*, 2, pt. 1:78.

7. Latrobe to Thomas Jefferson, 21 May 1807, in Latrobe, *Correspondence* 2:428. Hamlin, *Greek Revival*, 31; concurring is Boyd, "Adam Style," 346. "Flat Dome" in "Memorial to Congress," 1818, in Latrobe, *Correspondence*, 3:1015. See Hafertepe, "Banking Houses," 27–32.

8. [Cleveland], "On the Rise," 6.

9. *Historic Structures Report . . . Second Bank*, app. C.

10. William Strickland, *Port Folio*, September 1821, in Morrison, *Historic Structure Report . . . Interior of Second Bank*. Branch banks in Sutton, *Americans Interpret*, 26–28.

11. "Corner Stone," 128. *Daily American Advertiser*, 3 January 1833, in Gilchrist, "Philadelphia Exchange," 88. "Ventilator" in John C. Evans, insurance survey, 31 March 1834, in *Historic Building Report on . . . Exchange*. "Exchange Celebration."

12. John C. Evans, insurance survey, 31 March 1834, in *Historic Building Report on . . . Exchange*. See Gilchrist, "Philadelphia Exchange." To Thomas Jefferson, 21 May 1807, in Latrobe, *Correspondence*, 2:429.

13. Will of Stephen Girard, 1830, in *1848–1898*, 131–32. To Jefferson, 21 May 1807, in Latrobe, *Correspondence*, 2:428. Downing, "A Few Words on Our Progress in Building," 251. See Cutler, "Girard College," 133–34, 164–65.

14. Arey, *Girard College*, 48.

15. Hamlin, *Greek Revival*, 82–85.

16. Taylor, "Building for Democracy," 257; see also Cohen, "Building a Discipline." Gilchrist, "Philadelphia Exchange," 93. Entry, 21 November 1854, in Thoreau, *Journal* [1906], 7:73–74.

17. Owen, *Hints*, 93. "White for the White House," 22. Seale, *President's House*, 1:147, 163.

18. Pevsner, *Outline*, xx. Eliot, *Tremont House*, 7. Graff, *Celebrating Vermont*, 152–53.

19. Vokes and Edwards, *Geography*, 117–19. Latrobe to Robert G. Harper, 13 August 1815, in Scott, *Temple of Liberty*, 89. "Exchange Celebration," 293.

20. Bruce Laverty, "The Great Work: Thomas Ustick Walter and the Building of Girard College," in Laverty et al., *Monument to Philanthropy*, 93. Gallier, *Autobiography*, 41.

21. Snow, *History of Boston*, 328 n. Wilson, *Quincy*, 218.

22. Solomon Willard to Joseph Grennell, November 1831, in Wheildon, *Memoir*, 228. Willard, *Obelisk*, 15.

23. Willard, *Obelisk*, 24. "1804" in Stapleton and Guider, "Transfer and Diffusion."

24. Wheildon, *Memoir*, 244.

25. "Albany Female Academy," 116. Entry, 30 March 1839, in Hone, *Diary*, 1:387. Wainwright, "Andalusia."

26. Gamble, *Alabama Catalogue*, 46. Peatross and Mellown, *Nichols*, 18–19. *Journal . . . State of Alabama*, 49.

27. Gamble, *Alabama Catalogue*, 250–51. Gamble, personal correspondence. Newton, *Town & Davis*, 131.

28. Ware, *Georgian Period*, 1:255. Major, *Domestic Architecture*, 11–14. Lewis E. Crook, Jr., "Foreword," in Denmark, *Old South*, n.p. Jackson, *Development*, 196, 204, 208. Leopold Arnaud, in Hamlin, *Greek Revival*, xvii, xv. Pevsner, *Outline*, 229.

29. "Distinctively" in Liscombe, *Altogether American*, 192. Gallagher, *Mills*, 59. Mills to the committee, 10 February 1838, in "New Treasury," 26.

30. Watson, *Annals*, 1:244. Hall, *Aristocratic Journey*, 70. Ranlett, *Architect*, 2:71.

31. Hornor, *Description*, 57. To James Madison, 12 January 1783, in Chastellux, *Travels*, 378.

32. [Tucker], "Thoughts," 569, 560. See also Hamlin, *Greek Revival*, 377. Dunlap, *Arts of Design*, 1:2. [Tucker], "Thoughts," 559. Shaw, *Modern Architect*, n.p. Willis, *American Scenery*, 1:23–24. Cooper, *Home as Found*, 113. [Tucker], "Thoughts," 568. Neil, *National Taste*, 144.

33. [Royall], *Sketches*, 274. [Hunt], *Letters*, 141–44.

34. Eliot, *Tremont House*.

35. Arnaud, in Hamlin, *Greek Revival*, xvi–xvii. Smith, *Architecture of the United States*, xx. Marian Scott Moffett, "Foreword," in Wiencek, *Plantations*, 4. Gowans, *Styles and Types*. Liscombe, *Altogether American*, 192. Kennedy, *Greek Revival*, 270.

36. Benjamin Henry Latrobe, "Anniversary Oration to the Society of Artists," in Latrobe, *Correspondence*, 3:81, 76. Robert Mills, "The Architectural Works of Robert Mills," in Gifford, *Literature*, 88.

37. "Greek Fever," in Larrabee, *Hellas Observed*, ch. 3. "Corner Stone."

38. Patrick, *Architecture in Tennessee*, 118. Severens, *Southern Architecture*, 45. Garrett, *Classic America*, 292. Gamble, "White-Column Tradition," 53–55. Rusticus, "Fruits," 404. Hafertepe, *Abner Cook*, 142.

39. Severens, *Southern Architecture*, 44–45. Forsyth, "Address," 125.

40. Michael W. Fazio and Patrick A. Snadon, s.v. "Greek Revival architecture," in Wilson and Ferris, *Encyclopedia*, 78. Bonner, "Plantation Architecture," 380–81. Gamble, "White-Column Tradition," 55. Lane, *Architecture of the Old South* [1993], 177.

41. Loudon, *Suburban Gardener*, 120. *Philadelphia Gazette and Daily Advertiser*, 13 May 1818, in Whiffen, *American Architecture*, 153. Mills, "Architectural Works," 89.

42. Town, advertisement. Tuthill, *History*, 327.

43. [Tucker], "Thoughts," 560–63.

44. Davis, *Rural Residences*, n.p. See Allcott, "Scholarly Books."

45. On the primitive hut, see Herrmann, *Laugier*, and Rykwert, *Adam's House*.

46. Howley, *Follies*, 83–85. Timbs, *Dorking*, 204. Wrighte, *Grotesque*, 3. Loudon, *Encyclopedia*, 191. Goodwin, *Domestic Architecture*, no. 9. *Jones' Views*, 1:n.p.

47. Downing, *Architecture*, 3. Tuthill, *History*. Shaw, *Modern Architect*, 17–18, 7. Lee, *Elinor Fulton*, 116–17.

48. Howe, *Architecture*, 68. Bullock, *American Cottage Builder*, 35, 316, 35–36. Brown, *Carpenter's Assistant*, 16. Thoreau, *Walden*, 243. See Maynard, "Thoreau's House."

49. Lawrence, *Greek Architecture*, 141. Aiken, *Designs*, 2. Brown, *Carpenter's Assistant*, 22. Benjamin, *American Builder's Companion*, 33.

50. Journal, September 1836, in Hawthorne, *American Notebooks*, 18. Tuthill, *History*, 21. [Fowler], *House*, 10. Fowler, *Home for All*, 30. Loudon, *Encyclopedia*, 238.

51. [Tucker], "Thoughts," 561. "New-York Daguerreotyped," 353.

52. Weslager, *Log Cabin*, 289–91. Fitch, *Historic Preservation*, 296.

53. [Tucker], "Thoughts," 569. O'Gorman, *H. H. Richardson*, 10–11.

54. Latrobe, "Anniversary Oration," 83. Alison, *Essays*, 305. Cooper, *Home as Found*, 113. Tuthill, *History*, 301.

55. *Scenery of the United States*, 61. Arnot, *Gothic Architecture*, 2. Tallmadge, *Story of Architecture*, 97.

56. Crook, *Greek Revival*, 130. Charles G. Page, weathering test, 1847, in Owen, *Hints*.

57. Entries, 25 April and 13 May 1844, in Strong, *Diary*, 27, 32.

58. Stanton, *Gothic Revival*, chs. 1–3.

59. Bartell, *Hints*, 23–25, 124. Downing, *Cottage Residences*, 23. Davis, *Rural Residences*, n.p. Cooper, *Home as Found*, 117, 129, 113.

60. Martineau, *Retrospect*, 1:84; see also Hall, *Travels*, 1:72–74. Marryat, *Diary*, 107. *Scenery of the United States*, 29. Entry, 25 April 1844, in Strong, *Diary*, 28. [Gilman], "Architecture in the United States," 453. Downing, *Cottage Residences*, 22–23.

61. For attacks on Girard, see Taylor, "Building for Democracy," ch. 6. Bremer, *Homes*, 2:7. Stirling, *Letters*, 252–53; see also Leukoff, *Charleston*, 83. Watson, *Annals*, 1:249.

62. Tuthill, *History*, 300. Cooper, *Home as Found*, 113. [Peabody], "Downing on Rural Architecture," 8–10. "Billiard rooms" in *Northern Traveller* [1826], 290. [Gilman],

"Architecture in the United States," 439. Jane Biddle to Nicholas Biddle, 1835/36, in Wainwright, "Andalusia," 28.

63. Ross, "Street Houses," 491–92. Downing, *Cottage Residences*, 11. *Scenery of the United States*, 61.

64. Owen, *Hints*, 63. Entry, 6 December 1854, in Thoreau, *Journal* [1906], 7:79. On Union Depot, see Curran, "*Rundbogenstil* and Romanesque," 1:270–75, and Curran, "German Rundbogenstil," 370–72. See also Meeks, "Romanesque," and Pierson, "Upjohn and . . . Rundbogenstil."

65. Sloan, *Model Architect*, 1:48. [Gilman], "Architecture in the United States," 450, 438. Hamlin, "Rise of Eclecticism," 8. Howells, *Lost Examples*, pl. 23.

66. *Philadelphia as It Is in 1852*, 138.

67. Charles E. Peterson, "The Historic American Buildings Survey: Its Beginnings," in Stamm and Peatross, *Historic America*, 7–21. On the Jayne, see Peterson, "Ante-Bellum Skyscraper"; Weisman, "Philadelphia Functionalism"; Maass, *Gingerbread Age*, 90. *Completion Report*. Peterson, personal correspondence.

68. Thomas U. Walter to Levi Lincoln, 29 January 1838, in "New Treasury," 15.

69. [Gilman], "Architecture in the United States," 455. O'Gorman, "Billings," 57–59; see also O'Gorman, *Accomplished*.

70. Frassanito, *Early Photography*, 71–81.

71. Laverty, *Monument*, 117.

72. Newton, *Town & Davis*, 110–12.

BIBLIOGRAPHY

The following abbreviations are used: HABS, Historic American Buildings Survey, Library of Congress; *JSAH, Journal of the Society of Architectural Historians.*

Ackerman, James S. *The Villa: Form and Ideology of Country Houses.* Princeton, N.J.: Princeton University Press, 1990.

Adams, Annmarie, and Sally McMurry. *Exploring Everyday Landscapes: Perspectives in Vernacular Architecture.* Vol. 7. Knoxville: University of Tennessee Press, 1997.

Aderman, Ralph M., et al. *Washington Irving: Letters.* Vol. 2: *1823–1838.* Boston: Twayne Publishers, 1979.

Aiken, Edmund. *Designs for Villas and Other Rural Buildings.* London: J. Taylor, 1808.

"Albany Female Academy." *Zodiac* 1, no. 8 (February 1836): 116–17.

Alcott, Amos Bronson. *The Journals of Bronson Alcott.* Edited by Odell Shephard. Boston: Little, Brown, 1938.

Alexander, Robert. "The Arcade in Providence." *JSAH* 12, no. 3 (October 1953): 13–16.

Alison, Archibald. *Essays on the Nature and Principles of Taste.* 1790. Reprint, Boston: Cummings and Hilliard, 1812.

Allcott, John V. "Scholarly Books and Frolicsome Blades: A. J. Davis Designs a Library-Ballroom." *JSAH* 33, no. 2 (May 1974): 145–54.

Ambulator: or, A Pocket Companion in a Tour Round London, Within the Circuit of Twenty-Five Miles. 7th ed. London: Scatcherd and Whitaker, 1794.

American Wooden Bridges. New York: American Society of Civil Engineers, 1976.

Anderson, Grace. "The Century Club." *Architectural Record* 179, no. 7 (July 1991): 136–39.

Andrews, Malcom, ed. *The Picturesque: Literary Sources and Documents.* 3 vols. The Banks, East Sussex: n.p., 1994.

Appleton, Jay. *The Experience of Landscape.* New York: Wiley, 1975.

———. "Prospect, Refuge and the Picturesque." *The Picturesque* no. 29 (Winter 1999): 1–15.

Archer, John. "Country and City in the American Romantic Suburb." *JSAH* 42, no. 2 (May 1983): 139–56.

———. *The Literature of British Domestic Architecture, 1715–1842.* Cambridge, Mass.: MIT Press, 1985.

Arey, Henry W. *The Girard College and Its Founder.* Philadelphia: Sherman, 1869.

Arnold, Dana, ed. *The Georgian Villa.* Phoenix Mill, Eng.: Alan Sutton, 1996.

Arnot, D. H. *Gothic Architecture Applied to Modern Residences.* New York: D. Appleton, 1849.

Atkinson, William. *Views of Picturesque Cottages with Plans.* London: T. Gardiner, 1805.

Baigell, Matthew Eli. "John Haviland." Ph.D. diss., University of Pennsylvania, 1965.

Baird, Robert. *Impressions and Experiences of the West Indies and North America in 1849.* Philadelphia: Lea & Blanchard, 1850.

Barber, John W., and Henry Howe. *Historical Collections of the State of New York.* 1841. Reprint, Port Washington, N.Y.: Kennikat Press, 1970.

Barnard, Henry. *School Architecture.* New York: A. S. Barnes, 1848.

Barnum, P. T. *Struggles and Triumphs.* New York: Macmillan, 1930.

Bartell, Edmund. *Hints for Picturesque Improvements in Ornamented Cottages.* London: J. Taylor, 1804.

Beecher, Catharine. *A Treatise on Domestic Economy.* 1841. Reprint, New York: Schocken Books, 1977.

Beiswanger, William L. "Thomas Jefferson and the Art of Living Outdoors." *The Magazine Antiques* (April 2000): 594–605.

Benjamin, Asher. *The American Builder's Companion.* 6th ed. 1827. Reprint, New York: Dover Publications, 1969.

———. *Practice of Architecture.* Boston: Carter, Hendee, 1833.

Bermingham, Ann. *Landscape and Ideology: The English Rustic Tradition, 1740–1860.* Berkeley: University of California Press, 1986.

Betts, Edwin Morris. *Thomas Jefferson's Garden Book, 1766–1824.* Philadelphia: American Philosophical Society, 1944.

Betts, Richard J. "The Woodlands." *Winterthur Portfolio* 14, no. 3 (Autumn 1979): 213–34.

Bickham, George. *The Beauties of Stow.* London: E. Owen, 1750.

Birch, William. *The Country Seats of the United States of North America.* Bristol, Pa.: W. Birch, 1808.

Birch's Views of Philadelphia . . . With Photographs of the Sites in 1960 and 1982 by S. Robert Teitelman. Philadelphia: Free Library of Philadelphia, 1982.

Bishir, Catherine W., et al. *Architects and Builders in North Carolina: A History of the Practice of Building.* Chapel Hill: University of North Carolina Press, 1990.

Bonner, James C. "Plantation Architecture of the Lower South on the Eve of the Civil War." *Journal of Southern History* 11, no. 3 (August 1945): 370–88.

Boyd, Sterling M. "The Adam Style in America: 1770–1820." Ph.D. diss., Princeton University, 1966.

Bremer, Fredrika. *The Homes of the New World; Impressions of America.* 3 vols. London: Arthur Hall, Virtue, 1853.

Bridenbaugh, Carl. *Cities in Revolt: Urban Life in America, 1743–1776.* New York: Alfred A. Knopf, 1955.

Brown, Frank Chouteau. "The First Residential 'Row Houses' in Boston." *Old-Time New England* 37, no. 3 (January 1947): 60–69.

Brown, Richard. *Domestic Architecture.* 1841. Reprint, London: Bernard Quaritch, 1852.

Brown, William. *The Carpenter's Assistant: Containing a Succinct Account of Egyptian, Grecian and Roman Architecture.* 1848. 4th ed., Worcester, Mass.: Edward Livermore, 1851.

Brownell, Charles E. "In the American Style of Italian: The E. C. Litchfield Villa." M.A. thesis, University of Delaware, 1970.

———, et al. *The Making of Virginia Architecture.* Richmond: Virginia Museum of Fine Arts, 1992.

Bryan, John Morrill. *An Architectural History of the South Carolina College, 1801–1855.* Columbia: University of South Carolina Press, 1976.

———, ed. *Robert Mills, Architect.* Washington, D.C.: American Institute of Architects Press, 1989.

Bryant, William Cullen, ed. *Picturesque America; or, The Land We Live In.* Multivolume. New York: D. Appleton, 1872–74.

Bullock, John. *The American Cottage Builder.* New York: Stringer & Townsend, 1854.

———, ed. *The History and Rudiments of Architecture.* New York: Stringer & Townsend, 1853.

Burchard, John, and Albert Bush-Brown. *The Architecture of America: A Social and Cultural History.* Boston: Little, Brown, 1961.

Bushman, Richard L. *The Refinement of America: Persons, Houses, Cities.* New York: Alfred A. Knopf, 1992.

Butler, Frances Anne. *Journal.* 2 vols. Philadelphia: Carey, Lea & Blanchard, 1835.

Butler, Joseph T. *Washington Irving's Sunnyside.* Tarrytown, N.Y.: Sleepy Hollow Restorations, 1974.

Cable, Mary. *Lost New Orleans.* Boston: Houghton, Mifflin, 1980.

Callow, James T. *Kindred Spirits: Knickerbocker Writers and American Artists, 1807–1855.* Chapel Hill: University of North Carolina Press, 1967.

Cantor, Jay E. "The New England Landscape of Change." *Art in America* 64, no. 1 (January–February 1976): 51–54.

Carter, Thomas, and Bernard L. Herman, eds. *Perspectives in Vernacular Architecture.* Vol. 4. Columbia: University of Missouri Press, 1991.

"The Catskill Mountains." *New Mirror* 1, no. 23 (9 September 1843): 353.

A Century of Population Growth. Washington, D.C.: Government Printing Office, 1909.

Chambers, William. *A Treatise on the Decorative Part of Civil Architecture.* 1791. Reprint, New York: Benjamin Blom, 1968.

Chandler, Tertius. *Four Thousand Years of Urban Growth.* Lewiston, N.Y.: St. David's University Press, 1987.

Chastellux, marquis de. *Travels in North-America in the Years 1780–81–82.* 1786. Reprint, New York: White, Gallaher, & White, 1827.

Christman, Margaret C. S. *1846: Portrait of the Nation.* Washington, D.C.: Smithsonian Institution Press, 1996.

Cleaveland, Henry W., William Backus, and Samuel D. Backus. *Villa and Farm Cottages.* 1855. Reprint, New York: D. Appleton, 1864.

Cleaveland, Nehemiah, with James Smillie. *Green-Wood Illustrated.* New York: R. Martin, 1847.

[Cleveland, H. R., Jr.] "On the Rise, Progress, and Present State of Architecture in North America." *North American Review* (October 1836). Reprinted in *Architectural Magazine* 4, no. 35 (January 1837): 3–19.

Cobbett, William. *A Year's Residence in the United States of America.* 1818. Reprint, Carbondale: Southern Illinois University Press, 1964.

Cocke, John Hartwell, to Charles Tyler Botts. 1844. Coll. 640, Box 112, Special Collections, University of Virginia Library.

Cohen, Jeffrey A. "Building a Discipline: Early Institu-

tional Settings for Architectural Education in Philadelphia, 1804–1890." *JSAH* 53, no. 2 (June 1994): 139–83.

Cole, Thomas. "Essay on American Scenery." Lecture to American Lyceum Society, New York, 8 May 1835. *American Monthly Magazine*, n.s., 1 (January 1836): 1–12. Reprinted in John W. McCoubrey, ed., *American Art, 1700–1960: Sources and Documents*. Englewood Cliffs, N.J.: Prentice-Hall, 1965, 98–109.

———. "Letter to the Publick on the Subject of Architecture." n.d. Detroit Institute of Arts microfilm ALC 1.

Combe, George. *Notes on the United States of North America, During a Phrenological Visit in 1838–9–40*. 2 vols. Philadelphia: Carey & Hart, 1841.

Completion Report of Construction Project, Demolition of Buildings at 234–244 Chestnut Street. 1958. Independence National Historical Park archives, Philadelphia.

Cook, Clarence. "The Late A. J. Downing." *New York Quarterly* 1 (October 1852).

[———.] "The Home of the Late A. J. Downing." *Horticulturist*, n.s., 3, no. 1 (January 1853): 20–27.

Cooke, W. B., and G. Cooke. *A Picturesque Delineation of the Southern Coast of England*. Multivolume. London: John Murray, 1814–26.

Cooledge, Harold N., Jr. *Samuel Sloan, Architect of Philadelphia, 1815–1884*. Philadelphia: University of Pennsylvania Press, 1986.

Cooper, James Fenimore. *Home as Found*. 1838. Reprint, New York: G. P. Putnam's Sons, 1913.

———. *Notions of the Americans: Picked Up by a Travelling Bachelor*. Edited by Gary Williams. Albany: State University of New York Press, 1991.

———. *The Pioneers*. 1823. Reprint, New York: G. P. Putnam's Sons, 1913.

[Cooper, Susan Fenimore.] *Rural Hours*. 1850. 4th ed., New York: G. P. Putnam, 1851.

Copley, John Singleton, and Henry Pelham. *Letters and Papers of John Singleton Copley and Henry Pelham*. Massachusetts Historical Society vol. 71. 1914.

Copley, Stephen, and Peter Garside, eds. *The Politics of the Picturesque: Literature, Landscape and Aesthetics Since 1770*. Cambridge: Cambridge University Press, 1994.

"Corner Stone of the Exchange." *Hazard's Register of Pennsylvania* 9, no. 8 (25 February 1832): 128.

Cowper, William. *The Poetical Works of William Cowper*. Edited by R. A. Willmott. 2d ed. London: George Routledge, 1855.

Crocker, Mary Wallace. "Asher Benjamin: The Influence of His Handbooks on Mississippi Buildings." *JSAH* 38, no. 3 (October 1979): 266–70.

Crook, J. Mordaunt. *The Dilemma of Style: Architectural Ideas from the Picturesque to the Post-Modern*. Chicago: University of Chicago Press, 1987.

———. *The Greek Revival: Neo-Classical Attitudes in British Architecture, 1760–1870*. London: John Murray, 1972.

Crowley, John E. "'In Happier Mansions, Warm, and Dry': The Invention of the Cottage as the Comfortable Anglo-American House." *Winterthur Portfolio* 32, nos. 2–3 (Summer–Autumn 1997): 169–88.

———. *The Invention of Comfort: Sensibilities and Design in Early Modern Britain and Early America*. Baltimore: Johns Hopkins University Press, 2001.

Curran, Kathleen A. "The German Rundbogenstil and Reflections on the American Round-Arched Style." *JSAH* 47, no. 4 (December 1988): 351–73.

———. "The *Rundbogenstil* and the Romanesque Revival in Germany and Their Efflorescence in America, ca. 1844–1864." 2 vols. Ph.D. diss., University of Delaware, 1986.

Cutler, John B. "Girard College Architectural Competition, 1832–1848." Ph.D. diss., Yale University, 1969.

Cutler, Manasseh. *Life Journals and Correspondence of Rev. Manasseh Cutler, LL.D.* 2 vols. Edited by William Parker Cutler and Julia Perkins Cutler. Cincinnati, Ohio: Robert Clarke, 1888.

Dare, Charles P. *Philadelphia, Wilmington and Baltimore Railroad Guide*. Philadelphia: Fitzgibbon and Van Ness, 1856.

Davis, Alexander Jackson. *Rural Residences*. 1837. Reprint, introduction by Jane B. Davies, New York: Da Capo Press, 1980.

[Davison, Gideon Miner.] *The Fashionable Tour*. 4th ed. Saratoga Springs, 1830.

Davy, Henry. *Views of the Seats of the Noblemen and Gentlemen in Suffolk*. Southwold: By the author, 1827.

Dayes, Edward. *The Works of the Late Edward Dayes*. 1805. Reprint, London: Cornmarket Press, 1971.

de Roos, Frederick Fitzgerald. *Personal Narrative of Travels in the United States and Canada in 1826*. London: William Harrison Ainsworth, 1827.

Deák, Gloria Gilda. *Picturing America, 1497–1899*. 2 vols. Princeton, N.J.: Princeton University Press, 1988.

Dearn, T. D. W. *Sketches in Architecture*. 1807. Reprint, Westmead, Eng.: Gregg, 1971.

Denmark, Ernest Ray. *Architecture of the Old South*.

Atlanta, Ga.: Southern Architect and Building News, 1926.

"A Description of the State-House, Philadelphia, in 1774." Historic Structures Report, Part 1, on *Independence Hall* (March 1959), 2.

Dickens, Charles. *American Notes for General Circulation.* Edited by John S. Whitley and Arnold Goldman. 1842. Reprint, New York: Penguin Books, 1972.

Dickey, John M. *Historic Structures Report: Laurel Hill Cemetery.* Media, Pa.: Friends of Laurel Hill, 1979.

Dietz, Karen Ann. "A Home in the Woods: Summer Life in the Adirondacks." Ph.D. diss., University of Pennsylvania, 1992.

Dilts, James D., and Catharine F. Black, eds. *Baltimore's Cast-Iron Buildings and Architectural Ironwork.* Centreville, Md.: Tidewater Publishers, 1991.

[Dix, John.] *Local Loiterings, and Visits in the Vicinity of Boston.* Boston: Redding, 1845.

Dosch, Donald F. *The Old Courthouse.* Saint Louis, Mo.: Jefferson National Expansion Historical Association, 1979.

Downing, A. J. *The Architecture of Country Houses.* 1850. Reprint, New York: Dover Publications, 1969.

———. *Cottage Residences.* 1842. 5th ed., New York: John Wiley & Son, 1873.

———. "Design for a Swiss Cottage." *Horticulturist* 3, no. 6 (December 1848): 287.

———. "A Few Words on Our Progress in Building." *Horticulturist* 6, no. 6 (June 1851): 249–53.

———. "A Few Words on Rural Architecture." *Horticulturist* 5, no. 1 (July 1850): 9–11.

———. "Hints to Rural Improvers." *Horticulturist* 3, no 1 (July 1848): 9–14.

———. [Introductory essay.] *Horticulturist* 1, no. 1 (July 1846): 9–10.

———. *Rural Essays.* Edited by George W. Curtis. 1853. Reprint, New York: Da Capo Press, 1974.

———. "On Simple Rural Cottages." *Horticulturist* 1, no. 3 (September 1846): 105–10.

———. *A Treatise on the Theory and Practice of Landscape Gardening.* New York: Wiley and Putnam, 1841.

———. *A Treatise on the Theory and Practice of Landscape Gardening.* 6th ed. New York: A. O. Moore, 1859.

———. "Wheeler's Rural Homes." *Horticulturist* 6, no. 12 (December 1851): 567–70.

Downs, Arthur Channing, Jr. "Downing's Newburgh Villa." *APT Bulletin* 4, nos. 3–4 (1972): 1–113.

———. "Inigo Jones's Covent Garden: The First Seventy-Five Years." *JSAH* 26, no. 1 (March 1967): 8–33.

Dunlap, William. *History of the Rise and Progress of the Arts of Design in the United States.* Edited by Alexander Wyckoff. 3 vols. 1834. Reprint, New York: Benjamin Blom, 1965.

[Dwight, Theodore.] *Things as They Are: or, Notes of a Traveller Through Some of the Middle and Northern States.* New York: Harper and Bros., 1834.

Dwight, Timothy. *Travels; In New-England and New-York.* 4 vols. New Haven: Timothy Dwight, 1821.

Early, James. *Romanticism and American Architecture.* New York: A. S. Barnes, 1965.

Eberlein, Harold D., and C. Van D. Hubbard. "The American 'Vauxhall' of the Federal Era." *Pennsylvania Magazine of History and Biography* 68, no. 2 (April 1944): 150–74.

Eberlein, Harold D., and A. E. Richardson. *The English Inn Past and Present.* Philadelphia: J. B. Lippincott, 1926.

Edwards, Jay D. "The Origins of Creole Architecture." *Winterthur Portfolio* 29, nos. 2–3 (Summer–Autumn 1994): 155–89.

1848–1898. Semi-Centennial of Girard College. Philadelphia: Girard College, 1898.

Ellet, Charles, Jr. *A Popular Notice of Suspension Bridges, with a Brief Description of the Wire Bridge Across the Schuylkill, at Fairmount.* Philadelphia: John C. Clark, 1843.

[Eliot, W. H.] *A Description of Tremont House.* Boston: Gray and Bowen, 1830.

Elliott, C. W. *Cottages and Cottage Life. Containing Plans for Country Houses, Adapted to the Means and Wants of the People of the United States.* Cincinnati: H. W. Derby, 1848.

Elmes, James. *Metropolitan Improvements; or London in the Nineteenth Century.* London: Jones, 1827.

Emerson, Ralph Waldo. *The Letters of Ralph Waldo Emerson.* Edited by Ralph L. Rusk. 10 vols. New York: Columbia University Press, 1939.

———. *The Portable Emerson.* Edited by Mark van Doren. New York: Viking, 1946.

"Exchange Celebration." *Hazard's Register of Pennsylvania* 12, no. 19 (9 November 1833): 293.

"Farm and Villa of Mr. Donaldson." *American Agriculturist* 5, no. 3 (March 1846): 88–90.

Fay, Theodore S. *Views in New-York.* New York: Peabody, 1831.

Fearon, Henry Bradshaw. *Sketches of America.* London: Longman et al., 1818.

Fitch, James Marston. *Historic Preservation: Curatorial*

Management of the Built World. 1982. Reprint, Charlottesville: University Press of Virginia, 1990.

Flint, Timothy. *The History and Geography of the Mississippi Valley*. 2d ed. 2 vols. Cincinnati, Ohio: E. H. Flint and L. R. Lincoln, 1832.

Forsyth, John. "Address . . . Before the Chunnenuggee Horticultural Society," 1 May 1851. *Soil of the South* [Columbus, Ga.] 1, no. 8 (August 1851): 124–27.

Foster, Augustus John. *Jeffersonian America: Notes on the United States of America Collected in the Years 1805–6-7 and 11–12 by Sir Augustus Foster, Bart*. Edited by Richard Beale Davis. San Marino, Calif.: Huntington Library, 1954.

Foster, Kathleen A., with Kenneth Finkel. *Captain Watson's Travels in America: The Sketchbooks and Diary of Joshua Rowley Watson, 1772–1818*. Philadelphia: University of Pennsylvania Press for the Barra Foundation, 1997.

Fowler, Orson Squire. *A Home for All*. New York: Fowler and Wells, 1848.

[———.] *The House: A Pocket Manual of Rural Architecture*. New York: Fowler and Wells, 1859.

[———.] *New Illustrated Rural Manuals*. New York: Fowler and Wells, 1859.

Frassanito, William A. *Early Photography at Gettysburg*. Gettysburg, Pa.: Thomas Publications, 1995.

Friedman, Terry. *James Gibbs*. New Haven and London: Yale University Press, 1984.

Fuller, Margaret. *Summer on the Lakes in 1843*. 1844; reprint, Nieuwkoop: B. de Graaf, 1972.

G. S. G. "Plan of a Cheap Cottage." *Southern Cultivator* [Augusta, Ga.] 7, no. 3 (March 1849): 42.

Gallagher, Helen. *Robert Mills*. New York: Columbia University Press, 1935.

Gallier, James. *Autobiography of James Gallier Architect*. Introduction by Samuel Wilson, Jr. 1864. Reprint, New York: Da Capo Press, 1973.

Gamble, Robert S. *The Alabama Catalogue, Historic American Buildings Survey: A Guide to the Early Architecture of the State*. Tuscaloosa: University of Alabama Press, 1987.

———. Personal correspondence. January 2001.

———. "The White-Column Tradition: Classical Architecture and the Southern Mystique." In Susan Ford Wiltshire, ed., *The Classical Tradition in the South: A Special Issue, Southern Humanities Review*, 1977, 41–59.

Gammon, Mitzi. *The South*. New York: Bantam Books, 1991.

Gardner, Alexander. *Gardner's Photographic Sketch Book of the Civil War*. 1866. Reprint, New York: Dover Publications, 1959.

Garrett, Wendell. *Classic America: The Federal Style and Beyond*. New York: Rizzoli, 1992.

Gascoigne, Bamber, and Jonathan Ditchburn. *Images of Twickenham*. Richmond-Upon-Thames: Saint Helena Press, 1981.

Gayle, Margot, and Carol Gayle. *Cast-Iron Architecture in America: The Significance of James Bogardus*. New York: W. W. Norton, 1998.

Geist, Johann Friedrich. *Arcades: The History of a Building Type*. Cambridge, Mass.: MIT Press, 1983.

Gelernter, Mark. *A History of American Architecture: Buildings in Their Cultural and Technological Context*. Hanover, N.H.: University Press of New England, 1999.

"General Notices." *Architectural Magazine* 1, no. 8 (October 1834): 314–15.

Gibson, Jane M. *Fairmount Water Works*. 1978. PA-51, Historic American Engineering Record, Library of Congress.

Gifford, Don, ed. *The Literature of Architecture*. New York: E. P. Dutton, 1966.

Gilchrist, Agnes Addison. "The Philadelphia Exchange: William Strickland, Architect." *Transactions of the American Philosophical Society*, n.s., 43, pt. 1 (March 1953): 86–95.

[Gilman, Arthur D.] "Architecture in the United States." *North American Review* 58, no. 123 (April 1844): 436–80.

Glassie, Henry H. *Folk Housing in Middle Virginia*. Knoxville: University of Tennessee Press, 1975.

Glatfelter, Charles H. *A Salutary Influence: Gettysburg College, 1832–1985*. 2 vols. Gettysburg, Pa.: Gettysburg College, 1987.

Goodwin, Francis. *Domestic Architecture*. London: For the author, 1834.

Gosse, Philip Henry. *Letters from Alabama, (U.S.), Chiefly Relating to Natural History*. 1859. Reprint, Mountain Brook, Ala.: Overbrook House, 1983.

Gowans, Alan. *Images of American Living*. Philadelphia: Lippincott, 1964.

———. *Styles and Types of North American Architecture: Social Function and Cultural Expression*. New York: Icon Editions, 1992.

Graff, Nancy P., ed. *Celebrating Vermont: Myths and Realities*. Middlebury, Vt.: C. A. Johnson Memorial Gallery, 1991.

Gray, Ralph D. *The National Waterway: A History of the*

Chesapeake and Delaware Canal, 1769–1985. 2d ed. Urbana: University of Illinois Press, 1989.

Greenough, Horatio. *Form and Function: Remarks on Art by Horatio Greenough.* Edited by Harold A. Small. Berkeley: University of California Press, 1947.

———. *The Travels, Observations, and Experience of a Yankee Stonecutter.* Introduction by Nathalia Wright. 1852. Reprint, Gainesville, Fla.: Scholars' Facsimiles and Reprints, 1958.

Guide to Laurel Hill Cemetery, near Philadelphia. Philadelphia: C. Sherman, 1844.

Guter, Robert P., and Janet W. Foster. *Building by the Book: Pattern-Book Architecture in New Jersey.* New Brunswick, N.J.: Rutgers University Press, 1992.

Hafertepe, Kenneth. *Abner Cook: Master Builder on the Texas Frontier.* Austin: Texas State Historical Association, 1992.

———. "Banking Houses in the United States: The First Generation, 1781–1811." *Winterthur Portfolio* 35, no. 1 (Spring 2000): 1–52.

———. "An Inquiry into Thomas Jefferson's Ideas of Beauty." *JSAH* 59, no. 2 (June 2000): 216–31.

Hafertepe, Kenneth, and James F. O'Gorman, eds. *American Architects and Their Books to 1848.* Amherst: University of Massachusetts Press, 2001.

Halfpenny, William, and John Halfpenny. *The Country Gentleman's Pocket Companion, and Builder's Assistant, for Rural Decorative Architecture.* London: Robert Sayer, 1753.

Hall, Basil. *Forty Etchings, from Sketches Made with the Camera Lucida, in North America, in 1827 and 1828.* London: Simpkin and Marshall, 1829.

———. *Travels in North America, in the Years 1827 and 1828.* 2 vols. Philadelphia: Carey, Lea & Carey, 1829.

Hall, John. *A Series of Select and Original Modern Designs for Dwelling Houses, for the Use of Carpenters and Builders: Adapted to the Style of Building in the United States.* 2d ed. Baltimore: John Murphy, 1840.

Hall, Margaret. *The Aristocratic Journey: Being the Outspoken Letters of Mrs. Basil Hall Written During a Fourteen Months' Sojourn in America, 1827–1828.* Edited by Una Pope-Hennessy. New York: G. P. Putnam's Sons, 1931.

Halleck, Fitz-Greene. *Fanny, with Other Poems.* New York: Harper & Brothers, 1839.

[Hamilton, Thomas.] *Men and Manners in America.* 2 vols. in 1. 1833. Reprint, New York: Augustus M. Kelley, 1968.

Hamlin, Talbot. *Benjamin Henry Latrobe.* New York: Oxford University Press, 1955.

———. *Greek Revival Architecture in America.* New York: Oxford University Press, 1944.

———. "The Rise of Eclecticism in New York." *JSAH* 11, no. 2 (May 1952): 3–8.

Hammond, Charles A. "'Where the Arts and the Virtues Unite': County Life Near Boston, 1637–1864." Ph.D. diss., Boston University, 1982.

Hanson, Victor Davis. "Democracy Without Farmers." *Wilson Quarterly* 24, no. 2 (Spring 2000): 68–79.

Harding, Walter. *The Days of Henry Thoreau.* New York: Alfred A. Knopf, 1965.

Harvey, George. *Harvey's Scenes of the Primitive Forest of America.* London: George Harvey, 1841.

Haviland, John. *The Builder's Assistant.* 3 vols. Philadelphia: John Bioren, 1818–21.

Hawthorne, Nathaniel. *The American Notebooks.* Edited by Claude M. Simpson. Columbus: Ohio State University Press, 1972.

———. *The Blithedale Romance and Fanshawe.* Columbus: Ohio State University Press, 1964.

Hazard, ed., *The Register of Pennsylvania* 1, no. 10 (28 February 1828): 152–54. In "Independence Hall/19th Cent.," Independence National Historical Park archives, Philadelphia.

Herbert, Gilbert. "The Portable Colonial Cottage." *JSAH* 31, no. 4 (December 1972): 261–75.

Herrmann, Wolfgang. *Laugier and Eighteenth Century French Theory.* London: A. Zwemmer, 1962.

Hindle, Brooke, ed. *Material Culture of the Wooden Age.* Tarrytown, N.Y.: Sleepy Hollow Press, 1981.

Historic Building Report on Philadelphia (Merchants') Exchange. Philadelphia: Independence National Historical Park, 1958.

Historic Structures Report, Part II on Second Bank of the United States. Philadelphia: Independence National Historical Park, 1962.

Hitchcock, Henry-Russell. *American Architectural Books.* New York: Da Capo Press, 1976.

———. *Architecture: Nineteenth and Twentieth Centuries.* New York: Penguin Books, 1977.

Hitchcock, Susan Tyler. *The University of Virginia: A Pictorial History.* Charlottesville: University of Virginia Press, 1999.

Hoffman, C. F. *Wild Scenes in the Forest and Prairie, with Sketches of American Life.* 2 vols. New York: William H. Colyer, 1843.

[Hofland, Barbara.] *A Descriptive Account of the Mansion and Gardens of White-Knights.* London: W. Wilson, 1819.

Hogan, Pendleton. *The Lawn: A Guide to Jefferson's University.* Charlottesville: University of Virginia Press, 1987.

Holly, Henry Hudson. *Holly's Country Seats.* New York: D. Appleton, 1863.

The Home Book of the Picturesque: or American Scenery, Art, and Literature. 1852. Reprint, Gainesville, Fla.: Scholars' Facsimiles & Reprints, 1967.

Homes of American Authors. 3 vols. New York: D. Appleton, 1854.

Hone, Philip. *Diary of Philip Hone.* 2 vols. 1927. Reprint, New York: Library Editions, 1970.

Hornor, T. *Description of an Improved Method of Delineating Estates, With a Sketch of the Progress of Landscape Gardening in England.* London: J. Harding, 1813.

How to Build, Furnish and Decorate. New York: Co-operative Building Plan Ass'n, 1883.

Howard, J. Murray, Curator and Architect for the Academical Village, University of Virginia. Personal correspondence. 2 July 2001.

Howe, Hezekiah. *Architecture.* New Haven: H. Howe, 1831.

Howells, John Mead. *Lost Examples of Colonial Architecture.* 1931. Reprint, New York: Dover Publications, 1963.

Howley, James. *The Follies and Garden Buildings of Ireland.* New Haven and London: Yale University Press, 1993.

Hudgins, Carter L., and Elizabeth Collins Cromley. *Shaping Communities: Perspectives in Vernacular Architecture.* Vol. 6. Knoxville: University of Tennessee Press, 1997.

[Hunt, Freeman.] *Letters about the Hudson River and Its Vicinity, Written in 1835 and 1836.* New York: Freeman Hunt, 1836.

Hussey, Christopher. *The Picturesque: Studies in a Point of View.* 1927. Reprint, Hamden, Conn.: Archon Books, 1967.

Hutchins, Catherine E., ed. *Everyday Life in the Early Republic.* Winterthur, Del.: Henry Francis du Pont Winterthur Museum, 1994.

Hutslar, Donald A. *The Architecture of Migration: Log Construction in the Ohio Country, 1750–1850.* Athens: Ohio University Press, 1986.

———. "The Log Architecture of Ohio." *Ohio History* 80, nos. 3–4 (Summer–Autumn 1971): 172–271.

"Independence Hall/19th Cent./Repairs & Alterations Steeple." Card File, Independence National Historical Park archives, Philadelphia.

[Ingraham, Joseph Holt.] *The South-West.* 2 vols. New York: Harper & Brothers, 1835.

Irving, Washington. *History, Tales and Sketches.* New York: Library of America, 1983.

———. *Washington Irving: Letters.* 4 vols. Edited by Ralph M. Aderman et al. Boston: Twayne Publishers, 1982.

J. M. "Philadelphia," 11 May 1834. *Architectural Magazine* 2, no. 14 (April 1835): 190.

Jackson, Joseph. *Development of American Architecture, 1783–1830.* Philadelphia: David McKay, 1926.

Jackson, Kenneth T. *Crabgrass Frontier: The Suburbanization of the United States.* New York: Oxford University Press, 1985.

Jackson-Stops, Gervase, et al., eds. *The Fashioning and Functioning of the British Country House.* Studies in the History of Art, 25. Washington, D.C.: National Gallery of Art, 1989.

[Jacques, Daniel H.] *The House: A Pocket Manual of Rural Architecture.* New York: Fowler and Wells, 1859.

Jarvis, Barbara. Research Group, Empire Mine State Historical Park, Nevada City, Calif. Personal correspondence. 4 November 2000.

Jefferson, Thomas. *Notes on the State of Virginia.* 1782. Reprint, London: John Stockdale, 1787.

Jensen, Robert. "Board and Batten Siding and the Balloon Frame: Their Incompatibility in the Nineteenth Century." *JSAH* 30, no. 1 (March 1971): 40–50.

Johnson, Samuel. *The Rambler.* Edited by W. J. Bate and Albrecht B. Strauss. 3 vols. New Haven and London: Yale University Press, 1969.

Johnston, Norman B. *Eastern State Penitentiary: Crucible of Good Intentions.* Philadelphia: Philadelphia Museum of Art, 1994.

Jones' Views of the Seats, Mansions, Castles, Etc. of Noblemen and Gentlemen in England. 3 vols. London: Jones, 1829–31.

Journal of the House of Representatives of the State of Alabama. Tuscaloosa: McGuire, Henry and Walker, 1830.

Kahn, Renee, and Ellen Meagher. *Preserving Porches.* New York: Henry Holt, 1990.

Kaiser, Harvey H. *Great Camps of the Adirondacks.* Boston: D. R. Godine, 1982.

Kalm, Peter. *The America of 1750: Peter Kalm's Travels in North America, The English Version of 1770.* 2 vols. Edited by Adolph B. Benson. New York: Dover Publications, 1964.

Kaye, Myrna. *There's a Bed in the Piano: The Inside Story of the American Home.* New York: Little, Brown, 1998.

Kennedy, Roger G. *Architecture, Men, Women and Money in America, 1600–1860*. New York: Random House, 1985.

———. *Greek Revival America*. New York: Stewart Tabori and Chang, 1989.

Kennon, Donald R., ed. *A Republic for the Ages: The United States Capitol and the Political Culture of the Early Republic*. Charlottesville: University Press of Virginia, 1999.

———. *The United States Capitol: Designing and Decorating a National Icon*. Athens: Ohio University Press, 2000.

Kidd's London Ambulator. Bound with *Kidd's New Picture of London*. London: W. Ingham, [ca. 1840].

King, David. *The Complete Works of Robert and James Adam*. Oxford: Butterworth Architecture, 1991.

Kirker, Harold, and James Kirker. *Bulfinch's Boston, 1787–1817*. New York: Oxford University Press, 1964.

Kloss, William. *Samuel F. B. Morse*. New York: Harry N. Abrams, 1988.

Knight, Richard Payne. *The Landscape, A Didactic Poem*. 1795. Reprint, Westmead, Eng.: Gregg, 1972.

———. *The Progress of Civil Society*. London: W. Bulmer, 1796.

Knowles, Jane Boyle. "Luxury Hotels in American Cities, 1810–1860." Ph.D. diss., University of Pennsylvania, 1972.

Kowsky, Francis R. *Country, Park, and City: The Architecture and Life of Calvert Vaux*. New York: Oxford University Press, 1998.

Kylloe, Ralph. *Rustic Traditions*. Salt Lake City, Utah: Gibbs Smith, 1993.

Laing Stores. HABS report NY 31–NEYO 76, Library of Congress.

Lancaster, Clay. *The Japanese Influence in America*. New York: Abbeville Press, 1983.

Lane, Mills. *Architecture of the Old South*. New York: Abbeville Press, 1993.

———. *Architecture of the Old South: Mississippi and Alabama*. New York: Abbeville Press, 1989.

Lang, William Bailey. *Views, with Ground Plans, of the Highland Cottages at Roxbury*. Boston: L. H. Bridgham and H. E. Felch, 1845.

Lanman, Charles. *Letters from a Landscape Painter*. Boston: J. Monroe, 1845.

Larkin, Jack. *The Reshaping of Everyday Life, 1790–1840*. New York: Harper & Row, 1988.

Larrabee, Stephen A. *Hellas Observed: The American Experience of Greece, 1775–1865*. New York: New York University Press, 1957.

Latrobe, Benjamin Henry. *The Architectural Drawings of Benjamin Henry Latrobe*. 2 vols. Edited by Jeffrey A. Cohen and Charles E. Brownell. New Haven and London: Yale University Press, 1994.

———. *The Correspondence and Miscellaneous Papers of Benjamin Henry Latrobe*. Edited by John C. Van Horne. 3 vols. New Haven and London: Yale University Press, 1984–88.

———. *The Journals of Benjamin Henry Latrobe, 1799–1820: From Philadelphia to New Orleans*. 3 vols. Edited by Edward C. Carter II, John C. Van Horne, and Lee W. Formwalt. New Haven and London: Yale University Press, 1980.

———. *The Virginia Journals of Benjamin Henry Latrobe, 1795–1798*. 2 vols. Edited by Edward C. Carter II. New Haven and London: Yale University Press, 1977.

Laverty, Bruce, et al. *Monument to Philanthropy: The Design and Building of Girard College, 1832–1848*. Philadelphia: Girard College, 1998.

Lawrence, A. W. *Greek Architecture*. 4th ed. New Haven and London: Yale University Press, 1983.

Lay, K. Edward. *The Architecture of Jefferson Country: Charlottesville and Albemarle County, Virginia*. Charlottesville: University Press of Virginia, 2000.

Lee, Antoinette J. "The Rise of the Cast Iron District in Philadelphia." Ph.D. diss., George Washington University, 1975.

Lee, Hannah Farnham Sawyer. *Elinor Fulton*. Boston: Whipple & Damrell, 1837.

[———.] *Three Experiments of Living: Living Within the Means. Living Up to the Means. Living Beyond the Means*. Boston: William S. Damrell, 1837.

Leigh's New Picture of London. London: Leigh & Son, 1834.

"Letters from New England.—No. 1." *Southern Literary Messenger* 1, no. 2 (15 October 1834): 85–86.

Leukoff, Alice F. *Charleston: Come Hell or High Water*. Charleston, S.C.: Leukoff and Whitelaw, 1976.

Levasseur, A. *Lafayette in America in 1824 and 1825; or, Journal of a Voyage to the United States*. 2 vols. Philadelphia: Carey and Lea, 1829.

Lewis, Gene D. *Charles Ellet, Jr.: The Engineer as Individualist*. Chicago: University of Illinois Press, 1968.

Lewis, Judge Edwin O., to Conrad L. Wirth. December 1956. Independence National Historical Park archives, Philadelphia.

Linden-Ward, Blanche. *Silent City on a Hill: Landscapes of Memory and Boston's Mount Auburn Cemetery*. Columbus: Ohio State University Press, 1989.

Linley, John. *The Georgia Catalogue, Historic American*

Buildings Survey: A Guide to the Architecture of the State. Athens: University of Georgia Press, 1982.

The Lions of Philadelphia. Crissy & Markley, ca. 1860.

Liscombe, Rhodri Windsor. *Altogether American: Robert Mills, Architect and Engineer, 1781–1855.* New York: Oxford University Press, 1994.

———. "A 'New Era in My Life': Ithiel Town Abroad." *JSAH* 50, no. 1 (March 1991): 5–17.

Longstreth, Richard. "Architectural History and the Practice of Historic Preservation in the United States." *JSAH* 58, no. 3 (September 1999): 326–33.

———. *The Mall in Washington, 1791–1991.* Studies in the History of Art, 30. Washington, D.C.: National Gallery of Art, 1991.

Lossing, Benson J. *The Pictorial Field-Book of the Revolution.* 2 vols. New York: Harper and Bros., 1855.

———. *Vassar College and Its Founder.* New York: C. A. Alvord, 1867.

Loth, Calder, and J. T. Sadler, Jr. *The Only Proper Style: Gothic Architecture in America.* Boston: New York Graphic Society, 1975.

Loudon, J. C. *An Encyclopedia of Cottage, Farm, and Villa Architecture.* 1833. New ed., London: Longman et al., 1839.

———. "On the Means of Forming a Just and Correct Taste in Architecture." *Architectural Magazine* 1, no. 2 (April 1834): 49–53.

[———.] "Perspective View and Ground Plan of a Cyclopean Cottage." *Architectural Magazine* 2, no. 22 (December 1835): 533–34.

———. *The Suburban Gardener, and Villa Companion.* London: Longman et al., 1838.

Lounsbury, Carl R., ed. *An Illustrated Glossary of Early Southern Architecture and Landscape.* New York: Oxford University Press, 1994.

Lowell, J. R. "The Rural Cot of Mr. Knott." *Horticulturist* 6, no. 6 (1 June 1851): 254.

Lugar, R. *Architectural Sketches for Cottages, Rural Dwellings, and Villas, in the Grecian, Gothic, and Fancy Styles.* London: J. Taylor, 1823.

———. *The Country Gentleman's Architect.* 1807. Reprint, Westmead, Eng.: Gregg, 1971.

Lyell, Charles. *A Second Visit to North America.* 3d ed. 2 vols. London: John Murray, 1855.

———. *Travels in North America.* 2 vols. London: John Murray, 1845.

Maass, John. *The Gingerbread Age.* New York: Rinehart, 1957.

MacCorkle, William Alexander. *The White Sulphur Springs.* New York: Neale Publishing, 1916.

Maccubbin, Robert P., and Peter Martin, eds. *British and American Gardens in the Eighteenth Century.* Williamsburg, Va.: Colonial Williamsburg Foundation, 1984.

Major, Howard. *The Domestic Architecture of the Early American Republic: The Greek Revival.* Philadelphia: J. B. Lippincott, 1926.

Major, Judith K. *To Live in the New World: A. J. Downing and American Landscape Gardening.* Cambridge, Mass.: MIT Press, 1997.

Malton, James. *A Collection of Designs for Rural Retreats, as Villas. Principally in the Gothic and Castle Styles of Architecture.* London: J. and T. Carpenter, [1802].

———. *An Essay on British Cottage Architecture.* 1798. Reprint, Westmead, Eng.: Gregg, 1972.

Mansbridge, Michael. *John Nash: A Complete Catalogue.* Introduction by John Summerson. New York: Rizzoli, 1991.

Marryat, Frederick. *Diary in America.* Edited by Jules Zanger. 1839. Reprint, Bloomington: Indiana University Press, 1960.

Martineau, Harriet. *Retrospect of Western Travel.* 2 vols. London: Saunders and Otley, 1838.

Marx, Leo. *The Machine in the Garden: Technology and the Pastoral Ideal in America.* New York: Oxford University Press, 1964.

Maynard, W. Barksdale. "'Best, Lowliest Style!': The Early-Nineteenth-Century Rediscovery of American Colonial Architecture." *JSAH* 59, no. 3 (September 2000): 338–57.

———. "'An Ideal Life in the Woods for Boys': Architecture and Culture in the Earliest Summer Camps." *Winterthur Portfolio* 34, no. 1 (Spring 1999): 3–29.

———. "The Picturesque and American Architecture: A Reappraisal." Ph.D. diss., University of Delaware, 1997.

———. Review of *To Live in the New World: A. J. Downing and American Landscape Gardening,* by Judith K. Major. *JSAH* 57, no. 3 (September 1998): 347–50.

———. "Thomas Cole Drawing on Stone Found at Cedar Grove." *American Art Journal* 30, nos. 1–2 (1999): 133–39.

———. "Thoreau's House at Walden." *Art Bulletin* 81, no. 2 (June 1999): 1–23.

McAlester, Virginia, and Lee McAlester. *A Field Guide to American Houses.* New York: Alfred A. Knopf, 1992.

McMordie, Michael. "Picturesque Pattern Books and Pre-

Victorian Designers." *Architectural History* 18 (1975): 43–59.

McMurry, Sally, and Annmarie Adams, eds. *People, Power, Places: Perspectives in Vernacular Architecture.* Vol. 8. Knoxville: University of Tennessee Press, 2000.

McNulty, J. Bard, ed. *The Correspondence of Thomas Cole and Daniel Wadsworth.* Hartford: Connecticut Historical Society, 1983.

McPherson, James M. *Ordeal by Fire: The Civil War and Reconstruction.* New York: Alfred A. Knopf, 1982.

Meeks, Carroll L. V. "Henry Austin and the Italian Villa." *Art Bulletin* 30, no. 2 (June 1948): 145–49.

———. *The Railroad Station: An Architectural History.* New Haven: Yale University Press, 1956.

———. "Romanesque Before Richardson in the United States." *Art Bulletin* 35, no. 1 (March 1953): 17–33.

Merritt, Howard S. *To Walk with Nature: The Drawings of Thomas Cole.* Yonkers, N.Y.: Hudson River Museum, 1981.

Middleton, Charles. *Picturesque and Architectural Views for Cottages, Farm Houses, and Country Villas.* 1793. Reprint, Westmead, Eng.: Gregg, 1972.

Milbert, J. G. *Itinéraire pittoresque du fleuve Hudson.* Paris: n.p., 1828–29.

Mills, Robert. "The Architectural Works of Robert Mills." Reprinted in Don Gifford, ed., *The Literature of Architecture.* New York: E. P. Dutton, 1966.

———. "Architecture in Virginia." *Virginia Historical Register and Literary Companion* 6, no. 1 (January 1853): 37–42.

———. *Guide to the Capitol of the United States.* Washington, D.C.: n.p., 1834.

———. *Specifications of the Manner of Executing [the Annex].* Washington, D.C.: n.p., 1851.

———. "An Unpublished Diary by Robert Mills, 1803." Edited by Hennig Cohen. *South Carolina Historical and Genealogical Magazine* 51, no. 4 (October 1950): 187–94.

Mitchell, B. R. *British Historical Statistics.* Cambridge: Cambridge University Press, 1988.

[Mitchell, Donald Grant.] *Rural Studies, with Hints for Country Places.* New York: Charles Scribner, 1867.

Morrison, A. C. *Historic Structure Report: The Interior of the Second Bank of the United States.* Denver, Colo.: National Park Service, 1973.

Morrison, David, to Andrew Jackson, 6 December 1831. Hermitage archives, Tennessee.

N. H. "Architecture of Country Houses." *Horticulturist* 5, no. 3 (September 1850): 139–41.

Nairn, Ian, and Nikolaus Pevsner. *The Buildings of England: Surrey.* 2d ed. Revised by Bridget Cherry. London: Penguin Books, 1971.

[Naval Asylum, Philadelphia.] Newspaper clipping. Library Company of Philadelphia, (6)1322.F.175a.

Neil, J. Meredith. *Toward a National Taste: America's Quest for Aesthetic Independence.* Honolulu: University Press of Hawaii, 1975.

"New Treasury and Post Office Buildings." *House Report* 737, 25th Cong., 2d sess. (29 Mar. 1838), ser. no. 335, 11–19.

Newton, Roger Hale. *Town & Davis, Architects.* New York: Columbia University Press, 1942.

"New-York Daguerreotyped. Group First: Business-Streets, Mercantile Blocks, Stores, and Banks." *Putnam's Monthly* 1, no. 4 (April 1853): 353–61.

Nichols, Frederick Doveton. *The Early Architecture of Georgia.* Chapel Hill: University of North Carolina Press, 1957.

Niles Weekly Register (Baltimore), 4th ser., 1, no. 5 (26 Sept. 1829): 70.

Noble, Allen G. *Wood, Brick, and Stone: The North American Settlement Landscape.* Vol. 1: *Houses.* Amherst: University of Massachusetts Press, 1984.

Noble, Louis L. *The Life and Works of Thomas Cole.* Edited by Elliott S. Vesell. 1853. Reprint, Cambridge, Mass.: Belknap Press of Harvard University Press, 1964.

The Northern Traveller. New York: J. Disturnell, 1844.

The Northern Traveller. 2d ed. New York: A. T. Goodrich, 1826.

Nygren, Edward J., with Bruce Robertson. *Views and Visions: American Landscape Before 1830.* Washington, D.C.: Corcoran Gallery of Art, 1986.

O'Gorman, James F. *Accomplished in All Departments of Art: Hammatt Billings of Boston, 1818–1874.* Amherst: University of Massachusetts Press, 1998.

———. "H. and J. E. Billings of Boston: From Classicism to the Picturesque," *JSAH* 42, no. 1 (March 1983): 54–73.

———. *H. H. Richardson: Architectural Forms for an American Society.* Chicago: University of Chicago Press, 1987.

———. *Three American Architects: Richardson, Sullivan, and Wright, 1865–1915.* Chicago: University of Chicago Press, 1991.

Over, Charles. *Ornamental Architecture in the Gothic, Chinese and Modern Taste.* London: Robert Sayer, 1758.

Owen, Robert Dale. *Hints on Public Architecture.* New York: Putnam, 1849.

"The Pagoda." *Casket* [Philadelphia], n.s., 11 (November 1828): 509.

Papworth, John Buonarotti. *Rural Residences, Consisting of a Series of Designs for Cottages, Decorated Cottages, Small Villas, and Other Ornamental Buildings.* 1818. Reprint, Westmead, Eng.: Gregg, 1971.

Parissien, Steven. *Regency Style.* Washington, D.C.: Preservation Press, 1992.

Parry, Ellwood C., III. *The Art of Thomas Cole: Ambition and Imagination.* Newark: University of Delaware Press, 1988.

Patrick, James. *Architecture in Tennessee, 1768–1897.* Knoxville: University of Tennessee Press, 1981.

Peabody, Charles A. "Rural Homes." *Soil of the South* [Columbus, Ga.] 2, no. 4 (April 1852): 253.

[Peabody, W. B. O.] "Downing on Rural Architecture. Rural Architecture in America." *North American Review* 56, no. 118 (January 1843): 1–17.

[Peacock, James.] *OIKIΔIA, or, Nutshells: Being Ichnographic Distributions for Small Villas.* London: for the author, 1785.

Peat, Wilbur D. *Indiana Houses of the Nineteenth Century.* Indianapolis: Indiana Historical Society, 1962.

Peatross, C. Ford, and Robert O. Mellown. *William Nichols, Architect.* Tuscaloosa: University of Alabama Art Gallery, 1979.

Peck, Amelia, ed. *Alexander Jackson Davis, American Architect, 1803–1892.* New York: Rizzoli, 1992.

Peck, Robert McCracken. "The Cult of the Rustic in Nineteenth-Century America." M.A. thesis, University of Delaware, 1976.

Peck's Tourist's Companion to Niagara Falls. Buffalo, N.Y.: William B. & Charles E. Peck, 1845.

Perry, Richard L. "The Front Porch as Stage and Symbol in the Deep South." *Journal of American Culture* 8, no. 2 (Summer 1985): 13–18.

Peterson, Charles E. "Ante-Bellum Skyscraper." *JSAH* 9, nos. 1–2 (March and May 1950): 27–28.

———. Personal correspondence. November 2000.

Peterson, Fred W. *Homes in the Heartland: Balloon Frame Farmhouses of the Upper Midwest, 1850–1920.* Lawrence: University Press of Kansas, 1992.

Pevsner, Nikolaus. "Address Given . . . at the Inauguration of the New Art and Architecture Building of Yale University, 9 November 1963." *JSAH* 26, no. 1 (March 1967): 5–7.

———. *The Buildings of England: Cumberland and Westmorland.* London: Penguin Books, 1967.

———. *An Outline of European Architecture.* New York: Charles Scribner's Sons, 1948.

———. *Some Architectural Writers of the Nineteenth Century.* Oxford: Clarendon Press, 1972.

Pfanz, Harry W. *Gettysburg: The Second Day.* Chapel Hill: University of North Carolina Press, 1987.

Philadelphia as It Is, and Citizens' Advertising Directory. Philadelphia: J. P. Gray, 1834.

Philadelphia as It Is in 1852. Philadelphia: Lindsay & Blakiston, 1852.

The Picturesque Pocket Companion, and Visitor's Guide, Through Mount Auburn. Boston: Otis, Broaders, 1839.

Pierson, William H., Jr. *American Buildings and Their Architects: The Colonial and Neoclassical Styles.* Garden City, N.Y.: Doubleday, 1970.

———. *American Buildings and Their Architects: Technology and the Picturesque, the Corporate and the Early Gothic Styles.* Garden City, N.Y.: Doubleday, 1978.

———. "Richard Upjohn and the American Rundbogenstil." *Winterthur Portfolio* 21, no. 4 (Winter 1986): 223–42.

Placzek, Adolf K., ed. *Macmillan Encyclopedia of Architects.* New York: Free Press, 1982.

Plaw, John. *Ferme Ornée; or Rural Improvements.* London: I. and J. Taylor, 1795.

———. *Rural Architecture; or Designs from the Simple Cottage to the Decorated Villa.* 1796, 1802. Reprint, Westmead, Eng.: Gregg, 1971.

Pocock, W. F. *Architectural Designs for Rustic Cottages, Picturesque Dwellings, Villas, &c.* 1807; reprint, Westmead, Eng.: Gregg, 1972.

Poesch, Jessie. *The Art of the Old South: Painting, Sculpture, Architecture, and the Products of Craftsmen, 1560–1860.* New York: Alfred A. Knopf, 1983.

———. "A British Officer and His 'New York' Cottage: An American Vernacular Brought to England." *American Art Journal* 20, no. 4 (1988): 74–97.

Poesch, Jessie, and Barbara SoRelle Bacot, eds. *Louisiana Buildings, 1720–1940: The Historic American Buildings Survey.* Baton Rouge: Louisiana State University Press, 1997.

Poffenberger, Brien J. "Jefferson's Design of the Capitol of Virginia." M.A. thesis, University of Virginia, 1991.

Power, Tyrone. *Impressions of America During the Years 1833, 1834, and 1835.* 2 vols. Philadelphia: Carey, Lea and Blanchard, 1836.

Prime, Alfred Coxe. *The Arts and Crafts in Philadelphia*

Maryland and South Carolina, 1786–1800. Series 2. Walpole Society, 1932.

Prothro, Kimberly. "Thomas Jefferson's Virginia State Capitol: A Construction History, 1780s to 1964." Historic American Buildings Survey report VA 44–RICH, 9, 1988.

Pugin, A. W. N. *The True Principles of Pointed or Christian Architecture.* 1841. Reprint, London: Henry G. Bohn, 1853.

Quinan, Jack. "Asher Benjamin and American Architecture." *JSAH* 38, no. 3 (October 1979): 244–62.

Ranlett, William H. *The Architect, A Series of Original Designs, for Domestic and Ornamental Cottages and Villas.* 2 vols. 1847–49. Reprint, New York: Dewitt & Davenport, 1851–53.

Rees, Abraham. *Cyclopaedia.* Multivolume. Philadelphia: Samuel F. Bradford, 1810–24.

Reiff, Daniel D. *Houses from Books: Treatises, Pattern Books, and Catalogs in American Architecture, 1738–1950.* University Park: Pennsylvania State University Press, 2000.

Reinberger, Mark E. "The Baltimore Exchange and Its Place in the Career of Benjamin Henry Latrobe." Ph.D. diss., Cornell University, 1988.

"Remarks on the Progress and Present State of the Fine Arts in the United States." *Analectic Magazine* 6 (1815): 363–76.

Reps, John W. *The Making of Urban America: A History of City Planning in the United States.* Princeton, N.J.: Princeton University Press, 1965.

Repton, Humphry. *The Landscape Gardening and Landscape Architecture of the Late Humphry Repton, Esq.* New ed. Edited by J. C. Loudon. London: Longman, 1840.

[Richards, T. A.] "Sunnyside, The Home of Washington Irving." *Harper's New Monthly Magazine* 14, no. 79 (December 1856): 1–21.

Ricketson, Anna, and Walton Ricketson. *Daniel Ricketson and His Friends: Letters Poems Sketches, Etc.* New York: Houghton, Mifflin, 1902.

Rilling, Donna J. *Making Houses, Crafting Capitalism: Builders in Philadelphia, 1790–1850.* Philadelphia: University of Pennsylvania Press, 2001.

Ritch, John W. *The American Architect.* New York: C. M. Saxton, 1847.

Robertson, Archibald. *A Topographical Survey of the Great Road from London to Bath and Bristol.* London: For the author, 1792.

Robinson, P. F. *Rural Architecture, or A Series of Designs for Ornamental Cottages.* London: Rodwell and Martin, 1823. 4th ed., London: Henry G. Bohn, 1836.

Robinson, Solon. "A Cheap Farm-House." *American Agriculturist* 5, no. 2 (February 1846): 57–58.

Rockwell, Charles. *The Catskill Mountains and the Region Around.* New York: Taintor Brothers, 1867.

Roos, Frank J., Jr. "Ohio: Architectural Cross-Road." *JSAH* 12, no. 2 (May 1953): 3–8.

Ross, William. "Street Houses of the City of New York." *Architectural Magazine* 2, no. 21 (November 1835): 490–93.

[Royall, Anne Newport.] *Sketches of History, Life, and Manners, in the United States.* New Haven: For the author, 1826.

Ruskin, John, as Kata Phusin. "The Poetry of Architecture." *Architectural Magazine* 5, no. 48 (February 1838): 56–63.

Rustic Work. New York: Rustic Construction Works, [ca. 1910].

Rusticus. "Fruits, Flowers, &c." *Soil of the South* [Columbus, Ga.] 3, no. 1 (January 1853): 403–5.

Rykwert, Joseph. *On Adam's House in Paradise: The Idea of the Primitive Hut in Architectural History.* 2d ed. Cambridge, Mass.: MIT Press, 1981.

St. George, Robert Blair, ed. *Material Life in America, 1600–1860.* Boston: Northeastern University Press, 1988.

St. Méry, Moreau de. *Moreau de St. Méry's American Journey [1793–1798].* Edited by Kenneth Roberts and Anna M. Roberts. Garden City, N.Y.: Doubleday, 1947.

Salmon, William. *Palladio Londinensis.* 1734. Reprint, Westmead, Eng.: Gregg, 1969.

Saxon, A. H. *P. T. Barnum: The Legend and the Man.* New York: Columbia University Press, 1989.

The Scenery of the United States. New York: D. Appleton, 1855.

Schimmelman, Janice G. *Architectural Books in Early America.* New Castle, Del.: Oak Knoll Press, 1999.

Schoepf, Johann David. *Travels in the Confederation (1783–1784).* 2 vols. Edited by Alfred J. Morrison. Philadelphia: William J. Campbell, 1911.

Schuyler, David Paul. *Apostle of Taste: Andrew Jackson Downing, 1815–1852.* Baltimore: Johns Hopkins University Press, 1996.

———. "English and American Cottages, 1795–1855: A Study in Architectural Theory and the Social Order." M.A. thesis, University of Delaware, 1976.

———. *The New Urban Landscape: The Redefinition of City Form in Nineteenth-Century America.* Baltimore: Johns Hopkins University Press, 1986.

Scott, Pamela. *Temple of Liberty: Building the Capitol for a New Nation.* New York: Oxford University Press, 1995.

Scottish Pioneers of the Greek Revival. Introduction by Malcolm S. Higgs. Edinburgh: Scottish Georgian Society, 1984.

Scully, Arthur, Jr. *James Dakin, Architect: His Career in New York and the South.* Baton Rouge: Louisiana State University Press, 1973.

Scully, Vincent J., Jr. *The Shingle Style and the Stick Style: Architectural Theory and Design from Richardson to the Origins of Wright.* New Haven and London: Yale University Press, 1971.

Seale, William. *The President's House: A History.* 2 vols. Washington, D.C.: White House Historical Association, 1986.

Severens, Kenneth. *Charleston: Antebellum Architecture and Civic Destiny.* Knoxville: University of Tennessee Press, 1988.

———. *Southern Architecture.* New York: E. P. Dutton, 1981.

Shaffer, Robert B. "Emerson and His Circle: Advocates of Functionalism." *JSAH* 7, nos. 3–4 (July–December 1948): 17–20.

Shanley, J. Lyndon. *The Making of Walden, with the Text of the First Version.* Chicago: University of Chicago Press, 1957.

Shaw, Edward. *The Modern Architect; or, Every Carpenter His Own Master.* Boston: Dayton and Wentworth, 1854.

Shepherd, Barnett. "Sailor's Snug Harbor Reattributed to Minard Lafever." *JSAH* 35, no. 2 (May 1976): 108–23.

Shupe, Barbara, et al. *New York State Population, 1790–1980.* New York: Neal-Schuman Publishers, 1987.

Simo, Melanie Louise. *Loudon and the Landscape: From Country Seat to Metropolis, 1783–1843.* New Haven and London: Yale University Press, 1988.

Sloan, Samuel. *City and Suburban Architecture.* Philadelphia: J. B. Lippincott, 1859.

———. *The Model Architect.* 2 vols. Philadelphia: E. S. Jones, 1852.

Smith, G. E. Kidder. *The Architecture of the United States.* Vol. 2: *The South and Midwest.* Garden City, N.Y.: Anchor Books, 1981.

Smith, J. Frazer. *Plantation Houses and Mansions of the Old South.* 1941. Reprint, New York: Dover Publications, 1993.

Smith, R. A. *Smith's Illustrated Guide to and Through Laurel Hill Cemetery.* Philadelphia: Willis P. Hazard, 1852.

Snow, Caleb H. *A History of Boston.* Boston: Abel Brown, 1825.

Snyder, Martin P. *Mirror of America: The Developing Life of Philadelphia Seen in Engravings, 1801–1876.* Gladwyn, Pa.: M. P. Snyder, 1996.

Soane, John. *Sketches in Architecture.* London: Messrs. Taylor, 1793.

Springside Landscape Restoration newsletter. Fall 2000.

Stamm, Alicia, and C. Ford Peatross. *Historic America: Buildings, Structures, and Sites.* Washington, D.C.: Library of Congress, 1983.

Stanton, Phoebe B. *The Gothic Revival and American Church Architecture: An Episode in Taste, 1840–1856.* Baltimore: John Hopkins University Press, 1968.

Stapleton, Darwin H., and Thomas C. Guider. "The Transfer and Diffusion of British Technology: Benjamin Henry Latrobe and the Chesapeake and Delaware Canal." *Delaware History* 17, no. 2 (Fall–Winter 1976): 127–38.

Stephenson, Sue Honaker. *Rustic Furniture.* New York: Van Nostrand Reinhold, 1979.

"Still Unidentified." *JSAH* 11, no. 2 (May 1952): 24.

Stillman, Damie. *English Neo-Classical Architecture.* 2 vols. London: A. Zwemmer, 1988.

Stirling, James. *Letters from the Slave States.* London: John W. Parker and Son, 1857.

Stowe, Harriet Beecher. *Uncle Tom's Cabin; or, Life Among the Lowly.* Boston: John P. Jewett, 1852.

Strickland, William. *Journal of a Tour in the United States of America, 1794–1795.* Edited by J. E. Strickland. New York: New-York Historical Society, 1971.

Strong, George Templeton. *The Diary of George Templeton Strong.* Edited by Allan Nevins and Milton Halsey Thomas. 1952. Reprint, Seattle: University of Washington Press, 1988.

Strother, David H. *Virginia Illustrated.* New York: Harper & Brothers, 1857.

———, as Mark Pencil. *The White Sulphur Papers, or Life at the Springs of Western Virginia.* New York: Samuel Colman, 1839.

Strout, Cushing. *The American Image of the Old World.* New York: Harper & Row, 1963.

Stuart, James, and Nicholas Revett. *The Antiquities of Athens.* 5 vols. London: John Haberkorn, 1762–1830.

"Suburban Gardens.—Parmentier's Garden." *New-York*

Farmer, and Horticultural Repository 1, no. 8 (August 1828): 189.

Summerson, John. *Architecture in Britain, 1530–1830*. 7th ed. Harmondsworth: Penguin, 1983.

Sutton, Robert K. *Americans Interpret the Parthenon*. Niwot: University Press of Colorado, 1992.

Sylvanus. "Random Notes on Horticulture." *Horticulturist* 3, no. 5 (November 1848): 222–24.

"A Talk About Public Parks and Gardens." *Horticulturist* 3, no. 4 (October 1848): 153–58.

Tallmadge, Thomas. *The Story of Architecture in America*. New York: W. W. Norton, 1927.

Tatman, Sandra, and Roger Moss. *A Biographical Dictionary of Philadelphia Architects, 1700–1930*. Boston: G. K. Hall, 1985.

Tatum, George B., and Elisabeth Blair MacDougall, eds. *Prophet with Honor: The Career of Andrew Jackson Downing, 1815–1852*. Washington, D.C.: Dumbarton Oaks, 1989.

Taylor, Michele Taillon. "Building for Democracy: Girard College, Political, Educational and Architectural Ideology." Ph.D. diss., University of Pennsylvania, 1997.

Temple, Nigel. *George Repton's Pavilion Notebook: A Catalogue Raisonné*. Aldershot, Eng.: Scolar Press, 1993.

Thomson, J. *Retreats: A Series of Designs . . . for Cottages, Villas, and Ornamental Buildings*. London: M. Taylor, 1835.

Thoreau, Henry D. *The Correspondence of Henry David Thoreau*. Edited by Walter Harding and Carl Bode. New York: New York University Press, 1958.

———. *Journal*. 6 vols. Edited by John C. Broderick et al. Princeton, N.J.: Princeton University Press, 1981–2000.

———. *Walden*. Edited by J. Lyndon Shanley. Princeton, N.J.: Princeton University Press, 1971.

———. *The Writings of Henry David Thoreau: Journal*. 14 vols. Edited by Bradford Torrey and Francis H. Allen. New York: Houghton Mifflin, 1906.

———. *A Year in Thoreau's Journal: 1851*. Introduction and notes by H. Daniel Peck. New York: Penguin, 1993.

Timbs, John. *A Picturesque Promenade Round Dorking, in Surrey*. 2d ed. London: For the author, 1823.

Tocqueville, Alexis de. *Democracy in America*. Translated by George Lawrence and edited by J. P. Mayer. 1835. Reprint, New York: Harper and Row, 1966.

Todd, Sereno Edwards. *Todd's Country Homes and How to Save Money*. Hartford, Conn.: Hartford Publishing, 1870.

Toole, Robert M. "An American Cottage Ornée: Washington Irving's Sunnyside, 1835–1859." *Journal of Garden History* 12, no. 1 (January–March 1992): 52–72.

———. "Springside: A. J. Downing's Only Extant Garden." *Journal of Garden History* 9, no. 1 (January–March 1989): 20–39.

"A Topographical and Historical Description of Boston, 1794." *Collections of the Massachusetts Historical Society for the Year 1794*. Vol. 3:241–304. Boston: Munroe & Francis, 1810.

Town, Ithiel. Advertisement. *New-York Evening Post* (1 November 1825): 4.

Trollope, Frances. *Domestic Manners of the Americans*. Edited by Donald Smalley. 1832. Reprint, New York: Alfred A. Knopf, 1949.

[Tucker, George.] "Thoughts of a Hermit—For the Port Folio. On Architecture." *Port Folio* 4, no. 6 (December 1814): 559–69.

Tucker, Louis. *The Massachusetts Historical Society: A Bicentennial History, 1791–1991*. Boston: Northeastern University Press, 1995.

Turner, O. *Pioneer History of the Holland Purchase of Western New York*. Buffalo, N.Y.: Geo. H. Derby, 1850.

Turner, Paul Venable. *Campus: An American Planning Tradition*. New York: Architectural History Foundation, 1984.

Tuthill, Louisa C. *History of Architecture from the Earliest Times*. Philadelphia: Lindsay and Blakiston, 1848.

Upton, Dell, ed. *America's Architectural Roots: Ethnic Groups That Built America*. Washington, D.C.: Preservation Press, 1986.

———. "Pattern Books and Professionalism: Aspects of the Transformation of Domestic Architecture in America, 1800–1860." *Winterthur Portfolio* 19, nos. 2–3 (Summer–Autumn 1984): 107–50.

———. Review of *Field Guide to American Houses*, by V. and L. McAlester. *Winterthur Portfolio* 20, nos. 2–3 (Summer–Autumn 1985): 211–13.

Van Zandt, Roland. *The Catskill Mountain House*. New Brunswick, N.J.: Rutgers University Press, 1966.

Varden, Richard. "Design for a Suburban Villa." *Architectural Magazine* 3, no. 32 (October 1836): 464–75.

Vaux, Calvert. *Villas and Cottages*. 1857. New York: Harper & Brothers, 1872.

"A Visit to the Virginia Springs During the Summer of 1834. No. 1." *Southern Literary Messenger* 1, no. 9 (May 1835): 474–77.

"A Visit to the Virginia Springs, During the Summer of

1834. No. II. Salt and Red Sulphur." *Southern Literary Messenger* 1, no. 10 (June 1835): 544–47.

Vokes, Harold E., and Jonathan Edwards, Jr. *Geography and Geology of Maryland*. Rev. ed. Baltimore: Maryland Geological Survey, 1974.

Wainwright, Nicholas B. "Andalusia, Countryseat of the Craig Family and of Nicholas Biddle and His Descendants." *Pennsylvania Magazine of History and Biography* 101, no. 1 (January 1977): 3–69.

"Waiting for Lord Rogers's Urban Renaissance." *Economist* 356, no. 8182 (5 August 2000): 53–54.

Walter, Thomas U., and J. Jay Smith. *Two Hundred Designs for Cottages and Villas*. Philadelphia: Carey and Hart, 1846.

Ward, Barbara McLean. Review of Jessie Poesch, *The Art of the Old South*. *Winterthur Portfolio* 20, no. 1 (Spring 1985): 83–86.

Ward, Samuel G. "Notes on Art and Architecture." *Dial* 4, no. 1 (July 1843): 107–15.

Ware, William Rotch. *The Georgian Period*. 3 vols. 1898–1901. Reprint, New York: U. P. C. Book, 1923.

Warville, Jacques Pierre Brissot de. *On America*. Vol. 1: *New Travels in the United States of America Performed in 1788*. 1792. Reprint, New York: Augustus M. Kelley, 1970.

Washington, George. *The Papers of George Washington*. Edited by W. W. Abbot et al. Confederation series, multivolume. Charlottesville: University Press of Virginia, 1992.

Waters, Michael. "The Conservatory in Victorian Literature." *Journal of Garden History* 2, no. 3 (July–September 1982): 273–84.

Watkin, David. *The English Vision*. New York: Harper & Row, 1982.

Watson, John Fanning. *Annals of Philadelphia, and Pennsylvania, in the Olden Time*. 2 vols. 1842. Reprint, Philadelphia: J. B. Lippincott, 1870.

————. "Itinerary of a Summer Tour of 1827 [to Niagara]." MS, Watson Family Papers, Joseph Downs Collection, Winterthur Library.

————. "Summer Excursions of Year 1831." MS, Watson Family Papers, Joseph Downs Collection, Winterthur Library.

————. "To Note & Observe. Travelling Notes of J. F. Watson. Trip to Manahawkin—July 1833. To Cape May Island—July 1834. To Harrisburgh &c in Jany 1835." MS, Watson Family Papers, Joseph Downs Collection, Winterthur Library.

————. "Tour to New England & Plymouth Rock." September 1856. In "Excursion Notes," MS, Watson Family Papers, Joseph Downs Collection, Winterthur Library.

————. "A Trip to the Sea Shore 1823." MS, Watson Family Papers, Joseph Downs Collection, Winterthur Library.

————. "Watson's Speech in 1840." In "Lucy Watson's Account of New Settlers. 1762," Am. 2705, Historical Society of Pennsylvania.

Webster, Daniel. *The Works of Daniel Webster*. 6 vols. Boston: Little and Brown, 1851.

Weisman, Winston. "Philadelphia Functionalism and Sullivan." *JSAH* 20, no. 1 (March 1961): 3–19.

Weld, Isaac. *Travels Through the States of North America*. 3d ed. 2 vols. London: John Stockdale, 1800.

Wentz, Abdel Ross. *Gettysburg Lutheran Theological Seminary . . . History, 1826–1965*. 2[?] vols. Harrisburg, Pa.: Evangelical Press, [1965].

Wermiel, Sara E. *The Fireproof Building: Technology and Public Safety in the Nineteenth-Century American City*. Baltimore: Johns Hopkins University Press, 2000.

Werner, M. R. *Barnum*. New York: Harcourt, Brace, 1923.

Weslager, C. A. *The Log Cabin in America*. New Brunswick, N.J.: Rutgers University Press, 1969.

Wheeler, Gervase. *Rural Homes; or Sketches of Houses Suited to American Country Life*. New York: Charles Scribner, 1851.

Wheildon, William W. *Memoir of Solomon Willard*. Boston: Monument Association, 1865.

Whiffen, Marcus. *American Architecture Since 1780: A Guide to the Styles*. Cambridge, Mass.: MIT Press, 1969.

————. *American Architecture*. Vol. 1: *1607–1860*. Cambridge, Mass.: MIT Press, 1981.

"White for the White House." *JSAH* 10, no. 2 (May 1951): 22.

Wiebenson, Dora. *The Picturesque Garden in France*. Princeton, N.J.: Princeton University Press, 1978.

Wiencek, Henry. *Plantations of the Old South*. Birmingham, Ala.: Oxmoor House, 1988.

Willard, Solomon. *Plans and Sections, of the Obelisk on Bunker's Hill*. Boston: Charles Cook, 1843.

Willis, N. P. *American Scenery*. 7 vols. London: George Virtue, 1840.

————. *Rural Letters and Other Records of Thought at Leisure*. New Orleans: Burnett & Bostwick, 1854.

————. "The Vacation." In *The Atlantic Souvenir; A Christ-*

mas and New Year's Offering. Philadelphia: Carey, Lea & Carey, 1828.

Wilson, Alexander. *The Life and Letters of Alexander Wilson*. Edited by Clark Hunter. Philadelphia: American Philosophical Society, 1983.

Wilson, Charles Reagan, and William Ferris, eds. *Encyclopedia of Southern Culture*. Chapel Hill: University of North Carolina Press, 1989.

Wilson, Daniel Munro. *Three Hundred Years of Quincy, 1625–1925*. Boston: Wright & Potter, 1926.

Wilson, Richard Guy, ed. *Thomas Jefferson's Academical Village: The Creation of an Architectural Masterpiece*. Charlottesville: University of Virginia Press, 1993.

Windham, Kathryn Tucker. *Alabama: One Big Front Porch*. Huntsville, Ala.: Strode Publishers, 1975.

Wirt, William. *The Letters of the British Spy*. 1803. 10th ed., New York: Harper and Brothers, 1837.

Wise, Daniel. *Summer Days on the Hudson: The Story of a Pleasure Tour from Sandy Hook to the Saranac Lakes*. New York: Nelson & Phillips, 1876.

Withey, H. F., and E. R. Withey. *Biographical Dictionary of American Architects*. Los Angeles, Calif.: New Age Publishing, 1956.

Woodforde, John. *Georgian Houses for All*. London: Routledge & Kegan Paul, 1978.

Woods, Mary N. "Thomas Jefferson and the University of Virginia: Planning the Academic Village." *JSAH* 44, no. 3 (October 1985): 266–83.

Wordsworth, William. "The Brothers" [1799–1800]. In *Selected Poems and Prefaces*, edited by Jack Stillinger, 130–39. Boston: Houghton Mifflin, 1965.

———. *Wordsworth's Guide to the Lakes*. 1810. 5th ed., 1835. Reprint, Oxford: Oxford University Press, 1970.

"The Work of Messrs. Carrère & Hastings." *Architectural Record* 27, no. 1 (January 1910): 2–120.

Worsley, Giles. *Classical Architecture in Britain: The Heroic Age*. New Haven and London: Yale University Press, 1995.

Wright, Frances. *Views of Society and Manners in America*. Edited by Paul R. Baker. Cambridge, Mass.: Belknap Press of Harvard University Press, 1963.

Wrighte, William. *Grotesque Architecture, or Rural Amusement*. New ed. London: I. and J. Taylor, 1790.

Yarmolinsky, Avrahm. *Picturesque United States of America 1811, 1812, 1813, Being a Memoir on Paul Svinin*. New York: William Edwin Rudge, 1930.

Z. "Emigration of Architects to North America." *Architectural Magazine* 1, no. 9 (November 1834): 384.

Zimmer, Edward F., and Pamela J. Scott. "Alexander Parris, B. Henry Latrobe, and the John Wickham House in Richmond, Virginia." *JSAH* 41, no. 3 (October 1982): 202–11.

Zukowsky, John. "Castles on the Hudson." *Winterthur Portfolio* 14, no. 1 (Spring 1979): 73–92.

INDEX

Life dates are given for selected architects and builders of the period. Pages in *italics* have illustrations

Bond, Richard, 87; Gore Hall, 94, *262*; Lawrence Hall, *262*; Merchants' Exchange (Portland, Me.), 21, *22*

Books. *See* Classical literature; Pattern books; Villa books

Boston, *12*, 64–65, 237, 271; Boston Museum, 276, *277*; Brazer's Building, 270–71; Bunker Hill Monument, Charlestown, 238–39, *239*; Colonnade, 182; Copley House, 178, 182; Custom House, 69, 276; East Boston station, 18; Exchange Coffee House, 237–38; Grecian Temple (Point Cottage), Rainsford's Island, 267, *268*; King's Chapel, *20*, 237; Massachusetts General Hospital, *12*; Massachusetts Historical Society, *20*; Medical College, *12*; Merchants' Exchange, 69, 239, *240*; Mount Auburn Cemetery, 36–37, 46, 53, 84, 108, 123; Quincy Market, 237; suburbs, 123–25, 142; Suffolk County Jail, *12*; Tontine Crescent, 20, 52–53, *53*, *57*, 80, 140; Tremont House, 13, *16*, 19–20, 44–46, 67, 116, 234, 238, 252; Trinity Church, 68–69. *See also* Concord, Mass.; Harvard College

Bowes, Joseph, *51*

Brackets, 150–52

Brady, Josiah R. (ca. 1760–1832): Merchants' Exchange (New York), *18*; Saint Thomas's Church (New York), 55, *56*

Bremer, Fredrika, 35, 113, 115, 141, 182, 184, 193, 204, 206–7; on Brooklyn, 127–29; in Charleston, 210; on Greek Revival, 266–67; on Highland Garden, 92; on Hudson Valley, 120, 131; on villas, 13; on the West, 137

Brick, in building, 1, 18, 20, 21, 37, 38, 74, 97, 219, 228, 229, 269; stuccoed, 92, 239, 244

Bridges, 46–49, *47*, *49*, *190*

Bridport, Hugh, 52

Brimmer, George M.: Trinity Church (Boston), 68–69

Britain: and American architecture, 4, 25–26, 51–52, 57–66, 90–94, 98–101, 116–19, 126; emigrant architects, 24–25, 33, 51–52; and Jefferson, 61–62, 198–99; population of, 10–11, 51, 127, 132; porches in, 168–73, 213; suburbs of, 10–11. *See also* London

Brongniart, Theodore (1739–1813): Bourse, 249

Brooklyn, N.Y., 127–29; Green-Wood Cemetery, 108, 264; Rose Cottage, 128–29; Waring House, *129*

Brooks, Samuel H., 100

Brown, Richard, 173, 208

Brown, William, 30, 119, 142, 174–75, 257

Bryant, Gridley J. F. (1816–1899): Suffolk County Jail, *12*

Bryant, William Cullen, 114

Bucklin, James C. (1801–1890): Providence Arcade, 66, 187–88, *188*, *189*

Bulfinch, Charles (1763–1844), 52–53, 118, 219; Colonnade, 182; Massachusetts General Hospital, *12*; Tontine Crescent, 20, 52–53, *53*, *57*, 80, 140; U.S. Capitol, 13–14, 38, 74, *75*, 238; University Hall, *262*

Bullock, John, 65, 257

Burlington, N.J.: Chapel of the Holy Innocents, 264, *265*; Doane House, 52; Saint Mary's, 264, *265*

Burlington, Richard Boyle, earl of, 61

Burn, William (1789–1870): John Watson's School, 246, *247*

Burton, Decimus (1800–1881): Albany Cottage, *174*; Colosseum, 199; Greenough Villa, *115*

Busby, Charles A., 52

Button, Stephen Decatur (1813–1897): Odd Fellows' Cemetery, 86

California, *vi*, 15, 16, *17*, 99, 122, 123, *124*

Cambridge Camden Society, 264

Cambridge, Mass. *See* Boston; Harvard College

Camden, S.C.: Bethesda Presbyterian Church, 23, *245*; Johann De Kalb Monument, 23, 96, *245*

Canada, 184, 204, 263

Cape May, N.J., 141, 193

Carlyle, Thomas, 4

Catherwood, Frederick (1799–1854), 52

Catskill, N.Y.: Catskill Mountain House, 112, 194, *195*, 217; Cedar Grove (Thomson-Cole House), 112–13, *113*, 114

Chalgrin, J. F. T. (1739–1811): Palais du Luxembourg, 73

Chambers, William (1723–1796), 51, 65, 68, 82–83, 153, 244, 256, 257, 258, 260; Kew

Gallier, James, Sr. (1798–1866), 24–25, 33, 51; Municipal Hall (New Orleans), 236–37

Gärtner, Friedrich von (1792–1847), 270

Georgia, 122, 135, 158–59, *159*, 178, *179*, *185*, 208, *210*, *222*, 253–54. *See also* Savannah, Ga.

Gettysburg, Pa., 8, 277–79; Lutheran Theological Seminary, 219–20, *220*; Pennsylvania College, 219–20, *220*, 226, 229, 260

Gibbs, James, 61–62; Saint Martin-in-the-Fields, 62, *63*; Saint Mary-le-Strand, 61

Gilman, Arthur D. (1821–1882), 271, 276

Gilmor, Robert: Glen Ellen, 94, *95*

Gilpin, William, 153

Girard, Stephen. *See* Philadelphia: Girard College

Glen Ellen. *See* Gilmor, Robert

Godefroy, Maximilian (1765–1840?), 51

Goodwin, Francis (1784–1835), 91, 100, 149, 168, 207, 257

Gosse, Philip Henry, 141, 155, 185–86

Gothic Style, 69, 80–81, 85, 86–88, 94, 101, 112, 162, 258, *261*, 261, 262–64, 266, 271, 274, 278; and board-and-batten, 142; cottages, 123, 144–45; expansion of, 55, 99; on the Hudson, 131–32; and rustic, 101; on ships, *35*

Graff, Frederick (1774–1847): Fairmount Waterworks, 40–41, *41*, *49*, 83, *190*, 232–33

Great Britain. *See* Britain

Greek architecture, 1, 39, 81–82, 199, 221–22, 233, 252, 258; Choragic Monument of Lysicrates (Lantern of Demosthenes), 1, 71, 73, 102, *226*, *228*, 230–31, 252, 267; Choragic Monument of Thrasyllus, *232*; Delos Doric, *xiv*, *21*, 39, 71, 81; Erechtheum (Temple of Minerva Polias), 224, 226–27, 248, 251, 252; Parthenon, 71, 184, 225, 226, 250, 258, 259, 264, 267; Temple on the Ilissus, 187, 214, 222, 226, 251, 252; Temple of Zeus, 231; Tower of the Winds, 71, 188. *See also* Doric cabin; Stuart and Revett

Greek Revival: alternatives to, 269–76; in Britain, 221, 246–49; expansion, 220–21; as fad, 260–63; *Greek Revival Architecture in America* (Hamlin), vii, 245–46; and Greek War for Independence, 252–53, 261; in

Philadelphia, 223–33; politics and economics, 252–55; reaction against, 260–68; and slavery, 253–54; and the South, 253–54; twentieth-century attitudes toward, 244–46. *See also* Greek architecture

Greek War for Independence, 252–53, 261

Greeley, Horace, 122

Greene, John Holden (1777–1850): Franklin House Hotel, 98, *100*; Granite Block, 98; Roger Williams Bank Building, 98, *100*

Greenough, Horatio, viii, 36, 58, 67

Griffith, Thomas, 52

Grotto, 102–4

Hadfield, George (1763–1826), 51; State Department, *248*; U.S. Capitol, 71

Halfpenny, William and John, 107

Hall, Basil, 9, 12–13, 63–64, 109, 116, 142, 183, 184, 185, 194, 204, 206, 209, 212; Riceborough, Ga., sketch, *210*

Hall, John, 33

Hall, John G., 52

Hall, Margaret, 182, 208–9, 249

Halleck, Fitz-Greene, 67

Hallet, Stephen (ca. 1760–1825), 71

Hamilton, Thomas (1784–1858), 246; Burns Monument, 268

Hamilton, Thomas (tourist), 66–67, 211

Hamilton, William: the Woodlands, 104, 133, 211

Hamlin, Talbot (*Greek Revival Architecture in America*), vii–viii, 61, 70, 80, 221, 223, 232, 245–46, 252, 271

Harrison, Peter: King's Chapel, 20, 237

Harrison, William Henry, 153, *154*

Harvard College, 94, 260–61, *262*

Harvey, George (ca. 1800–1878), 52; "Burning Fallen Trees," *158*; Sunnyside, 88–92, *90*, *210*

Hatfield, Robert G. (1815–1879): Sun Iron Building, 43–44, *45*

Haviland, John (1792–1852), 51, 82; Arcades (Philadelphia and New York), 187; Eastern State Penitentiary, *2*, 82; Franklin Institute, *232*; Independence Hall, 96; New Brighton, 126; Pagoda and Labyrinth Garden, *82*, 82–83

Haviland's Inn, Mrs., Rye, N.Y., 116

Robinson, Peter F. (1776–1858), 100, 145, 174;
 Vaughan Gate Lodge, *147*
Roebling, John A. (1806–1869), 48
Rogers, Isaiah (1800–1869): Harvard
 Observatory, *262*; Merchants' Exchange
 (Boston), 69, 239, *240*; Merchants' Exchange
 (New York), 239; Tremont House, 13, *16*,
 19–20, 44–46, 67, 116, 234, 238, 252
Roman architecture, 38, 61–62, 71, 73, 81, 85,
 171, 187, 203, 222, 223, 227, 236, 252, 256;
 Pantheon, 71, 236; Temple of Zeus (Athens),
 231
Romanesque Style, 58, *59*, 87–88, 261, 269,
 270
Rossville, Ga.: McDonald-Ross House,
 158–59, *159*
Roxbury, Mass.: Highland Cottages and Glenn
 Cottage, 34, 125, *126*
Royall, Anne, 250–51
Rules. *See* Architectural ideas
Rundbogenstil, 269, *270*
Rush, William, 40
Ruskin, John, 35, 36, 87, 150, 151, 154
Rustic, 28, 101–10, *106*, 125; and log houses,
 152–53; tree-trunk columns, *5*, 105–8, *107*,
 109, 151

Saint Louis, Mo., 16, 48, 52, 137; Courthouse,
 55, *56*, 57
St. Méry, Moreau de, 63
Salmon, William, 101, 203
Saratoga, N.Y., 211: Congress Hall, 193–94,
 194
Savannah, Ga., 16, 179
Schulze, Paul (1827–1897): Boylston Hall and
 Appleton Chapel, Harvard, 261, *262*
Schuylkill River (Pa.) villas, 132–34; Belmont,
 133, 184, 204; Eaglesfield, 133, *134*, 184,
 204; The Hills, 133; Landsdowne, 215;
 Lemon Hill, *41*, 134; Old Gray's Ferry
 Tavern, *84*, 190; Sedgeley, 81, 94, 133, 184;
 Solitude, 133; Sweetbriar, 134; Vaughan's
 Inn and Gardens, 83, 103–4, 190; the
 Woodlands, 104, 133, 211
Scott, Walter, 85; home of, Abbotsford, 88, 118
Sedgwick, Catharine, 68. *See also* Burlington,
 N.J.
Shadows, in architecture, 148–51

Shaw, Edward (b. 1784), 68–69, 121–22, 142,
 250, 257, 263; *Modern Architect, 34*
Sheldons and Slason's Quarry, Vt., 234
Shutters. *See* Blinds
Sidney, James C., 52
Singleton, Henry: New Saint Louis
 Courthouse, 55, *56*, 57
Slavery, 5, *6*, 46, 57, 136, 160, 163, 176–78,
 206, 207, 242, 253–54
Sloan, Samuel (1815–1884), 15, 26, 65, 111,
 150, 174, 204, 213; on Gothic Style, 271;
 Longwood, 136; "Mansion," *131*; "Southern
 Mansion," 136, *137*, 180; survival of works,
 23
Smirke, Robert (1780–1867): Covent Garden
 Theater, 226; General Post Office, 246
Soane, John (1753–1837), 39, 106; Bank of
 England, 223–24; Board of Trade (New
 Treasury), 248, *249*; House of Lords, 223
South, architecture of the, 33, 122, 135–36,
 154, 180, 184–86, 204–5, 206, 207, 211, 244,
 245; and Greek Revival, 253–54
South Carolina, 20, 178, 179, 182, 199. *See also*
 Camden, S.C.; Charleston, S.C.
Springside (Vassar Estate), Poughkeepsie, N.Y.,
 131, 145–48, *147*, 151; Apiary or Bee House,
 145, *147*; log house, 161, 163
Staten Island, N.Y., 125–26; Elliottsville, *127*;
 New Brighton, 126; Sailor's Snug Harbor,
 222
Stephens, Luther: Fayette County (Ky.)
 Courthouse, 68
Stone, in building, 1, 4, 39, 44, 48, 73, 85,
 122, 214, 227–28, 229–30, 231–32, 233–39,
 235, 260, 276; in Boston, 20; and new styles,
 263–64; and vaulting, 37–38. *See also*
 Quarries; Quincy (Mass.) granite; Vaulting
Stowe, Harriet Beecher: *Uncle Tom's Cabin, 5,*
 163, 254
Strickland, William (1788–1854), 25, 38, 46,
 85, 219; Independence Hall steeple, 96–97,
 97; Merchants' Exchange (Philadelphia), 10,
 23–24, *25*, 227, 229–31, *230*, 232, 236, 253;
 Miller Monument, Laurel Hill Cemetery,
 86; Second Bank of the United States, 1,
 199, 219, 225–29, *226*, 229, 240, 245, 255,
 262–63; U.S. Naval Asylum, 213–14, *214*,
 215, 231

Utile et dulce, *32, 35–37, 42–49, 140, 216, 255, 256*

Utility. *See* Utile et dulce

Vassar, Matthew. *See* Springside (Vassar Estate), Poughkeepsie, N.Y.

Vaughan, Samuel: Inn and Gardens (Pa.), *83, 103–4, 190*

Vaulting, *20, 21, 37–38. See also* Stone, in building

Vaux, Calvert (1824–1895), *51, 92, 207;* Apiary or Bee House, Springside, *145, 147;* Central Park, *79–80;* Downing memorial urn, *80;* log house, Springside, *161, 163*

Vauxhall Gardens, London. *See* Tyers, Jonathan

Veranda, *142, 173, 174, 203–4. See also* Porch

Vermont, *234, 235;* State House, Montpelier, *21, 234, 236*

Vignon, Alexandre Pierre (1763–1828): Madeleine, *231*

Villa books, *25–34, 81, 101–2, 135;* and board-and-batten, *143–45;* and porches, *170*

Villas, *10, 26–30, 170;* of Boston, *123, 125;* definition of, *119;* of Hudson Valley, *130–32;* of New York, *125–32;* of Philadelphia, *132–35;* popularity of, *111–23;* in the South, *135–36;* in the West, *136–39. See also* Cottages; Country seats; Suburbs

Virginia, *18, 97, 156, 157, 160, 168–69, 180, 263;* springs, *194–97, 200–201, 215. See also* Charlottesville, Va.; Richmond, Va.; Washington, George: Mount Vernon; White Sulphur Springs, Va.; Williamsburg, Va.

Wadsworth, Daniel, *108*

Walpole, Horace: Strawberry Hill, *262*

Walsh, Thomas W., *52*

Walter, Joseph, *228*

Walter, Thomas U. (1804–1887), *1–4, 69, 85, 86, 100, 228, 274, 276, 279;* Andalusia, *175, 240, 241, 242, 267;* Girard College, *1–4, 2, 3, 9, 38, 68, 231–33, 236, 264, 266, 267, 279;* Jayne Building, *271–74, 272, 273, 274;* Saint James Episcopal Church (Wilmington, N.C.), *99;* U.S. Capitol, *38, 74, 89, 235, 260, 279.*

Ward, Samuel G., *36*

Ware, Samuel (1781–1860): Burlington Arcade, *187*

Warren, Russell (1783–1860): Providence Arcade, *66, 187–88, 188, 189*

Warville, Jacques P. B. de, *116*

Washington, D.C., *48, 71, 72, 88, 141;* Downing memorial urn on Mall, *80;* Patent Office, *xiv, 20, 21, 88, 233, 246, 247;* President's House (White House), *66, 233;* Smithsonian Institution, *58, 59, 79, 87–88, 263;* State Department, *248;* Treasury Department, *20, 70, 233, 246–49, 248, 252, 274, 275, 276;* Trinity Church, *89;* U.S. Capitol, *1, 13–14, 38, 69, 70–76, 72, 74, 77, 89, 222, 233, 235, 236, 238, 241, 260, 279;* Washington Monument, *234, 248*

Washington, George (1732–1799), *88, 96, 177, 229;* Mount Vernon, *86, 118, 167, 168, 169, 204–5, 208, 215*

Watson, John Fanning, *64, 109, 134, 149, 193, 267*

Watson, Joshua Rowley, *133–34, 155, 183, 204, 215;* cottage sketches, *184*

Webster, Daniel, *160, 239*

Welch, John W., *52*

Wells, William: Cyclopean Cottage, *143–44, 145*

Wernwag, Lewis (1769–1843): Colossus Bridge, *48, 190*

West Indies, influences from. *See* Porch

West Virginia. *See* Virginia

Wheeler, Gervase (ca. 1815–1870), *30–31, 51, 122, 168, 207, 214;* Olmsted House, *36*

White Sulphur Springs, Va., *154, 175, 191–92, 196, 200–201*

Wight, Peter B.: Street Hall, *59*

Wildmont, Llewellyn Park, N.J., *278*

Wilkins, William (1778–1839), *24;* Downing College, *198;* University College, *231*

Willard, Solomon (1783–1861), *237–39;* Bunker Hill Monument, *238–39, 239;* Divinity Hall (Harvard College), *262*

Willcox, William H., *182*

Willett, James H., *52*

Williamsburg, Va., *13, 97;* Capitol, *62, 214–15;* College, *201, 215;* Palace Green, *200*

Willis, Nathaniel P., *64, 91–92, 109, 123, 140, 250;* home, Glenmary, *31*